sellphotos.com

sellphotos.com

Your guide to establishing a successful stock
photography business on the Internet

Rohn Engh

WRITER'S DIGEST BOOKS
CINCINNATI, OHIO

www.writersdigest.com

Other fine Writer's Digest Books are available from your local bookstore or direct from the publisher.

Visit our Web site at www.writersdigest.com for information on more resources for writers.

06 05 04 03 02 6 5 4 3 2

Library of Congress Cataloging-in-Publication Data

Engh, Rohn
 Sellphotos.com / Rohn Engh.
 p. cm.
 ISBN 0-89879-944-9 (alk. paper)
 1. Photography—Marketing. 2. Photography—Business methods. 3. Stock photography. I. Title.

TR690.E534 2000
770'.68'8—dc21 99-049666
 CIP

Editor: Megan Lane
Production editor: Christine Doyle
Production coordinator: Kristen Heller
Interior designer: Sandy Conopeotis Kent
Cover photo © Mitch Kezar, kezarphoto.com

About the Author and PhotoSource International

R ohn Engh is well known in the stock photo field as an editorial photographer, columnist, lecturer, newsletter publisher and author.

He began his career as an editorial photographer and in 1966 moved his family from Maryland to the hinterlands of western Wisconsin to a hundred-acre farm on Pine Lake, selling his photos from there to markets all over the United States. He's the originator of the first marketletter (1976) for editorial stock photographers, the *PhotoLetter*. Rohn established the business, Photo-Source International, which he operates from his barn office at his farm. He added another marketletter, the *PhotoDaily*, delivered every day by fax, E-mail, and the World Wide Web, which brings the photo needs of markets such as Time-Life Books, National Geographic and Harcourt Brace to subscriber photographers. He produces additional marketing aids for independent stock photographers, including audio- and videotapes and manuals on various aspects of managing your own stock photo business. He also publishes a monthly eight-page informational newsletter, *PhotoStockNotes*, for stock photographers and photo researchers. His first book for stock photographers, *Sell & Re-Sell Your Photos*, currently in its eighth updated edition, has sold over ninety-six thousand copies and is regarded as the number one practical reference guide by stock photographers around the world. Rohn and his wife, Jeri, have two grown sons, Dan and Jim.

Acknowledgments

M y wife and I live in a farmhouse that dates back to 1886. The Nelson family who built this house toiled from early morning light to dusk to make ends meet. To enjoy these surroundings, they had to steal time away from daily chores. I am grateful to be living at a time when, with the flick of a switch, I can be swiftly connected to friends, news and information from around the world—and all from a house that was built in 1886. Thank you Internet and World Wide Web.

My greatest thanks go to the friends and colleagues who have so generously shared their knowledge and expertise with me. This book truly would have been impossible without them.

Many of these folks are regular columnists to our newsletter, *PhotoStock-Notes*, and not only have contributed to this book but also help put substantive content into *PhotoStockNotes*. My gratitude to our columists: Julian Block, Dianne Brinson, Sharon Cohen-Powers, Joel Hecker, and Effin and Jules Older.

This book also includes direct insights, explanations and observation from the following individuals, veterans in their specialized areas: Jagdish Agarwal, Jeanne Apelseth, David Arnold, Cradoc Bagshaw, Royce Bair, Georgienne Bradley, David Brownell, Alan Carey, Tom Carroll, Skye Chalmers, Phil Coblentz, Jim Cook, Dennis Cox, Joel Day, Denny Eilers, Joe Farace, Bob Finlay, Charles Gillespie, Steve Holt, Mitch Kezar, Steve Knox, Brent Madison, Scott McKiernan, Peter Miller, Larry Mulvehill, Boyd Norton, Richard Nowitz, Dale O'Dell, Jim Pickerell, Ann Purcell, Seth Resnick, Ernest Robl, Bernadette Rogus, Lorilee Sampson, George Schaub, Ron Schramm, Flip Schulke, Michael Sedge, Bob Shell, Don Tibbits, Joe Viesti and Jim Whitmer.

Just as crucial to the depth and dimension of what you'll read in these pages are so many people whose experiences and willingness to butt heads with me over the years have added immeasurably to the hopper here at PhotoSource International, and their contributions are woven significantly throughout these pages. Thanks go to Elizabeth Buie, Peter Burian, Steve Carver, Bob and Carol Culver, Donna Gates, Spencer Grant, Bob Grytten, Michal Heron, David Liebman, Doug Peebles, Tom Perrett, Elsa Peterson, Galen Rowell, Allen Russell, Gary Russell, Ron Sanford, Pete Silver, Rick Smolan and Tom Stack.

I'd like to give special mention to Crimson Star, Web page columnist for *PhotoStockNotes*, whose Web expertise has added incalculably to this book. Another big thanks goes to Bill Hopkins, photographer plus computer on-line columnist to our newsletter, whose technical acumen and accuracy have also been great contributions. Our in-house Webmaster, Owen Swerkstrom, was always on hand to correct my miscues.

And I'm deeply indebted to our crew of typists (keyboardists) extraordinaire: Lacey Holland, Jeff Klawiter, Neil Kral, Belinda Rutledge, Annie Swerkstrom and Joe Wilker.

The staff here at PhotoSource International—Bruce Swenson, my right-hand man, and mainstays Alice Dannenmueller, Angie Dobrzinski, Kathy Kloetzke and Deb Koehler—kept the ship afloat during just about six months of "book takeover," and I can't thank them enough.

My companion on the front cover is Jeri, my wife and best friend for thirty-nine years. If there's polish to this book, she put it there. She's the writer in the family.

I've reserved the last word for Megan Lane, editor of *Photographer's Market*, who accomplished the Herculean task of editing. Thanks to her incredible patience and capable eye, you have this book in your hands.

—Rohn Engh

About the Information in This Book

F aster than a speeding bullet—that's how quickly information can change today. Phone and fax numbers and, especially, Web and E-mail addresses are all in a state of constant change. Every effort has been made to have all resources up-to-date at the time of printing. As time moves along, however, changes will occur. I welcome any corrections to the information in this book. Send me an E-mail (changes@photosource.com) to let me know what you've found, and I'll make the updates in the next addition.

Thanks, Rohn

Table of Contents

□ □ □

□ □ □

Introduction

YOUR PARTNER—THE WORLD WIDE WEB

As an independent stock photographer, you are on the edge of a revolution. It's a digital revolution, but not one focused specifically on digital photography. That can wait. We are in a revolution on how images—traditional and digital—are located, delivered and paid for.

"Bob, it's a whole new ball game. We're in the minor leagues right now, but in a few short years, we'll all be playing in the majors," I said to my friend, Bob Finlay, from Pennsylvania.

Bob wasn't sure what I was talking about. He has been a photographer since childhood (he's now retired) and has a collection of thousands of beautiful photos. They have won prizes and contests. But because the subject matter of his pictures is scattered across the board (from aviation to sunset scenes), it has been difficult for him to achieve consistent sales through his attempts to market his photos via traditional methods.

Photobuyers at the special interest magazines and publishing houses that have dominated the editorial marketplace since the sixties traditionally have wanted to deal with editorial photographers who have deep coverage in the particular subject matters their publications specialize in. These buyers generally haven't wanted to deal with freelance photographers who may have excellent photos but whose subject matter is scattered all over the board, with only thin coverage in any one area. Because of the amount of time and work it takes a buyer (up until now, that is) to establish a working relationship with a photographer, buyers have wanted to make sure that a photographer could be an ongoing resource, with in-depth coverage of the subject areas the buyers need.

Turning the Corner

No more. "The World Wide Web is changing the marketing landscape," I said to Bob. "Thanks to search engines on the Web, photobuyers no longer have to rely on finding photographer specialists in their subject areas. Nor do buyers need to go through the former labor-intensive process to search out, say, 'a recent image of a soapbox derby on the Fourth of July.'

"In the past, photo researchers who needed that 'just right' image would have to look through library books that featured soapbox derbies. They would phone associations of soapbox derby people and get standard cliché shots, some of them decades old. And they would have to sift through images at a local stock agency."

"Now what do they do?" Bob asked.

"When a photobuyer needs a picture of a soapbox derby, he can locate a photographer who has the picture, or locate the picture itself, in just minutes—sometimes seconds—with the search engines on the World Wide Web."

"Yes," said Bob. "I've heard you can buy flowers on the Web, even automobiles. Why not photos?"

And then he asked, "But aren't images sold through the Web going to be expensive?"

"It depends on their use," I said. "If you are an ad agency and want exclusive use of the photos and need model releases for the photos, the on-line Web sites can arrange that for you, and you'll pay a hefty price for that exclusivity.

"On the other hand, if a buyer doesn't need to be concerned about model releases or who else has also used a particular picture, she'll find a variety of fees, ranging from $5 to $35 per photo, on services that offer 'royalty-free' images. Another reason for modest fees for royalty-free images is that buyers will find a great range in quality of the photos, and have to expect to pick and choose.

"Low fees work for the royalty-free companies because their transaction processes are automated. In contrast, 'protected-rights' stock photo companies, because they can offer a purchase history of an image and because their individualized service process is labor-intensive, must charge high fees. Independent stock photographers can charge somewhere in between."

"But could a photo editor or researcher find that Fourth of July soapbox derby picture in one of those massive on-line photo Web sites?" Bob asked.

"The large image services that are on-line would rarely have a picture as specific as that. They post mainly generic pictures that can be used for a variety of situations. They like photos that lend themselves to multiple usage, giving the promise of extra mileage for each picture they accept for their services. But there's a drawback. If a photo lends itself to a variety of uses, it probably wouldn't be the optimum choice for a specific use.

"Here's where the Web now offers individual photographers the opportunity to compete with the major on-line agencies," I said.

"How so?"

"Most independent stock photographers can offer photo coverage that buyers can't find at the on-line Web sites of agencies. The agencies feature primarily generic pictures on their Web sites, whereas independent photographers, even when they have large files of general images themselves, usually also have one or several specialties and can feature descriptions of more highly specific pictures for buyers, such as 'ultralight flight over Victoria Falls,' or 'air traffic controller.' "

"You mean the photographers feature text descriptions of photos? Shouldn't they display the photos themselves?"

"No, not for their initial directories of images. If a photo researcher needs a highly specific picture, say of a soapbox derby on the Fourth of July, he doesn't want to start off by searching through reams of Fourth of July pictures or soapbox derby pictures. He'd rather first locate a *source*—a photographer who is an expert in soapbox derbies or parades. The quickest way to do that is to make a Web search by checking text description rather than searching

through actual photos. It's been said, 'A picture is worth a thousand words,' but on the Web, a word comes up a thousand times faster than a picture. A photo researcher would rather search through a thousand words than a thousand 500K JPEG pictures. Photo researchers are interested in first finding sources for their photos.

"They can use Web search engines to accomplish this. Then they'll ask to see the pictures."

The Same Firepower

"Once the majority of photo researchers begin using the power of the Web," I said, "an individual stock photographer will have the same firepower as a major stock agency. It won't matter to a photo researcher if the image comes from a major stock agency or an individual stock photographer. If it's on target, the photo editor will make arrangements to buy it."

How the Web Became a Viable Marketplace

The Web is changing the way we do our shopping. What was once the dominion of the mail-order catalogs is now becoming the realm of the Web.

As recently as three years ago, it was useless to use the Internet as a source for stock photography. Now, just as the Web is fast becoming the medium of choice for consumers who like to "catalog shop," this transition is also occurring in stock photography.

What has contributed to this change in the picture-search process for photo researchers?

The convergence of technological developments, plus hardware and software innovations, have improved the Web to where it is now becoming a workable alternative marketplace for stock photographers and photobuyers.

Here are contributing factors.

Computers: speedier, more powerful, cheaper

Modems: more powerful, swifter, cheaper

Storage: lower cost of digital compression

Scanners: more selection, lower prices, finer quality

Telephone lines: speedy and becoming user-friendly (with speedier cable technology on the horizon)

Browsers: easy to use and free

Computer literacy: steadily rising in publishing circles

Software: easy and simple Web authoring tools

CD-ROM: catching on; DVD-ROM on the horizon

Digital delivery: soon to become commonplace

Royalty-free: creating new markets and educating new buyers

World Wide Web: For *photographers*—several services to choose from; for *photobuyers*—increasing numbers of photographers and photographs to choose from, speedily found by using search engines with text descriptions of images and photo specialties; virtual portfolios available upon request

Bob said, "Well, it just so happens I have a great shot of a soapbox derby taken on the Fourth of July. I'm a member of PSA [Photographic Society of America], and the picture was chosen to be exhibited at our annual PSA International Conference in suburban Chicago last year. What do I do next?"

"Rush, don't walk," I said. "Put text descriptions of all your top images in a Web site that can act as a directory. Some Web sites also let you exhibit examples of your images.

"If you do place actual photos on the Web, remember to also list a text description of them. Reason? AltaVista's AV FotoFinder [http://www.altavista.com], the ArribaVista Image Searcher [http://www.ditto.com] and Scour.Net [http://www.scournet.com] index millions of sample images in highly specific subject areas. Photobuyers will find your sample photos if you also give the text description. Other text photo search engines are on the horizon."

"This is all fine, but I'm just a drop in a bucket when it comes to pitting myself against the big stock agency conglomorates," Bob said.

"Pay it no mind," I said. "You can live anywhere and still be an important resource to your contact people. My friend Dale O'Dell, who lives in the small community of Prescott, Arizona, is always in touch with his clients worldwide. Dale says that the usual business psychology is no longer a factor for him. He points out that on the Web we are judged *only* on our work and not how cool our studios are, where we're located, how we dress, if we're ugly, or old, or young or whatever. In cyberspace only the work matters. The 'schmooze factor' is meaningless.

"Dale says that he's discovered the Web is the perfect place for the 'virtual portfolio.' It used to cost him about $50 to send a portfolio to a potential client and back via Federal Express, only for the buyer to say something like, 'Nice work, but we have no use for it.' Now, at least with a portfolio or selection of images posted to a Web site, not getting the job or not making the sale is a lot cheaper."

Hundreds of thousands of first-rate photos sit languishing in people's shoe boxes and files around the country, going no place but out of date. The Web now offers more photographers an opportunity to share their photos with the world.

WHY THIS BOOK IS IMPORTANT

Now that the World Wide Web has breathed new life into your favorite subject, photography, not only can you easily locate a workshop, a photo travel safari or the best prices for your camera equipment, but you can join the flourishing new industry of the World Wide Web photography sales.

Not long ago, it was nearly impossible for independent photographers to sell their photos themselves. You had to be either a "name" photographer or associated with a stock photo agency, which took a 50 percent commission on any sale of your photos.

All this has changed. With the Web you can make direct sales (and receive

100 percent). You can also make valuable photobuyer contacts for further sales and assignments that will last as long as you care to remain in business.

Yes, this is a book about business. But it is not a book about work. Work is something many people avoid at all costs, or is something they grit their teeth at and put up with to earn money to make ends meet.

But what if what you love to do can make you money? That's what will happen when you begin using the principles in this book. Since you love taking photos, I will encourage you to follow simple business practices that will put you in touch with photobuyers who are at this moment waiting to buy *your* photography.

The World Wide Web has made this possible. Never before in the history of communications has it been so easy to match a seller with a buyer. In Marco Polo's day, it took months, even years, to make business connections. Today, it's a matter of seconds.

Even if your collection of photos is small, you can still begin today to enter this field and increase your sales while you build your inventory.

Do you need computer experience to be a player in the World Wide Web? Yes, but not much. Because the title of this book, *sellphotos.com*, attracted your attention, I'll assume that you have a collection of photos and you either own a computer and have an E-mail address or are seriously considering purchasing and establishing the same.

If so, you are ready to go. If not, consult Resources, page 229, for a short course on World Wide Web search techniques and a glossary of terms I use in this book that you may not be familiar with. I assure you that if you are not computer literate, after your first sale you will quickly get up to speed.

The Digital Age has brought a kind of democracy to the world of photography. If you have a sensitive eye for pictures and are willing to work at marketing them, you don't need to be a "name" photographer or member of an elite group to say, "I just published another of my images."

No longer is it necessary to go through years of schooling, be honored with awards, recognized in the press or have an uncle who is a publisher to get your photos in print—and get paid for it.

Successful photography, for many years, was the domain of photographers who owned extensive equipment, expensive studios and a large ad in the yellow pages. They joined elite organizations and were showered with ribbons and awards for their work.

That age has passed. The automatic controls on cameras these days make it very possible for a person with a sensitive and creative eye for the visual to also produce technical quality and jump to the head of the publishing line. This might seem upside down to some readers. "Photographers should work their way up, pay their dues, the same way I did," a veteran photographer might say.

Things are changing, and changing fast. *Sellphotos.com* is an attempt to catch you up with photo-publishing opportunities you might be missing out on

because you thought you couldn't compete with "the big guns," the established photo entrepreneurs; that it would take you too much time, too much effort to get yourself prepared for professional results, establish the right contacts and enter the world called the new media, the realm of e-commerce, Web sites, CD-ROM catalogs, WebTV, on-line galleries, E-mail, photography chat groups, search engines, portals, vertical portals and more.

What if you have no track record, no history of publishing? In the new economy of the Digital Age, a track record is no longer a prerequisite. In fact, in some cases, if an enterprise nowadays boasts that it has been in business since 1975, red flags go up. "Who cares?" many art directors will say. They suspect a generation gap and might even be apprehensive of dealing with that company for fear it is resistant to change and not up to digital speed. So, if the icons of the photo-publishing industry are tumbling and the hierarchy of the photographic royalty have been dethroned, who or what will fill the void?

No one knows, exactly. And that's why I have written this book—to assemble the factors that will help discern which way the industry is moving. The Information Superhighway has already been constructed. Through these recent years of its early existence, I have chosen not to travel it in my own vehicle but to hitchhike. During the last decade I've had a good observation post as a photographer, columnist, author, publisher, seminar giver, lecturer and independent business owner. As a hitchhiker I'm in a good position to hear the voices of our industry's leaders, naysayers and decision makers. You'll find the names of picture buyers and photographers you recognize all through this book. Like me, they are opinionated, and I share their views with you.

If you read the weekly and monthly trade magazines in our field (which now rightly include computer/digital publications as well as photography periodicals), you'll discern that not only photographers but the entire corporate world is in limbo. New technology is continually developed and implemented at such rapid speed that many corporate decision makers find themselves overwhelmed, bewildered and in transition. You are not alone. You have good company as we all grope through this change, struggling to decide which card to play in this game of digital poker.

The computer industry has been the flagship in this renaissance. Internet-enabled businesses such as Gateway and Dell Computer are the leading architects. Other industries—auto, chemical, banking and other sectors—are seeing that if they, too, don't become Internet-enabled they will be left out in the cold.

Vendors are enticing consumers; whiz kids are ousting veterans; hucksters are conning the unwary; upstart enterprises are toppling established businesses; new methods are replacing the clunky ones; photo industry stars of the past are waning and taking self-imposed retirement; new updates and versions of software are outpacing the tried-and-true systems. It's all a big

mess. Or a big exciting volcano. Or so it seems. But there *is* sense to be made of it all. In this book, I have sorted out detours and road signs, pointed out dead ends and cleared some of the fog from the highway you are traveling. Have a great trip through the following chapters. Good luck and good marketing!

WHOM IS THIS BOOK FOR?

Someone once said that success is living the life you'd like to live. This book can help you open the door to that kind of success. In this book I deal with the division of photography called editorial stock photography.

Whether you work full time or part time, editorial stock photography allows you to be your own boss, work on your own time schedule, take paid vacations, take the pictures you—not a client—want to take and now, with the advent of Internet technology, compete head-to-head with even the largest stock photo agencies. For the full-timer, editorial stock photography also allows you to live wherever you want to live.

If you're already a pro in a different area of photography—wedding/portraits, journalism, commercial/advertising—and have always wanted to enjoy the freedom and creativity that stock photography offers, this book can show you new avenues of enrichment, as well as how to make the transition to selling your own photos.

If you're a part-timer and a newcomer to the marketplace, you're going to find this book enlightening.

If you've always loved photography but have never known quite how to get started, your day has come.

This book will help you break into selling your editorial stock photography

A Special Note to Those Who Are Just Starting Out

You have great photos. I know that because you have bought this book. You know that others know you have great photos because they have told you. They've even said, "You should get those published."

And that's where it ended. You haven't known *how* to get them published.

Your photos are gathering dust in a drawer or a shoe box somewhere, going nowhere.

But they should be published. Others should be able to enjoy them. And your photos should earn money for you. This book will show you how they can.

It's not as difficult as you might think. No, you don't have to be a computer wizard to take advantage of today's technology. You don't have to know HTML, Java or how to program.

The equipment is simple. In addition to your camera, you need only a minimum of equipment, available at any local computer or office discount store.

Do you need award-winning pictures to qualify? Not at all. The real judge of what's a worthy photo is the photobuyer who is seeking a highly specific picture. If you have that picture, it's worth gold to them, and to you.

and point you in the right direction. It'll give you tips on what others have tried and succeeded—or failed—at. Most of all, it will give you the opportunity to share your talent with others. If you have the desire and the discipline, you'll be published in magazines, books, periodicals and Web sites you've never heard of, countries you might not even know how to spell and special interest books that happen to be on subjects of special interest to you.

Read on!

Keeping Up With the Times

THE CHANGING STOCK PHOTO INDUSTRY

A century ago, magazines featured mostly text. Graphics were secondary. Today, it's reversed. If you include advertisements, our periodicals today feature more graphics than text. The new "automated" stock photo services (with photos on CD-ROMs that offer lower prices for photos) are providing quality generic images to publishers who previously couldn't afford photography as an option. As a result, new markets are now opening up for photographers who produce generic images.

The stock photo industry has finally come around to recognizing a previously largely neglected major marketing principle (one that we actually have been espousing here at PhotoSource International since our beginning). To wit: There's a vast market of photo buyers who are not interested in high-fee, RP (rights-protected) photos. (See an explanation of rights-protected photos on page 2.) They simply want images they can temporarily use, one time, in one of their low-circulation, limited-readership publications.

Let me backtrack.

In the fifties, there were few stock photo agencies. When I returned from a trip through Africa in 1958, I sought out an agency from the few listed in the Manhattan telephone directory. My photos landed at Photo Researchers, a two-person, New York City hole-in-the-wall on Forty-second Street. Photo Researchers is still there today, expanded into a huge operation.

The dozen or so rights-protected agencies of the fifties have increased to several hundred agencies today. In the late eighties this rights-protected stock industry was at its peak. Today it's still thriving, but with the emergence of the massive corporate digital agencies (Corbis, Getty, PNI, Image Bank, Index Stock Imagery, FPG, The Stock Market, Comstock, SuperStock, etc.), many of the smaller stock photo agencies are being bought out or being absorbed in mergers.

The Transformation

The Digital Age has transformed other major industries: communications, transportation, banking, plus the military and government. It was bound to transform our stock photo industry, and has.

In the past, traditional rights-protected stock agencies demanded very high fees for their images, and why not? They had the market all to themselves. There was no Kmart counter in the stock photo industry.

The formation of massive digital stock agencies has changed all this. These new companies are able to reach out to markets that couldn't afford the traditional high stock fees of the past. Using volume as their guide, rather than managed exclusivity, these digital agencies have proved that there was a sleeping market for their inexpensive CD-ROMs and on-line offerings.

This movement has opened a whole new market area for individual photographers whose files are filled with generic photos that, up to this point, have been going nowhere. Today, by using the power of automation, digital photo corporations are selling generic images for very low fees: $35, $15, $10 and $3. Although the per-photo fee is not high, the cumulative year-end total royalties often add up to a tidy sum.

Do these lower fees deflate the market? We have seen in other industries that they do not. The textbook progression is that after a leveling-out period, thanks to lower fees, the market actually expands. If you have an automated volume product at a lower fee, the bottom line usually improves. The consumers benefit, and so does the corporation. It's called free enterprise.

This marketing approach is what we have been espousing here at Photo-Source International since 1976 when we introduced our first marketletter, *PhotoLetter*—still in existence today. Back then we observed there were thousands of small graphic houses, regional publishers, denominational houses and small book publishers whose budgets would not allow the use of $200, $300 or $3,000 images.

Many of our subscriber members, by concentrating on only a few specialized markets among these lower-budget buyers, found they could earn healthy incomes by selling to these markets in volume. In the seventies, these photographers in effect automated their selling methods and reduced administrative costs, much the way corporate digital stock houses have learned to do today.

The theme of my first book, *Sell & Re-Sell Your Photos*, emphasizes this approach. If the picture is good, more than one photobuyer is going to want to use it when there's no cross-readership conflict and the price is within their budget. The early stock photography pioneers found it was a lot less stressful selling a photo ten times at $75 to these lower-budget editorial markets than selling one picture at $750 in the high-pressure commercial arena.

What Is Editorial Stock Photography?

You know what photography is, and you know what stock photography is—yes?

Take another look. During the past couple of decades, an aspect of photography has been growing to where it is now planted firmly on the scene as a photographic division in its own right: editorial stock photography.

These are the photos of everyday slices of life, the insights into the human condition, the events and vignettes and moments you spot and then hurry to capture with your camera. Editorial stock photos show people involved, doing things; they feature specific geographical locations; they give a "real" look at every aspect of human activity and the world of nature. As legendary Magnum photographer Elliot Erwitt has said, "[Photos] have got to tell you something that you haven't seen, or touch you in some way emotionally. . . ." As to his personal preference, he says, "With regard to photography that I respect, my view is fairly narrow. I like things that have to do with what is real, elegant, well presented and without excessive style. In other words, just fine observation."

Editorial stock photos are in contrast to commercial stock photos, which are the slick scenic and product shots—the gorgeous sunset, the healthy senior citizen couple bike riding through autumn leaves—that we see in advertisements and commercial promotions.

Commercial stock photos have to conform to what sells. The commercial photographer must engineer the photos to fit into commercial clients' needs and trends in the industry and to appeal to a wide, general audience. The resulting photos are often called generic images because they can fit a variety of uses.

Editorial stock photos are produced by a different approach. Rather than appeal to the commercial needs of clients, the editorial stock photographer follows her own interest areas and targets certain segments of life and culture that she enjoys photographing. Examples: medicine and health, sports, social issues, travel, etc. The photographer then sells these photos to markets that use images in those specific subject areas.

Buyers in the commercial field include designers at graphic houses, corporate art directors and ad agency creative directors. There's much turnover in these positions, so developing consistent working relationships with these markets is frustrating and difficult.

In the editorial field, the buyers range from photo editors at books and magazines to photo researchers, the people who are hired by publishers and art directors to seek out highly specific pictures. There's less turnover and more longevity with editorial buyers, and editorial stock photographers can enjoy strong long-term working relationships with their buyers, which translates to more consistent sales.

A BRIEF HISTORY OF THE WEB

On TV and radio, in magazines and newspapers, you've heard the terms *the Internet* and *the Web* used interchangeably, and you're scratching your head asking, "Are they the same thing?" No, they are not.

The Internet is the huge worldwide interconnected computer communications network, originally developed for military use, eventually used for academic, commercial and personal research, and for E-mail communication. You

connect to the Internet through on-line services, such as CompuServe, Prodigy, America Online (AOL) or—most commonly—your local ISP (Internet Service Provider). The Internet is the whole grocery bag. The Web is one of the items in the grocery bag.

The World Wide Web is one *part* of the Internet, but it's the fastest-growing part. Thousands of companies, organizations and individuals are setting up their own Web sites. A Web site is actually an Internet location that contains information about a company or individual and allows for the use of color images and photographs, as well as text.

To "build" a Web site on the Internet, a person purchases a "domain" address, which can be a personal or business name and is uniquely hers. A Web site for personal use is like a meeting place for communication; and for business use, it can be like a catalog or a store, where potential customers can "come in," get information, learn about what products are for sale and then purchase them. You can also send E-mail to a Web site's "store owner," to ask questions or to make comments.

The Internet came first, before the World Wide Web. By the early nineties, the Internet had 25 million people using it. The World Wide Web concept came along in 1994, offering personal or business locations on the Internet. Surfing the Web back then meant encountering orange text and primitive designs. By 1995, the University of Minnesota and then Netscape launched browsers capable of rendering graphics.

At first the business community was intrigued by the Web, but in the early days most people thought of it as an interesting toy their teenagers could play with, not as something having far-reaching potential for commercial purposes.

Nevertheless, enthusiasts at Intel, Microsoft, Apple Computer and a host of other hardware and software manufacturers launched into developing authoring tools and bells and whistles for this curious phenomenon known as the Web. Many business backers jumped aboard. Some realized it was premature and quickly jumped back off before losing their shirts. Others miscalculated and went into bankruptcy.

But by 1996, Internet traffic had doubled in size to 57 million, and a good deal of this growth was due to the fledgling Web. The potential of the Web was beginning to attract the attention of entrepreneurs who understood the technology and could foresee what some called outrageous applications. (Who could have ever predicted search engines or gigantic portals such as Amazon.com?)

Internet traffic (including Web traffic) in 1999 is expected to reach at least 147 million, up from 120 million in 1998. Sixty thousand new users of the Internet jump on every day, according to Lucent Technologies. The Web, with its new and improved tools, has come into its own and has reached the point where it can revolutionize your stock photo business. Like the invention of the elevator in the mid-1880s opened up the possibility of building skyscrapers, the Web now opens previously unimagined possibili-

ties for photographers in the new millennium. The chart below shows how strategists and research companies expect the Web to grow and keep growing. (For updates of the size of the Internet, check International Data Corporation's Web site at http://www.idc.com/F/eI/123199ei.htm or http://www.estats.com/estats.usage_nav_tools.html.)

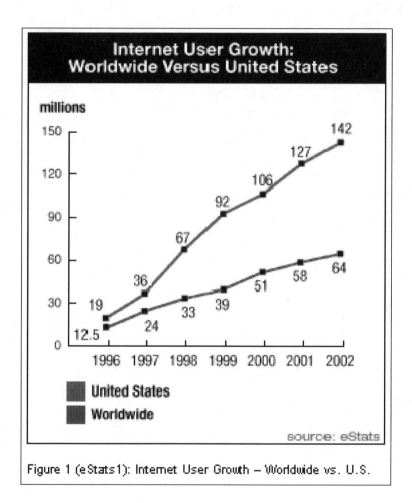

Figure 1 (eStats1): Internet User Growth – Worldwide vs. U.S.

Creating Your Web Presence

YOUR WEB SITE—THREE OPTIONS

A photographer asked this question on the Cracker Barrel, our home page's Q&A bulletin board: "Do you think I should build a Web site?"

My response was to turn the question back to her and ask, "Do you think I should buy a boat?"

Unless you do your homework, it probably would not be a good idea to build a Web site. No more than I should go out and buy a boat before examining my options and my reasons.

One of the purposes of this book is to let you see the World Wide Web backdrop through the eyes of fellow stock photographers who are moving along a route you may want to follow. The function of a Web site for you is to position yourself where photobuyers who search the Web for images they need can find you and your photos. At your Web site, you can have information for buyers about your specialties and you can take orders for picture sales.

There are all sorts of creative ways to use a Web site to get your photos in front of buyers. But take care. Some of the Web sites I've seen are mere ego galleries, the result of falling prey to Web promoters who entice prospects to place their pictures out on the Information Superhighway on a dark night without a road map.

Vanity publishing houses have used this technique in relation to writers for years. A writer pays to have his book manuscript published. The vanity publishing company prints it and gives the writer 5,000 copies. Then the writer is on his own to figure out how to promote the book, advertise it and fulfill orders. The experience becomes an ego buster when after a year's time, 4,900 copies of the book are still in the writer's garage. Not because the contents of the book aren't good, but because of the writer's lack of know-how in the essential area of marketing. (Be sure to read "Get Yourself Known," starting on page 94.)

A similar scenario can transpire for photographers who put images on Web sites without backing up that move with learning how to promote their Web presence and give service to photobuyers in a professional manner.

So, should you build a Web site?

If you do your homework, yes—but here's another caution: Sometimes a photographer will launch into building her own site and end up with a product

that looks very much like a family photo album. Here you need to remember "You don't get a second chance at a first impression."

If you find your Web design skills are inadequate, get help. If consultant fees are too high for you, you can often trade your photography skills with a consultant or Web designer who is in need of images for his business or who would like a family portrait.

A Web site should reflect the same professionality that your letterhead, labels, logo and other promotional materials do. Remember, when photobuyers first find your site, a major part of their assessment of you is going to be the professional approach you put to your site. If you expect first-class treatment from a buyer, you'll want to put your best foot forward and provide a first-class Web site.

What's the best kind of site to have? That depends on you, the stage you're at with your stock photography and your own style of operation. Assess the following economy, standard and premium sites, and see which approach rings bells for you just now.

THE ECONOMY SITE
The Free Site

The price is right. It's *free*. A Web site of your own. Sounds too good to be true? In the past, it might have been. But today, free enterprise is making it possible for anyone with a computer and a modem and a half hour of time to establish global presence on the WWW (World Wide Web).

A few years ago it would have cost you anywhere from $50 to $300 a month to maintain a Web presence, not to mention several hundred dollars for start-up costs, and hours of learning HTML (HyperText Markup Language), the text language used to create documents on the Web. Also, you had to pay for a browser, the software that allows you to look around the Web for various resources and information. Today, all this is free, and extensive HTML knowledge isn't necessary to set up a stage one, plain-vanilla Web site to get started and get your feet wet.

What's behind all this free stuff?

Advertising.

The commercial Web world started out by trying to charge customers for the services on the Web. Very few takers. As Web traffic increased, Web operators followed the lead of commercial TV and began charging advertisers. It worked. Much of the revenue now comes from advertisers rather than from customers.

Where to Go, What to Do

There are several popular companies that will host your Web site for free. And they're not your local ISPs (Internet Service Providers), who might *say* they will give you a free Web site but sometimes charge you a $50 setup fee and a monthly toll. Also, some ISPs won't provide you with Web self-publishing tools to design your page.

You'll need to consider that tied to the free Web site offer from these companies comes your commitment to accept advertising banners on your site. The revenue goes to the Web company, not to you. Another drawback: Although you are provided free E-mail, your address will not be the usual you@yourbusinessname.com, but a long string of slashes and hyphens that will indicate you are operating from a free site. But, again, the price is right, and the free site can be good training ground.

Free Web site companies offer a variety of benefits, ranging from templates for easy page creation to storage space, reliable on-line connectivity, feedback forms, font and color choices. Most of the companies offer essentially the same services. A list of free Web site directories can be found at http://www.1netcentral.com/. Click on "Free Website directories."

Listed below are several companies that provide free services that make it possible for you to set up a Web page in thirty minutes, even if you have no Web experience at all.

GeoCities (http://www.geocities.com) is an innovative Web service that allows you to build a free home page based on a Neighborhood concept, grouping home pages in theme areas such as Broadway, CapitolHill, Hollywood. Follow the simple instructions at the GeoCities site (there are a few steps to go through and they take about fifteen minutes). In addition to text, you can add photos and illustrations to your site. How-to instructions are provided by GeoCities. In the end, you'll have a plain-vanilla Web site that can be embellished as you develop your computer knowledge. GeoCities provides multiple pages, fifteen megabytes of space and a free E-mail address.

Angelfire (http://www.angelfire.com) requires no computer knowledge to build a free Web site. Follow the simple instructions at the Angelfire site (there are about a dozen steps, and they take about thirty minutes). At Angelfire you are allowed five megabytes of data storage. You can also add photos and illustrations to your site. Angelfire provides unlimited pages and free E-mail.

Tripod (http://www.tripod.com) sounds like a photography-oriented site, but it isn't. Though this may be a good one to initially hook up to because you'll receive a URL (Uniform Resource Locator) that reads tripod. You're allowed five megabytes of space.

Switchboard (http://www.switchboard.com) is a person find service that also offers a free home page plus E-mail using the My Studio Web page design tool.

Instant Digital Photos

An easy way to start working with digital photos is to send your roll of film to a processor, such as Seattle FilmWorks. You'll receive not only your finished pictures but, if you elect, a disk that includes your digitized pictures. It's an easy way to learn the process through hit and miss. Photographer-author Joe Farace has written a book on the subject, for entry-level photographers: *PhotoWorks Plus: How to Use Every Feature.*

You are offered five different layouts to choose from and two megabytes of space.

Jayde (http://www.jayde.com/freeweb.html) offers ten megabytes of space, free E-mail and forums.

FreeYellow (http://www.freeyellow.com) offers twelve megabytes of space and will submit your domain to search engines.

Netcenter from Netscape (http://www.netscape.com/promotions/acqbms1 .html?cp = hom08mmbr) offers free personal E-mail, free start-up page, instant messaging and automatic software updates.

XOOM (http://www.xoom.com), unlike the others listed here, offers unlimited Web site space, in addition to free page builder, FTP software, E-mail, free clip art and a chat room section. This is the site that Brent Madison uses (see page 23).

MyFreeOffice (httm://unit1.myfreeoffice.com/main.html) allows unlimited space, Web hosting, no HTML needed and free "your name" E-mail.

This is not a complete list. Other similar free sites are continually coming onto the World Wide Web. Some of these may have dropped off by the time you are reading this. Others you can find by typing in "free Web sites" at a search engine on the Web. A good place to start is http://www.allfreestuff.com or http://www.freecenter.com.

Be on the lookout for Web sites that may be fronts to acquire photos for their own commercial advantage. As an example, at this writing, a "free" Web page offer from theglobe.com says in its license agreement (section 10.2) that any material you put on your Web pages actually belongs to theglobe.com for whatever way it wants to use it. Check out the license agreement before you sign up for a free Web page with any company.

Remember, a free Web site can be a jumping-off place—you can get the feel of the Web and try it out. As you get more comfortable with the Web, you may prefer to design your own site, without all the advertising banners, with an eye toward moving into the realm of professional sites.

Examples of Economy Sites

Note: Whenever searching for an address on the World Wide Web, be sure to type the URL (Uniform Resource Locator) exactly as it's described. Otherwise, the screen might say, "Page not found" or some other error message.

The Nearly Free Site

The two major on-line services, AOL and CompuServe, offer Web site services for a $10 monthly fee. These services include a start-up kit and a home page with enough megabytes to get you started.

Inquire at CompuServe (http://www.compuserve.com) (800) 848-8990, or America Online (http://www.aolpress.com/press/index.html) (800) 827-6364.

AB Photographic Stock Images
 http://members.tripod.com/~AB_Photo
Denis Bachmann
 http://www.geocities.com/Eureka/7696
Bes Stock Photo Library
 http://members.xoom.com/BadGuyKen
Joe King
 http://members.historicwings.com/mustang21photo
Charlie Pruett
 http://www.geocities.com/Area51/Cavern/6734
Bob Savage Photography
 http://www.geocities.com/SoHo/9270

Chris Walter
 http://www.geocities.com/Hollywood/Hills/3177
Clifford White
 http://www.geocities.com/Colosseum/Park/9322

THE STANDARD SITE

If we are to call a free site an economy site, then we might call your next option a standard site. With a standard site, you'll provide more bells and whistles for your visitors, and your site will cost you some modest fees. The standard Web site will have an air of professionality to it—and may be all you'll need to compete in the world of on-line photo sales. For order taking, you can request that potential buyers use your toll-free phone number. You can also have them fax or E-mail you. A photocopy of your order form will suffice.

Your local ISP (Internet Service Provider) will want to act as your host (the server that directs Internet traffic) but it is not necessary to use a local company. In our case here in Wisconsin at *PhotoSource International*, we use a company in Mountain View, California. The cost of Web hosting can range from $10 per month (if you pay three years in advance), to $150 per month, if you have a large site like ours (http://www.photosource.com).

Shop around. Start by using a search engine and search for "Web hosting." The larger the fee and the larger the Web hosting service, the more bells and whistles you can expect: unlimited E-mail addresses, autoresponders, T3 lines, traffic statistics and editing functions. However, at first you may not need many of these aids and services; you can always add them later as response to your Web site increases.

If you already have a free site and are ready to graduate to the next stage, then, on page 21, read the instructions on how to set up a standard site, written by our *PhotoStockNotes* monthly columnist and resident Web guru Crimson Star.

If you do not already have a free site, the first step to setting up your standard site, an independent Web site in which you have a unique address on the Internet, is to obtain your address or Web domain.

How to Get a Web Domain

To set up your own standard Web site, you must first register a name for your site, which is actually your Web address. You register with and pay a modest fee to InterNIC, the company that presently handles domain registration. A domain name in the electronic world of the World Wide Web is like a trademark in the paper world of commerce.

As you know, a trademark allows you to be exclusive. When you establish a "mark of your trade" (we call it a logo in modern days), you make a visual connection between your product and your customers. But an official trademark (a design or symbol, or particular style of lettering for your name or the name of your product) registered with the Patent and Trademark Office allows you exclusivity for only a specific *visual* representation of your name. Someone else

can use the same name for his trademark as long as he has a different visual presentation of it, for example, a different style of lettering, different color, etc.

A domain name on the World Wide Web, however, allows you an exclusive text representation. In other words, you own the words—and no one else can own your choice of word or words for your name, your domain, in the electronic world.

Another advantage of a World Wide Web domain name is the cost. A trademark might cost you anywhere from $245 to $800 (at this writing), depending on the legal services you hire to register your trademark. Also, you need to renew (and pay for) your trademark registration every five years. At this writing, a domain name on the World Wide Web will cost you just $70 for the first two years, renewable every year after that for $35 per year.

Choosing A Name

You need for your domain name to identify what your Web site is all about. You might be tempted to choose an abbreviated name, such as grtphts.com instead of greatphotos.com, thinking to save yourself and your clients from typing in a long name. Don't.

The automation features on the Web will do most of the typing for you. For example, in an E-mail to a client, if you list http://www.greatphotos.com, your software will underline it and serve the whole thing up on your E-mail in true butler fashion. All your client needs to do is click on the resulting (colored) line that appears.

That particular name (greatphotos.com) has probably been reserved by now. But take heart, there are hundreds—thousands—of imaginative names still available. (It's good you bought this book early in the life of the World Wide Web!)

Finding out if a name is available is easy. On your computer, or a local library's computer, type this address in any browser: http://www.networksoluti ons.com. This is the Web site of InterNIC, the company you'll register with. Type in your choice of name and put a dot after it and then the letters *com*. *Com* stands for commercial, which is what you are. (Incidentally, *edu* is education, *org* is organization, *net* is network, *gov* is U.S. government and *mil* is U.S. military.) The InterNIC site will tell you if that name is already being used.

Once you run through your list of choices for a domain name and find one that's available, the InterNIC site will instruct you through the sign-up procedure.

A domain name for your Web address (and your E-mail) indicates to Web visitors that you're a serious player on the Internet. Now you're ready to set up your site. Read "The Standard Site" (see page 21) to learn the ABCs of setting up a standard business Web site.

For details on how to set up your Web site, see Crimson Star's section on our home page at: http://www.photosource.com/crimson/learning.html. Here Crimson takes you through the simple steps of inception to launch.

The Standard Site

by Crimson Star

DO YOU NEED A WEB SITE?

Can you afford a Web site? Can you create a Web site yourself? Can you attract editors, photo researchers, and other prospective clients to your Web site?

Yes, to all counts! Contrary to what you may have heard, setting up a modest Web site is easy and does not require any special or expensive resources.

WHAT IS A WEB SITE?

A Web site is actually a collection of small files located on a computer's hard disk, and accessible by a universal program called a "Web browser." You can develop, test and run a Web site on your own computer, right now, without spending any money.

Then when you are satisfied that your Web site is ready for the public, you will need to spend some money, but not much. You'll need a modem, preferable 56K or higher, and an Internet account—usually $15 to $20 per month—in order to move your Web site off of your computer and onto a "Web server." A Web server is just another computer, but it is accessible by everyone in the world who has access to the Internet.

Let's get started. The first thing you need is a Web browser, which allows you to view Web sites. There are hundreds of browsers available, including these three that I use: Netscape Navigator, Netcom NetCruiser, and CompuServe's Spry Mosaic. Other popular browsers are Microsoft's Internet Explorer, Delrina Comm Suite 95 and Quarterdeck Internet Suite. You don't even have to pay for a Web browser, since most are available for "free." If you purchased a modem recently, you probably received free copies of one of these browsers. If you have already signed up with an Internet Service Provider (ISP), they have most likely provided you with a free Web browser. If you are on any computer-related mailing lists, you may have received free Web browser software (the mailers hoping that you will sign up for whatever services they offer). TIP: Make sure your Web browser is Netscape-compatible, or it will not properly display most Web sites.

If you do not have a modem yet, just find a friend who already has an Internet account and ask him/her to download a free Web browser for you. Once you have installed your Web browser, you are ready to build your own Web site!

CREATE YOUR OWN WEB SITE

A Web browser reads files that conform to the HyperText Markup Language standard (HTML) [see sidebar page 22]. Although these files are standard test files, they are usually called HTML files and often have a filename extension of *.htm* or *.html*. You can create HTML files with any editor or word processor that saves files in standard ASCII [see Resources 229] or text format. I created my Web site using the Notepad program that is included in MS Windows.

When your Web browser reads an HTML file, it displays all of the text from that file on your screen, one page at a time (hence the term "Web page"). Each HTML file will also contain some special formatting commands that the Web browser will use to format the text on your screen, or even to display photographs or other graphic images. Yes, you will need to learn the basics of

HTML. No, it's not hard. No, it won't cost you a penny. Actually, it will be great fun.

There are thousands of HTML tutorial materials available for free. Since you could waste the rest of your life trying to decide which one to get, PC users should just get the one that I used when I first learned HTML: *The Only Web Publishing Tutorial You'll Ever Need!* by Brian J. Collopy.

I recommend Version 1, which is available on CompuServe, in the Internet Resources Forum, Library 9 (WWW/Hypertext Tools), as file HTMTUT10.ZIP. If you do not have a CompuServe account, but you do have Internet access, Version 2 is available at: http://www.bcent.com/html.html.

Since Version 2 covers more material than you might need at this time, try to get Version 1 and stick to the basics for now. If you do not have access to CompuServe or the Internet, have an on-line friend get one of these versions for you. NOTE: This tutorial is shareware. You may obtain it and try it out for free, but if you plan to use it on a continuing basis, you are obligated to register it for a small fee.

LOCATING YOUR WEB SITE

Install the tutorial and follow the examples. Pay particular attention to the section where the author tells you how to set up your HTML files on your own hard disk, and how to point your Web browser to those files.

Did your Panic Index just shoot through the roof? Relax. It's really not complicated. Every resource available on the Internet has a unique address (URL), including each Web site. You instruct a Web browser to connect to a Web site by identifying the address of that Web site. If the address starts with *http*, the browser knows that it must connect to the Internet in order to find that Web site. If the address starts with a filename, the browser knows that the Web site is on your own computer, and it will not even try to log on to the Internet.

KEEP IT SIMPLE

Do not try to do everything at once. Concentrate first on text displays. They're the easiest to set up. As you learn the basics, focus on general design. Eventually you can learn to introduce photos and banners to your Web site, and also, how to make "hot links" to other Web sites with subject matter similar or related to yours.

WHAT IS HTML? Well, there are two answers. Some technobuffs say HTML describes a Web document's structure. Others say it describes a Web document's appearance. Today, thanks to standardization, we can say HTML handles both structure and appearance.

HTML, the first Web language tool, was invented in 1989 by an Englishman, Tim Berners-Lee, as a program for displaying plain text and hyperlinks in the old-fashioned Web browsers. In 1993 the first graphics-based browser, Mosaic, was introduced. It displayed a primitive Web page, using HTML. At first there was no standardization to HTML, then Netscape and Microsoft came along with their browsers, and a standard was born. Everyone followed in line.

Today, thanks to HTML editors (software that relieves you of learning HTML code), you can easily create complete Web sites and high-impact pages. These editors are often offered free to new members of a Web mall. HTML is evolving much the same way word processing evolved in the last decade. It's getting better and better, and easier and easier. The newest form of the language is XML (Extensible Markup Language).

Your goal is still to determine how a Web site really works, and if a professional Web site can benefit your business. You want an ISP (Internet Service Provider) that will host your "test" Web site. Yes, it is still a test Web site even though it will be open to the public.

Some ISPs offer personal Web sites to customers, for free, or for a small additional charge. These personal Web sites are usually limited to one or two megabytes of disk space.

Other ISPs offer a variety of business Web site plans starting at about $25/month, although $150/month might be more typical for a site that provides lots of extras. [Refer to "The Premium Site," page 29].

You do not need to place your Web site with the same ISP that you use for normal Internet access.

Once you sign up with an ISP, it is a simple matter to reconfigure your browser to access your new ISP over your modem. It is also fairly simple to copy your Web pages to the new ISP and bring your Web site to life. Visit my own Web site for links to design guidelines, to search engine links, for graphics info, free promotional ideas, link exchanges, additional HTML tags and other neat stuff.

Crimson Star is a computer consultant and photographer who lives in Jasper, Alberta, Canada. Phone: (403) 852-4111. Fax: (780) 852-4350. E-mail: crstar@crimsonstar.com. Web site: http://www.crimsonstar.com.

Examples of Standard Sites

Brent Madison's (http://members.xoom.com/MadisonImage, E-mail: madison images@pobox.com) has stock photography that has appeared in publications ranging from the *Los Angeles Times* "Travel" section to coffee-table books. When he travels, it's usually in the Orient, his specialty area. He's figured out a way to get there inexpensively. He lives there—in Thailand.

"The Web offers me the opportunity to be in touch with my photobuyers in the States and around the globe almost instantaneously," says Brent. He and his wife, who are originally from Canada and the United States, moved to Japan in 1996. Three years and thousands of images later, they went on to Thailand, their latest base of operations.

Brent speaks Japanese, and is quickly learning Thai. "I have a definite advantage over the traveler who breezes through in a week's time. Where they might catch some images in passing, I can often talk to the people I photograph, learn about their stories and develop a deep connection to my photographs."

Brent has pioneered a system that more and more of his photobuyers are beginning to accept. "By concentrating on a small number of buyers who frequently need photos from Asia, it's worth my time to work up a relationship and explain my system to them."

His method is not complex. When Brent finds a photo request in our marketletter the *PhotoDaily* (he receives it by E-mail), he E-mails the prospective buyer to say that a selection of images awaits the buyer at Brent's Web site. The buyer clicks on Brent's URL (see above), and a personalized greeting page

appears on the screen inviting the specific buyer to click on the selection. Brent includes a personalized note to the buyer along with details about the photos and how to select them for use.

On the greeting page are notices to other photobuyers, also. "This affords a little self-promotion for my work," says Brent. "First it connotes to the buyer that he or she is dealing with a pro, plus it gives the buyer an opportunity to see other selections of my photos."

He also includes separate pages as galleries for viewing, with each linking page having its own theme (for example, Japan, Burma, Europe, etc.).

"When a buyer chooses to lease a photo, they have several options for how they'd like to receive it. I can send the original (or a reproduction-quality dupe) by airmail or FedEx, or I can send them a high-resolution digital file, either on disk, by airmail or on-line. Until the Web gets faster, I actually prefer not delivering large image files on-line, but it's still an option.

"Most buyers are becoming familiar with this process; about 50 percent of those I deal with are willing to learn because of the obvious speed advantage. Once they learn the process, they're willing to deal with me and others through this method as the process of choice," says Brent. "It would be nearly impossible to deal long distance with photobuyers if it weren't for the Web."

For equipment, Brent uses his Nikons, Nikkor lenses and Fuji film (Velvia, Provia and sometimes Astia). He also shoots black and white (Kodak Plus X and Tri X). He scans his photos with his Nikon CoolScan III connected to a Mac G3 Laptop. For high-resolution submissions, he scans his images at a local service bureau. (You can find service bureaus in the yellow pages under "Digital Services." Ask other local photographers which ones do the best job.)

"I love to travel and meet people. Combining this with my interest in photography, I am building a large and dynamic collection of Asian images. Living thousands of miles from my markets can be unnerving at times, but I am now becoming known for my strong Asian file—all workable because of my Web system." (See page 25.)

Richard Nowitz (http://www.nowitz.com), full-time photographer, is living his life's ambition: to photograph exotic peoples and places. His clients include *National Geographic Traveler, Condé Nast Traveler* and other national and international travel magazines and book publishers.

Richard has blazed an exciting trail for himself, far from the days when he was a pharmacist in Albany, New York. He subscribed to our original marketletter, the *PhotoLetter*, and began testing his talents by making sales to small regional publications. Eventually the road led to Israel, where he lived for fourteen years, and back to Washington, DC, where he began picking up assignments at *National Geographic World* magazine.

He utilizes digital technology *big time* to market his work. With a $400 CD writer and a $1,200 Sprint Scan, he creates CD-ROMs of his images. He also uses a local service bureau that employs the Photo CD format, with discs that hold one hundred images with five resolutions of each. He sends these CD-

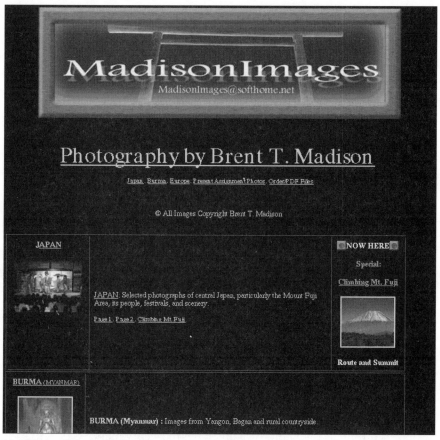

© Brent T. Madison, *MadisonImages@softhome.net*

ROMs to prospective photobuyers to search a disc for specific pictures.

"The traffic on my Web site is accelerating," notes Richard. "When it opened in March 1997, it was picked as best photo site worldwide by *USA Today*. Yet I'm always surprised when a photobuyer calls and says they've seen my site and would like to purchase a picture."

Richard's newest venture has him placing more than eight hundred pictures on his server (located in Colorado) using the searchLynx software, developed by James Cook. (See software list on page 219.) This system allows a photo researcher to enter any number of keywords to search for a particular image using the searchLynx software. The pictures can be any size in the searchLynx system, but for security reasons, most photographers enter them in at 12 to 20K (large enough to convey the impact of the photo, but too low a resolution for print reproduction quality).

"Not only do I direct potential clients to my image database," says Richard,

"but they'll be able to seek out pictures by any keyword they choose. If a buyer sees a picture they like, I can upload it in larger format, or E-mail it, or deliver the original next day by FedEx.

"It takes time to catch up with technology. And it takes more time to harness it and reap its benefits," continues Richard. "And, of course, you can't forget your original focus—that of being a stock photographer!"

Jim Whitmer (http://www.whitmers.com), a stock photographer, is enthusiastic about his Web site.

Jim says, "My first Web site was nothing more than an on-line sell sheet. It didn't work, other than the PR benefit, such as mentioning my URL on my business cards and stationery.

"The big difference came when I increased the quantity of images on my site to seventeen hundred (and growing). Now, my clients are using my Web site in lieu of my print catalogs. I have very few clients that aren't digital to some extent."

Jim periodically updates his Web site with new images when he returns from an assignment. "I then send an E-mail message to my regular customers to let them know they can view them," says Jim. "Very often the sales will pay for much of the expense of my trip!"

"Visitors can view his images in low res. To order a high-res image, customers can phone, fax or E-mail Jim with their requests, indicate the file formats they prefer, sizes and dpi (dots per inch).

At this point Jim sets a fee for the customer based on the picture's usage. "I prefer not to publish a price list for my photos," says Jim. "Each customer is different, and by knowing how the picture will be used, its frequency of use and distribution, we can arrive at a fair price."

Jim then E-mails the photo (usually in ten to twenty minutes) or burns the image to CD-ROM for the customer.

Presently, Jim does not deal in royalty-free (RF) photos. "We will continue with a simple usage fee per image. We feel this would be in the best interest of our clients."

Charles B. Gillespie, M.D. (http://www.imagesbycbg.com) and I recently renewed our friendship and I asked him some questions about his Web site.

Q: Why did you decide to build a Web site?

A: I received a memo from my agent about two years ago stating that they could no longer hold my stock photos in their files unless I had them scanned and returned on CDs. As I had several thousand photos in their files, the cost of the requested process was beyond my budget at the time. As an alternative for marketing my portfolio from home rather than in the hands of agents, I spoke to a friend who had extensive experience in developing Web sites. His explanation of the potential of a personal Web site sounded as if it would meet my immediate and future needs.

Q: Now that you have it up and running, how do you promote it?

A: Word of mouth; letters to friends, photography and publishing organizations; personal calling and address cards; display exhibits; links to other sites on the Internet.

Q: Have you made any sales?

A: Yes, but not as many as I hope to have in the future. Actually, though, I have made more sales via the Web site than I did using the stock agencies in the past.

Q: Did you scan your own photos for use on the Web?

A: Yes, using a Minolta QuickScan 35 unit.

Q: If you had to do it again, would you design and build a Web site differently?

A: I have already had one major revision, which primarily involved chang-

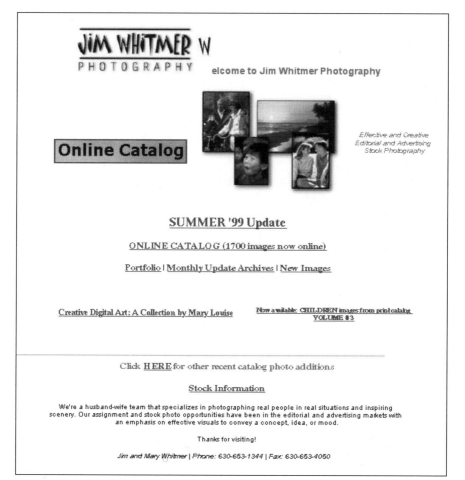

ing the site fonts so as to allow better visual recognition, especially for older people. There have been other more minor revisions, which basically consisted of adding some new subsections, which are identified as posters and new art on the Web site.

Here are some further examples of standard sites if you'd like to check into them:

Fratelli Alinari
http://www.alinari.com

Gary Auerbach
http://www.webphoto.com/gary_auerbach

Peter Balazsy
http://www.pbpix.com

Black Star
http://www.blackstar.com

Ron Brown
http://www.xmission.com/~photofx

Charles Campbell
http://photonaturalist.com/photography.html

Arthur Coleman
http://www.arthurcoleman.com

Culver's Travels-Photos
http://members.aol.com/ctpix

Custom Medical Stock Photo, Inc.
http://www.cmsp.com

Mark and Audrey Gibson Stock Photography
http://www.markgibsonphoto.com

Jazz Photo Source
http://www.jazzphotosource.com

Kerik Kouklis
http://www.jps.net/kerik

Herman Moll
http://www.photo-expressions.com

Jim Morris
http://www.wgn.net/~morris

911 Pictures
http://www.911pictures.com

Jim Pickerell
http://www.pickphoto.com

Lynn Radeka
http://www.radekaphotography.com

Gerard Rhinn
http://www.rhinn.com

Jane Rollins
http://www.webphoto.com/jane_rollins

Kurt Ross
> http://www.kurtross.com

Lori Lee Sampson
> http://www.sampsondesign.com/stock

Eugene Schneider
> http://webhome.idirect.com/~cavlier

Michael Schwarz
> http://www.michaelschwarz.com/stock.html

Eric Scouten
> http://www.scouten.com

THE PREMIUM SITE

Premium usually connotes "more expensive," and so it is with the premium Web site.

To set up a premium site, like with your other options of economy and standard sites, you can call in a consultant. A consultant usually can save you a lot of grief, and a lot of cash. That being said, on the other hand, if you make the mistakes on your own, your failures tend to refine your skills.

However, if you want your premium site up and running quickly, consulting with a Web site designer is the best way to go. Living close to your consultant is not necessary. You can contract with a consultant who lives in Australia and find you'll navigate just fine.

Choosing a Consultant

The usual way to find a consultant for your premium site is to do some homework. Surf the Web and locate sites that appeal to your sense of style and approach to photography. Ask yourself such questions as, "If I were a photobuyer, would this site be appealing to me? Is it too artsy? Is it too clunky?"

When you find at least six sites that appeal to you, do some research. Find out who designed the sites. Then proceed from there to contact those people.

There's an old saying in the creative world, "Don't try to appeal to your sophisticated friends." Don't make the mistake of focusing too much on appearance to the expense of solid content. You could find yourself in possession of a Web site that may win some design awards but has few visitors.

Make sure the consultant you choose understands your vision of priorities, which should be built around your product—your photos—and your service to photobuyers. This way you can avoid getting stuck with a fee for results that may not be the ticket.

The Cost

What will a premium site cost? The answer is the same as that for the question, What does a boat cost? Answer: It depends.

But to give you a ballpark figure, a modest premium site (with the help of a consultant) will cost around $5,000; a moderate one, $15,000; and a full-

blown one, $35,000. Of course, you can modify those estimates at both ends. If you were to do your Web help shopping in New York City, the fee may be higher. In Wichita, it might not be as high. Again, the results are the most important consideration. You want quality; you'll pay for quality. (But you can still negotiate and barter to reach a workable arrangement.)

There are many positives to validate your investment in your premium site. It may be to your tax advantage and/or to your public relations advantage, or it may bolster your professionalism.

Will you realize a return on investment soon? Probably not. The World Wide Web has not advanced to a stage where a premiere photo Web site can guarantee sales. And, of course, there's always the consideration, Do you have the product that will fill the needs of your customers?

The Ingredients

Your premier Web site and the other sites on the Web can be likened to the periodicals on the magazine rack at an office waiting room: You'll find a variety, ranging from low-budget publications to slick national periodicals. They compete for each other's attention.

In a sense, photo Web sites do the same. They compete for the photobuyer's attention. A well-designed Web site, like the cover of a magazine, will attract a potential client's attention. But like a book or magazine that has a superb cover, to be successful the interior has to match the exterior.

The content of your Web site and the ease with which a visitor can respond to your offerings will determine the success of your site.

To help your customers respond, offer them options such as payment by credit card, security for their credit card transactions and a shopping cart. Following is a brief discussion on how you can offer these elements to your customers.

Accepting Credit Cards

We have all heard that if a business accepts credit cards, it can increase its sales by a large percent. What's the process for establishing a credit card merchant account? If you work through your local bank, the process is arduous and a hassle. You have to have had a long association with your bank, plus you'll be asked to pay $500 in advance for a "terminal." Of course, as an E-mail operator you won't need a terminal since you will process your orders electronically using the software provided by your credit card processing organization. Nevertheless, some banks will require you to purchase the terminal hardware anyway, as a token of your sincere effort to follow through on your plans.

It makes more sense to work through the Internet to get a credit card system established for your business. Just as you can shop for a new car, or a new mortgage, or finance new computers on the Internet, the same holds true for getting a merchant credit card account. And the Internet process doesn't present as many barriers or require as many hoops to jump through as your local

bank does. One drawback might be if you reside outside the United States, in which case you would want to set up a corporation in the United States—a big task, but perhaps worth the trouble if you plan to increase your business.

Although we here at PhotoSource International gained our merchant credit card status through our local bank more than twenty-five years ago, I would advise you to go, don't stop, and head straight to the Internet to find information about how to set up your merchant account. Local banks, you'll find, are usually sluggish when it comes to processing applications for merchant accounts. And some banks don't accept American Express. Others don't accept VISA or MasterCard.

NOVA Information Systems (http://www.novainfo.com) is the organization we use at PhotoSource International, and it seems to be the granddaddy of credit card processing organizations. If you are a well-established business, can supply bank references, have have a good credit rating and have a substantial volume of sales, a company like NOVA is willing to work with you.

But how about the SOHO (small office/home office) company that is just starting and has no established track record?

Steve Holt, from Oregon, a subscriber to one of our marketletters and a Web consultant himself, has gone through the process of signing up with a credit card processing service. "I started out with ibill," says Steve, "but we mutually parted ways when my monthly revenue didn't meet the new upgraded ceiling they established."

However, Steve then switched to another service, CCNow (http://www.cc now.com, [877] CCNOW-77, service@ccnow.com), which he found much easier to work with. "For their shopping cart, they provide you with buttons for your products and also a check-out button. Your products must be in tangible form, e.g. CD-ROMs, disks, prints. They do not accept merchant accounts for digital (nontangible) products. However, this may change in the future as e-commerce becomes more prevalent on the Internet. Also unlike most Internet service providers and merchant accounts, the shopping cart came with no up-front or monthly fees which can really eat up your profits. This is particularly attractive if you do not know ahead of time what your site's sales volume will be."

The site is also secured, so you can accept credit cards. One benefit is that there are no up-front or pretransaction costs. However, the monthly fee is 9.5 percent of your gross revenue. You receive a check or a free electronic funds transfer from them once a month.

Is setting up an account difficult? "It wasn't for me," says Steve. "About all the computer knowledge you need to know is how to work a text editor. You basically follow the instructions, specifying your return URL, and cutting and pasting the resulting text into your own pages. Then you're up and ready to go in no time."

Steve's Web site is at http://www.stockpix.com. His shopping cart is found on the "store side."

ON-LINE CREDIT CARD PROCESSING

For a small percent of your gross income, a number of Internet companies will provide a merchant account for you. As long as you have a good credit rating, they are willing to work with you.

Automated Transaction Services Inc.
http://www.atsbank.com/frames/main/index.html

BIT Software
http://www.bitsoftware.com

CCNOW
http://www.ccnow.com

Charge.Com
http://www.charge.com

ClearCommerce Corp.
http://www.clearcommerce.com

ClickBank
http://www.clickbank.com

Credit Card Network, USA
http://www.creditnet.com

Cybercash
http://www.cybercash.com

echarge
http://www.echarge.com

GlobeSet, Inc.
http://www.globeset.com

ibill
http://www.ibill.com

InternetSecure
http://www2.internetsecure.com

Octagon Technology Group
http://www.otginc.com

PaymentNet, Inc.
http://www.paymentnet.com

Total Merchant Services
http://www.tms2.com/cash.html

Vantage Services, Inc.
http://www.vanserv.com

WebCash Corporation
http://www.webcash.com

Searching for a Credit Card Processor

Use search engines such as Lycos, Excite, Yahoo! or AltaVista to get an overview of how independent sales organizations (sometimes called I-Sales) work. These are the folks like ibill and CCNow who are ready, for a fee, to handle your credit card processing for you. They usually work on a per-transaction basis. For an Internet company (which you are), the fee will run from $.30 to $.35, plus a percentage, usually 2½ percent of the day's total credit card orders.

Most companies don't require a minimum per month. Some require you to have been in business two years. They will check your credit history. If it's reasonably good, you're OK. The only thing they can't accept is if bankruptcy is in your business history. Some companies will put restrictions on the kind of business you're in—for example, auctions, adult material, etc. They publish the restrictions on their Web sites. If you're involved in any of these, they'll charge you slightly higher fees.

Security and Shopping Carts

You've probably done some shopping in a Web site that offers a shopping cart. You place items on your own sales receipt, and at the end of the transaction, the software adds up your items and asks you to approve the transaction plus type in your credit card number. Depending on the amount of traffic your Web site is receiving, whether it's the economy, standard or premium, you might want to consider this option from a credit card processing company, which usually charges you an extra fee per month, around $30 to $60, for the credit card security feature plus the shopping cart function. Some sites will offer you both; others will offer the two services separately.

As with all purchases you make, you'll want to be aware of the hidden fees. Here is a checklist of questions to ask.

- [] What, if any, is the minimum revenue per month I need to maintain?
- [] Are there any restrictions on my kind of Internet business?
- [] Since I am an Internet site, do I need to purchase any hardware?
- [] What is the actual cost of the software? Can I purchase it outright?
- [] Is there an application fee?
- [] Do you charge a local bank fee (usually ten dollars per month)?
- [] Do you have twenty-four-hour customer support service?
- [] Do you handle all credit cards, including American Express?
- [] How long have you been in business?

Some companies come up with fees that are illogical, so you might find yourself asking even more questions than I've suggested.

On the Web, use a search engine to locate "merchant card service." As starters, here are two companies to check out: Total Merchant Services, http://www.tms2.com, (888) 463-8723, ext. 10; E-Commerce Exchange, http://www.ecx.com, (800) 748-6318, ext. 2098.

Examples of Premium Sites

Galen and Barbara Rowell (http://www.mountainlight.com) established their multifaceted photography business in 1983. Aspiring stock photographers will find the Rowells' home page to be a good example of a premier Web site.

I met the Rowells in 1985, when Galen and I were speakers at a small workshop in Telluride, Colorado. Galen is also a longtime subscriber to our *PhotoDaily* marketletter service.

Galen is world famous for his outdoor photography and environment concerns. Both he and Barbara are accomplished pilots. Their travels have taken them to all seven continents, and their resulting photos have appeared in publications worldwide. Galen is known for his extensive coverage for *National Geographic* of many Himalayan countries, such as Nepal, Pakistan and Tibet. He has produced thirteen large-format books.

Go to http://www.mountainlight.com/simpleform.html for an example of how to guide customers through the ordering process (see page 35).

Seth Resnick (http://www.sethresnick.com) is well known in our industry as an accomplished commercial photographer. He can always be found in the forefront of new waves of the information revolution, pioneering processes that take advantage of technology without sacrificing quality of service and product.

Seth emphasizes managed-rights photography. "None of our images appear in a clip art collection," says Seth. "We can tell a client exactly where the images have appeared, if there are similars and if they are released."

At Seth Resnick's site you are not going to find an art director's design award, but something much more valuable—a nuts-and-bolts guide to how to price your commercial stock photography. Seth's fee structure is based on exact use. To arrive at an exact fee that a client can expect to pay, Seth asks his clients these questions.

1. Is the photo for electronic or print use?
2. What is the size of the image to be used?
3. Is the image for personal use, corporate use or advertising use?
4. What is the length of display: onetime nonexclusive, one month, six months, one year or other?
5. What is the size of the press run (if use is print).
6. If use is for Web page, what is the location of the image, for example, home page, secondary linked page or banner advertising on a secondary site.

Depending on the use of the photo, Seth then guides the potential client to a published rate chart. Seth's rate chart is a valuable guide for other stock photographers to measure their own pricing scales.

"I'm happy to share this with other stock photographers," says Seth. "I'm all for sharing information as we all struggle through this transition period where pricing stock photography is often a mystery to newcomers." (See page 36.)

Mountain Light Online Order Form

Home
News Room
Calendar
Galen Rowell
Barbara Rowell
Gallery
Bookstore
Posters
Filters
Workshops
Stock Dept
Articles
Resources
Contact us

You can use the tab key to move from one blank to the next.

First Name: _____ **Last Name:** _____

Company: _____

Street No: _____

City: _____

State: _____ **Postal Code:** _____

Country: _____

Telephone: _____ **Fax:** _____

E-mail: _____

Order Request

Enter name of item you wish to purchase, and the number of items.
If you are interested in attending a workshop, enter your preference for workshop level and date.

Would you like your gift sent wrapped and ready for delivery?
For an additional $5.00 per item we will gift wrap your books in this jungle-print wrapping paper. Please type "giftwrap" here _____ and add the charge to your total if you would like us to wrap your gift.

California Residents must add 7.25% sales tax.

Alameda County Residents must add 8.25% sales tax.

Shipping charges vary; see item description for correct amount.

_____ **Total** of all items ordered, including tax (if applicable), gift wrapping and shipping.

_____ **Type** of credit card: (Visa, Mastercard or Discover)

_____ **Card Number**:

_____ **Expiration Date**

If you do not feel confident to send both the credit card number and expiration date in the same e-mail, we suggest sending two **separate** e-mails.
First e-mail include: the: **card number** and your **name.**
Second e-mail include: **expiration date** and your **name.**

We will send you an e-mail upon **receipt** of your order to let you know when to expect your items.

[Submit] [Reset]

Here are more examples of Premium Web sites.

Archivision
http://www.archivision.com

Steve Bloom
http://www.stevebloom.com

Bridgeman Art Library
http://www.bridgeman.co.uk

Comstock Stock Photography
http://www.comstock.com

Contact
http://www.contactimages.com/home.asp

Tim Ernst
http://wilderness.arkansasusa.com

Robert Farber
http://www.farber.com

Wolfgang Kaehler
http:wwwwkaehlerphoto.com/page40.htm

Mitch Kezar
http://www.kezarphoto.com

Liaison International Stock Photography
http://www.liaison-news.com/stock1.html

© Seth Resnick

Photo District News
 http://www.pdn-pix.com/PIX/index.html
Lorne Resnick
 http://www.lorneresnick.com
L.L. Rue Stock Photo Gallery
 http://www.rue.com/gallery.html
Terry Staler
 http://www.earthscenics.com
Visuell International
 http://www.piag.de
Art Wolfe
 http://www.mountainzone.com/artwolfe/home.html

THE WEB PHOTO MALL

Your Web site is your basic storefront. You've just looked at three options you can choose from to set up shop, plus seen how you can create a credit card program, a shopping cart and security for credit card shoppers. Your next stage is to set up the site of your choice and bring in the customers. In a classical brick-and-mortar business for which you are not using the Internet to attract customers, you would face the daunting job of advertising and promotion. On the World Wide Web, you still have to promote your work and your site, but your job is made easier. In the following chapters, I'll let you know how to accomplish the important promotion aspect of your business, and at little expense to your budget.

It might seem that the logical and easiest way to promote your photography would be to place your photos in a Web photo mall, where the mall Webmaster will (hopefully) aggressively bring in customers.

Web galleries, or photo malls, *are* an easy way to get your photos on the World Wide Web. However, some photo malls that you'll encounter are a "nice place to visit but you wouldn't want to live there." Others are "ritzy" and your pocketbook or your accountant would cringe at the thought of signing up. Some are nice for the ego but not very practical (there are few visitors!). Test the waters. Use the free Web tracking service, Alexa (http://www.alexa.com), to find out how many visitors are coming to the Web mall. Observe the activity at Web photo malls from your cyber surfboard, and then decide whether to take the plunge.

Your business can benefit if you establish a presence for yourself on the Web. But you need to look closely at whether you should plan to make your Web site primarily a place to display your photos. While it sounds logical for a photographer to set up her Web site to be a gallery of photos, be careful when considering placing a selection of images on a service provider's Web photo mall. The sales don't always come in.

Avoid the temptation to subscribe to a Web photo mall that will simply display your images without any link to the photo-buying community. Becom-

ing part of one of these Web gallery communites is akin to exhibiting your photos at an art fair. A lot of fun but not much profit. It's true you can make sales from a Web photo mall. And it's true you can win the lottery.

The Web photo mall concept is new and only now beginning to attract photo-buying customers. And if you don't have customers, you're not in business.

We speak with ten to twenty photo editors each day here at PhotoSource International. We ask them if they are surfing the net for photos or if they look at on-line images. They tell us that starting right in looking at groups of photos is too time-consuming. First they locate photographers who have coverage in the subject matter. Then they look at a photographer's actual photos.

Lest you think I am painting a picture of doom and gloom for the Web mall concept, I am not. It has great promise. The reality right now, though, is that in its immature and slow picture-call-up state, the on-line photo mall is missing the main ingredient: customers.

Keep in mind that your Web site is a business venture. For your venture to be successful, you need to attract customers: photo-buying customers. At this point in time, photobuyers are beginning to migrate onto the Web, learning that the Web is a tool that can make their photo search and acquisition tasks easier. However, these buyers are utilizing *text* descriptions of photos and photographers' specialties. Buyers are not surfing the Web to get involved in the time-consuming prospect of looking at pretty pictures at a Web mall gallery.

Soon, on-line advances will impact the photography business in monumental ways. Photobuyers won't want to do business any other way. One such advance is the vertical portal. Portals, such as Absolute Authority (http://www.absoluteauthority.com), direct visitors who are looking for highly specific information (or photos) to highly specialized sites.

Examples of Photo Mall Sites

To take a look at what a photo mall looks like, here are a few examples to tap into. (The first two are free mall sites.)

PhotoLoft.com (http://www.photoloft.com) identifies itself as an on-line photo-album community and digital-imaging commerce center. PhotoLoft.com provides free software for uploading files, and print software that lets you output high-resolution images. You receive twenty megabytes of free storage space.

PhotoNet (http://www.picturevision.com) is a product of PictureVision, owned by Eastman Kodak, and is similar in design to PhotoLoft.com. It is tied to photofinishers across the nation, such as Wolf Camera and Mystic Color Lab.

CompuSolve
 http://www.cmpsolv.com
International Freelance Photographers Organization
 http://www.aipress.com/stock.html

Mira
 http://www.mira.com/
OzImages
 http://www.apn.net.au
PhotoSourceFolio
 http://www.photosourcefolio.com
PictraNet
 http://www.pictranet.com
Portfolios Online
 http://www.portfolios.com/
Press Informations Agentur GmbH
 http://www.piag.de
Press Room
 http://www.pressroom.com
ProNet Portfolio
 http://www.pronet.d-pics.com/
Stock Connection
 http://www.pickphoto.com
The Virtual Gallery
 http://www.photoshot.com

Alternatives to the Photo Mall

A good approach is to enter the World Wide Web in two stages: (1) Set up a text-based site with keywords that photobuyers can swiftly search to find the kind of photos you have; (2) later, once you become acquainted with the Web and how it works, advance to adding image-display capability.

Too often, I find that photographers are in love with their photos—and will place them on the Web at any cost. I liken this to the grandparents who go overboard showing off pictures of their grandchildren.

If you plan to sell your photos on the Internet, ask your customers, the photobuyers, how they go about locating the photos they need.

Using a Text Search

While photobuyers haven't been attracted to viewing hundreds of slow-moving photos in Web malls, increasing numbers of buyers are coming to the Web to do business. Photobuyers are realizing that acquisition of that on-target picture is as close as their computer, thanks to text listings of photos available from stock photo agencies and enterprising photographers.

So spend your time and the modest cost it takes productively: Set up a nonportfolio Web site. List your specialties and photos with text descriptions. (You can either build your own stock list Web site or rent a site from a service such as our PhotoSourceBank.) Of course, include some slam-dunk sample pictures on your home page to give buyers an idea of your style. In the early stage of your Web career, I would say six images would be sufficient. Your

traffic will tell you how to proceed and at what speed.

If you confine yourself to a text-only Web site at first, you'll position your-self to do business by the Web immediately. Search engines are democratic. If a photo researcher is looking for the source of a collection of photos that contains pictures of an orangutan, the search engine might select you (if that's one of your specialties) before a major stock agency. (See chapter three for more about search engines.) With a text-only site, you also have the ground-work in place to be ready to fly when photo transactions on the Web really come into their own.

To view a typical text search site, check out these Web pages at our Photo-SourceBank section: http://www.photosource.com/psb/psb_1582.html and http://www.photosource.com/psb/psb_6057.html.

Information Overload

Sometimes too much information can be as much a burden as too little information.

Web surfers are finding that they can spend hours trying to ferret out a usable paragraph or description on a topic of interest. Photo researchers are discovering that if they aren't careful in how they search for particular photos, they can get inundated with unwieldy amounts of choices. A novice Internet photo researcher is heard to say, "I've spent more time on the Internet research-ing this photo need than I ordinarily would spend using my old methods!"

We are experiencing the growing pains of technological innovation, and two things must remedy the problem: (1) computer programmers have to come up with improved searching devices (their "artificial intelligence" systems aren't human enough!); and (2) we as operators of the search programs have to refine searching techniques so that the disadvantages (volume being a two-edged sword) of an Internet search don't outweigh the benefits.

In each case, have patience. Refinements are on the way.

CHAPTER 3

Working With Photobuyers

TRANSITION!

The customers for your editorial stock are photo editors in the publishing industry. Many of them—maybe half—are not aware of, or choose not to take advantage of, the information revolution in the field of stock photography.

The Web is turning the corner, and the road ahead looks like it will be bringing increased business to stock photographers. But only if their customers join the Web world. Search engines on the World Wide Web are rapidly improving the picture-finding capabilities of the Web. The day is not far off when electronic photo buying will replace traditional transaction methods. Increased Web awareness on the part of photobuyers will make this possible.

I didn't always feel this way about the potential of the Web for stock photographers. In fact, I spent almost three years, starting in 1992, sending out warning signals to readers of my newsletters and columns about the dangers of the Internet for editorial photographers.

Back then I advised my readers *not* to jump onto the Internet bandwagon. The wagon had wobbly wheels, and the band was playing off-key. The road was dusty and had no service stations. Internet travelers were in effect expected to volunteer as pioneers and test the road out, at their own expense.

In the beginning, those who didn't heed my advice found themselves saddled with expensive and inoperable equipment, inappropriate software and an empty bank balance.

This being said, I *have* always had a warm place in my heart for the concept of the Internet, even before the advance of the Web. I even put PhotoSource International marketletters on-line back in 1984. However, over these years I've observed the inertia of photobuyers at editorial markets regarding the new technology. And I've seen software and hardware suppliers fail, trying to figure out where the market will go. Ruefully, I dubbed the Internet the "Imposternet."

Now There's Hope

Things are decidedly looking up, although common problems still exist. We are still stuck with the mountainous problem of slow speed for pictures and graphics using the phone lines, which most photographers and photobuyers

use for Web surfing. "But why go over or around the mountain when we can tunnel through it?" software producers started asking a few years ago. And so was born the concept of search engines. You've probably heard of Lycos, Infoseek, Yahoo!, AltaVista and a dozen others. They have been around for a few years, but recently they've been refined to where they have become real tools for the stock photo industry. They still don't solve the speed problems for picture review, but they facilitate speedy access to picture *description* (text) and retrieval.

Search engines are now a bright light at the end of the mountain tunnel for stock photographers and photobuyers.

Where the Road Leads

Just how do the improved search engines affect the stock photography business?

During my two decades of providing market information for editorial stock photographers, I've seen firsthand the consistency of the work methods of editorial stock buyers. They want content-specific pictures, not generic clichés, and in their search for these pictures, photo editors and researchers first seek out subject matter information, *then* they begin looking at actual pictures.

In the past, if you were a photo researcher and were looking for, say, action pictures of the humpback whale in Hawaii, you'd most likely consult your Rolodex and locate photographers known to have pictures of whales. Or you'd go to your list of Hawaiian photographers. Or you would go to the mammals section of a stock agency and see what it has in the way of whales and hope that it has the humpback. Or you would check at your library for books on sea life, in case any included a section on whales, and then locate the photographer who took the pictures.

In library science this is called narrowing the search. You start with an inverted isosceles triangle and eliminate items that don't conform to your search. Pretty soon, thanks to your detective work, you get to the pinpoint bottom of the triangle. In those earlier days, you'd be satisfied with the "good

WHAT IS A SEARCH ENGINE?

In essence, search engines locate specific information for you on the World Wide Web. You can find out how many trail bikes are manufactured monthly in South Korea, or the hometown zip code of a long-lost cousin. Because search engines inquire by text (ciphers made up of zeros and ones), it's easy for them to locate specific subject matter on someone's Web page in a matter of seconds.

And how do these search engines get this information? Two ways: Anyone can fill out the information form that all search engines provide, for inclusion in the search engine's evolving database. Or some engines, such as AltaVista, will scan millions of Web sites daily and collect information from these sites into their massive databases.

enuf" images your search finally located. Books in your library testify to this archaic way of finding photos.

There are two things wrong with this method of research: First, you waste time by spreading your searching net over such a broad field of possibilities. Second, the search is so exhausting that just about any picture of a humpback whale you finally dig up will satisfy you.

Today the Web provides photo researchers with a new, speedier, more efficient avenue for picture search and acquisition. Using a search engine, the photo researcher keys in: "humpback whale" + "stock photo" + Hawaii. This is a reverse of the pyramid search method mentioned above. A photo researcher now starts at the bottom of the inverted triangle. In a matter of seconds he comes up with seventeen Web sites that list the Hawaiian (Kohola) humpback whale. The photo researcher E-mails a photo request letter to the photographers' Web sites, outlining the specific photo need, and asks the photographers to give the photo researcher a call if they can fill the specs. Five photographers, three who live in Hawaii, one in Japan, and one in Virginia, say they have what the researcher needs.

Even these speed searches will one day be outpaced by new technology coming down the highway. It's called software agents. Photo editors, using cyberspace messengers, will be able to send out these software agents when they leave work in the evening. The agents will do a convenient "roundup" of all the day's image requests and have information about them the following morning.

Then there are several ways photo editors will be able to view a stock photographer's pictures. They could ask the photographer to E-mail some selections, or they can download selections on the photographer's Web site for viewing. (These E-mail or Web page photos are usually 72 dpi [dots per inch]. Since computer monitors can't conveniently support photos of a larger dpi size, it's not necessary to transmit them at a higher resolution.) Or buyers could ask photographers to mail, as quickly as overnight, selections of their images on CD-ROMs or disks. Or buyers could use the Stone Age method of having the photographer mail the original transparencies.

WEB READABILITY

David Arnold, Internet speaker, columnist and consultant, has three simple tricks to get good readability on your monitor screen.
1. Break your material into bit-sized pieces (chunking).
2. Leave plenty of white space around the pieces (spacing).
3. Draw your visitors' eyes to the pieces.

For more information on these principles and how to apply them to your Web site, visit http://www.davidarnold.com/write.htm

Once buyers make their picture decisions, they'll request high-resolution copies of the images, or the original transparencies. Then it's business as usual.

Your Job: Educate the Customer

Photo editors, designers, photo researchers and art directors don't appreciate photographers telling them how to run their businesses. So it might be a while before using the Web becomes standard procedure. All of the technology is in place; it's only a case of having the picture buyers read the manual. We might have to wait until most of the current photo editors retire. We are dealing with human nature. Change doesn't come easy.

A transition is always painful, even when it's beneficial. Like water that crystallizes into ice, a transition happens gradually. Before water hardens to ice, it goes through a mushy period. That's where we are now.

You can accelerate progress by offering (socially correct) insights to your photo editors about the tools now available to them on the Web. But do get your mind-set prepared; change *is* barreling down the pike.

Use this Photographer's Wish List To Photobuyers to assess how your buyers stack up. The more of these points a photobuyer offers you, the more you want to nurture an ongoing business relationship with that buyer.

A Photographer's Wish List to Photobuyers

1. Return photos promptly.
2. Pay on acceptance.
3. Include tearsheets when available.
4. Include credit line and copyright notice.
5. Offer fair prices.
6. Properly pack photos for return shipment.
7. Know your rights: Do not insist on model releases unnecessarily.
8. Do not use fishing trips to get ideas for the staff photographer.
9. Pay return postage for established photographers.
10. Be professional. (If you expect first-class treatment, you've got to give it.)
11. Pay research fees.
12. Buy directly from freelancers.
13. Return all E-mail and phone calls.
14. Develop an "available photographer's" list and put me on it.

PHOTO DELIVERY IN TODAY'S CYBER ENVIRONMENT

When you look at photographs from the turn of the nineteenth century, you see horse-drawn carts mingling with gasoline-powered vehicles in the streets of major cities. Horses eventually left the picture, but it took another quarter of a century.

Will the same slow transition take place in the field of stock photography? Despite the available technology, photobuyers and some photographers insist on clinging to the tried-and-true photo distribution methods of the past.

If you've heard of Sam Walton, you know that he pioneered the "just in

WHY PHOTOBUYERS DON'T RETURN CALLS

Internet speed aside, you are still going to find an age-old communication problem between photobuyers and photographers. It's the "Photobuyers don't return my calls" syndrome. I've asked several photo researchers what their reasons are for sometimes not returning photographers' calls.

Tyler Pappas, Photo Research: "We work under incredible deadlines. When I'm searching for a picture, I let photographers on PhotoDaily know the deadline and ask them to call before submitting. If the deadline is, say, Monday, and for one reason or another the photographer can't reach me by phone on Monday, it's best not to call on Tuesday and expect me to return the call, because the tight deadline has passed for that project and I'm already tied up in work on a new one."

Joseph Taylor, *The World & I*: "I'm glad for the opportunity to explain my side of the issue. First of all, we value the photographers who submit to our publication, so communication with them is of great importance. If I don't return a call, it's usually because it was a case of getting behind and trying to catch up to the next deadline. I hope this is not discouraging to photographers (not getting a return call), but sometimes there are not enough hours in the day to make the calls. I hope photographers understand why calls sometimes are not returned, and that they realize we definitely need their services."

Leslie Wigon, Infinity Features: "I appreciate the photographers' concern. They are in business, just like I am. Some of them are a Mom just like me and work at home. So they can appreciate if I don't return a call if I already have the picture. I know it appears rude, but everybody's time is of essence in this business. Additionally, the photographer will sometimes describe the picture they have and then say, 'Give me a call.' But what if the picture they describe is not on target? I know it must be frustrating to the photographer, but that's an element in this business we all have to contend with. Finally, and I hesitate to be critical, but some amateur photographers' work is not up to standard. I shouldn't be expected to return phone calls of photographers who need more experience and training before they enter this profession."

Billie Porter, Photo Research: "*If* I get fifteen calls from people I don't know, I tend to return the calls that sound the most likely to have what I need. I take them in order received, and if I find a few that sound promising, I will probably not return the call from those who say only to call if I need to. Actually I appreciate those, as it leaves me free to choose, but I guess the photographer feels he missed a chance for a sale, or at least a satisfying contact. That is sad, and perhaps we both lose, but it's those budgets that drive the issue.

"What is the solution? For me, it is E-mail. I think E-mail is the best thing since the wheel was invented, and because it is quick and free, it means I can reply to any number of calls with very little input of time. Also, some photographers who respond that way include attachments or links to a Web site that will offer a scan of what they have, and that really helps.

"Now that the electronic world makes it possible for publishers to produce books three times faster than they did ten years ago, we all are pressured to do things faster than ever."

Julie Smith, Harcourt Brace & Company: "Returning phone calls is a problem. That's why I ask suppliers to fax first. It's a good idea for the photographer to write in the fax something like, 'If you've already filled the photo request, or if my sample fax image doesn't meet your specs, no need to fax back.' For the most part I do return the calls (or usually faxes) of photographers that respond to my requests. With faxes, it's sometimes easier because I can just jot my response on the fax they sent me and send it right back."

Elyse Rieder, Photo Editor: "At times I will post a request in the PhotoDaily and I'm barraged with phone messages from photographers. I use my best judgment and intuition as to which photographers really might 'hit the target' and which are not 'hearing' what I need and are just eager to send me whatever they have. A smart photographer will leave me a long, detailed description of their image. If it meets my needs, you can bet they're going to hear from me. If they just leave me their phone number or a vague description, chances are they won't get a return call.

"I often limit my choice to the first two or three photographers who I think will hit the mark. I'll put off phoning back the others until I see what arrives. A photographer who's a few days late in phoning me might have exactly what I'd asked for, but I won't call back. I have to place limits on the volume of submissions and Federal Express shipping fees once I receive a worthy slide.

"Freelance photo researchers are pressed for time due to ever shorter deadlines and ever restricted budgets. And yes, this even includes phone calls. So, please don't take it personally if I don't always return your calls."

time" supply mechanism. That's where a hardware store or similar retailer never runs out of bolts and nuts because the bar codes or cash register signals to a computer residing at the nuts and bolts supplier that the store has reached its "replace now" level. This eliminates (among other things) a salesperson to take orders, the need to contact the supplier when inventory is getting low and keeping unpopular items on the shelves. This is the opposite way from how goods were sold in the past. The tail wags the dog, so to speak.

Walton's supply mechanism, which has helped today's retailers cut prices, can also be useful to the stock photo industry. Since book and magazine publishers know their editorial lineups months in advance, such a system could help photo researchers find "just-right" digital review images far ahead of proposed schedule dates.

Sixteen years ago, I wrote in our *PhotoLetter* marketletter that within the decade there would be a new dawn for stock photographers thanks to the blossoming Digital Age. The decade came and passed. No dawn. Human nature just won't allow change to happen that fast. I've shifted my predictions. Now I have a new prediction. Dawn is just around the corner. Brick-and-mortar retailing in the stock photo industry will begin to crumble as we pass over into the beginning years of the twenty-first century. If you're reading this in 2005, you're saying, "Yes, I guess it's here. The information revolution for editorial stock photographers has arrived."

E-Commerce Is Right for Stock Photography

In the new world of e-commerce, you need never run out of toothpaste, shaving cream or aspirin again. It's possible now to simply have all such items arrive at your home on time on a regular basis. As we move into the Digital Age, and as publishers become even more specialized in their need for specific content, immediate availability of photos will also be the norm.

Say your specialized area is dogs. You attend dog shows on a regional and national level. When you return from your shoot, you edit your photos and E-mail a selection to each of your clients to add to their in-house libraries. Since these are longtime trusted clients of yours (I can assure you that you need have no sleepless nights for fear someone in the publishing houses is going to steal your photos), you know that each time they select one of your digital images for publication, they will send you a check, or better, they will wire the money directly to your bank account. I have touted this system ever since the first printing of my book *Sell & Re-Sell Your Photos* in 1981, and I am still reaping the benefits of this system, even though I have not been actively taking photos for the past decade.

Some of your clients may wish to keep only thumbnail images on hand. Others may want you to download high-resolution images. Others may need only text descriptions of your images and ask you to send specified original transparencies only when they are certain they will be using them for publication.

This permanent-file system—even better than Sam Walton's because it allows portions of your digital stock collection to reside on the hard drive of your trusted editorial clients—saves you hours of marketing, prevents transparency losses and keeps you at the head of the line with many clients at the same time.

Although local digital storage of your photos might not start tomorrow, you can expect that it will be in full blossom within five years. You have the chance to start building files of photos within your photo-marketing strength areas (see page 61) now that match the needs of photobuyer clients and offer you a lifetime of sales opportunities.

HOW TO SUBMIT YOUR IMAGES
Standard Mail Submissions

The digital revolution has not advanced to the stage where most of your clients can or want to accept digital files. The solution is to deliver your original transparencies by carrier or the U.S. Postal Service.

Some photographers hesitate to send out their original slides. "It's too risky," they say. But consider the risk of *not* sending your slides as they gather dust in your files. Originals can safely be sent if you package them well. Send only to established publishing houses that have been in business at least three years, and you'll be sure of dealing with photobuyers with professional ethics who reliably return your material. Again, these are publishing houses you have researched and established contact with. At PhotoSource International, we have been working with photobuyers for twenty-five years and have established a star system to let subscribers know of a publisher's track record. It is extremely rare that a subscriber will have the experience of slow pay, no pay or damaged prints or slides. But it does happen, even in our experience. Besides, I can't think of any business where there's no risk involved, even if it's minimal.

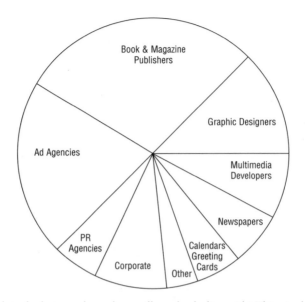

As an editorial stock photographer, whom will you be dealing with? This pie chart shows the markets most stock photographers have as their targets. Editorial stock photographers tend to focus on book and magazine publishers. Both commercial and editorial stock photographers also have common target markets: ad agencies, PR agencies, calendar and greeting card companies, newspaper publishers and multimedia developers.

When submitting your photos, make every attempt to deliver a crisp, professional-looking package. One photobuyer told me that he receives about twenty pounds of mail every morning. He separates it into two piles—one that he attacks immediately and a second that he will go through "when time permits." I asked him how he knew how to separate the piles and he answered, "By the professionalism of their packaging."

The Package
A photographer competes with all the other twenty pounds of freelance material when his package arrives. Use a packaging system that will stand out. I have noticed that the white mailers made of stiff cardboard give an excellent appearance. A good feature of this mailer is a slotted end flap, which makes the package easy to open and close. A photobuyer can use the same mailer to return the photographs. The mailers can be recycled several times, since they are made of heavy material and hold up well. This type of mailer also saves you from having to pack your photographs awkwardly in two pieces of cardboard wrapped with rubber bands. Instead you can put your photos in trim-looking plastic sleeves for a nice presentation. The white is preferred over the manila because the white gives a more professional look and pops out on a photobuyer's desk.

As long as we're considering the book-by-its-cover judgment, you should invest in some deluxe personalized stationery and address labels. Remember: Frequently your only contact with a potential buyer is via your Web site or the package you submit. You might go even further and have a label printed with your name and return address, which you'll include inside the mailers with return postage for the photobuyers.

Give the same attention to a professional-looking appearance for the inside of your package. Plastic sleeves for both black and whites and slides help. They come in the 8″×10″ size (.3000 mil) for black and white and are available at the plastic distribution houses listed in the yellow pages. Plastic slide pages for color transparencies are available at camera stores. Besides presenting a fresh appearance, the sleeves protect your shipment from coffee spots, scratches and general wear and tear.

Unless you subscribe to the FedEx or UPS service, you will no doubt be delivering your package via the U.S. Mail. I have found all three of these services equally acceptable. Assuming you will utilize the U.S. Postal Service, you will find Priority Mail as the most effective. Shipping your photographs registered mail is acceptable, of course, but expensive. However, always invest in a return receipt. In twenty-five years, I've had only one shipment lost by the U.S. Mail and one by UPS, and the return receipts came in handy to track them both down.

Be sure to include return postage. Photobuyers not only expect it, many require it. Some refuse to return photographs if the return postage is not included. Best way to cover return postage costs: Write a check for the amount of postage. Some buyers then pay the return postage and also return your check!

Use a computer label to identify your pictures with your name plus a picture number. In case a photobuyer wants to refer to a specific picture in his correspondence with you, he'll refer to the picture number. Stock photos, because they are often generic, generally do not need captions. However, some buyers may require them. Their photo guidelines will be your guide.

Writing the Cover Letter

Always include a cover letter. It can be short. In fact, the briefer the better. It should be addressed to a specific editor or buyer. Find the person's name through your initial research on the Web or in the current *Photographer's Market.*

A typical letter might read like the one on page 50.

Note: If the photobuyer is able to receive digital submissions, send an E-mail with sample preview (72dpi) scans.

The following letter may not be prize-winning literature, but it's the kind photobuyers welcome. It gives them everything they want to know in case they are interested in you. In fact, make typeset copies of this letter and use it as a

Dear _____:

Enclosed please find [number] [slides, 8″ × 10″ black-and-white/color prints] for your consideration. They are available at $_____ (color) and $_____ (black and white) for onetime publishing rights, inside editorial use. Additional rights, such as electronic rights, are available. Please include credit line and copyright notice as indicated.

You are welcome to scan or photocopy the enclosed picture(s) for your files for future reference. My name, address, and print # are included with each picture.

I'd appreciate your bringing the enclosed pictures to the attention of others at your [publishing house] or [company office] who may be interested in reviewing them.

You are welcome to hold this selection for two weeks (no holding fee). I have enclosed postage for its return.

Thank you for your attention.

Sincerely,

[Your name]

form letter. Potential buyers then know you mean business and that you're a pro and constantly sending photos out.

E-mail Submissions
The Package
There is no package. Internet submissions eliminate the hassle of stationery, labels, sleeves, overnight deliveries, return postage, holding fees and packing your photos. And not to mention the risk of losing or damaging the pictures themselves.

If only more photobuyers would accept digital submissions! At this writing, about 30 percent of the buyers in the editorial field are able to accept digital submissions. In the commercial stock field, it's about 75 percent.

Writing the Cover Letter
Again, always include a cover letter—the briefer, the better—addressed to a specific editor or buyer.

A typical E-mail to a potential buyer might read like the one on page 51.

Again, it's essential that you state a fee—within the fee range you've found

Dear _____:

My photography work matches your publication's interest area, [mention the interest area here]. I have recently posted several new (72-dpi) images at http://[yourdomain] .com/section.html, and I invite you to view them. High resolution are available upon request and can be delivered via E-mail, CD-ROM or regular mail.

The images are available at $_____ (color) and $_____ (black and white) for onetime publishing rights, inside editorial use. Additional rights, such as electronic rights, are available. Please include credit line and copyright notice as indicated.

I'd appreciate your bringing these images to the attention of others at your [publishing house] or [company office] who may be interested in reviewing them.

Thank you for your attention.

Sincerely,

[Your name]

the publication or company pays (by doing your homework on the Web or in market directories).

Before sending your images via real mail or E-mail, compare your shipment to this list.

Selection: Do your photographs fall within the targeted interest area of the photobuyer?

Style: Do your photographs follow the illustrative style the photo editor needs for the tone of his publication or project? Have you personalized your letter and tailored it to the special interest needs of the buyer? (General "fishing trips" by stock photographers, whether sent by E-mail or standard mail, are not appreciated by photobuyers.)

Quantity: Are you sending enough images? For an average submission, a minimum of two dozen is advisable; in a mailed packet, a maximum of fifty. There are exceptions to this, such as the response to a specific photo need request, or the single, truly spectacular shot in the special interest area of a photobuyer. Also, depending on the nature of the buyer's needs, you will want to send one hundred or more images at certain times for volume needs.

Quality: Can your photographs compete in aesthetic and technical quality with stock photography the photobuyer has previously used?

Appearance: Is your E-mail addressed to the correct person at the publishing house or company? Is your standard mail submission neatly packaged?

SOME ADVICE FROM A PRO

Jim Whitmer, with his wife, Mary, has worked in the editorial stock photography field for over twenty-five years. He has followed advancements in the digital field and has rolled with them. Thanks to the tight market list he has developed, he is able to communicate with photobuyers almost entirely by E-mail.

Whenever Jim and Mary return from a trip, they post a selection of photos on an accessible Web page on their Web site called Monthly Photo Updates. (To view a typical page, see http://www.whitmers.com/updates.html.)

Jim also sends periodic CD-ROMs to his major clients. The discs are categorized by Jim and Mary's specialized photo strength areas: Teens, Minorities, Scenics, Families, International, Religious Themes and Education. (See page 61 for information about determining your own photo strength areas.) Each CD-ROM contains over seven hundred images with the note: "You can use any image on this CD for layout and design purposes, and then contact us for the high-res image file."

If your package doesn't conform to the suggestions above, then hold off submitting. Eagerness is a virtue, but as in any contest, you must match it with preparedness. Photobuyers will remember you if you can deliver the right goods in a professional manner. And they will most certainly remember you if you don't.

SENDING ORIGINAL TRANSPARENCIES

The digital revolution overcomes a barrier that has long plagued the independent stock photographer: sending original transparencies.

The beauty of digital transmission of photos is that one image can be seen in forty (or forty million!) different places—all at one time. But even though the digital concept is sound, and the technology is available, many of your photobuyers will continue to cling to traditional twentieth-century methods for accepting transparencies.

We are all faced with the dilemma and transition that this technology presents. Should we wait until the greater majority of our buyers are up to digital speed, or should we operate as if digital photography did not exist?

My advice would be: Go about business as usual. As long as you've developed existing clients, you can always make the transition to digital when they are ready. Eventually, when they *are* ready to make the transition (it's usually a budget decision), you'll be able to offer advice. By helping them through the transition period, you'll have increased their dependence on you as a supplier.

Interim Marketing

In the meantime, you'll need to wrestle with the agelong problem of sending original transparencies to most of the photobuyers on your market list. Since

your images are your stock-in-trade, you want to have them available when you get a photo request. If some of your original transparencies are at a photobuyer's, being held for consideration, those images are tied up and can't be out there available for sales opportunities.

Stock photographers are put in a bind when a photobuyer holds a transparency longer than normal. ("Normal" is two to three weeks.) On the one hand, if, after three or four weeks, you ask for the transparency's return, you might lose a possible sale. And on the other, if you let it remain at the publishing house, you have taken it out of circulation and others can't see it (or buy it).

One of the answers to this dilemma is to always make in-camera dupes when you are photographing. This way you'll always have extra "originals" and not be at a disadvantage when one buyer holds your picture(s) too long. Another answer is to make 70mm reproduction-quality dupes of your very best images. Then you can circulate several copies to potential buyers.

How Long Should They Hold Them?

What is an acceptable amount of time to hold an image? Magazines, with their short turn-around time, will usually hold a picture no longer than two weeks. Book publishers, in contrast, because of the complexities of putting an entire book together, will hold a picture six to eight weeks or more, depending on the situation.

Publishers to avoid are those who by their actions show a disregard for photographers and little or no sensitivity to their need to keep pictures moving. Either because of faulty administrative practices or just plain ineptitude, these photo editors tend to hold pictures well beyond a fair length of time. Publishers of bird, horse and pet magazines particularly will often be lax and sometimes cantankerous in their attitude toward photos and photographers. (This probably comes from their advantage of having a huge number of photos and photographers to choose from.)

No Worries: The Permanent File

Probably the best way to solve the holding problem is to place your duplicate slides in a publishing house(s) that maintains a permanent file (see page 58). This, of course, would be a publisher you've worked with a good while and who has a track record for handling photographers well.

In a central art library, an administrator files your (reproduction-quality) duplicate slides or black-and-white prints for possible future use. When a photo researcher at the publishing house uses one of your pictures, you receive a check. After publication, the image is returned to the central file until it is reused, and a fee again is paid to you.

This no-worry method has been used for years by longtime stock photography professionals.

The Digital Advantage

Once publishing houses begin to realize the digital advantage of storing reference photos in this manner, you will be able to scan appropriate photos in your collection and download them digitally to a publishing company's central art library. In the long run, it's much more to your advantage to let a trusted buyer scan a selection of your images to keep on file at his company than to hoard them at home where no one can see them.

As far as thievery goes, yes, I have had a couple of reports where a new art director has come in and assumed that all the photos in the digital file belonged to the publishing house and therefore were usable at no fee. However, this is rare, and we're talking early stages of a new technology, and new working methods, and such change is always fraught with mistakes and inconsistency. Give it a chance. You'll find that as we progress in this digital revolution, we'll find fewer and fewer errors.

You'll also update your digital files when you return from a trip or assignment. You'll repeat this process with each of the small core of publishing houses you work with. And, because you are a specialist in their specialized interest area (aviation, environment, agriculture, butterflies, backpacking) and supply them with just what they require, there will be little need for them to go outside their central libraries to obtain those just-right images.

It's Not All Peaches and Cream

Fellow stock photographer and longtime friend Dennis Cox sent me a copy of a letter he recently sent to a photobuyer. He penned a note, 'Rohn—thought you would like to see . . .'

His letter illustrates the contention that sometimes arises in our industry when publishing houses naively attempt to acquire photos for an upcoming project without taking into consideration the photographer's copyright.

In this case, the art director was assembling a number of photos for an upcoming CD-ROM. He chose a previously published photo of Dennis's and sent him a "congratulatory" letter that his photo had been accepted.

Dennis had not been informed of the project. His response is on page 55.

Does this sort of misunderstanding happen often in the stock photo industry? No. But to prepare you for the exceptions, Dennis and I thought it would be helpful to share this letter with you.

Photobuyers, for the most part, have been given a bad rap. They are *not* difficult to work with if approached with professionalism and awareness of the demands on their time. In fact, many can be a joy to work with. It is wise to remember that the photobuyer faces constant deadlines, has her own opinion about recalcitrant stock photographers and is under no obligation to educate you in the fine points of business etiquette. Your task is to show the buyer you are a valuable resource for her.

Most of your personal contacts with photobuyers will be by phone or E-mail due to the far-flung geographical distribution of your markets. Here are ten

RE: "Congratulations! Your image was chosen to appear in the 'Lakes of Africa' CD."

Dear _____:

Congratulations yourself. You have used my image of Lake Kariba, Zimbabwe, without my prior authorization which is a violation of Federal Copyright Law.

Please note that I must be notified in advance of any intention to use my photographs, that a fee must be negotiated before usage, and an invoice stating usage rights must be issued prior to publication. It is standard business procedure for a photobuyer to issue a purchase order and to make payment upon receipt of an invoice from the supplier proscribing the licensing rights to the images to be published. Without my invoice you do not have any rights to the use of my images.

Sincerely,

Dennis Cox

tips to help ensure a rewarding relationship with photobuyers:

1. Do your homework. Know the special interest areas of your photobuyers. Know the content and what their publications look like, so that you can be prepared to carry out the next nine steps.

2. Present a "give" list. Don't be a "gimmie." You don't inquire with questions to the photobuyers. You let them know you can provide them with photos in such and such areas (areas you are aware are dealt with by the buyers) and that you are in a position to be a regular supplier of them. In the course of the conversations, you draw out what specific current needs the buyers have, all the while emphasizing what experience or qualifications put you in a position to be an important resource for the photobuyers and their publications.

3. Introduce yourself cheerfully. The way you open the conversation will set the tone for the entire exchange and impression.

4. Be open. Be candid. Evasiveness or ambiguity won't work. Clarify to yourself your purpose for the call, the points you want to provide to the photobuyer, and then straightforwardly go for it. For example, don't use the excuse, "I am updating my database."

5. Be optimistic. Exude a sense of confidence. A positive attitude will encourage your buyers to want to see various ways they can use your services. Yet don't be overbearing or confident to the point of arrogance.

6. Be complimentary. A well-placed, well-meaning compliment about the photobuyer's publication, last layout, insightful coverage, etc., will serve you well.

7. Talk about other things. Do not spend the entire time talking about yourself. Discuss briefly one or two current topics related to the photobuyer's area of concern. The more social you are, the more likely your source will favorably respond. Of course, don't overdo it!

8. Return the favor. You might share with the photobuyer some bits of information you have learned from other sources in the field. However, be certain not to betray anyone's trust.

9. Be charitable. Allow that 75 percent of photobuyers don't have time to return phone calls from unknown (to them) prospects, especially after a deadline has passed. Solution: It's nothing personal. Maintain equanimity and sail on. Persevere with new submissions for new needs, and you'll score at some point.

10. Understand model releases. Even though model releases are not required 99 percent of the time for editorial usage (illustration purposes in books and magazines), this subject strikes fear in the heart of many photobuyers. Some seem to think they are protecting themselves and their jobs if they require model releases. They are not concerned with their or your first amendment rights. When photos are used to inform and educate and even entertain, model releases are not required. If the magazine or book photobuyer you're speaking with requires releases, it's a signal to you to politely end the conversation and move on to the many markets who know their first amendment rights.

ROYALTY-FREE, A ROYAL BATTLE?

The new model of digital stock photography espouses digital cameras, scanners and methods of selling the results on the Web, on CD-ROMs and on-line (royalty-free, photo clip art, Web galleries, etc.). These innovations are a disruption to the normal way of doing business in the commercial stock photo industry. New innovations in any industry traditionally cause havoc, and they challenge the workforce into taking sides on these changes that supposedly will enhance society or an individual's life.

History shows that in the past, any changeover to new ideas in commerce was slow to take hold. The process usually took two generations. The sewing machine is a good example. It wasn't readily accepted. Two generations of tailors fought it. The guilds fought it. ("What can a machine do better than a good seamstress?") According to the Singer Sewing Machine corporation, it was a period of sixty years before tailors and seamstresses finally made the changeover.

However, things are speeding up; now it usually takes only one generation—about thirty years—to incorporate a major change. Many elements considered standard in our lives have taken this one-generation road to accep-

tance: credit cards (1950s); TV (1940s); facsimile machines (1930s).

The forces opposed to new technology are usually those that want to preserve the status quo. Newspapers opposed radios. Horse traders opposed the steam engine and automobiles. The railroads opposed airplane travel. And why not? Proponents of the existing methods had invested their careers in perfecting the way commerce was conducted. Any intrusion could be fatal to their businesses.

With digital imagery and its use in commerce and industry and on the World Wide Web, we can expect similar resistance to rear its head.

Photographers who have depended on commercial stock photography for their livelihood have businesses to protect and an ax to grind. Their argument is logical. If they have been producing traditional commercial stock photography these many years, it's not a pleasant prospect to see their investments go south with the introduction of royalty-free (RF) images.

One recourse they might have is for all commercial stock photographers to ban together and boycott the royalty-free industry. Another way would be to take the course that some workers did during the Industrial Revolution: They would throw a shoe into the motor works of one of the newly introduced machines. The word for wooden shoe in French is *sabot*, and that's how the word *sabotage* came into use. In today's digital world, the extreme grumblers fight back as hackers and introduce viruses.

There *are* certain innovations and changes that have been accepted quickly—take the Walkman, VCRs, pagers and cell phones. But these are innovations that *add* to, not *replace*, existing technology.

The replacement technology faces a tougher battle. The decision to reject or accept new business innovations is always in the hands of those in power. And those in power usually are not ready to hand over the reins to new ideas, especially if the changeover threatens their positions of power. Not until a decision maker has retired or is replaced is the changeover made. This is what usually takes a generation—thirty years.

The desktop computer, as you know, was first introduced into the business world in the mid sixties. Amazingly, it took thirty years before this innovation was generally accepted. And as you know, some diehards still don't accept it.

Digital imagery faces the same inertia. While it is struggling for acceptance, many photographers will provide good reasons why we should not embrace this technology. Not yet.

George Schaub (E-mail: george.schaub@cygnuspub.com), the author of *Shooting for Stock* and an editor in the photography trade magazine world, contends that digital photography is not yet mature and can't compete with film when it comes to picture quality. "Film cameras and technology are still vastly superior," says George. "If you shoot digital, you still have to convert it to some reasonable form anyway. And, frankly, there's a lot less work shooting film. If agencies want digital files, a film scanner is the best investment, rather than blowing money on a [very quickly obsolete] digital camera."

Joe Farace (E-mail: jfarace@juno.com), a writer in the photography trade arena and a stock photographer, agrees. He's concerned also about the maturity of the digital products. "We can expect in the field of digital imaging that you will encounter product cycles measured in *months* instead of the *years* that used to be expected to develop traditional optical and photochemical products," says Joe. "New digital imaging hardware that you buy for your studio is quickly replaced with even newer models or later versions that produce better results in less time and at less cost.

"For people just getting started in digital imaging, this almost immediate obsolescence is the single most frustrating aspect of the process. Since this trend is not going to change, I have four words of advice: 'Get used to it.'"

Does Joe Farace own a digital camera? "No, I don't," says Joe. "And I probably won't for a while. Although 90 percent of the images I sell are in digital form, only 10 percent are originally created digitally. For the kind of photography I do, I'm happier originating those images on film, *then* converting them into a digital format for sales and distribution."

Resistance comes from photographers in the field who view the digital distribution of RF images, on-line photos and CD-ROMs at very low prices as undermining their very existence as stock photographers.

Ron Schramm, of Chicago, is one such photographer. He writes, "I've made a good living at selling my stock photos up until now. With the advent of digital images, I find photos similar to my style are being sold for one-tenth the price I usually charge. This is unfair. How could those rates possibly support production of quality images? Even at volume sales, how could this system create a business that is viable? This is almost giving away the images. To me, it seems like this royalty-free business model is ethically bankrupt and fiscally insane, and won't result in a living wage for the great majority of photographers."

Another photographer, who requested anonymity, sees a greater problem in the digital arena: thievery. When I wrote in my weekly newsletter, *Photo-AIM*, that I encourage stock photographers to allow their regular editorial buyers to put selections of the photographers' images (either prints or digital images) into the buying companies' central art libraries, this photographer admonished me by saying that I was accelerating the downfall of many traditional stock photographers.

His reasoning was that company pirates could steal the images from the databases and use the pictures for their own use and not pay for them. Who knows if this will come to pass? But you can rest assured that I wouldn't advise this system if I didn't have a solid grounding from my many years of experiencing and observing the industry and its ethics.

In my first book, *Sell & Re-Sell Your Photos*, I also encouraged photographers to place their extra prints and slides in what I called The Permanent File in the major publishing houses that they deal with. Although that suggestion sounds like I'm placing a lot of faith and trust in photo editors, it was based

on sound business reasoning. I had already been doing it for twenty years, since 1961, without a problem. Built into this plan is that you choose your regular buyers, who know you and your work and to whom you've made repeat sales. In the thirty years since I started my newsletter service, I have never heard from a photographer that someone "stole" a picture from such a file. To the contrary, I've heard from many a photographer reporting surprise checks from a publisher thanks to photos kept in his company library. And to add to this, I still receive checks from publishers for the use of pictures of timeless content that they have on file that I took thirty-five years ago. It's always a nice treat to take my wife, Jeri, out to a fancy lunch establishment across the river border in Minnesota on the proceeds from a photo that I took back in our lean years when a peanut butter sandwich was the lunch money we could afford.

Will the same honesty prevail in the new media of today? I think so. Although there might be a larger window for infringers to make mistakes, either intentionally or innocently, we now have robust firepower in the form of strong legal council from the large corporate stock agencies who are continually on the alert for examples of digital image thievery.

In the swift moving pace of today's technology, "borrowing" creative ideas and products won't be of great concern because the idea or creation doesn't hang around that long. For example, a wallpaper design company might fear placing its creations on the Web because a competitor might steal them. The reality: By the time the competition puts the "look-alike" into production, the original company has put its efforts into designing new creations that will replace the outdated ones.

"And they'll save themselves a bunch of money otherwise spent on attorney's fees, trying to sue for infringement," says California photographer Tom Carroll. "I'd prefer to put my time to producing photos rather than hiring lawyers, going to court and chasing after suspicious infringers."

The phenomenon of speedy replacement of products even extends to large-scale military machinery. For example, The F-15C, our current air superiority fighter, will be unable to dominate the air in the next century. Today, it is at rough parity with current foreign aircraft and will be surpassed by at least three foreign aircraft that are either operational or in development: the French Rafale, the Eurofighter 2000 and the Russian Su-35. Proliferation of these modern fighters combined with highly capable surface-to-air missile (SAM) systems pose a formidable challenge to the F-15's survivability.

Even if a spy were to steal secrets about the F-15C, the information would already be outdated by the time a foreign country put them into use.

In the Web photo commerce of the near future, we will no doubt experience a learning curve in which innocent infringers will make mistakes, and they will be drawn and quartered in the trade media or their wrists will be slapped by the high-powered attorney types from corporate headquarters.

While digital databases present some new concerns, it's still my position

that it's to your advantage to deposit your editorial stock images (repeat, your *editorial* stock images, not your commercial stock images) with your regular photobuyers on your market list. Otherwise your pictures will only gather dust in your own files or database and not bring profits to you.

The permanent-file method is a photographer-proved way to multiply yourself. While you are asleep, your images can be working for you. (For other "multiplying" ideas, be sure to read chapter nine.)

And speaking of multiplying yourself, photographer Joe Viesti (see chapter ten) made a decision to do just that when royalty-free came on the stock photography scene.

He runs The Viesti Collection, a small stock agency. He foresaw that the new royalty-free business model could possibly put him and his agency out of business. He took this approach: He moved his business from New York City to the mountains of Durango, Colorado, and used the efficiency of the World Wide Web—not to sell his photos in the RF model but, instead, to turn his agency's images into products such as calendars, cards, memos, posters and other paper products. His Web site is now a hub for potential clients and current clients to visit for viewing and making transactions.

But *will* royalty-free be the undoing of stock photographers? In chapter ten I suggest not. As we have seen with past business innovations, the mass-produced Model T didn't put Cadillac or Rolls-Royce out of business. When ready-made clothing came along, it didn't put tailors out of business; it increased their worth and their esteem. In chapter five I suggest that the democratization of stock photography will spark photographers to reexamine their reasons for being in business. It will inspire them to fine-tune not only their personal philosophy about stock photography but the business approaches they take in dealing with their clients of the future (see chapter four).

Choosing Your Market Strength Areas

CHOOSING YOUR MARKET STRENGTH AREAS

The Internet has leveled the playing field. An individual stock photographer can now have the same access and importance to photobuyers globally as a multinational corporate stock photo agency.

Photobuyers, using the power of the Net, will locate you if you play your marketing cards right. And you will find new buyers without leaving the comfort of your desk at home. And it doesn't matter if your desk is in a high-rise in Dallas or at the end of a telephone line at the bottom of the Grand Canyon.

You want to find your corner of the market. But first, you must find out who *you* are photographically. In my previous book, *Sell & Re-Sell Your Photos*, I outlined a simple exercise to help you do this. It's a quick, sometimes surprising and fun way to help you get in touch with yourself. It goes like this.

Photographically, Who Am I?

Save a Sunday afternoon to complete this exercise. It will be invaluable in helping you avoid the wheel spinning you'll do if you jump into photo marketing without having the information this exercise and chapter will provide. If you are reading this book a second time because your stock photography enterprise is sputtering and coughing and you're wondering what went wrong, read this chapter *carefully*. Many photographers fail to do so and then fail. As the saying goes, "When all else fails, read the directions."

Take a piece of paper and make two columns like the ones in the box on page 64. Head the column on the left "Track A," the column on the right "Track B." The columns can extend the length of the page or pages, if necessary.

Next, fill in the Track B column with one-line answers (in no special order) to these questions.

 1. What is the general subject matter of each of the periodicals you subscribe to or would like to subscribe to (or receive free)? (For example, if you subscribe to *Today's Pilot*, you would write "aviation.") Write something for each magazine. Do you welcome catalogs in the mail? What's the subject matter? Write it down.

2. What is your occupation? (If you've had several, list each one.) Also include careers you'd like to pursue or are studying for or working toward.

3. When you are on a photo-taking excursion, what subjects (for example, rustic buildings, football, celebrities, sunrises, roses, waterfalls, butterflies, fall foliage, children, puppies, Siamese cats, hawks, social statements, girls) do you enjoy photographing the most? Use as many lines as you wish. The order is unimportant.

4. List your hobbies and pastimes (other than photography).

5. If you were to examine all of your slides and contact sheets, would you find threads of continuity running through the images? (For example, you might discover that you often photograph horses, train stations, rock formations, physical fitness buffs, minority groups.)

6. What are your favorite armchair interests? (For example, if a passing interest is solar energy, astronomy or ancient warfare, write it down.)

7. What is your nearest city of more than 500,000 population?

8. What state do you live in?

9. List any nearby (within a half day's drive) geographical features (ocean, mountains, rivers) and man-made interests (iron or coal mine, hot-air-balloon factory, dog-training school).

10. What specialized subject areas do you have ready access to? (For example, if your neighbor is a bridge builder or a ballerina, or a relative is a sky diver, or your friend is an oil-rig worker, list them.)

If the list in Track B includes any of the following, *draw a line through them*: landscapes, birds, scenics, insects, plants, wildflowers, major pro sports, silhouettes, experimental photography, artistic subjects (such as the "art" photography in photography magazines), abstracts (such as those seen in photo-art magazines and salons), popular travel spots, old movies, monuments, landmarks, historic sites, cute animals. Transfer all of the subjects that you just drew a line through to Track A.

You'll find your best picture *sales* possibilities in Track B. Track A shows high-risk marketing areas for you. Most photographers have spent a great deal of their time photographing in the Track A areas. Because the subjects in Track A are such popular areas, photobuyers can find these pictures easily in stock agencies, on CD-ROMs and on-line.

When you get off Track A and onto Track B, you'll stop wasting time, film, postage and materials. You'll get published, receive recognition for your specialization in photography and deposit checks. Let's examine the Track B and Track A of one hypothetical photographer, John, whose interests are listed in the chart on page 64.

1. John subscribes to magazines dealing with gardening, electronics and antique automobiles. Not only do these reflect John's interests, but the combined total for photographs purchased for magazines and books in these three areas can exceed $150,000 per month. Yet most of John's picture-

taking energy and dollars have been put into Track A pictures, which have limited marketing potential because of the law of supply and demand.

2. John's occupation is grocery store manager. The trade magazines in this area spend about $20,000 per month for photography. John could easily cover expenses to the national conventions each year, plus add an extra vacation week at the convention site, with income generated by his camera.

 John is a former teacher and retains his interest in education. His experience gives him the insight and know-how to capture natural photographs of classroom situations. Such photos are big sellers to the education field, denominational press and textbook industry. Let's make a conservative industry estimate of the dollars expended each month for education-oriented pictures: $800,000.

3. In his picture-taking excursions, John usually concentrates on scenics, flowers, fountains, insects, sunsets and historic sites. These all have limited marketability for the independent freelancer without a track record with the big agencies and top magazines. However, John could place some of these Track A pictures in stock agencies for periodic supplementary sales. A stock agency that specializes in insects, for example, will be interested in seeing the quality of John's pictures. Some of John's other Track A pictures belong in different stock agencies. Use the Internet to search out specialized stock agencies.

4. John's favorite hobby is antique cars (which was already listed in his response to question one). He can easily pay for trips to meetings and conventions through judicious study of the market needs for photography involving antique cars.

 John also lists snowmobiling as a hobby. More than $80,000 a month is expended on photography in publications dealing with winter fun in season.

5. John finds that he photographs picturesque old barns every chance he gets. The market is limited (Track A). One day he may produce a book or exhibit of barn pictures, but it will be a labor of love.

6. His armchair interest is old movies. Related photos offer no marketing potential unless placed in a specialized photo agency.

7, 8. The nearest large city to John is Minneapolis, and he lives in Wisconsin. (Chapter nine will explain how to capitalize on your travel pictures.)

9. The Mississippi and St. Croix Rivers are nearby, plus several state parks. (Again, see chapter nine.)

10. John's neighbor is a TV cameraman. John could get specialized access to television operations and be an important source to photobuyers who need location pictures dealing with the TV industry. John's brother is a dentist, so John has access to the field of dentistry. Publications in each of these areas easily spend a combined $20,000 per month for pictures.

Let's take a closer look at Tracks A and B.

Track A	Track B	
Scenics	Gardening	Snowmobiling
Flowers	Electronics	Old barns
Fountains	Antique automobiles	Old movies
Insects	Grocer	Minneapolis
Sunsets	Teacher	Wisconsin
Historic sites	Scenics	Mississippi River
Old movies	Flowers	St. Croix River
	Fountains	Interstate Park, others
	Insects	TV cameraman
	Sunsets	Dentist
	Historic sites	

Track A: The Prognosis Is Guarded

These are the areas of formidable competition. Track A pictures are used in the marketplace all right, but it's a closed market. Photobuyers have tons of these photographs in inventory, or they locate them easily from their favorite top pros, or they click one from a clip art disc or an on-line service, or they contact a stock agency that has thousands upon thousands to select from. If you want to concentrate your efforts in the Track A area of photography, I suggest you stop reading right here because you'll need to put every minute of your time into making a go of it. Only a handful of freelancers in this country—most of them full-time pros—are successful at making their incomes from Track A pictures.

If you're not planning to concentrate on Track A pictures but you still want to take them, one solution is to put your Track A shots into a Web photo gallery and then not worry about how often they sell for you. Every once in a while, you may get a nice surprise check. (Chapter two shows you how to determine which gallery is for you.) A second solution is to turn to producing decor photography and set up a separate Web site for this enterprise. Keep in mind, though, that you can't expect either of these solutions to result in *regular* sales for you. Decor photography is a labor of love; the big moneymaker at a gallery is the owner. Practically speaking, your forte and solid opportunity for immediate and consistent sales—in other words, your strong marketability areas—remain in Track B.

Track B: The Outlook Is Bright

Take time to do a complete job of filling out Track B, and you'll find that you've sketched a picture of who you are photographically. This list is your PS/A, your personal photographic marketing strength/areas. You have vital advantages in these areas. You offer a valuable resource to photobuyers in these

specialized subjects. You have access and an informed approach to pictures in these areas that many photographers do not have. You are already something of an expert in many of these Track B areas, and the subject matter appeals to you. Your competition in marketing Track B pictures is manageable.

Not all of your interests, of course, lend themselves 100 percent to photography. But you will be surprised how many do. For example, chess has spawned few periodicals that require pictures. But pictures of people playing chess have varied applications: concentration, thinking, competition—good illustration possibilities for textbooks or for educational, sociological or human-interest magazines.

Photobuyers for the Track B markets will encourage you to submit pictures by purchasing more and more of your photo illustrations. Gradually you'll receive higher fees—and eventually assignments. Pretty soon, you'll consider graduating to higher-paying markets in your specialization area(s). Your efforts and sales in the nuts-and-bolts areas of Track B may one day even justify the time you still may wish to give to Track A photos, which actually *cost* you money to try to market.

Throughout this book, I'll refer to you and your PS/A, your Track B list. When I refer to *you*, the photographer, I mean for you to adapt what I'm saying to *your* particular photographic strengths and approaches. When I say *you* I won't mean *me* or any other reader of this book. Another photographer would fill out this chart differently. He would also be an important resource to an editor or editors, but rarely would the two of you be in competition for the attention of the same photobuyers. Your task will be to find your own mix of markets, based on the areas you like and know best, and then hit those markets with pictures they *need*.

REFINE YOUR PHOTO MARKETING

Don't be tempted to be all things to all photo editors. This is usually the first mistake the fledgling photo illustrator makes. Photo editors recognize that one

SHOOTING FOR SALES

Sharon Cohen-Powers is the stock photography columnist for our newsletter, *PhotoStockNotes*. Here are her thoughts on the subject of shooting for sales.

The trick to shooting stock is to photograph well-known subjects a touch better. There's a fine line between being too artsy and making the ordinary look extraordinary. Extraordinary shots sell, artsy ones don't—at least not as often. The best way to know what to shoot is to see what's already been shot, or better yet, what's already been used. Go through every popular magazine at your disposal. If you manage your stock shooting correctly, it is possible to create a happy balance between shooting what sells and what you love. In the best of all worlds, one should and will support the other.

Sharon may be contacted by phone, (516) 432-8000, or E-mail, office@wildlifephoto.com.

photographer can't be *that* versatile. Their primary concern is that they get material that's accurate and knowledgeable to present to their readers and advertisers. The editors would prefer to work with a photographer who already knows something about the interest areas of their magazines.

Focus on a market area that appeals to *you*, such as outdoor recreation, aviation, medicine, education. These categories and hundreds of others are listed by classification in the directories on page 68. Select certain publications in your interest areas. On your deluxe letterhead (see "Professional-Looking Stationery," page 102), request their Photographer's Guidelines.

Many specialized markets work with monthly photography budgets ranging from $1,000 to $10,000. Many spend $40,000 to $90,000 (per month—not per year). If you zero in on just ten specialized markets, you will have, as they say in the marketing field, found your "corner of the market." The photo editors of these markets will consider you an important resource.

Once you have made some sales to an editor, she will be interested in sending special assignments your way. It's on these assignments that you'll take additional photos to add to your stock photo files. If you engage in your photo marketing as a spare-time endeavor, you'll still be able to handle lengthier assignments by scheduling them on your vacation time (and as a result give yourself free vacations!).

Get prepared for a genuine assignment by giving yourself some "practice" assignments this coming year. Using photo stories in one or two of your targeted publications as guides, duplicate the photos used by that photographer, and teach yourself how to develop photo essays.

Use Market Guides

Once you know your photographic strengths, you'll find your corner of the market more easily. Several excellent market guides exist that will point you in the right direction. Keep in mind that, because of the publishing lead time, directories, even telephone directories, are up to one year older than the date on the cover. These directories will point you in the direction you want to go. For the most up-to-date information, follow up your leads by using Web search engines. Use your directories to give you a general idea of potential markets for your photographic strengths.

Which directories are best for you? You'll find out by matching the subject categories in your Track B list with the market categories covered by the different directories. The most popular directory among newcomers to stock photography is *Photographer's Market*, an annual directory that lists 2,000 up-to-date markets. This directory not only tracks personnel changes in the industry, but also lists the fees photobuyers are willing to pay for stock photos. (For a list of directories, see pages 68–71.)

Treat your directories like tools, not fragile glassware. Keep them handy, scribble in them, paste in them, add and tear out pages. For specific names, titles, updated addresses and phone numbers, keep your directories current

yourself by making personal changes whenever you learn of them through your correspondence, phone calls, Web searches or newsletters. Your directories are a critical resource for developing your own solid photobuyer file.

You can find most directories at any large metropolitan library, and many of them are stocked by your local community or branch library. Some are available on the Internet.

Some directories may be too expensive for you. They may also be too expensive for your community or branch library. Ask the librarian to borrow such a directory through the interlibrary loan service (or its equivalent in your area). If the book is not available at a regional library, the service will locate it at the state level. It generally takes two weeks to locate a book. Since the books you order will be reference manuals, your library will probably ask that you use them in the library. However, you can photocopy the pages you'll need, thanks to the fair use doctrine of the U.S. Copyright Act.

Chart Your Course—Build a Personalized Market List

Successful businesspeople in any endeavor aim to reduce the possibility of failure by reducing or eliminating no-sale situations. Why attempt to sell your pictures to a market where the no-sale risk is high? Build a no-risk market list, and begin to see your photo credit line in national circulation.

Consult the Internet and all of the directories available to you, and build a list of potential markets for *your* material by combing through the categories that match your photographic strengths. This might take several evenings of effort, but the investment of time is worth it.

Discover additional markets for your pictures at newsstands, doctors' offices, business counters and reception rooms. You can also order lists of markets in specific categories from PhotoSource International. We provide computerized printouts of names and addresses of contact persons and photobuyers in every imaginable area.

Your homework should result in a list now tailored to your exact areas of interest. If you have several areas of interest, should you make several lists? My advice would be to keep one master list on your database and make categories within the list according to your various PS/A areas. Then, when you repair or replace a listing, you need do it only once. A listing of possible markets begins on page 68.

New Generation Media and the Emerging New Media Markets

New generation media is a phrase stock photographers will hear more and more in the coming decade of the new millenium.

Where'd it come from? It's a term that reflects the increasing ways advanced technology allows us to transmit information in today's high-tech world.

The good news: These evolving forms of image creation and image delivery have created new markets for you. As a successful stock photographer, you should be aware of what's ahead. Continue looking to the traditional print

American Auto Racing Writers and Broadcasters Association
Directory of Members, 911 North Pass Ave., Burbank, CA 91505
American Book Trade Directory
R.R. Bowker, 121 Chanlon Rd., New Providence, NJ 07974
American Society of Association Executives
1575 Eye St., NW, Washington, DC 20005
American Society of Journalists and Authors Membership Directory
Directory of Professional Writers, 1501 Broadway, Suite 302, New York, NY 10036
American Society of Picture Professionals Directory
409 S. Washington St., Alexandria, VA 22314-3629
American Universities and Colleges
Walter de Gruyter, Inc., 200 Saw Mill River Rd., Hawthorne, NY 10532
Amphoto
1633 Broadway, New York, NY 10019
AMSP Directory of Stock Agencies
14 Washington Rd., Suite 502, Princeton Junction, NJ 08550
Associated Church Press
P.O. Box 306, Geneva, IL 60134
Association for Educational Communication and Technology Directory
1126 Sixteenth St., NW, Washington, DC 20036
AT&T Toll-Free 800 Directory
55 Corporate Dr., Room 24C36, Bridgewater, NJ 08807
Bacon's Newspaper/Magazine Directory
Bacon's Information, 332 S. Michigan Ave., Chicago, IL 60604
Bakens Publications
Manual and Publications, 14 E. Jackson Blvd., Chicago, IL 60604
Biological and Agricultural Index
The H.W. Wilson Company, 950 University Ave., Bronx, NY 10452
The Bowker Annual
R.R. Bowker, 121 Chanlon Road, New Providence, NJ 07974
Business Publication Rates
3004 Glenview Rd., Wilmette, IL 60091
Canadian Almanac and Directory
Canadian Almanac and Directory Publishing, SS St. Clair Ave., W, #225,
Toronto, Ontario M4V 2Y7, Canada
Cassell's Directory of Publishing in U.K., Commonwealth & Overseas
Cassell Academic, 370 Lexington Ave., New York, NY 10017
Catholic Almanac
Our Sunday Visitor Inc., 200 Noll Plaza, Huntington, IN 46750
Catholic Periodical and Literature Index
Catholic Library Association, 1400 Montgomery Ave., Bryn Mawr, PA 19010

Celebrity Service International
 1780 Broadway, Suite 300, New York, NY 10019
Consumer Magazines and Farm Publications
 3004 Glenview, Wilmette, IL 60091
Decor, Commerce Publ.
 408 Olive St., St. Louis, MO 63102
Directory of West Coast Book Publishers
 Creative Options, P.O. Box 601, Edmonds, WA 98020
Editor and Publisher Company
 575 Lexington Ave., New York, NY 10022
Educational Marketer Yellow Pages
 701 Westchester Ave., White Plains, NY 10604
Encyclopedia of Associations
 Gale Research, Inc., 835 Penobscot Bldg., Detroit, MI 48226
Family Page Directory
 H&M Publishers, P.O. Box 311, Rhinebeck, NY 12572
Gale Directory of Publications & Broadcast Media
 Gale Research, Inc., 835 Penobscot Bldg., Detroit, MI 48226
Gebbie Press
 All-In-One Media Directory, P.O. Box 1000, New Paltz, NY 12561
Gift and Decorative Accessory Buyer's Directory
 Geyer McAllister Publications, 51 Madison Ave., New York, NY 10036
Gold Book of Photography Prices
 Photography Research Institute, Carson Endowment, 21237 S. Moneta Ave.,
 Carson, CA 90745
Great American Photography Directory L.A.
 Photogram, P.O. Box 2015, San Gabriel, CA 91778
Guide to American Directories
 Todd Publications, P.O. Box 635, Nyack, NY 10960
Interior Design Publications
 475 Park Ave. S., New York, NY 10016
The Journal of the Society for Photographic Education Directory
 Exposure Magazine, P.O. Box 1651, FDR Post Office, New York, NY 10150
Literary Market Place
 R.R. Bowker, 121 Chanlon Rd., New Providence, NJ 07974
Magazines for Libraries
 R.R. Bowker, 121 Chanlon Rd., New Providence, NJ 07974
National Directory of Magazines
 Oxbridge Communications, 150 Fifth Ave., Suite 302, New York, NY 10011
National Research Bureau
 424 N. Third St., Burlington, IA 52601

National Trade and Professional Associations of the U.S.
 Columbia Books, Inc., 1212 New York Ave., NW, Suite 330, Washington, DC 20005
New York Publicity Outlets
 Public Relations Plus, Inc., Post Office Drawer 1197, New Milford, CT 06776
Newsletters in Print Directory
 Gale Research, Inc., 835 Penobscot Bldg., Detroit, MI 48226
Newspaper Markets
 Althea Publications, 46 Bell Hollow Rd., Bldg. 5, Putnam Valley, NY 10579
O'Dwyer's Directory of Corporate Communications
 J.R. O'Dwyer Company, 271 Madison Ave., New York, NY 10016
O'Dwyer's Directory of Public Relations Firms
 J.R. O'Dwyer Company, 271 Madison Ave., New York, NY 10016
Patterson's U.S. Education
 Educational Directories Inc., P.O. Box 199, Mount Prospect, IL 60056-0199
Photographer's Market
 Writer's Digest Books, 1507 Dana Ave., Cincinnati, OH 45207
Photoworkshop and Travel Directory
 Shutterbug, 5211 S. Washington Ave., Titusville, FL 32780
Professional Photo Source
 568 Broadway, Suite 605A, New York, NY 10012
Publishing Newsletter
 H&M Publishers, P.O. Box 311, Rhinebeck, NY 12572
Reader's Digest Almanac and Yearbook
 Reader's Digest Association, 260 Madison Ave., New York, NY 10016
Register of the Public Relations Society of America
 33 Irving Place, New York, NY 10003
Society of American Travel Writers Directory (SATW)
 4101 Lake Boone Trail, Suite 201, Raleigh, NC 27607
Standard Directory of Advertisers
 National Register Publishing, 121 Chanlon Rd., New Providence, NJ 07974
Standard Periodical Directory
 Oxbridge Communications Inc., 150 Fifth Ave., Suite 302, New York, NY 10011
Stock Photo Deskbook
 Exeter Company, 767 Winthrop Rd., Teaneck, NJ 07666
Travel Publications Update
 Travel Market Sources, 5337 College Ave #258, Oakland, CA 94618
Ulrich's International Periodicals Directory
 R.R. Bowker, 121 Chanlon Rd., New Providence, NJ 07974
Working Press of the Nation
 R.R. Bowker, 121 Chanlon Rd., New Providence, NJ 07974
The World Almanac
 World Almanac Books, One International Blvd., Suite 444, Mahwah, NJ 07495

World Photography Sources
 Directories, 68 Caddy Rock Rd., N. Kingstown, RI 02852
World Travel Directory
 Ziff-Davis Publishing Co., 1 Park Ave., Room 1011, New York, NY 10016
Writer's and Photographer's Guide to Newspaper Markets
 Helm Publishing, P.O. Box 10512, Evansville, IN 47734
A Writer's Guide to Chicago-Area Publishers and Other Freelance Markets
 Gabriel House, Inc., 9329 Crawford Ave., Evanston, IL 60203
Writer's Guide to West Coast Publishing
 Hwong Publishing, 10353 Los Alamitos Blvd., Los Alamitos, CA 90720
Writer's Market
 Writer's Digest Books, 1507 Dana Ave., Cincinnati, OH 45207
The Yearbook of American and Canadian Churches
 Abingdon Press, P.O. Box 801, Nashville, TN 37202
Yearbook of Experts, Authorities and Spokespersons
 Broadcast Interview Source, 2233 Wisconsin Ave., NW, #301, Washington, DC 20007

media—magazines, books, textbooks and catalogs. But also look to the pioneering electronic media—the communication companies utilizing television, video processing, CD-ROMs, Web sites, on-line productions and new concepts such as videophones, desktop image delivery, screen-touch educational tools and on-demand picture retrieval. Many of the latter elements are poised to explode into wide use.

Classic commercial stock photography (the familiar scenics and generalized "situation" shots) as we've known it over the past decades will continue to be in demand, but the overwhelming supply of these generalized stock shots, available now on CD-ROMs and from discount sources on-line, will diminish their value—and soon their price tags.

The new generation media market is so vast that it utilizes what has come to be known as micromarketing, the ability to isolate specialized markets and respond to them efficiently. Micromarkets are specialized (niche) markets.

To survive in the face of the new generation media, stock photographers will become even more specialized. The rules haven't changed; only the targets have. The demand by photobuyers for content-specific images will spur the new generation media photographers to focus on specific subject areas they enjoy, and to service those markets whose needs match those areas. The generalist (the classic commercial stock photographer) will change from having generalization in the forefront. All photographers will still be able to market generalized photos, thanks to World Wide Web search engines for photo retrieval, but the main game will be specialization.

New Generation Photobuyers

How would you like to work with photobuyers who call you by your first name, allow you to call them collect and look forward with anticipation to your deliveries of pictures? And there's more. Your photobuyers are easy to please and rarely want to art-direct your images. Also rare: disputes, lost or damaged images, legal suits. Your buyers are accountable, and your relationship with them and their companies are long-term and worthwhile. Each new photobuyer you find in your particular market areas will be worth $20,000 to $50,000 in sales to you over the average ten to twelve years you maintain this buyer relationship.

New Generation Photography

I've described the new generation photobuyers, who are beginning today to change their buying patterns from broad based and general, to targeted and specific. Because media today is becoming more and more targeted in its focus, with each market aiming at a specific segment of the customer base out there, product content requirements—text, sound, photos—are following the same pattern, that is, becoming very specific.

No longer can a product appeal to a wide audience. Instead, an advertiser or publisher selects only a segment of that audience as his target. As a supplier of images, if one of your areas of strong coverage dovetails with a buyer's photo needs, you have made a match.

The new generation media, thanks to the Web, computers and sophisticated database technology, will appeal to consumers of special interests: medicine, education, agriculture, transportation. And not only the broad spectrum of each of these areas, but special interests *within* these categories as well. Medicine, for example, separates into a multitude of disciplines, such as nursing, surgery and pediatrics. And pediatrics breaks down into areas of infancy, child care, childhood diseases and more.

For the editorial stock photographer, the generic picture is out and the content-specific picture is in. New media conduits like CD-ROMs and Interactive TV will require highly specific images to target their particular highly specific audiences. Even the generic pictures that adorn the walls of executives' offices will soon give way to highly specific photos that reflect the taste and interest of the person. Why choose to hang a photo of a waterfall or covered bridge when you can select a photo of your favorite antique auto or an Olympic Games highlight? They're all locatable now, thanks to the Internet.

A Comparison of the Classic Stock Photographer and the New-Generation Photographer

The new generation media photographer who focuses within a vertical market and deals primarily with editorial buyers has a much better chance for success than with the former approach of across-the-board picture taking geared for the advertising market, the approach used by the earlier classic stock photographer.

Here's a capsule course of the differences between the two approaches and the work styles that go with them.

	New Generation Media Photography	Classic Commercial Stock Photography
Vertical Markets	Yes—Specialized	No—Across the Board, Generalist
Theme Media	Always	Sporadically
Well-Being	Clients: Easy to Please	Clients: Hard to Please
Long-Term Use	Photo Matures	Trendy
	Long Shelf Life	Short Shelf Life
	Historical Use	Stale Eventually
Model Releases	None Required	Required
Unique Content-Specific	Highly Specialized	Standard Clichés Made in Taiwan Clichés
Client Accountability	Solid, Responsible Always There Permanent	Not Always Accountable Temporary
Your Knowledge, Background	Expands As You Develop	Jack-of-All-Trades
Art Direction	None You Call the Shots	Usually Art-Directed
Voyage	Create the Trail	Follow the Trail
Picture Use	The Need to Know	The Need to Buy
Relationships	Worthwhile, Long-Term	Short-Lived
Need	Meeting Your Needs	Meeting Their Needs
Digital Technology	Sometimes Used	Often Used
Shooting on Spec	Yes—to Build a Stock File	No—Not Advisable
Equipment	Minimal	Varied and Costly
In-Public Photographing	Easy	Difficult
Revenue	Less Up Front Less Overhead	More Up Front Few Residuals
Filing Images	By Subject Manageable	By Number Across the Board
Disputes With Art Directors, Photobuyers	Rare	Frequent
Competition	Limited	Everywhere
Referrals	Yes—No Competition	No—Always Competition
Expectations for Future	Fits the New Media Concept (Vertical Marketing)	Laboring Under Antiquated Way of Doing Business (Horizontal Marketing)
Retirement	Valuable Asset	Unusable Asset
Gratification	Yes	Limited

In the new generation of picture acquisition, look for more buyers to buy in volume, dozens of images at a time.

New media markets are continually springing up. Many of them are starting to appear in the market directories listed earlier. You can also discover what they are by doing subject searches on the World Wide Web. Research the areas of your subject interest to find who needs your images.

Hidden "History" Markets

With the advent of TV documentaries, CD-ROMs, century highlight books, Web sites and millennium collections, editorial photos are enjoying a resurgence. Don't throw anything away. Those photos you thought could serve no purpose, because they were outdated, can now earn dollars the second and third times around.

The first fifty years of editorial stock photography were lean years for photographers. Few photographers imagined their photos were worth much more than the immediate compensation they received from a magazine, book publisher or assignment. In addition, to save filing space, many photographers threw out extra "baggage" of outdated negs and transparencies. Little did they realize they were tossing away a gold mine.

In the early days, some photographers had special agreements with their publishers or newspaper and magazine editors that ownership of the photos that were bought could revert back to them (the photographers) after three years. In some cases it was a shorter period of time. (This was in the days before the revision of the copyright law kept ownership with the photographer.)

Unfortunately, some photographers didn't take advantage of this kind of provision. They were busy with their other projects and went on to other things as the photo industry matured. Their original negs and transparencies, lying dormant in files at book companies, newspapers and magazines, were ushered out by a junior assistant or inexperienced clerk to make room for contemporary work. What could have been an annuity for a photographer disappeared into the dumpster.

Of course, some organizations had the foresight, manpower and funds to catalog and save everything. One example is Time-Life. It's files of photos chronicle the life and times of America since 1936. The latest count of images was twenty-one million, kept in a climate-controlled library at the base of Rockefeller Center in New York.

When the director of the Time-Life library, Beth Iskander, gave me a tour of the collection, I saw youthful pictures of Muhammad Ali (thirteen books have been written about him in the last decade), Frank Sinatra, astronaut John Glenn, Eleanor Roosevelt and countless others. These were pictures taken by long-gone photographers who never thought about the legacy they were creating on film.

Recently, I had a talk with Flip Schulke, famed photographer of the Martin Luther King Jr. era and the subsequent years of political unrest. He said, "As

a young photographer in the sixties, I didn't throw anything away. After all, I thought of my pictures as my kids. Who gives their *kids* away?" As a result, Flip has a deep selection of outtakes from his assignments and self-assignments.

"Today, I'm making more money from those pictures than I did back when I took them," he says. Flip's books and photos of Martin Luther King Jr. have brought in six figures. A recent sale to a major TV network for a TV special netted $24,000 in one month.

He also is authoring a St. Martin's Press book about Muhammad Ali. Flip is working with the University of Minnesota and Macalester College (where he graduated) in St. Paul, Minnesota, on a CD-ROM featuring his photos of Dr. King.

"Stock photographers should realize that their editorial photos serve as a pension, an annuity, as you get older. When you're an editorial stock photographer, everything becomes part of history," he said.

Flip pointed out that many photographers might not have the funds to produce their own CD-ROMs (see "How to Establish Your Own CD-ROM Service," page 188). One way of getting around this is to donate your collection (with limited copyright) to a university, college or museum that has the budget to edit and make the selection process, catalog the pictures, produce the CD-ROM and promote it. The institution and the photographer then share in the profits.

"Some schools, however, don't always have the funds to follow through on the complete process. If they don't, the pictures will sit around in a box, the same way they did at your studio. Choose carefully."

For present-day photographers, Flip warns that despite the convenience digital cameras offer to photographers and publishers, the process can backfire. In many cases, a city desk editor will take a disk from a digital camera, choose only one or two shots from the photos on the disk, say of a fire scene, and then hand the disk back to the photographer. To utilize the disk space, the photographer will erase the remaining pictures to start on a new assignment. This may save expensive disk space, but it destroys the outtakes that might prove valuable to the photographer's historical collection.

Flip Schulke advises that every photo has historical significance: "Hold on to your photos. They are your future social security."

Sell and Resell From Your Special Interest Photo Files

Photo researchers turn to specific photographer specialists to find deep selections of photos of specific subject matters (Hollywood personalities, football stars, the Louisiana bayous, skiing in Vermont, etc.). Rather than search a general photo database, such as AltaVista (http://altavista.com) or ArribaVista, now Ditto.com, (http://www.ditto.com), which can result in lengthy search time, photo researchers/buyers prefer to work with sources who they know have special interest databases that will provide quality work and a great number of images to select from.

If you position yourself as an expert in certain special interest areas, begin building archives of these images and put your information as a resource out there on the Web, photo researchers will come to you first, before attempting their searches through a general interest database.

Notice how quickly nowadays TV networks come up with a film clip of a known personality when that person flares up in the news, or shots of a particular location or event for dimensional coverage.

In the early days of TV, back in the fifties, nightly news program producers were lucky if they could come up with even one film clip of major news makers or events. Experience taught them to save film clips in archives so they could beat the competition when something happened of news importance that involved a particular celebrity, place or activity.

Today, the public *expects* the stations to provide footage of known personalities, events and locations. The public expects the same from the new media, such as the Web and other areas of the Internet, as the new media increasingly become research resources for background and depth regarding current or historical events and coverage of specific interest areas. Pin down *your* niche markets and you'll continue to sell and resell.

WHY IT'S MORE EFFECTIVE TO SPECIALIZE AND BE PROACTIVE

Thanks to the global nature of the World Wide Web, photobuyers and photo researchers no longer depend on the stock photo agency down the street for that just-right image. *You* may have it, and the buyer might be in Hong Kong or Alaska.

Whether the size of your photo collection is large or small, it's likely you have specific photos in your stock file that certain editors are looking for at this moment. That makes you an important resource to those editors. How those editors find you and your photos is the question.

To be a successful editorial stock photographer, *must* you specialize in one or a few areas, such as medicine, teens, backpacking? Not necessarily. Today, thanks to Web technology, you *can* be a generalist, with photos in a variety of subject areas, all across the board, and make consistent sales. But there's no doubt that developing one or several specialty areas is the more dependable pathway to success. When an editor finds you, she usually represents a particular special interest, and if you have a deep selection of photos in that area, you've just met a photobuyer who will be a long-term customer for you.

The way you approach your marketing falls into two basic camps: reactive and proactive.

You, the Reactive Photographer

Definition: You react to a broad spectrum of customers who need a continuous supply and variety of photos. You advertise your photo collection in print catalogs or on the Web. You then react—that is, respond—to the inquiries from buyers.

Twenty-Five Tips for Marketing Your Photographs

1. Find your photographic markets, then create for those markets.
2. Photobuyers purchase pictures they need, not what they like.
3. Twenty thousand photographs a day are purchased by the publishing industry alone. Part of that market could be yours.
4. Start marketing your photographs today by studying the markets to find your targets.
5. A good, marketable photograph includes background plus person(s) plus symbol plus involvement.
6. Photos that evoke a mood will sell again and again. Let the viewer "read into" your photo.
7. You need a model release if it will be used commercially for an ad or endorsement but not if it is used editorially for information, education or illustration.
8. The key to a good relationship between you and a photobuyer is your reliability factor.
9. Rent your photos (for onetime use); don't sell them.
10. Look like a pro, even if you don't feel like one yet.
11. Midsummer and midwinter are the heavy purchasing months for editorial photobuyers.
12. A good stock agency is one that sells the types of photos you make.
13. Don't work harder; work smarter.
14. Tapping the editorial markets lies as close as your computer.
15. You can pay for your vacation by using your camera to create pictures that editorial photobuyers need.
16. Photobuyers aren't interested in your talent, they're interested in whether or not you can deliver the kinds of pictures they need.
17. One reason a photobuyer won't purchase a photo: The photographer didn't state his fee. Do your homework and find out the use of the photo and the particular market's fee range.
18. You can reduce photographic throwaways by previsualizing marketable image possibilities.
19. Photo researchers will locate you if your Web site contains a text description of your photos.
20. Technical excellence counts with photobuyers, but they're more interested in what your photo communicates.
21. Keep your photo-marketing goals to yourself; share the goals by accomplishing them.
22. To consistently sell your photos you must sell yourself, on the phone, on the Web, in your E-mails.
23. Proper packaging of a photo submission can mean the difference between whether an editor views your material or sends it back to you unopened.
24. By the inch it's a cinch; by the yard it's hard. Start with the smaller markets and work your way up.
25. You can make unsolicited submissions, provided you do your homework first, spell the photobuyer's name right and send on-target photos.

Before the World Wide Web, it was an uphill battle to be a successful reactive independent stock photographer. Persons with excellent photography found it difficult to publish their images on a broad scale. Yes, an occasional exhibit of one's work or an expensive ad page in a stock photo catalog or magazine would bring in some customers. But in most cases even those sales were lucky to be break-even propositions.

Stock photo agencies were the only recourse for the reactive photographer. But everyone has heard of the stock agency blues. You place your photos in a stock agency and they often gather as much dust there as they did in your own shoe box at home. And you have to deal with the accompanying restrictions, restrictions, restrictions: "You may not place your photos with another agency," "You may not withdraw your photos before five years" and so on.

Today, the World Wide Web provides new marketing tools for the reactive independent stock photographer. Photographers are able to list their photos and display examples of their work on Web sites. By using search engines, buyers are guided to these sites where they can seek out photos that will fit the themes of their current projects. Then the buyers contact the photographers to do business.

You, the Proactive Photographer

In addition to your reactive marketing, you'll also be proactive. Definition: In contrast to waiting for customers to come to you, as in your reactive marketing, you use proactive marketing techniques to actively go after customers.

You're going to learn in this book that proactive photographers who aggressively market their work themselves have the better chance of seeing their credit lines in national circulation consistently. As we talked about in the section "Choosing Your Market Strength Areas" (see page 61), stock photographers who want to take the initiative to go after their buyers develop working lists of photobuyers whose special interest areas match their own photo strength areas (PS/A). In other words, proactive marketing works well for the specialist.

In the early days of stock photography, most publishing houses and magazines were very general and across the board in subject matter and in their photo needs. For their stock photography, they depended on photographers who developed broad generic collections of images.

When TV mushroomed into a strong presence in our culture, general magazines, such as *Life*, *The Saturday Evening Post*, *Look* and *Colliers* faded in popularity. In their place, smaller-circulation special interest magazines and book publishers blossomed. These markets each focus on one primary subject area: gardening, skiing, sailing, pets, horses and so on. Proactive photographers seek out markets that deal with subject areas that match their own photo interest areas, and they work to install themselves on the available photographers lists of those markets. A proactive stock photographer with strong coverage in the area of sailing, for example, seeks out publishers whose material constantly requires sailing photos.

Today, thanks to the Web, there are expanded and brand-new vistas for both of your marketing avenues—your reactive approach with your generic photos and your proactive approach for your photos in your specialized areas.

Specialization Is the Key

The media world is now specialized. TV channels, let alone different TV programs, are targeted to definite market niches. So are magazine and book publishers and radio stations. When new media arrives, either by computer on-line or satellite/cable TV, it also will be targeted to vertical (specialized) audiences. To ignore this is to limit your photo sales opportunities.

In the past, before the media world became so specialized, stock photographers had to be generalists. Then along came the early seventies when stock photo agencies began blossoming, and the independent generalists, working on their own, found themselves having to compete with the massive generalized files of these stock agencies—an impossible task.

Nowadays, editorial photographers are finding success by choosing select numbers of categories they enjoy and staying with them, to become experts in those areas. Physicians do this. Musicians do this. As consumers, we all turn to a specialist when we need the best and the latest.

Vertical marketing (specialization) for photographers has an added benefit. Classic general stock photographers, who are often required by agency art directors to produce generalized trendy pictures, face a dilemma. Many of their photos become stale and dated after a few years. By contrast, an editorial vertical marketer's images can become more valuable precisely because they are highly specialized. Depending on subject area, they can offer long illustrative life, rare insight and historical perspective.

Flip Schulke (see page 74) can come in here again as a good example. In the sixties Flip turned his camera to covering demonstrations and political unrest, and focused extensively on Martin Luther King Jr.—at formal events, at church and at home—capturing images of that man and era that will ever be valuable.

Flip could have made the quick buck by working with ad agencies to turn out exquisite clichés, but he took the long view. Today it's paying off. His windows on the "times he was living in" are bringing him substantial residual sales. If he ever puts his photos on CD-ROM, he can sell them in that manner, too, without fear of infringement because his photos are content-specific. They are unique to Flip Schulke.

The trend toward specialization does not mean we are coming to a static resting place in our development as stock photographers. Indeed, as is happening in many of the sciences, electronics and even molecular biology (using DNA as its model), our path along specialized routes may all converge into one gigantic ballroom where we return to the happy days of being generalists. All of this could happen when science and technology overcome the bottleneck problems that happen when we acquire massive amounts of information and have no speedy system to acquire, transmit or filter it. Inventions such as

molecular computers may one day be the solution. Locating and transmitting pictures will be as quick as turning the page in this book. In the meantime, it's back to putting bread on the table, and specialization is the key.

You Are Your Own Art Director

Many photographers enter the marketplace believing that their photography is judged on how pleasing it is aesthetically. They soon discover that in editorial vertical marketing, buyers buy a picture not because it has won an award or they personally like the picture but because they *need* the picture.

Photobuyers may have their office walls adorned with pleasing scenics or trendy photo-art decor, but they are *buying* photos that fill their publishing and production needs in their specialized subject areas.

The most successful of the new generation media photographers we work with at PhotoSource International are those who have found a niche or a few specific niches that they enjoy. Their interests are so strong that wild horses couldn't pull them away. As they build their market lists of buyers who are seeking photos in their interest areas, the incoming checks become more consistent.

Unlike classic stock photography where the photographer must tussle to please the art director, new generation photographers whose pictures match the needs of their chosen market list need only please themselves. They have developed themselves as experts in these areas. If they themselves are satisfied with their photo results, they know they will please their buyers and the buyers' readerships.

In new generation stock photography, you step out of the marathon of classic (general) stock photography to run a select race in a targeted area where the competition is manageable. If you have been a generalist in the past, this means taking a difficult plunge to move in a new direction. You'll find the struggle of the crossover to specialization reaps satisfying rewards.

Vertical Marketing

Vertical markets: a number of markets that share a single subject area; that is, various photobuyers and publishers who need photos in one related subject area. A new generation stock photographer with an interest in that subject deals with those buyers. There are many such theme publishers, who focus on specific subject areas—environment, music, boating, deserts, medicine, rural life, celebrities, outdoor recreation, landscaping and so on. There are some twenty-five hundred categories. The various publishers in each category each spend $10,000 to $50,000 per month on photography. Most photographers find they don't need more than two to five "theme" market areas (which translates to a total of thirty to one hundred photobuyers on their market lists). Our research shows that an editorial photographer stays with a theme publisher for an average of at least ten years. A specific photobuyer may leave the publishing house, but the theme of the publishing house remains the same,

assuring the photographer a long-term sales relationship with that market.

Here's a scenario that will help to describe the concept of vertical marketing: "I think I'll choose a Pepsi," the lady in front of the vending machine says. She pushes the right button and out comes the soft drink of her choice.

Vertical marketing works much the same way. The soft drink lady makes a choice based on preference and makes payment for it. If you were to open the interior of the machine, you would find that the soft drink cans are all lined up in a vertical row. All soft drinks of one type are slotted into one vertical column, ready for dispensing. There's no crossover. The cans *must* be lined up in the same dispensing vertical row, or the machine will deliver a wrong selection to the customer.

If you were the serviceman and haphazardly placed the cans in the machine in random positions, the results would be chaotic and make a lot of customers unhappy.

No Central Theme

Most newcomers to stock photography make the mistake of building a stock file in random fashion with no central marketing theme. Their picture-taking choices are all across the board. However, since a photobuyer's publication appeals to a vertical market, buyers turn to vendors who can reliably supply them with pictures within those specialties. They can't afford to waste time on a vendor (you) that does not supply depth of coverage in the vertical markets they need.

No-Tears Marketing

If the customer at the vending machine is mistakenly served up a soft drink not of her choice, she becomes irritated and pounds on the machine and demands a return of her money. "This is *not* what I wanted!" The wrong soft drink she received may be of excellent taste and quality, but it doesn't fit her needs. This illustration may help to assuage your disappointment when a photobuyer rejects your submission of excellent pictures. The pictures may be of high quality, but you are vending them to the wrong buyer. They don't fit his needs.

Stay within the subject areas that you enjoy photographing. At this moment, buyers for those subjects are searching for you. Don't waste film or time on picture taking that doesn't fit into your vertical markets.

Content-Specific—What Is It?

Sometimes, a classic commercial stock photographer will tell me, "I *am* a specialist. I concentrate on nature."

No. "Nature" is not content-specific. Nor is animals (which is in the category of nature). Nor wildlife (which is in the category of animals). When you zero in on, for example, wildlife of Southeast Asia, *then* you have a specialty, and the resulting photos are content-specific.

To put this in perspective: If you were a photobuyer looking for orangutans

of Borneo, who would you go to first? A nature photographer, an animal photographer, a wildlife photographer or a photographer whose collection is strong in wildlife of Southeast Asia? To be at the right place at the right time to make a sale, you can increase the law of probability by understanding the content-specific concept and employing the vertical marketing techniques used by hundreds of successful editorial photographers.

General image, scenic photo illustration (landscapes, ocean waves, backgrounds, New England fall color, etc.) as a major emphasis for photographers has been on the decline. Such photos still sell, but the monumental supply now far exceeds the demand. It has become inbred. Only a handful of photographers can still make their livings off these photos. In addition to the oversupply, there are now loud and clear signs of the trend *away* from generalized pictures: discounts, copycat photographers, "no research fees," slower payments to suppliers.

However, there will always be a need for strong photo illustration in new-generation specialized markets. You'll have the best chance of being selected by buyers if you are a specialist with depth of coverage in their areas of need.

The great general magazines of the past—*Life, Look, The Saturday Evening Post* (that's where I got my start)—started the move away from general interest products when they folded back in the sixties. Taking their place, special interest publications started blossoming. The change has been gradual but now, in the nineties, has come to full flower: General interest is out; specialization is in. To move ahead, remove yourself from the past. Look the fading classic general stock photo in the eye and let it go. Take that first step toward new generation specific photo illustration. Tailor your photos to specialized vertical markets—the ones you enjoy and the ones where photobuyers at this moment are looking for *you*.

Overwhelmed by Competition

Are you overwhelmed by competition from other stock photographers? You shouldn't be.

Does your photo file contain mostly general images? Or have you positioned yourself and your files to focus on a select number of vertical markets in your strong photo interest areas? You will have little competition in the editorial stock photo arena if you have done the latter. And the small amount of competition you'll have there will turn out to be a plus, to keep you on your toes.

Sales Oriented or Customer Oriented?

Are you sales oriented? If you are a sales-oriented photographer, you may fail at editorial stock photography. Why? Many markets for the editorial stock photographer are publishing houses. Most photographers come to the editorial stock arena from sales-oriented experiences, dealing with the high fees (and high turnover of clients) in the commercial markets. Many such photographers drop out of editorial stock photography because they don't make sales right

away, or find that sales to media markets are at lower fees than they experienced in the field of advertising, assignment or other commercial photography.

Take a look at those who do succeed in the editorial stock photography field. How do they do it? At PhotoSource International we've followed many career photographers who are successful in this industry, and we've noted a common thread: They become customer oriented. Their first sales are usually losses—or at best, breakevens. But if they target their marketing, they create long-term, financially rewarding relationships with each photobuyer (customer). Their photography focuses on filling the needs of their select customers and, with patience, builds gradually to higher fees and consistency of sales to these customers.

THE MAGIC OF TOTAL NET WORTH

It's no secret that independent photographers who continue to be successful in the field of stock photography are those who have mastered not only photography but marketing.

Stock photographers who subscribe to our market listing services at Photo-Source International use our marketletters not only to make sales but to make *contacts*. They add new contacts to their specific market lists. While many commercial corporate stock photographers have broad, general market lists, our editorial freelance photographers have found success focusing on particular niches in which they enjoy working. They specialize in photographing in those specific market areas, and their specialized market lists rarely include buyers outside the perimeters of their own keen interest areas.

In other words these photographers are new generation stock photographers. They work from their home offices, be they in cabins in the Rockies or in high-rises in Dallas. Unlike the classic stock photographer, who is a generalist with a wide variety of stock, these new generation stock photographers are specialists who know their specialties well.

Total Net Worth

Our subscribers are applying vertical marketing. They establish working relationships with a dozen or more buyers in each of their vertical market areas. Since the editorial photographer stays with any one publishing theme market for ten years, she can count on that market for consistent sales. This is called the Total Net Worth concept and is the core of vertical marketing.

In the majority of cases, when a photographer makes a match with photobuyers who need photos in her vertical market areas, the cumulative sales per buyer over ten years or so can pull in $20,000 to $50,000. Even in the worst case scenario, figuring on the basis of a low-budget market and the working relationship lasting only one year, sales would total $1,000 to $1,500. These figures are based on my own experience and that of many of the editorial stock photographers who have subscribed to our market lead services over the past twenty-one years.

How to Use the Total Net Worth Concept to Your Advantage

This Total Net Worth concept is a marketing principle that is rarely taught in business schools. Most accounting and marketing majors have never heard of it. But if you apply this principle, you will find that it can be the most important building block in your marketing strategy.

At first glance it may seem that the way to determine the average worth of a customer is to divide your total sales by the number of customers you have. However, this doesn't take into account your noncustomers, that is, the customers (markets) you approach who do not purchase photos from you. You nevertheless have to research and contact these markets, and this cost of *not* acquiring a customer must be factored into your assessments and projections.

One positive aspect of using the Total Net Worth concept is that it allows you to determine just how much you can spend to obtain a new customer (publishing house, corporation publishing department, etc.) who eventually will pay you on average $20,000 to $50,000 over a ten-year period, or at a minimum, $1,000 over the course of a year.

There are several tools you can employ to market your collection of photos to potential customers: direct-mail campaigns, personal visits, postcards, posters, calendars, telephone calls, news releases, speaking engagements, seminars, Web sites, banner exchanges, affiliates, trade shows and so forth. It is important that you begin today to start tracking the method by which you gain each new customer. Your data will show you which promotional methods are the most successful for your particular operation, and thus which methods to put your biggest promotional dollars into.

Here's a checklist to help you gauge the effectiveness of the methods you use to pull in new customers (photobuyers).

☐ Does your prospect mailing list match your PS/A?
☐ Is your Web site professional looking?
☐ Is your timing right? (Don't contact prospects during holidays, for example.)
☐ Are you contacting your prospects on professional stationery?
☐ Is your sales message powerful and succinct?
☐ Have you included a mini catalog, brochure or sellsheet with on-target (for that prospective buyer) examples of your work?
☐ Are you contacting markets who have several photobuyers on staff? (Some publishing houses have twenty to thirty buyers to handle their several departments.)

The next step is to determine how many dollars you can put into the promotional method you have found to be the most effective. Using a tracking system, you can determine what a customer's Total Net Worth to you is. For example, using a worst-case scenario: Working at the entry level with low-budget customers and figuring extremely conservatively that a customer will

last only one year, you find you could spend up to $100 to acquire that customer and still break even. You'd break even because $100 is the net profit you can expect from one customer for one year at the low-budget level. Any additional customers you acquire as a result of the same promotion would give you your profit. Since your promotional package would cost about $1 (an industry average), you could afford to contact one hundred potential customers $(100 \times \$1 = \$100)$ and would break even with just a 1 percent response. If out of the one hundred you contact you land two or three or five steady customers, you're in the black. If you acquire ten (10 percent), you can make a potential net profit of $1,000 for the year, and ultimately $10,000, based on the total net worth of each customer over a ten-year span.

With experience gained through analyzing your data, you'll learn how many contacts you need to make, on average, to land one consistent customer. Then you'll know the maximum amount you can afford to spend at the low-budget level to acquire a new customer! This method provides insurance against making a bad business decision. The law of probability is on your side—and this is just the most conservative picture. You can apply the same assessment and method to the higher-budget markets you work with.

Customer Budget vs. Total Net Worth

To further illustrate how to determine a customer's total net worth, I have broken down your target customers into three levels, dependent on their budgets for purchasing photos. For each level, I have prepared a chart (below) of projected purchases and income. These are conservative averages. You may experience different numbers, either higher or lower. I have arrived at these averages by comparing my own numbers with those of other stock photographers in the industry. The numbers are therefore unscientific general averages.

Low-Budget Customer*

Purchases per year	Average $ order	% Profit in order	Profit in one year	Profit in ten years
10	$50	20%	$100	$1,000

Medium-Budget Customer*

Purchases per year	Average $ order	% Profit in order	Profit in one year	Profit in ten years
10	$500	20%	$1,000	$10,000

High-Budget Customer*

Purchases per year	Average $ order	% Profit in order	Profit in one year	Profit in ten years
10	$1,000	20%	$2,000	$20,000

*A customer may be one *photobuyer* (at a publishing house, firm, magazine, ad agency) or one *company* (with several photobuyers, whose purchases represent your sales to that one company).

From the above charts, it would seem sensible to aim for the highest budget possible. However, if you do, you can expect greater competition. This puts the lower-budget markets in a different light: If you start out with lower-paying customers, you'll find that more customers are available to you right away and the competition is not as great, which translates into the chance for more immediate sales and profit from the volume.

Each time you gain a new steady customer in the midrange chart, for example, you know that the total net worth to you of the customer is $10,000. With this kind of customer, you can effectively compete with photographers who are focusing on the top-dollar markets; you can match the latter's incomes by adjusting your marketing plan to (1) double the number of your customers or (2) cultivate your customers so they purchase twice as many photos on their average orders or so you double the amount of times per year that you make sales to them.

To arrive at your own charts is simple: Analyze your market list. How many markets have bought from you once, twice, five times, twenty times in one year? What is the average for one year? How many years have they stayed with you? (If you are just starting out, my charts will serve as educated guesses to go by until you accumulate your own averages.) What net profit do you get from each sale, on average? Be prepared to find that photobuyers new to you are hesitant at first to buy from you frequently or in volume. Once you have established relationships, and they find you're reliable and good to work with, they are more prone to make multiple purchases from you. The reason: Once you become familiar to them, they want to encourage you to continue submitting to them—you become the easy transaction, not the unknown quantity and time-consuming new person who is perhaps undependable.

I have presented this system conservatively. Actually, if you are aggressive and confident of the quality of your work and confident of the targeted value of your mailing list, you could lose money in the short term on your promotional campaigns and still come out ahead. The long-term income from your acquired customers would eventually eliminate the loss you experienced initially in acquiring them.

The Total Net Worth method of operating your marketing plan is simple to carry around in your head and enables you to make snap decisions because it synthesizes the "rules of your business" down to thumbnail answers. The Total Net Worth principle presents you with a model of your business, a simple mathematical statement as to how your business works and what works. And it provides you with a warning signal before you make a bad decision.

Once you have done the initial tedious work of tracking and analyzing your customers, ongoing analysis is easy and simple. A computer simplifies it even more, and most database programs can be designed to produce this informa-

tion. Getting the information by a pencil and data chart is also possible, just slower and less glamorous.

One final benefit is that once you have your numbers in place, you can project the impact that different business moves or decisions will have on your profit or loss picture. You can guide your business ship with far more precision toward horizons of greater profits.

Promoting Your Business

IMAGE SEARCHING ON THE WEB—YOUR INSTANT PORTFOLIO

Finding highly specific photos just got easier, thanks to the World Wide Web. Your task: Be where the action is—where photobuyers can find you and your work—so you can fill orders when the requests start coming in. The Web, by its very design, offers you a way to display an instant portfolio of your photos.

It's a simple technology. A photo researcher types in a given search criteria (example: "river cleanup on Wyomissing River"). A Web crawler finds targeted thumbnail-size pictures by searching millions of Web sites and delivers these images to the researcher's screen in seconds. It's not yet the most perfect image search mechanism (the researcher might be bowled over to get a couple thousand images to look at that relate to the words *river, clean-up* and *Wyomissing*), but the researcher *will* find the images he needs. Examples of this technology can be found at ArribaVista (http://www.ditto.com), AltaVista (http://image.altavista.com/cgi-bin/avncgi—no they are not sister and brother), and Scour.Net (http://www.scournet.com).

This kind of technology is a harbinger of Web searching of the future. The next commercial refinement the Web developers need to perfect is to make more targeted, specific searches possible. At this point that seems to be asking too much of the programmers, but it will eventually come.

You can also get your photos out there on the Web to prospective buyers by including keyword descriptions when you post your images or posting the text descriptions only. Photo researchers will land at your photos (or your text listings) when they make keyword searches for images, if you have the right keywords.

Copyright Infringement?

A few land mines currently present Web developers with a copyright problem. For example, can Web site owners invite the general public to view any and all images on the site, including yours? If infringement is detected, is the Web site owner responsible? Or the infringer? Or both?

From a promotional point of view, you will need to make a decision whether you want it possible for your images to be viewed without specific invitation. (Software is available to block visitors to your Web images.) You have to ask

the questions, Will this type of instant portfolio be of commercial benefit to me? Is the risk of financial loss by not getting my photos out there and available to photobuyers for possible sale greater than the risk of someone using them without paying me?

Each Web site has a Copyright/Terms of Use license notice. Be sure to read all licenses carefully. Some might attempt to claim copyright to your images, or at least unrestricted use of them, in exchange for allowing you to include your photos in their image search programs.

E-COMMERCE AND EFFICIENCY

Speed is everything when it comes to trade and commerce. You might have the best ice-cream sundae in the world, but if it takes you an hour to make it and another hour to deliver it, you've lost a lot of potential customers.

In our field of editorial stock photography, the same holds true. Independent stock photographers have historically been the David attempting to battle with the Goliath. All the more so today, when the advent of large conglomerate stock agencies in our industry within the past three years has sent a chill through the ranks of stock photographers (and smaller agencies).

"Will I be shouldered out into the cold?" most independents ask.

The answer might have been yes if the question were asked a decade ago. Back then the technology to compete would have cost an average small business, such as yours, $150,000 to $300,000. "Out of the question," you would have said then.

Today, it's very different. We are seeing the cost of entry into the world of Internet commerce dropping dramatically. The equivalent technology today is in the range of $4,000 to $10,000.

A small business armed with the correct hardware and software can effectively compete with the conglomerates.

Your Advantage

What's more, you have two advantages over the huge conglomerates: speed and price.

Any traditional conglomerate is bogged down with costly dinosaurlike administration. And paradoxically, this administration *adds* to the price of the products. In contrast, when photobuyers deal with you, they deal directly. The overhead factor is less and no middleman is involved, further reducing the per-photo fee to the buyer.

Since the stock photo collections of independent individual photographers conservatively total more than 450 million photos, why don't photobuyers today use independent photographers rather than the large stock agencies?

Because neither the photographers nor the buyers are up to speed yet. Not enough photographers are knowledgeable about what's called e-commerce. And not enough photobuyers are ready to abandon traditional shopping be-

havior. And without a built-in network to jump aboard, independents find themselves floating aimlessly in cyberspace.

A network is taking shape, however. You know its name. It's called the World Wide Web. Daily, more and more photo researchers are finding that by using the Web, they can eliminate costly hours of searching for just-right images. They can also save money by buying directly from the source (you).

In the future, savvy photo researchers will not need hand-holding from one of the conglomerates to find the photos they need. Using the increasing power of the Web, researchers will go swiftly to the source of the image (you) and deal directly for delivery of the product.

Mitch Kezar, a Minneapolis-based photographer with a specialty in the outdoors, especially hunting, fishing, dogs and outdoor sports, is one of the pioneers who is proving that this way of doing business is about to explode on the scene. He is already successful at it with a number of his clients. He has already scanned twelve thousand images that he's selling on the Web, and is busy scanning more.

Mitch explains: "Our site uses a keyword-searchable database to guide buyers first through thumbnail-size images. Then by clicking on the ones that interest them, clients see $5'' \times 7''$ watermarked images of available shots they can drag to a shopping basket. Which, then, of course, is E-mailed or phoned in to my office. We then ship the buyer the slides they want FedEx, or if they want digitized images we can scan the photos at a high res and digitally fulfill the request.

"We've polled about two hundred potential customers, who have shown great interest in being able to call up exactly what they're looking for—people who know the difference between a flushing dog and a retrieving dog, or a slip sinker from spinning bait.

"Our clients have lamented to us about experiences with calling large photo agencies for such niche-market images, only to find themselves wading through three hundred pulled images, all of them wrong content."

Such efficiency will appeal to everyone in the photo-buying community. And individual stock photographers will find themselves in demand.

Bernadette Rogus, a photographer's consultant headquartered in Prescott, Arizona, has this advice for stock photographers getting their feet wet on the Web: "A Web site is not an 'if you build it, they will come' thing. Once you've got your images on your Web site, you've still got to direct viewers to it. That means doing things like getting linked to other sites and getting on search engines. Merely submitting a site to a search engine is not enough—it's very difficult to get listed on certain search engines. We've been trying to get on Yahoo! for two years with no luck! An experienced and savvy Webmaster is helpful in accomplishing this.

"The Internet should not be one's sole marketing tool. The Web is just another marketing medium. *Do not* discontinue print marketing! Use the Web to augment your normal marketing campaign. We have our URL printed on

all our sourcebook ads and on our direct-mail pieces. Since print advertising is 'permanent' and you can't change the image once it's printed, the Web is the place for your newest imagery. Use your printed pieces to direct viewers to your Web site.

"The Web is a *great* place to show samples of your imagery to the largest possible audience. We used to Federal Express portfolios to clients. It cost about fifty bucks each way to send a nice case full of 8″ × 10″ chromes. More often than I'd like to remember, we didn't get the job. So, the studio would end up with a net of minus one hundred dollars to *not* get a job! Now we can direct potential clients to our Web site where they not only can see new works but download stock photo subject lists, learn about our location and get biographical information and the photographer's client list. This costs *much* less than Federal Expressing portfolios around the country. At least if you don't get the job after a client looks at the Web site, it doesn't cost any more than the normal monthly fee for Web hosting."

Worried about "image pirates"?

"Don't be paranoid about people stealing your images from your Web site. The Web is just another place to show your pictures (and if you don't show your pictures, it's *guaranteed* you won't sell a thing). Those that would steal an image from a Web site would steal it from a promo mailer or sourcebook ad anyway. Besides, if you really think about it, a stolen 72-dpi digital image from a Web site is not going to look as good as a flatbed scanned image from a stock catalog!"

So You See, You Will Be Able to Compete With the Giants

When Getty Images reduced the commissions of its core photographers from 50 percent to 40 percent, the stock photography community gasped. The large, rich stock agency conglomerates had previously been able to afford technology that had to this point, given them an advantage over independent photographers. But speed, price and automation now rule, and now we know that independent photographers no longer have to be at the mercy of these agencies.

The imminent increase in bandwidth speed, the advent of cable modems and the decrease in cost of e-commerce software and hardware are hastening the day when stock photographers will be able to have the tools to give service as complete and speedy as the big boys. And, of course, individual stock photographers able to deal directly with their buyers will enjoy 100 percent of the sales of their photos.

Arizona photographer Dale O'Dell says he sees no threat from the large stock photo conglomerates: "The Web has democratized marketing for independent photographers. Photographers don't sell a complete product like a manufacturer would; they sell parts of a product: a part of a book, CD-ROM or ad. We are not burdened with the weight of a manufacturing enterprise. We can produce and supply a single part of a product. This makes the Web an ideal marketplace for our wares. No longer will there be a need to send original

The Web Will Set You Free

If you've followed the stock market recently, you know that commerce in the United States is excited about what the World Wide Web has turned out to be: a very positive investment for many businesses. Whether costs drop or rise, the Web is here to stay. Economists (capitalists) have long predicted that, given mass production, everyone benefits, including the common worker.

In our stock photography industry, electronic automation and its benefits, originally available only to the large stock photo conglomerates, are now available to the individual stock photographer. This could spell disaster for the conglomerates because they are middlemen. Middlemen represent an extra fee photobuyers need to pay. "Why not go directly to the photographer?" now asks the photo researcher. This may soon become the norm, what with cheaper hardware, greater bandwidth, increasing Web literacy among photo researchers and a revived entrepreneurial spirit among stock photographers worldwide.

transparencies. If a client wants to see certain images, I can immediately post them to a private address on my Web site for viewing. This 'virtual portfolio' system eliminates the need for FedEx delivery—and it costs no more than what I've invested in my equipment. In my opinion there's no cheaper, faster way to get new photos in front of potential buyers." (See page 93.)

Marketing Secret Revealed

We can all benefit by taking a close look at what e-commerce has to offer editorial stock photographers. The formula goes like this: Find out the E-mail addresses of photobuyers whose photo needs are in subject areas that you cover in your areas of specialization. Contact them often (monthly, twice monthly) by E-mail with notices describing what you've photographed recently. In the body of your message, include a hyperlink to a page on your Web site where they can see a sampling of six of your newest images in their subject areas. No photobuyer will consider your E-mail as junk mail if you restrict your notices only to buyers whose photo needs match your photographic specialty areas.

If you have discovered fifty photobuyers who buy in your areas of specialization, and you gain a $1,000 average net profit from each of them over a year's time, you've made a tidy $50,000 for your coffers. You'll spend it however you wish, but I suspect you'll put a portion toward an airline ticket to somewhere on the planet where you've always wanted to photograph. In any case, when other photographers complain about "big business" taking over the industry, you can smile—all the way to the bank.

BLOW YOUR OWN HORN

It's no secret that the book and magazine industry buys large quantities of photos—daily. Medium-size publishing houses have a $20,000 or more per

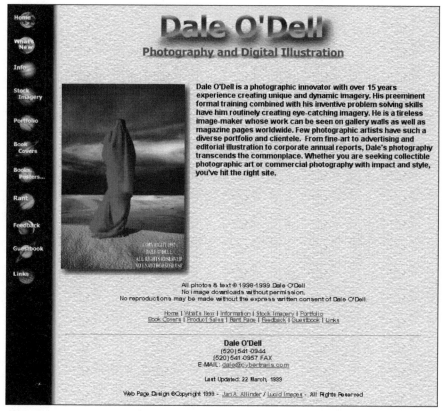

Dale O'Dell

month budget for photography. Large publishers pay out $40,000 to $80,000 per month.

You, the stock photographer, don't have the opportunity to advertise your work to these clients in the usual, conventional ways. The yellow pages are not available to you; neither are billboards, radio or other media. Since you are a "specialist" in your field of photography, you are faced with the task of figuring out a way to advertise yourself, without appearing, shall we say, immodest. I have seen great reluctance on the part of photographers who deal with the magazine and book industry to advertise themselves. They have the task of overcoming their resistance to self-advertising, or "horn blowing." It's a paradox because most talented photographers (because of their talent) find it uncomfortable to talk about themselves or promote themselves in glowing terms.

However, the fact remains: Many a genius has gone undiscovered to his beyond because he failed to allow himself to be discovered. Look at it this way: Picture the Bronx telephone directory and then imagine that you're in it,

and that you and all the rest of those names are modest, talented photographers. It would be preposterous (or even immodest . . .) on your part to imagine that the world was going to come along and discover *you*, wouldn't it? Sometimes it's actually immodest to be modest.

You happen to be a talented photographer. The viewing public deserves to see and enjoy your pictures. It is necessary for you to break out of the conditioning imposed on you by your relatives, your neighbors and your friends to not state your talent and achievements. You must transcend that circle and admit that if your photographs are going to be seen and enjoyed, you must blow your own photographic horn.

But since you are a sensitive person, such horn blowing is not going to set well with you. Here are four things to keep in mind that may help when you go about your trumpeting.

1. Many photographers, because they have successfully achieved a "name" in their local areas, lull themselves into supposing that the world is aware of their work. Not so. Think big. Blow that horn. Don't just toot it.

2. If you want your photo illustrations to continue selling, you have to continue selling yourself. Horn blowing is an ongoing task. Don't be satisfied that a photo editor, or potential client, is going to remember you next week because of your photographic successes last week. In the field of stock photography, keep this in mind: Your successes today are past history tomorrow.

3. Once you begin to promote yourself, you will be pleasantly surprised to find that those persons you predicted would be highly critical of your new promotional efforts will actually be the first to compliment you.

4. Because part of your motivation as a photographer is to share your photography with the world, you will find that the rewards of successfully promoting yourself (and therefore your photography) will far outweigh the personal discomforts of blowing your own horn.

Marketing your photos to the book, magazine and advertising industries is a business. Survival in this business depends on getting known, and staying known. Observe the advertising techniques other photographers use: reprints of previously published work, business cards, fliers, speaking engagements, seminar panels, radio and TV interviews, press releases, exhibitions, deluxe stationery, posters and now listing their photos in photographic directories on the World Wide Web. Start today to let the world know about your photography. Begin blowing your own photographic horn. No one else will.

The Easiest and Best Advertising—and It's Nearly Free
Stock photographers admit that about half of their time is spent in marketing their work. This translates to two and a half days of your work week. You can reduce this time investment by choosing the most effective ways to promote your stock photography.

Word-of-mouth works well, within a tight community. And with the added

channel of the World Wide Web, you can have multiple tools working for you to broadcast your stock photography to clients far afield and even globally.

Here are some other photographer-tested methods—both traditional and using the new electronic technology—that work.

Press Kit

Getting free publicity depends on giving people in the media the information they need in an organized and complete package. Prepare a professional-quality press kit so you're ready when one is needed.

Here are the ingredients of a basic press kit.

- 4″ × 5″ black-and-white photo (studio pose) of yourself—The background should be light, not dark. Include a color transparency of the same shot if feasible. You may want to include the image on a disk when appropriate. Here's a way The Image Bank includes a photo with its press announcements: "For an image to accompany this press release, please visit the following Web site address and click on the purple diamond labeled 'PR.'"
- Photocopies of former articles that feature you and your stock photography—Note: Don't include previous write-ups about you if you are contacting national publications; they don't like to be upstaged. *Do* include previous *national* coverage if you are contacting local media. Such clippings are justification for local editors that they can feel on solid ground to take a chance on featuring your story.
- Your business cards.
- A separate sheet that explains to anyone doing an article about you the who, what, where, why, and how of your business, in easily understood language—Be sure to include your name, address, phone, fax, Web and E-mail addresses on all sheets. Reason: Sheets often get separated. The editor may want to use one sheet's contents. If your contact information is not on it, it will get passed over.

Put all of your material in a heavy-duty, good-looking folder with pockets, and you've got your press kit. Distribute your press kit to key people in the media so they can call upon you when they're working on a story that could include your comments. In your cover note suggest that they add your press kit to their "experts" files for future reference.

Most editors and reporters are *generalists*, not specialists. They go to those expert files when they need to quote or to interview someone. If you can get your information into those files, and if they perceive you as a qualified resource, they'll call you.

Keep extra photos of yourself on file. The media is very time sensitive today. Mere hours can spell the difference between getting an article into the press or missing the opportunity. Update your mug shot every three or four years. Be prepared to E-mail a photo or complete "backgrounder" to the editor.

Inserts

Whenever you mail to a potential photobuyer, you may have extra space for a "ride-along" insert without tipping the postal scale into the next ounce. Include your sell sheet or testimonials from photobuyers.

Mail first class—not only for the speed but for the preference it receives upon arrival. Most mail room attendants are instructed to put first-class mail on the top of the pile. Bulk mail is put in a "when I have time" bin.

Use the free Priority Mail (red, white and blue) envelope provided by your local post office. It attracts attention.

Networking

When you attend group meetings, conferences or clubs, such organizations as American Society of Picture Professionals, Professional Photographers of America, American Society of Media Photographers, North American Nature Photographers Association and National Press Photographers Association keep your conversations *brief*—so that you get to talk to (and qualify) more prospects. You can do follow-ups later.

Ask questions rather than tell others about yourself. You'll be perceived as one who cares and who takes an interest in what others in the stock photography community are doing. At the same time, you're learning about potential areas of need for your stock photography services.

Network through computerized special interest groups (or forums) on the Internet, and on services such as editorialphoto.com, America Online, Prodigy and CompuServe. For example, there are several photo-oriented special interest groups on the Internet (see page 106). Fellow photographers post problems or questions, and overnight (or sometimes even minutes later), they get answers and comments from others around the country or world. PhotoSource International offers the Kracker Barrel on the Web, where stock photographers are able to pose questions about everything from copyright to scanning devices.

The World Wide Web offers hyperlinks to many photography-related sites for both networking and technical help. Photobuyers participate in the forums, also. Many fruitful business arrangements have been hatched on these services, including photo and writing assignments, partnerships and other deals.

Photo requests from editors, corporations and ad agencies are listed on several on-line services: VSN (Visual Support PhotoNet), PSI (PhotoSource International), AG Editions. For contact information and more outlets, see page 68. Subscribe and build your market contact list.

Photo Cards

Using your scanner and printer, make your own business cards. Or barter with a printer. You can supply photos for one of his projects, and he can supply you with printed business cards.

A photo of you or an example of your work on your business card will

make your card stand out among the others. To distribute more cards, challenge yourself to find creative ways to get them into the hands of more photobuyers in the next year. Here are some ideas for starters.

- Include two cards in your mailings to a buyer and encourage her to pass one on to a fellow buyer in her company or publishing house.
- When at meetings, trade shows, etc., practice the art of "give a card, get a card" by asking others for their cards. (And it will help you to remember names!) Be sure to jot notes on the back of the cards, for example, "Buys only calendar shots" or "She's a former biology teacher."
- Consider printing your card (with photo on it) as a magnetic refrigerator card or as a die-cut card to fit onto the recipient's Rolodex. It's perceived more as a business resource or tool than a promotional item. It can bring results lasting for years—even from someone who wasn't at the publishing house when you first gave or mailed your card. For a sample Rolodex card, inquire at MWM Dexter, Inc., (800) 641-3398. While you're talking with a representative there, ask for samples of the company's photo cards.
- Don't hoard your cards in the supply cabinet. Put them to work. Every time you mail, include your photo card. Keep in mind that people tend to not throw away photos—they go on bulletin boards, under glass desktops, etc.
- Write and design your card to *sell*. Get the help of a professional graphic designer if you think you need help in designing your photo card. Again, you can barter for this service.
- If you are a commercial service photographer, give supplies of your cards and/or flyers to clients and customers for distribution. Your suppliers, for example, can set your cards out for the taking at their retail locations.

Your Public Library

The ability to access needed information—timely, accurate, state-of-the-art information—is going to separate the winners from the losers as our information age gets more competitive in the years ahead.

You've already paid for library access through taxes or donations, so take advantage of this valuable resource. In many libraries, staff members are available to conduct varying degrees of free research for you—and even take requests by phone. You'll find the same help at vo-tech schools, colleges and universities.

Your public library is hooked into the Internet. If you aren't on the Web, here's where you can take a test-drive and get a feel for it. Helpful, friendly library staff will walk you through the steps if you are a novice at surfing. On the Web, you will find information about periodicals that feature photos in your PS/A.

Libraries subscribe to special interest magazines that will be helpful in giving you photobuyer leads, marketing ideas and other valuable information. These

subscriptions could cost hundreds of dollars each year, but at the library they're free. If you're a frequent visitor, you can make requests that your library subscribe to certain periodicals.

Free Publicity

Instead of looking at publicity as a matter of, What can I get for free? consider the situation from the point of view of the media you want publicity from. Every newspaper has empty space it needs to fill with articles and notations of interest to its readers. Radio and TV broadcast features aren't always major events. Local visual professionals (that's you!) can contribute to their broadcasts. All media need commentaries on issues that you may be in a position to offer.

Offer to appear on local radio and TV interview programs. Producers need guests who can speak articulately for taped interviews and live call-in shows. Offer to supply the visuals for the TV interview.

When you promote through the media, keep your press lists up-to-date. Public relations is an industry famous for job turnover. One way to keep your list current is to send out postcards—featuring one of your recent photos— that ask for any personnel changes.

Some private companies make it their business to offer always-current lists of public relations firms and their personnel. One example is Bacon's Publicity Checker, 332 S. Michigan Ave., Chicago, IL 60604; phone: (800) 621-0561 or (312) 922-2400, Web site: http://www.baconsinfo.com. These companies will also handle the duplication and distribution of your releases if you wish. Check out this reference tool in your local library or on the Web.

Get listed in directories. Reporters and editors in the media often turn to directories to find experts and company representatives for interviews—*especially at deadline time*. Gale Research publishes *The Directory of Directories*, which profiles thousands of directories each year.

If you are traveling abroad, you can mention (free) your itinerary at http://www.photosource.com/abroad/trvlmore.html. Photobuyers who need photos from the country you are traveling to may contact you.

To get national exposure and publicity for your photography work, you can be listed as an expert resource by contacting Mitchell Davis, Editor, *The Yearbook of Experts, Authorities and Spokespersons* (also known as the *Talk Show Guest Directory*), published annually.

Cultivate photo editors and reporters at the magazines and newspapers read by your prospects. These publications need experts to quote and sources to interview. They also need columnists, especially the trade-specific magazines. Let them know you're available to write about innovations and the new technology that affect our stock photo industry.

Send comments to reporters and editors from time to time on their columns. They appreciate honest feedback and even *praise* when warranted.

To identify prospective periodicals and columnists to contact, consult

Gebbie's *All-In-One Directory*, which lists the thousands of magazines and newsletters that are published in the United States. Their numbers will even increase as the desktop printing boom quickens its pace. Gebbie Press's directory also lists approximately 1,800 daily newspapers and 7,500 weekly, bi-weekly and triweekly newspapers, as well as all of the radio and television stations in the United States.

If you publish your own newsletter, you can use excerpts from other publishers' newsletters in your publication. One popular newsletter, *Communication Briefings*, is comprised largely of clips from other publishers' newsletters. Encourage other newsletter publishers to reprint articles from your publication.

Hold a contest, sponsor an award, hold a benefit; write and distribute a news release on it.

Free publicity is just the beginning of a total publicity-based strategy.

Distribute photocopies of favorable newspaper or magazine articles about you and your stock photo business. Highlight your name or business with a colorful marker. If your publicity appears in a major publication, ask the permissions editor to provide you with overruns. These are extras from when the presses run an extra few minutes. Offer to pay ten cents a piece for these overruns. Often they will be given to you free. For many of your clients and prospects, these reprints will be more effective than any brochure.

Free publicity awaits you if you include your Web site on the Yahoo! visual arts directory: http://dir.yahoo.com/business_and_economy/companies/photography/stock_photography.

Record the response from your free publicity. This will help you to measure the audience of the publication and whether it would be worth advertising in it in the future.

Referrals

Referrals are free. They are direct sales possibilities.

As an editorial stock photographer, you have a unique advantage. Unlike the commercial stock photographer who would rarely pass on a referral to another photographer, editorial stock photographers are always passing on jobs to fellow photographers. Why? If Jim Jones's specialty is animals, especially dogs and cats, and if he gets a request for a snowmobile picture (because he lives in Wyoming), he refers the client to his friend in Michigan who has snowmobiling and winter sports as her specialty areas.

Reward referrals. Do you need to provide a monetary reward? Make your own decision. But remember that a creative thank-you or a photo gift goes farther than straight cash. Try flowers, gift certificates for dinner, maybe a magazine subscription. At the very least, send a handwritten note of thanks and appreciation.

Are you following up later with both the person who sent the referral and the person who was referred? Fail to follow-up with people who send referrals,

Keep Your Name Alive

Marketing wisdom says that it costs five times as much to pull in a new customer as it does to keep a current customer. Build your client base slowly and cost-effectively. Target your promotional efforts to those photobuyers whose picture needs match your PS/A.

Once you have added new clients to your base of buyers, treat them like the treasure that they are. Many of these buyers (or the publishing houses they represent) can be lifelong sources of revenue for you.

Along with the usual courtesies, such as remembering them with notes during the holiday season, send them periodic news items, such as reprints of your work currently appearing in the national press. This assures them that they are working with a supplier other photobuyers value, and they'll want to stay on the bandwagon. Promotional material featuring your latest work, whether a postcard mailing or a twenty-four-page color catalog, seems to always pay for itself.

A good rule to remember: You are past history once you have published with a photobuyer. He needs to be continually reminded you are still alive.

and they will get the idea you don't appreciate the business. Create a system to be sure you're following up. Even a timely postcard is effective.

Do you ask your satisfied clients for letters of recommendation? Reprint these testimonials on the back of your stationery or on a separate flyer to include in your mailings. Frame and put some of the testimonials on the walls of your office. Make photocopies of them, and send them as a memo to your staff members.

Seek referrals from your vendors. Does your printer refer clients to you? Your computer vendor or software programmer? Maybe they don't even know what business you are in! If you want your vendors to refer clients to you, try referring more to them and emphasize the value you place on your relationship.

Research

Use research to spot emerging trends. Do you know where stock photography will be five years from now? Three years? One year? Are you prepared?

In addition to the information mentioned above under Your Public Library, here is another area the average layperson interested in researching the photo industry can take advantage of. Through your computer modem, you can log onto the World Wide Web and get asset reports, financial outlooks, industry perspectives, news about changes in the stock industry and much more. An excellent book about this area is *Naked in Cyberspace* by Carole A. Lane. Another is *Web Site Stats* by Rick Stout. A good research guide is *The Internet Research Guide* by Timothy K. Maloy. Software available (for PCs) is The Internet Spy and You, available at DLMSR Marketing, P.O. Box 17481, Jacksonville, FL 33245-7481.

Get free copies of industry trade magazines and newsletters by making your

requests for copies on well-designed letterhead and envelopes. Address the request to the advertising department, which always has ample review copies available for prospects.

Our governments (both federal and state) are rich repositories of market research. There's probably more research done by government than by all private entities combined. And as citizens, we have access to a lot of it—usually for *free*. Here are a few Web sites to peruse for information.

American Bar Association (ABA)
 http://www.abanet.org
American Law Sources On-line
 http://www.lawsource.com
CitySearch.com
 http://www.citysearch.com
Department of Commerce
 http://www.doc.gov
The Library of Congress
 http://www.loc.gov
The National Library of Medicine
 http://www.nlm.nih.gov
PR Newswire
 http://www.prnewswire.com
U.S. Court of Appeals, Federal Circuit
 http://www.law.emory.edu/fedcircuit
WhoWhere (Lycos)
 http://www.whowhere.com

You can conduct your own market research, too. Once or twice a year, design a survey questionnaire to measure the needs and attitudes of your customers. Then design a survey to assess the problems faced by your prospects that your services or product could solve. (Caution: Your surveys must have the look and professional feel of genuine surveys if people are going to fill them out.)

Use toll-free numbers to your advantage. Major corporations, vendors, camera supply houses, airlines, hotels and computer warehouses all have toll-free numbers. Call (800) 555-1212 to find the toll-free number of the business you want to call.

Are you keeping up with the printed research and articles in your field? Many Internet portals offer customized news (push technology) that can provide you with specific information of interest to you. When you go on-line, you can download what was "pushed" to you, then print it out to read at your leisure or save it in a folder.

Go through a directory such as Gebbie's *All-In-One Directory* (see page 99) each year for lists of publications you should be reading—or adding to your press lists. Include newsletters as well. A list of newspaper contacts, current and

up-to-date on disk, is available for a small fee from Travel Publications Update, 5337 College Ave., #258, Oakland, CA 94611, phone: (510) 654-3035, E-mail: PatSnide@aol.com.

Many trade publications are available free to qualified persons in the industry. When you contact a publisher, if your stationery reflects professionalism, you can often be added to complimentary subscription lists.

Professional-Looking Stationery

Your stationery may well be your most important marketing tool. Employ not the good, better or the best—but the *deluxe*. Important: Always include your address, phone, Web address and E-mail address on your stationery. Without them, clients may go to another supplier because they don't want to take the time to look up your contact information.

THE IMPORTANCE OF BEING FINDABLE

Demographers tell us that in a mobile society, we can expect most people to have a new address every five years. At PhotoSource International, we certainly find that to be true when we make a postal mailing to photographers on our database. Photographers move a lot.

If you have moved recently, it's important to personally let your buyers and clients know of your new address. Don't rely on the U.S. Postal Service to do the job for you.

A plus in our day and age is that technology offers ways we can make sure to stay in touch with our buyers, even during the transition of a move. Independent of any changes in your mailing address and regular phone number, your E-mail address and toll-free number can remain the same. You won't lose touch with your photobuyers if you have one or the other or both.

I recently experienced another way that photobuyers can find photographers.

Nancy Ritz, photo coordinator at Prentice Hall, the book publishing company, wrote to me saying she was returning one of my photos that her company had used in one of its textbooks. She pointed out that they've filed a digitized copy of the photo, and the number stamped on the back of the print is the database designation from the Corporate Digital Archive (CDA) of their parent company, Simon and Schuster. She said in her letter, "You are listed as the photographer, copyright holder, and source. When another buyer at Simon and Schuster should come across the photo, the information is already in our computers relating you to that photograph."

It's nice to know computers, databases and mergers of large publishing houses can have a beneficial reward for independent photographers. My digitized photo will probably remain in that CDA a long time.

And it's nice to know that photo, taken in 1978, is in an archive that can benefit not only me but my grandchildren, and possibly their grandchildren.

Get an E-mail Address and Keep It

An E-mail address can be a lifesaver for the peripatetic photographer. But choose your E-mail address carefully.

When you first break into the world of E-mail, you may be tempted by local and/or national Internet Service Providers to hook up with their E-mail services. They dangle alluring low fees, much as credit card companies will do, to bring you aboard. Then, be it six months or twelve months later, they're sure to raise their fees. Your problem: Should you switch to a cheaper company or stay with your original ISP? If you make the switch, it means that every place you've registered or listed your E-mail address will have to be changed. This includes all your printed matter, such as your business cards, sell sheets, flyers, stationery and invoices, plus your Web addresses and links where you have registered your name and Web site.

Lesson: When choosing an Internet Service Provider, pick one with a track record. We've all heard examples of low-fee start-up ISPs that are out of business in a few months. Instead, choose an ISP you estimate will be around for a long time (even though the cost may be somewhat higher). In the long run, you'll be happy you did.

You may want to sign up for private E-mail in addition to your regular business E-mail. A second E-mail (sometimes called Webmail) can be used much as you would use a nonpublished telephone number. There are several dozen companies that will offer you a free E-mail. Keep in mind that many of these free E-mail sites receive their profits from advertising. You can expect commercial intrusion to ride along with your message.

To find free E-mail services, use one of the search engines. Here's a sampling of what you will find.

EasyPost
>http://www.easypost.com

Friendly E-mail
>http://www.thedorm.com

GroupWeb Worldmailer.com
>http://www.worldmailer.com

HotMail (MSN)
>http://www.hotmail.com

Juno
>http://www.juno.com

Link Trader Web Mail
>http://www.linktrader.com/webmail

Unbounded M@il
>http://www.unbounded.com

People Find

Should you list your name and E-mail address on a people search? If you are a recluse, a hermit, an artist who doesn't want to be hounded by the press or

be bothered by relatives, no, don't submit your name and E-mail to a people-search feature at your favorite search engine. On the other hand, if you want to receive attention from photobuyers and other business entities that are a part of the stock photo industry, the answer is yes.

Sure, it's true, you might open yourself to receiving what most of us call junk mail. But think of it this way. You can recognize the difference between the subject matter of a junk mail pitchman and a response from a photobuyer. So the choice comes down to whether to put up with receiving twenty-four junk mail letters that take twenty-four seconds to delete for the chance to receive one E-mail from a photobuyer that might lead to a lifetime of future stock photo sales and assignments. No contest.

Photographer Directories
There are a number of photographer directories on the Internet that will list you and your areas of expertise. You have probably found a few favorites of your own. In case you have not come across these, here are some from my WWW bookmarks.

Andy Davidhazy's Photo Lists
 http://www.rit.edu/~andpph/photolists.html
Joel Day's STOCKPHOTO Site
 http://stockphoto.joelday.com
Folionet (AGT)
 http://www.folionet.com
Global Photographers Search
 http://www.photographers.com
The Guilfoyle Report
 http://www.gronline.com
Mira Photographers
 http://www.mira.com/membership
National Press Photographers Association
 http://metalab.unc.edu/nppa
Newsmakers
 http://www.newsmakers.net
Photographers Index
 http://photographersindex.com
Photonet
 http://www.vsii.com
PhotoServe
 http://www.photoserve.com
PhotoSourceBank
 http://www.photosource.com/psb
Portfolios Online Search
 http://www.portfolios.com/search

Michael Schwarz
 http://www.michaelschwarz.com
Stock Photo Electronic Directory
 http://www.redshift.com/~wtyler/intro.html
Stock Photographers (United Kingdom)
 http://www.contact-uk.com/CCC.pnames.htm
Stock Photography Collections
 http://www.mediafocus.com/stockspecials.html
WorldPhoto
 http://www.worldphoto.com

Let Them Find You on the Web

All Web sites are not created equal. With the help of a Web designer, you can encourage visitors (photo researchers!) to come to your site. The technique is not shrouded in mystery. The secret is to choose the right meta tags (see sidebar below) when designing your site.

A rule of thumb in choosing meta tags for stock photography sites is to follow the leader.

Conduct a test. Type in "stock photo" in one of the major search engines. Select a site by clicking on its name. Once the page loads, click on View on your browser's tool bar, and then click on Source (which stands for source code).

Observe which meta tags were used in designing this site. See how often they were used and how they were placed in the body of the source code.

This method isn't perfect, since different search engines use different search criteria, according to our Webmaster here at PhotoSource International, Owen Swerkstrom. He tells us also that "there are several meta tags, but the most important for search engines are the description and keywords." Also, he said, "Don't get overzealous with your keywords. Some search engines will relegate you to the bottom of the pile if you clump seven or more of the same keywords together in a short paragraph."

What Are Meta Tags?

Visitors can find your Web site if you've included keywords that describe your site in the first few lines of your Web page. Also, you, or the person who designs your site, will include a brief sentence describing your site. This latter information will remain transparent. Visitors won't usually be able to see it, but the Internet "spiders" that are used by search engines to locate information will.

If you have chosen the right meta tags, qualified visitors will land on your site when they use a search engine to pinpoint information about stock photography.

A good primer on meta tags can be found at http://www.businessla.com/business/searchengine.htm.

Photo-Related Discussion Groups on the Internet

You can find other photographers and they can find you when you participate in the chat groups available on the Internet. These discussion groups work by simply sending and receiving regular E-mail messages to and from others on a designated mailling list.

Below is a selection of photo-related mailing list servers on the Internet, gathered from various sources. Due to the nature of the Internet, lists will come and go without warning. So, when you go looking, you may not be able to find all the lists mentioned here.

Mailing lists function like party lines. You post a message to the list, and the list rebroadcasts the message to all subscribers. To start your subscription, send a message (some are specified in the list below) to the address for your area of interest. There is no charge to subscribe to any of the following lists.

Adobe Photoshop and related problems or suggestions
 photoshop@hipp.etsu.edu
Ask to be added to the list.

American Society of Journalists and Authors (ASJA) Contracts Watch
 (frequent talks about electronic rights, etc.)
 listproc@eskimo.com
In your E-mail, type "SUBSCRIBE ASJACW-L <first name> <last name>"

Discussion of wire service photography and photographers
 listserv@pressroom.com
In your E-mail, type "SUBSCRIBE WIRE PHOTO-L"

Photo history, related items also welcomed, especially with a historical twist
 listserv@asuacad.bitnet or listserv@asuvm.inre.asu.edu
In your E-mail, type "SUBSCRIBE PHOTOHST <your real name>"

For beginners and pros dealing with equipment and shooting assignments/
 stories
 majordomo@imsworld.com
In your E-mail, type "SUBSCRIBE PHOTO (nothing else)"

For professional photographers and advanced amateurs to exchange infor-
 mation and ideas
 listserv@internet.com
In your E-mail, type "SUBSCRIBE PHOTOPRO"

The Internet offers access to useful information about photography through these discussion groups. If there's information overload on the Internet, these discussion groups are the mother beehive. You will find yourself becoming selective when you surf among these groups. You'll eventually settle on one or two that meet your needs.

There are four types available: commercial forums, Usenet groups, E-mail lists and bulletin boards. Kracker Barrel at PhotoSource International's Web site, is a bulletin board.

Editorial Photographers (http://www.editorialphoto.com) is probably the

most important chat area for editiorial stock photographers. This discussion group is restricted to photographers who earn at least part of their income in the editorial market.

CompuServe and America Online each have forum areas dedicated to photographers.

The STOCKPHOTO list, moderated by Joel Day in Australia (see page 104), is the oldest Web stock photo discussion group I know of and with broad participation, perhaps because Joel keeps the reins tight and guards visitors from going beyond the scope of his subject matter: stock photography. Visit his STOCKPHOTO forum Web site at http://www.stockphoto.net to subscribe.

PhotoPro (http://206.30.88.71/) is another popular commercial site moderated (to keep everyone in focus on professional photography) by Jack Reznicki and Gary Gladstone. You can join the list at their site. Click on the word Forums, then on the Forum Signup button to follow instructions.

Usenet groups on the Internet (rec.photo) are open to the general public. They usually aren't moderated. You'll need software from your ISP and the name of the particular group's news server. Check with your ISP.

Here's a list of photography newsgroups.

rec.photo.
rec.photo.darkroom
rec.photo.digital
rec.photo.equipment.35mm
rec.photo.equipment.large.format
rec.photo.equipment.medium.format
rec.photo.equipment.misc
rec.photo.film + labs
rec.photo.marketplace
rec.photo.misc
rec.photo.moderated
rec.photo.technique.art
rec.photo.technique.misc
rec.photo.technique.nature
rec.photo.technique.people

To develop your own mailing list, you can consult these free how-to sites for more information.

http://websitepostoffice.netscape.com/
http://www.egroups.com/

Pricing Your Work

TYPICAL FEES

When you are asked, "What are you going to charge me for this photo?" you may feel you have to scramble for an answer. This section will help you to unscramble your thoughts about pricing.

As an editorial stock photographer, pricing is easy. The buyer sets the fee. Publishers set a budget for artwork, and photo editors try to find quality images that will fit the budget. This makes your pricing decisions easy. The photobuyers never ask. They tell you the fees and you make the decision to sell—or not. Unfortunately, the mergers in the book industry that were designed to make the companies more efficient have been translated into less pay when it trickles down to writers and photographers.

Through my years of watching how publishers establish budgets for their projects, I've figured out a pricing chart (shown below) based on seven budget range caterories.

So, if a photobuyer (or a photo researcher) calls you and wants to purchase a picture, immediately say, "What are you paying for a quarter-page?" Since the buyer has been mandated to spend a certain amount for each photo (85 percent of the pictures buyers use are quarter-page), the buyer will come back with an answer.

Pricing Your Editorial Stock Photography

To apply to publishers and publishing companies for onetime inside editorial use

Range Number	Color/Black and White
1	$301 to $500
2	$151 to $300
3	$126 to $150
4	$101 to $125
5	$ 76 to $100
6	$ 51 to $ 75
7	$ 25 to $ 50

It's rare that a buyer will say, "A fee hasn't been established yet."

If he does say this, say to him, "What did you pay on your last similar project?"

You see, pricing your pictures in the editorial field is usually already done for you. It's unlike the commercial stock photography field, where you need to use slick negotiating techniques until you can gain a good ol' boy (or ol' girl) status.

OK, say that you do get a call from a commercial client. What do you do? You switch hats and refer to a chart (shown below) close to your telephone. Remember, you're probably not going to get any repeat sales from this caller, so start at the top of the price range for the relevant category and try not to budge.

My commerical pricing chart is a guideline. You can refine it by checking into various commercial photography Web sites, using a search engine and the keywords "stock photography pricing."

The chart's prices are ballpark figures because your next step is to find out the use of your image and what the circulation of the publication will be (national, regional, local, etc.).

Three good sources to use for putting prices on your commercial stock photography are Michal Heron's *Pricing Photography*, Jim Pickerell's *Negotiating Stock Photo Prices* and Cradoc Bagshaw's software fotoQuote.

Foreign Sales

Stock photo sales flourish overseas. To get an estimate of what you should be charging commercial clients abroad for your stock photography, visit this German Web site: http://www.piag.de /IndexEnglisch/IndexHonorare.htm. Another helpful source for foreign markets is *Canadian Markets for Writers and Photographers* (see Resources, page 229).

Pricing Your Commercial Stock Photography

Major Magazine Ads	$500 to $1,000
Regular Magazine Ads	$300 to $500
Newspaper Ads	$200 to $300
Brochures	$250 to $350
Annual Reports	$250 to $350
Video Covers	$400 to $600
Calendars	$250 to $450
Posters	$300 to $500
Greeting Cards	$200 to $350
Postcards	$150 to $250

PRICING WEB PHOTOS—CONTRACTS

A general rule of thumb is to charge what you normally would for a quarter-page in that company's publication. Limit the use to six months and then renegotiate.

The answers to these questions will also influence your fee.

1. How many daily visitors does the Web publication get? A program like Alexa will help you determine this figure. The larger the number of visitors, the greater your fee.
2. What placement will the photo have within the Web site? A prominent place deserves a higher fee.
3. Will the company offer you a credit line? You should charge a slightly higher fee if you do not receive a credit line.
4. Is the local company national, regional or local in scope? Usually you can expect a higher fee from a larger national company than a local one.

As the Web grows exponentially in size, the pricing on Web use of photos will decrease. Already major photo clip art houses are offering royalty-free photos at low fees ($20 to $40).

Remember, though, if the photobuyer has come to you for one of your specific photos, you can rest assured that your photo is unique and applicable to her particular needs. Hold fast when the art director says, "Well Tony Stone Images is selling if for half that price."

They may be, but it's not the same photo. This buyer wants *your* photo. Stand firm.

The only drawback to entering into extended negotiations with a client is that the fee you decide on might be less than the dollar value you spent in negotiating time!

Cradoc Bagshaw, whose fotoQuote (see page 112) has proved popular for photographers trying to make price quotes in the commercial field, is fond of reminding photographers that all commercial stock photo sales are negotiations.

In some instances, a photographer who has produced an assignment for a client, gets a notice from the client that he plans on using one of the photos on his Web site. Cradoc says to stand firm: "When you buy a car the dealer says, 'This is our standard policy.' You know that you are free to come back with your own policy and the negotiation begins. Every commercial stock photo sale should work this way. Here are a couple of suggestions that we make in fotoQuote for your situation. You will find them in the Phone Scripts section of the Coach section."

Client: "We're going to use one of the images you took for us on assignment on our Web page. There won't be any additional charges, will there?"

Response: "Yes, there is a charge for licensing my image on your Web site. The Assignment Confirmation form that you signed before I shot the assignment for you clearly limited the use of the photos to the [Annual Report]. It

How to Price Photos for Web Site Use

Web site pricing is easy if you use the "One Dollar" formula. It applies to both editorial as well as commercial markets.

When a client asks, "What do you charge for Web site use?", return the question with your question, "How many visitors do you get each *day*?"

This question may stump them, but you can easily look like the expert when you suggest using Alexa. With the free software from Alexa (a company owned by Amazon.com) you call up www.alexa.com. At the bar at the bottom of your screen, click on, "traffic." The statistics will not only show you the owner and address of the company (you can spout that back to the client for verification) but the number of "Alexa visitors" they get each day. Alexa has its own formula for determining the visitor number, but it's generally based on a percentage of the total hits a Web site receives each day. For example, if your site receives 7,500 hits per day, Alexa says you get 2,500 visitors (about one-third the total number of hits).

Now that you've determined this figure, you are ready to apply my One Dollar formula. Most potential clients contacting you for a photo to use on the Web are interested in acquiring a photo for their home page, and my Dollar formula applies to his usage. If your client currently receives 300 daily visitors, you will charge them $300 per year. If they receive 3,000 visitors per day, you will charge then $3,000 per year.

A client may be just starting out and there will be no stats available at Alexa. Your response: "Who are your competitors? Can I assume you plan to keep up with them? Let's see what they are getting in the way of daily visitors."

Some companies may plan to use more of your photos elsewhere in their Web site. In this case it's discount time. The annual fee for the initial, primary photo will remain the same, but for the extra photos, divide the annual fee by the number of photos they plan to use. This will give you the per photo fee to charge.

You might find it necessary to make some bargaining concessions. To keep the style consistent in their Web site, they might want to use only one photographer's work—and plan to use many photos throughout their site. It may be good politics to adjust your price for volume purchase.

For nonprofit organizations that might have a high visitor count but a low budget, be prepared to make adjustments. In this case, your credit line prominently displayed could prove to be of useful promotional advantage, compensating for a lower fee.

was because of the limited usage that I was able to give you such a great deal on my fee for the assignment."

Client: "We don't have a budget to license your image on the Internet, because the Internet is experimental, and we're not making any money yet."

Response: "I appreciate that the Internet is new, but many advertisers are already finding out it can also be profitable. Some Web sites are getting as much as a million hits a day, and some are charging $30,000 a month for ads on their sites. I appreciate that you are taking a risk on the Internet, just as you do with any ad you run. If there wasn't a potential for return you probably

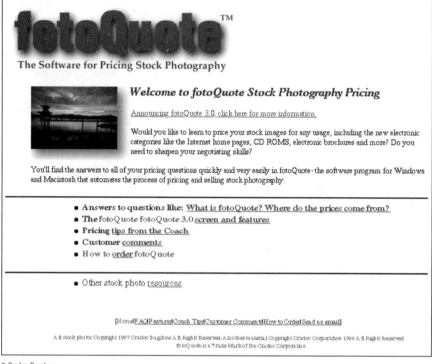

© Cradoc Bagshaw

wouldn't be advertising in this medium. Past experiences with [you/my other clients] has proven that my images create a powerful and effective draw in [your/their] ads. I feel that that will be the case here, too. If there is money to be made from this ad, my picture will help you do it."

Another proponent of standing firm when dealing with photobuyers is photographer Michal Heron. She advises, "A publisher usually asks for the whole bag of tricks instead of onetime rights. Two reasons: (1) They want to get more rights for less money. And often do. It's a successful technique with some photographers who aren't firm, or aren't sure how to assert their rights. (2) The buyer wants to avoid the paperwork involved with coming back to you later (and sometimes they, ahem, 'forget' to come back) for more rights. In stock photography, you have one simple policy to follow, no matter what the client asks for in their paperwork: *You* grant the rights, *you* specify exactly what rights are granted for the stated fee.

"If they can't live with that, you suggest what the fee would be for the broader rights they want. I always suggest that they'd be better off coming back when they are sure they need the additional rights, rather than pay now for rights for future editions which may never see the light of day. . . . the key here is that you are doing the licensing, and the more specific and clear the

better. Make sure that your invoice for the reproduction fee grants the rights they are getting—that invoice once paid is your agreement, it supercedes any request they made. When they pay the invoice, that's it, those are the rights they have. If you should get a check with restrictions on it—don't cash it, there should be no conflicting language on the check. What you have on your invoice is what you stick to."

Today's Contracts

Notice in the contract on page 114 how, in paragraph three, the publisher includes use of the photos in electronic databases and CD-ROMs.

In the next contract on page 115, notice how the publisher slips in its right to use your photos on its Web site (paragraph three).

In contracts like these, exercise your right to refuse to allow your photos to be additionally used on a Web site or CD-ROM without extra payment. Cross out that section of the contract, initial it and then return the signed contract. At that point you can negotiate the extra payment.

NEGOTIATING WHEN THE BUYER WANTS TO REUSE YOUR IMAGE

You receive a phone call from a photo editor requesting electronic rights and you respond:

"Let me confirm if I'm understanding correctly: You'd like to take those pictures I sold you for your textbook and put them onto a CD-ROM, for a print run of three thousand—and you'd like to know how much I would charge you for the package?"

There are two major elements to keep in mind in this negotiation: (1) You own the pictures, and if the publisher wants to go ahead with the project and use your pictures electronically, the ball is in your court. (2) The long-term relationship with your publisher is important. Over a ten-year period, you might do $250,000 worth of business with the publisher. You don't want to jeopardize this by being over-demanding about electronic rights.

The traditional answer for second use or subsequent reuse and reprints in *print* (paper) format is to charge 75 percent of the original fee, providing the photo is used in the same context. (If used for a completely different use, the general usage fee should be 100 percent, rather than 75 percent.) Publishers, of course, would like to avoid this extra charge when the pictures are used for *electronic* use, such as on a Web Site or a CD-ROM or optical disk. In this new and fairly untried area brought on by the Digital Era, some publishers are looking at trying to include electronic rights in your original agreements with them. Or, even more advantageous to the publishers, they will attempt to sign you on "work for hire" arrangements, in which they (not you) own the pictures. Only in rare situations (and for a price you couldn't refuse) would you want to sign a work for hire agreement.

Agreement for Limited Rights in Existing Literary Material
(Written, Photographic, Graphic and Any Other Type)

This agreement is made on this _____ day of _____ between _____ ,
_____ ("Publisher") And _____ _____
("Contributor") regarding Publisher's acquisition of limited rights in the material described below
("the Work"):

A. Title or Description:

B. Agreement

1. Publisher agrees to pay Contributor fee of _____ upon delivery of the Work and return of a signed copy of this agreement.

2. Contributor grants Publisher worldwide rights (exclusive publication rights for a period of 60 days from first publication, [limited rights] or [onetime rights]) in the Work.

3. Contributor grants Publisher a) promotional and publicity rights in the Work, and the right to use the Contributor's name, biography, and likeness in connection with publication, advertising, and promotion of the Work or the publication in which it appears; b) nonexclusive reprint rights in the Work, without fee, when reprinted or copied for reader convenience; c) the right to edit, revise, condense, abridge, crop, augment, retitle, or otherwise modify the Work to suit Publisher's requirements; and d) the right to reproduce and distribute the Work on microfilm, microfiche, electronic databases, CD-ROM, and any other similar system or medium now existing or hereafter developed.

4. Contributor warrants that a) the Work is original and the Contributor is the sole author thereof; b) it owns the rights granted hereby; c) Publisher's exercise of the rights granted hereby will violate no copyright or other proprietary right whatsoever; d) the Work will not defame any person. Contributor will be solely responsible for obtaining, in writing, permission(s) required for the Work (if any) and for delivering a copy of such permission(s) simultaneously with delivery of the Work.

Publisher: Contributor:

_____ _____
By: _____ By: _____
Editor: _____

 Name: _____
Title: _____ Title: _____
 Date: _____
 Taxpayer I.D. Number or Social Security Number

Photographer Agreement

THIS IS AN AGREEMENT between _____ ("Photographer") and _____ ("Publisher") _____, concerning rights to the photographs described below for use in Progressive Farmer magazine ("Magazine").

1. THE PHOTOGRAPHS. Photographer will provide by _____ all photographs taken by Photographer in connection with the following photography assignment: _____ .
 If Photographer does not deliver the photographs by the Due Date, Publisher may in its sole discretion elect not to accept the photographs.

2. PAYMENT. On receipt of the photographs in a form acceptable to Publisher, Publisher will pay Photographer $ _____ per day for _____ day(s) [plus documented expenses up to $ _____].

3. TRANSFER OF RIGHTS. Photographer grants to Publisher (a) first North American periodical rights, exclusive to Publisher for 90 days after the on-sale date _____ of the Magazine; (b) the right to publish the photographs in publications of Publisher or its _____ corporate affiliates; (c) promotional and publicity rights; (d) reprint rights; and (e) the right to post the photographs on Publisher's Web site, _____ .

4. PHOTOGRAPHER'S WARRANTIES. Photographer warrants to Publisher that the photographs do not infringe any copyright, do not invade anyone's privacy, and do not libel or slander anyone. Additionally, Photographer warrants that Photographer has made no commitments with any others with respect to the photographs or their use. Photographer will indemnify and hold Publisher and its affiliates harmless from any breach of the warranties in this paragraph. This paragraph will survive the termination of this agreement.

5. PUBLICATION; EDITING. Publisher will decide whether to publish the photographs, and if published, Publisher may crop and make minor editorial changes to the photographs if needed.

6. INDEPENDENT CONTRACTOR STATUS AND WAIVER. Photographer agrees that Photographer is an independent contractor and is not entitled to and will not claim any of the rights, privileges, or benefits of an employee of Publisher or any of its corporate affiliates (the "Company"). Photographer understands that Photographer will not receive any of the rights, privileges, and benefits that the Company extends to its employees, including, but not limited to, pension, welfare benefits, vacation, termination, or severance pay or other prerequisites by virtue of the Agreement or by virtue of Photographer's provision of services to the Company. Photographer hereby releases any and all right, claim, or interest to any privileges or to any benefit, welfare benefits, vacation, or termination pay, provided by, or on behalf of, the Company to its employees. Photographer will be solely responsible for payment and withholding of all income, employment, and other taxes.

7. OTHER BUSINESS AND EXPENSES. Photographer is free to advertise, to solicit business, and to contract to provide services to other persons and businesses. Photographer will be solely responsible for all business expenses, equipment, training and for obtaining medical, life, business, property, or other insurance.

8. TERM. This Agreement may be terminated by Photographer or Publisher on 30 days prior written notice. Notwithstanding any termination of the Agreement, the terms of this Agreement will continue to govern services that Photographer provides to Publisher.

9. COMPLETE AGREEMENT. This is the complete agreement of the parties, and it cannot be changed except by signed writing.

Photographer: Publisher:
_____ _____

Social Security #: _____ Title: _____
Date: _____ Date: _____

The 75 Percent Fee

The 75 percent fee can many times be an acceptable solution, except in the case of CD-ROM production. In these early days for CD-ROM marketing, publishers can be hesitant because of the risk that CD-ROM involves for them. CD-ROMs are not a proven winner in the educational publishing field, for example, because most schools (on all levels) are still using antiquated hardware. The publisher will suggest that you should be a partner in this CD-ROM venture and share some of the risk (to be compensated for later if the project is a success). This request may be reasonable, or unreasonable, depending on the association you've built with the publisher.

A common rule to remember is that freelancers generally charge too little. If you are new at freelancing, charge half again as much as you think would be a fair price if you're looking at less than the 75 percent of the original fee. You'll probably come closer to an appropriate fee.

Too much empathy with your publisher's pioneering spirit can get you into trouble if you charge too low a fee for electronic use. Also, if your fee is too low, the publisher might think your fee reflects the value you place on your images.

In the case of the above scenario, blurt out, "Seventy-five percent of first usage is my fee for electronic use," and see if it sticks. You can always negotiate downward.

Some publishers will assume that because they purchased one of your photos many years ago that they retain rights to use it again—at no charge. Now that publishers have discovered the World Wide Web, many of them are making a rush to place photos of yours (that they originally used ten, even fifteen, years ago) on their Web sites. You may have received a letter from a publisher similar to the one on page 117.

Caution, the honey comes first. The letter addressed to you by a person in the copyrights and permissions office of the publishing house softens you up with praise of your work.

How should you react to this "invitation"?

First of all, know that within the next decade, electronic transmission of photos will be commonplace among publishing houses. Publishers won't have the safekeeping of your images as a top priority. Signing this document might be tantamount to offering your photos unknowingly to other publishers, opening the door for a possible infringement case, that could cost you thousands of dollars to track down.

In this letter to you, the permissions editor says, "While the U.S. copyright law may be interpreted to permit the John Doe Publishing House to electronically publish and distribute your previous contributions to the John Doe Publishing House books and magazines . . ."—don't believe it.

Yes, it's true that a U.S. district court in New York State decided in August 1997 that publishers who had published articles (and by extension, photographs) in hard copies (newspapers and magazines) with the consent of the

The John Doe Publishing House acknowledges your notable contribution to its magazines and book department and wishes to apprise you of the following:

The Publishing House is considering publication and distribution of its magazines (dated 1981 forward) in electronic formats such as CD-ROM. While the U.S. copyright law may be interpreted to permit the the John Doe Publishing House to electronically publish and distribute your previous contributions to the John Doe Publishing House books and magazines, the publishing house nevertheless wishes to confirm your permission to include your works first published in John Doe Publishing House magazines and/or books from 1981 forward.

To indicate your agreement for your works previously published in the John Doe Publishing House magazines to now be republished, distributed, and otherwise used in electronic formats, please sign and return one of these identical documents in the enclosed envelope. The second copy is provided for your personal filing convenience.

Thank you for generously sharing your talent.

[Then you are asked to sign.]

As contributor (or contributor's representative) of works published in the John Doe Publishing House from 1981 forward, I agree to the terms above.

copyright owners (you!) could also republish the copyrighted material electronically (without your consent). The court used section 201(c) of the U.S. Copyright Act to come up with this decision (*Tasini* case). The court also recognized that the decision would deprive creators (you!) of important economic benefits. The court said that it was up to Congress to provide a remedy. The remedy materialized and *Tasini* was reversed on appeal in September 1999.

A publisher can no longer republish one (or many) of your photos in an electronic format unless you are paid an extra fee. What happens when you discover someone has already made use of your photo, without a fee and without your permission?

Get your money. Creative people sometimes forget that the bottom line of

Dear Ms. So-and-So:

I have received your request asking me to forgo any payment for a reuse of my photo(s) in electronic form by the John Doe Publishing House.

As you know, I license my photos for onetime use only. The fee for reuse is always 75 percent of the original first-time fee.

If it seems to you that I shouldn't charge you for electronic use, I request that you consider this: In the near future, when your Web site and CD-ROM publishing department is up and running full tilt, let's say you request to license one of my photos and pay me $100 for its onetime use for a project on your Web site. Then in a couple months you decide to use the same photo in one of your print magazines or books. Would it seem right for you to *not* pay me for its reuse?

I am returning your document. Please do not use any of my pictures electronically without my permission and without paying me an agreed-upon fee for their reuse.

Sincerely,

any business is the profit line. No matter what your talent, you'll miss the opportunity to see your photo credit line in national circulation if you don't have the funds to produce your pictures.

Here are five progressive steps to put into motion if a photobuyer makes an unauthorized use of one of your pictures. If step one doesn't succeed, proceed to the next step, and so on.

1. Send the stroke/slap/stroke/slap/stroke letter.
2. Follow up with a phone call.
3. Send the slap/stroke/slap/slap/slap/stroke letter.
4. Have your attorney write the "kiss 'n' make up" letter.
5. Take legal action.

Step 1: If a photobuyer uses a picture a second time and does not pay for it, it's usually out of ignorance or oversight. Be charitable. You can avoid the time-consuming educating tasks of the next four steps if you get your initial letter right. Stroke: "I have long admired your publication and have enjoyed doing business with you." Slap: "Thus my surprise to discover your second use of one of my photographs, with no payment." Stroke: "Perhaps this has just been an oversight." Slap: "Or perhaps you were unaware that industry

guidelines predicate that 75 percent of the original fee is paid for second use." Enclose a statement (invoice). Stroke: "Thanks in advance for resolving this matter." Note: With any of your correspondence, contact the editor on first-class, professional stationery.

Step 2: If you don't hear back within three weeks, follow up with a phone call. Use a script and practice it with a partner on an extension phone. Your tone and posture on the phone should be courteous but decisive and firm. ("All the world's a stage.") Keep a telephone log of the call and name of the person you spoke with (and same for any subsequent calls). This is called a *paper trail.*

Step 3: If still no results, send a stronger letter to show the buyer you mean business. Again, be courteous but firm. Be nice, avoid threats or any comments that will destroy the photobuyer's self-esteem. Remind him he may be in technical violation of the U.S. Copyright Act. For more impact, send the letter via fax, E-mail, Federal Express, etc. If you belong to a national photography organization, send a copy of your letter to its legal arm.

Step 4: It's now crossing over to where you'll have to ask yourself if the politics involved will damage a future working relationship with this photo-buyer. You may need to decide whether you want to compromise for the sake of ensuring future sales opportunities, or to risk jeopardizing this market on your list. If the latter, then go full steam ahead. Now it gets expensive. Review the details with your attorney who will write a standard "C'mon, folks, pay my client what she asks" letter.

Step 5: If big money is involved, initiate a suit. Ask your attorney to take it on a contingency basis (if you win, the attorney gets paid). Alternative: Take the photobuyer to small claims court (an education in itself). You'll have to travel to the state and city of the buyer. However, a summons has a good chance of snapping the photobuyer awake to where he'll send payment before things escalate to a hearing. Your situation has escalated beyond your original request for 75 percent. Now it's time to ask for a higher fee.

A few additional tips: Take charge. Suggest solutions. Initiate a plan of action. Follow through at each stage. Be persistent. Avoid dealing with photo-buyers or publishers who have been in business less than three years. Let others be the guinea pigs with such markets.

To avoid reuse problems altogether, place a label or rubber stamp on your

HINT: In your advisement for payment, ask for a fee one and a half times higher than the amount you feel you deserve. (You can justify the higher fee by naming costs of phone calls, administrative time, office correspondence, etc.) At the day of reckoning, the photobuyer will want to save face by offering a fee lower than what you asked for. You can allow it, and your relationship might survive intact.

invoice at the time of original sale that spells out reuse requirements (foreign rights, electronic use, etc.). State your terms, succinctly and diplomatically, for what would be an acceptable reuse transaction. This not only makes your business operation more professional but avoids later misunderstanding. (For examples of business forms, such as invoices, a good resource is Michael Willins's *The Photographer's Market Guide to Photo Submission and Portfolio Formats*.)

Protecting Your Copyright

PROTECTING THE IMAGES ON YOUR SITE

Increasing numbers of photo researchers are using the Web regularly to find and buy photos. You can position yourself so that your photos are among those they find and buy. But if you're like most photographers, the thought of putting your photos on the Web probably makes you cringe, fearing that someone is going to take your photos and use them without your knowledge. I get this question in all of my seminars: "How do I know if I send my pictures to an editor or if I display them on the Web, someone won't rip them off?"

OK, what about the security of your work if it's out there in cyberspace?

It's true that as the techno-whizzes of the information age have developed ever more refined technology to reproduce copyrighted work, there's been a tendency to think anything "out there" is public domain, for the use of anyone. As soon as a new technology would be introduced, some people would make the "finders-keepers" assumption. If it's out there, it must be free. Take it.

Each decade in the last half of the twentieth century has introduced a new way to copy.

Up to the 1950s: Clip a newspaper article.

1960s: Photocopy a page from a book.

1970s: Audiotape a song from the radio.

1980s: Videotape a TV segment.

1990s: Download a software program.

Is it any wonder the Nintendo-fed generation of today might have no problem with "swiping" a photo from the Web?

But rarely is such a theft calculated. Unauthorized use of a photo is actually infrequent, and when it does happen, it is usually the result of a mistake: Digital images in cyberspace or in a company's database are misinterpreted by some uninformed art directors to be there for unrestricted use, or an "innocent infringer" who is unaware of the nuances of copyright makes an honest mistake.

What have the "borrowed" photos been used for in most cases? Usually usage is in personal Web pages, calendars, newsletters and other personal or low-circulation projects.

To pursue these cases would be lost motion for the photographer. It would

cost more to take the person to court than the resultant court reward for infringement of copyright.

Instead, sail on, move forward and don't be apprehensive about making your photos accessible on a Web page, to let buyers know you exist.

Image Security

But *are* there any security measures available?

As history has proved, if you build a bigger lock, someone will come along and build a bigger hammer. However, there *are* a few ways to prevent theft on the Web, and more will have come along by the time you are reading this edition.

How can you protect yourself? This question was asked when Andrew Carnegie was building his free lending libraries across the nation in the thirties. Citizens would ask, "But aren't people going to steal the books?"

Before supermarkets came on the scene, the grocery store owner and his assistants would retrieve from the shelves what the customer wanted. It was the custom. When supermarkets were introduced, citizens said, "But won't the store owner lose? People will steal things."

As you know, it didn't work out that way. Call it native honesty on the part of the citizenry, or native trust in people on the part of the store owners. While some theft does go on, it's negligible. Large grocery chains build a 1 percent factor for theft into their pricing.

If the World Wide Web is to be successful, we will probably take the same approach.

If we hear of theft on the Web or read articles that alarm us with the supposed thievery that's going on, we learn that where this is happening is usually on "adult" sites. Well, what else is new?

Rarely do you hear of major thievery. For one example of typical "outright thievery," read Ann Purcell's experience on page 127. You'll find that the case turns out to be a good example of photobuyer ignorance.

It may turn out that Web thievery will flare up initially as use of the Web gets ever more widespread, and then settle to the usual 1 percent that we find in the rest of commerce, whether it be a candy store or a boutique. We will always have to put up with these 1 percent examples and accept that innocent infringers are a way of life in the creative community, whether it concerns videotapes, Hollywood film ideas, software or creative images.

Can You Protect Yourself?

Protecting your images on the Web can be done. You simply use a shareware program that puts a watermark on each of your digital photos. But, ugh! What an expression of distrust to a buyer who comes into your site and is confronted with a watermark obliterating part of your excellent photo. By watermarking photos, not only do you squelch a welcoming, friendly tone for the potential customer, but also you take away the impact and quality of your image.

It's like the sign that greets you on a restaurant door: "No Shoes, No Shirt, No Service." It's arguably cute, but it's what is called in the marketing field a barrier to entry.

No one wants bare feet in a restaurant, but the sign is the first thing a patron sees—a sour note, yet it is directed to maybe 2 percent of the population. As a restaurateur, wouldn't it be easier for you to have an extra pair of shoes waiting for that rare person who comes in shoeless, rather than subjecting 98 percent of your customers to an objectionable notice? In other words, don't set up barriers to entry for customers.

But alas, watermarks are not proving to be completely successful. Programs such as Photoshop will help you erase the watermark, if you're so inclined. A program such as unZign (http://alten.org/watermark) will help, too, although it's designed for the opposite reason—to test the effectiveness of your watermarks.

Digimarc (http://www.digimarc.com) is probably, at this point, the most popular of the security measures you can use if you decide to go the "secure" route. But Digimarc falls short of its promises, say Internet commercial photography observers. There's no visible sign of any embedded ID in the digitized image, but to find who is illegally using your photos takes a lot of administration. Once a month or so, you have to set a Web crawler free on the Internet that'll search every site to see if it can locate illegal images. Some may be entirely legal; others may be pirated.

What if you find an image being used on a Cub Scout site, or a nonprofit drug abuse center site? Do you come down hard on them? Or what if you do find one that is being illegally published? Do you go to court? Do you send a letter of "cease and desist"?

History shows that a request to cease usually works, but even then, the perpetrator, especially if it's an adult site, simply changes her domain name or E-mail address and it's back to business as usual.

Digimarc doesn't get good scores with Bob Shell, editor of the popular *Shutterbug* magazine. He says that Digimarc works well for the open field of the World Wide Web, but the Digimarc Web crawler or any software of its ilk can't go into fire walls of protected sites, and that's where many infringing Webmasters store their booty.

Beth Iskander uses Digimarc on the Time Inc. Picture Collection's 400,000 scanned images. "We've been satisfied so far," she says. "If something better comes along, we'll certainly try it."

Other image protection systems use a different approach. Copysight (http://www.ip2.com), for example, is less intense. It allows you to download an image, but won't allow E-mailing it or placing it on another Web site. This, in effect, acts as a warning to would-be infringers. Trouble with this one is that it is Java based and not all browsers speak that language. In any case, you can "screen grab," which right there opens the possibility of infringement.

A company out of Israel produces PixSafe and cSafe software (http://www

.csafe.com). This system operates through your server, which then controls access to certain images of your choosing. When potential infringers attempt to download those images, a box appears on the screen asking, "Do you want to purchase this image? If so, click here." But beta users of the program report that each potential user needs a plug-in (a mini software program that serves as a key to an adjunct program) in order to view the image. So you have lost hundreds of potential clients because they can't see your images because they don't happen to have that particular plug-in.

Other security programs that have come along include OwnerMark by Signafy (http://www.signafy.com/), which allows you to embed invisible and permanent data within your photo. This watermark information can include your name, address or any information you want—such as serial numbers, fingerprints and other tags that can distinguish an original from a copy. There's also HighWater's FBI (Fingerprinting Binary Images) out of England. The stock photo agency FPG uses an identification feature developed by the Newspaper Association of America (NAA) and The International Press Telecommunications Council (IPTC) to identify transmitted images and text. Out of Greece comes other watermarking software: Poseidon. Then there's Signum's SureSign. And there's probably more.

In the real world, yes, theft is happening, but in the real world, it's not much. We don't hear much from the large outfits, such as Getty Images, Index Stock Imagery, FPG, The Image Bank and Corbis, about theft of photos. Pros don't steal from pros in this industry. It's not worth it—to your pocketbook, to your career or to your well-being.

Fifty years of illegal copying, either by amateurs, innocent infringers or pros with commercial purposes, have not stopped producers of other intellectual property from moving forward. They recognize that the rare thief will always be gnawing away at the doorstep of creative work. To give in and simply remove art, photos and writing from the public is no solution.

Yes, displaying your pictures on the Web is a risk. But it's a much greater risk to not display them. It's a financial risk. Those pictures sitting at home gathering dust in your files won't be out earning dollars for you.

In the early days (the late seventies) of our marketletter the *PhotoLetter*, photographers would tell us, "I don't want to send my photos to editors I'm not familiar with. They'll use them without my permission and never pay me."

Has this ever happened? Yes, but in twenty-five years of publishing our marketletters, I can remember only two cases.

Will it happen on the Web? Probably. And if history is a good teacher, probably very rarely. In the meantime, I will continue to counsel editorial stock photographers to have faith in photo researchers and display good photography. Successful stock photographers will quietly and contentedly continue to use the Web as a showcase, to display their pictures, both to share their talent with viewers and to make sales.

WILL WE GET LEGAL PROTECTION FOR OUR PHOTOS ON THE WEB?

There are no solid answers to that question yet.

Your legislators in Congress have been tussling with the copyright law, attempting to bring it up into the twenty-first century. They are finding the Internet and Web present revision problems much more complex than the changes that went into the 1978 revision of the law.

Especially important to editorial stock photographers is the question, On the World Wide Web, which pictures need a model release and which ones don't? This involves the basic two kinds of stock photographs, editorial and commercial.

1. The truly editorial picture is taken by a photojournalist or "made" by a photographer to depict something that happened or could have happened.
2. The commercial photograph uses professional models to depict (in most cases) cliché situations (such as the pretty child romping through a wheat field with a bright red kite and a well-groomed pet dog).

Generally speaking, as we know, commercial photos need model releases and editorial photos don't, if they are used to inform and educate (in contrast to being used to endorse or promote a commercial product). When photos are used on the Internet, however, it presents problems for our First Amendment (freedom of the press). What happens if someone "borrows" an editorial picture from the Web that is not model released and uses it for commercial purposes?

Is the photographer liable? The agency? The proprietary on-line service, for example, CompuServe or AOL? Or what happens if someone borrows part of a picture and marries it with two or three other pictures, some that have model-releases and others that don't? And what happens if all of this takes place in a foreign country?

It might be easy to say, "All pictures on the Internet must have a model release."

That's a bureaucrat's dream. It would solve the problem, but it would diminish the free flow of information. It would shrivel the global concept of the Internet and return it to the Dark Ages.

Since the Internet knows no roadblocks, to curtail picture use on the World Wide Web would limit the free flow of information. The dilemma means that we might have to give up some of our proprietary rights in order to preserve the free flow of information in our society.

As far as tracking down misuse of our pictures on the Web, we can expect (hope) that security software will come up with answers. Currently the cost to find and convict an infringer carries a price tag much higher than any court-ordered monetary recompense.

Once the copyright dust settles, we'll probably find that both the commercial and governmental positions on cyberspace photos will be to expect payment for the pictures upon first usage and then basically "good luck" if you

anticipate honesty or try to track, locate and request payment for (unpaid) secondary usage.

The copyright law of the future, in order to be effective and enforceable, will have to have a tinge of moral law built into it.

WILL THEY STEAL YOUR SCANNED IMAGES?

A photobuyer calls, "We like the photos you sent us and have scanned two dozen of them into our database."

"You what?" is your response.

The buyer responds, "You have a lot of pictures that we feel we could use in the future. We're building an in-house reference file. Any problems with that?"

Consider it a compliment. Scanning of photos by a photobuyer needn't be a threatening experience. Twenty-five years ago, when photocopy machines were new, copying a photo "for the files" seemed tantamount to copyright infringement to stock photographers. Gradually we saw we were getting sales from the photocopied reference photos on file with photobuyers.

The same is happening with scanning. The photobuyers scan photos to obtain low-resolution (that is, not reproduction-quality) thumbnail-size images to put into their reference "view-only" databases. A software program cross-references them.

In the future, scanning your selections will be commonplace. No need to fear thievery any more than you do at the present. And particularly if you are working within the confines of a photo-buying community where you know your buyers and they know you, it would be odd to hear of larceny. It's important to remember that the photo-buying community that you are working in makes all the difference in the world when it comes to potential thievery.

In the editorial stock photo field, I've never heard of a buyer intentionally stealing a photo. There's no sense to it. The photo editor has a budget to work within; there's no material profit to him to "borrow" a photo on the sly. Besides, hundreds, thousands, of viewers, will see the photo. Most gangsters say that's not a good way to get away with something.

In commercial stock photography, we see a different attitude and a different morality. With commercial stock photography, there can be more motivation and opportunity to borrow someone's photo, perhaps for a short-run brochure or a limited ad or regional promotion. If you're involved strictly in editorial stock photography, this kind of information might be news to you. If you deal extensively in commercial stock photography, it's not a surprise.

A graver problem regarding digital images is that it's possible to easily pass them on to others (swapping). If an ad agency goes out of business (check the yellow pages and you'll see how often this happens from year to year) or photobuyers begin trading images, yours, or parts of yours, could be involved in the action.

Some commercial stock photography sites have turned what might be called

a lemon into lemonade. The Canadian stock agency PhotoSphere (http://www
.photosphere.com) actually offers *free* photos for the taking. The company
provides a free bimonthly tip sheet to subscribers, Creative Compost. The
license restrictions say you can use the images for layout ideas (comps) and
for noncommercial Web sites.

This is an example of a stock agency that has taken the gamble that the
benefits of discovering new customers by inviting copying of their selected
images outweighs the disadvantage of the possibility of someone purposely
stealing the images for commercial use.

"The main reason for the free photos is to bring interested buyers to our
Web site," says Steve Fooks, vice-president at PhotoSphere. "The free images
section gets our name recognized and gets people comfortable with obtaining
images from the Internet.

"We require that visitors supply us with their E-mail address. This address
is then included in our database of prospects. This database is then sent our
newsletter that PhotoSphere has created directly for the design community.
This newsletter completes the free image cycle. Every month when the news-
letter comes out, we have a new free images section that in turn adds more
people to the newsletter. At the present time we have almost fifty thousand
subscribers that receive a regular contact from PhotoSphere." (See Photo-
Sphere's home page on page 128.)

Another site to search out that uses this "free photos" approach is Webshots
at http://www.webshots.com.

Know Your Buyers

Again, however, if you are working as a specialist and deal with repeat buyers
in the editorial field, you will know your buyers and they will know you.
Encourage these folks, potential repeat buyers, to scan your photos for their
reference files.

I should say that I am in the minority on this question of photobuyers
scanning photos. Most of my opponents come from the commercial field or
are editorial stock photographers who also operate parts of their businesses
in the commercial field.

My thirty-five years observing stock photography tells me that for the edito-
rial stock photographer, thievery has never been a problem. But if you are like
most people and want to deal in both divisions of the stock industry, it is an
important problem to consider. With this in mind, here's one photographer's
negative experience.

Ann Purcell is one-half of the famous travel photography team of Ann and
Carl Purcell. In the early sixties Carl was chief of photography for the Peace
Corps. By 1981 Ann and Carl discovered their photography collection had
risen to 250,000, and they decided to do something about it. They formed the
Purcell team and now operate from their home/office in suburban Alexandria,
Virginia, with a collection of 680,000 slides from ninety-eight countries. Carl

broke into digital technology and has followed all of the advances. Their work appears in books (many written by them) and magazines nationally.

Ann's experience has to do with scanned in-house reference photos they let a company use. One of their photo agencies sent a selection of photos to a printer company for use in an ad. None of the photos were selected, but they were all scanned. "Lo and behold," says Ann, "about six months later, one of our photos came out as a full-page ad for the printer company. We took them to task, and they had to pay us $15,000 for the copyright infringement.

"They also paid us $10,000 for use of the picture. We were happy to get paid, but the whole thing was a time-involving hassle. Then they must have changed photo researchers because . . . lo and behold . . . six months after that episode, another follow-up ad used the *same* photo, again without permission! This time they paid $10,000 for the use/copyright infringement of the picture. That's $35,000, all because they had in-house reference scans and photo re-

searchers who knew nothing about USA copyright laws!"

Seth Resnick of Boston, well known for commercial work internationally, had a similar experience with a British newspaper. Seth says, "Personally I have caught three publications stealing images. When caught they each paid up. One publication, a major British business magazine, thought that since they did not need the original that they did not have to pay. Two others simply said that they planned on notifying me but hadn't gotten the chance. One was a U.S. publication and the other was an Italian publication. I believe that as a general rule the editorial market does try to uphold copyright. I think that photographers should worry and take steps to protect their images.

"In terms of protecting the copyright of images which appear on the Web, there is actually a lot that one can do. First, all the images and in fact the code are protected under federal copyright law. We also put all of our images into a frame made in Photoshop, which looks like a slide mount. In order to try and use the image, someone must first go into Photoshop and remove the frame, which makes the image tougher to steal."

A Simple Solution for Thievery

Seth has come up with a simple solution for editorial stock photographers. He gives each of his images a unique name, not just jpeg1 or jpeg2, so he can track them. These names can be searched for on any search engine, such as AltaVista (http://www.altavista.com).

I tried his idea and gave a unique name to an image of mine. I called it http://www.photosource.com/photos/rohn4.jpg. I typed the name into a search engine and in ten seconds the photo appeared on my screen. Try it. It works! Seth has refined the system so that he can capsulize the name to, as an example, sethresnickbernerslee1.jpg. You will see that it is located on his portfolio page (http://www.sethresnick.com).

"We randomly run searches on all of our images to see where they are located," Seth says. "Also, to insure protection of our copyright, I entered a legal agreement on our site which a visitor must check in order to enter the site (http://www.sethresnick.com/page1B.html).

"In addition, every time anyone visits the site, our server logs in their entry and keeps track of all information which is downloaded. If I get a message that someone downloaded 1.3 megs of information, I will monitor their site to make sure that none of our images appear. Further, they may get a little E-mail note thanking them for the visit, and thus reminding them that 'big brother' is watching."

At Seth's home page is a notice reminding visitors of his company's copyright policy.

I asked Seth about some of the available encryption software and watermarks.

"I'm familiar with encryption and watermarking, but my own system is secure enough that I do not see the need to go to this extent.

A Letter From Seth Resnick

Dear Visitor,

Welcome to my Web site. Photographers possess a special kind of vision, a unique way of seeing the world. Yet, we must combine this gift with a degree of business acumen if we are to succeed in sustaining our vision. I hope you enjoy my work and perhaps find it inspirational. The site is designed to be a showcase for my work and a resource for photography, from both a business and creative standpoint.

Market research shows that the majority of you are art buyers, art directors, designers and photo editors. The portfolio and stock research section are the reason you are here. The rest of you are photographers, amateur and professional, educators, students, programmers, and even a few Web surfers.

Many of you have been here many times before and have witnessed this site grow. Over the past few months we have added a registration page and have adopted a plan to track visitors to help insure copyright protection. The vast majority have filled out the registration page and have agreed to a copyright contract. As the concerns of privacy are heightened, a handful of you, mostly those not affiliated with the profession, have protested the request to agree and fill out a registration form.

WHY DO I HAVE TO REGISTER?

Photography is my profession. My income is derived by producing images and licensing use rights. Copyright is the very essence of a photographer's existence. I am very sorry that more photographers and artists do not understand this concept. We must take steps to insure that our images never become public domain. We require that you not use any image from the site other than simply to view them in your browser. My goal for having a Web site is indeed to show work, but it is more importantly to lease my work. Further, every use must be recorded so that we can certify the exclusivity rights for any particular image.

Have you ever purchased software, leased a car, purchased anything on-line, or acquired a credit card? All of these scenarios require you to enter into a legal agreement with the disclosure of personal and contractual information. Leasing the right to use images is exactly the same. For these reasons we must ask you to agree with our copyright contract and to register for entrance into the site.

Yes, Continue with registration | No Thanks, I'll Leave

Copyright Seth Resnick, permission granted.

"Times have changed a lot just in the past few years with regards to what is and isn't acceptable, especially within corporate America. Three years ago corporate America would take for company and personal use lots of software and other items found on the Web. Since then corporate America has clamped down, much like with the area of sexual harassment. Almost every major company now has a written policy regarding stealing and the Web. If you are caught, you are out the door, period."

Seth Resnick has his finger on the pulse of corporate America. It's refreshing to hear as we move into the Digital Age that corporations are becoming aware of the impropriety of "borrowing" images from the Web or from in-house scanned images received from outside sources.

At PhotoSource International we have seen also that innocent infringing of photographers' images has usually been done by an inexperienced new recruit, and rarely by a photo researcher who likes her job. Publishing houses are corporations, too. We owe gratitude to the Purcells, Seth Resnick and other aware photographers in our stock photo industry—both editorial and commercial—who continue to pave the way and head off potential infringement of our stock photography.

Running a Professional Business

KNOWING HOW TO PUT YOUR FINGER ON IT:—CATALOGING YOUR TRANSPARENCIES, PRINTS AND DIGITAL IMAGES

Efficiency is essential if you market your pictures. Establish a workable identification system—and stick to it. But what's a good system?

In the early days of the computer, we were told that there would be no need for paper in the future. Everything would be done electronically. Countless trees would be saved.

Then why are OfficeMax, Staples and other office supply chains going strong?

The paperless society never came to pass and looks even less likely today. Paper is here to stay.

We were also told that film soon would be out and digital files and prints in. Many of us find ourselves working in film (transparencies or color negatives) part-time and digital part-time, and film looks like it's going to be around a long time.

This means that our filing system might need to be both manual and digital.

Or you may have no digital files at the moment, or you prefer to stay with film and use only the World Wide Web to transport your images to photobuyers.

This, of course, affects the kind of filing system that would be most practical for you. In this chapter, I'll address both manual and digital systems. You can pick out what is useful to you according to your own particular business mix.

Keeping Them in Order

Your files will grow, both in size and diversity, as your photo business grows. Listed below in order of importance are thirteen basic files to establish.

1. Transparencies
2. Prints (black and white, color)
3. Contact sheets
4. Negatives (black and white, color)
5. Digital images
6. Market lists (file by publishing house rather than an individual file for each photo editor—some publishing houses have as many as thirty editors)

7. Cross-reference list (your photos—color, black and white, and digital—should be cross-referenced on a computer database or on 3″ × 5″ file cards if you don't have a computer)
8. General correspondence and business files
9. Tearsheets (file by frequently-asked-for categories, according to your PS/A)
10. Photo story/article (file story ideas, finished stories and those in progress)
11. Accounts receivable/payable
12. Reminders (file by month for future reference)
13. Sample copies of your market list magazines and other potential clients

If you follow the marketing principles in this book and resist snapping pictures of every subject that comes into your viewfinder, focusing your picture taking on your PS/A instead, you'll find you can spend more time at picture taking and less at picture filing.

Stock photo sales come from photos that you can access quickly. If finding a picture for a photobuyer takes a long time, the business of stock photography soon becomes discouraging to you.

Photobuyers want to see a selection of photos and then choose one. That's why your photos should be filed by PS/A. You can quickly browse through your file on, say, aviation, when an editor requests jet engines. You'll also come across other jet engines that might not have been cross-referenced in your filing system.

Photographer Tom Carroll of Capistrano Beach, California, who is now in his seventies says, "I'm glad I started out with a specific sequential system when I first began my photography career fifty-two years ago. Today I can locate any slide or neg that I need. No problem."

Your filing system should meet the needs of your marketing system, not the other way around. With that in mind, I will describe a general example of a system that would be applicable for a photographer who has anywhere from one hundred to three thousand marketable pictures, and who plans to follow the principles in this book and focus his shooting on his PS/A. What follows is a cataloging system that is flexible, simple and photographer-tested.

Black-and-White/Color Prints

Here is the heart of your black-and-white and color prints cataloging system: negative sleeves, contact prints of each roll, PS/A identification system, a 3″ × 5″-card cross-reference system (or computerized, if you wish, on today's available programs—see "Software," page 219) and a contact sheet file. Your system can begin inexpensively with these essentials. You can add on as your stock of pictures increases.

One of the best ways I've seen to identify your black-and-white prints or color negatives is the letter-number (alphanumeric) system. Here's how to set it up: For your identification on each print, use a letter of the alphabet to signify which category of your PS/A the print is in. For example: A = Camping,

B = Rural/Agriculture, C = Aviation, D = Family Living, E = Automotive, F = Construction, G = Underwater. Follow the letter with a number signifying the number of rolls you've taken in that category. Since each roll (in editorial stock photography) is generally of the same subject matter (your specialization), filing by sequential roll number allows you to keep your subject matter limited physically in one negative sheet or one contact sheet or one folder in your computer.

Example: You are on your fifteenth roll of black-and-white or color (negative) underwater photography, and you are printing from frame number twenty-four. The number of your print would be G-15-24. (The contact sheet number would be G-15.) The next roll of underwater pictures you take would be roll sixteen. The table on page 135 will give you some examples of filing alphabetically or numerically.

Incidentally the APS (Advanced Photo System), brought into the market back in 1996, will enhance this filing process because you can remove the film cartridge in the middle of a roll and replace it with a different partially used roll when you change your venue or subject matter. This will allow the final APS contact sheets to contain images of the same general subject matter. You can then send copies of these APS contact sheets (cards) off to buyers, when you're dealing with photo editors on your market list who accept color prints or digitized photos made from color negatives.

There's a disadvantage, however, with APS. George Schaub, the author of *Shooting for Stock*, says, "APS (28mm) is a small-format negative film, and suffers from just being that. Yes, scanners with integral APS readers are available, but again, original image size will determine enlargeability."

Ernest Robl, author of the self-paced workshop *Getting Serious About Photography*, agrees. "The APS system is geared toward shooting *negatives*. With the exception of some types of news photography, the standard for professional photography (and the type of image most publishers want for reproduction) is a positive—a transparency. Except for Fuji, there are no APS transparency films at this time."

Here you have to make the decision whether you want the advantage of easy filing or film quality. Some photobuyers today are still influenced by the attitudinal posture of the past, when photobuyers liked the more impressive large-format images. When I first began my career as a stock photographer, most of the magazines and even the newspapers favored the ol' 4″ × 5″ size over 35mm. Photographers were suspect if they arrived with 35mm cameras around their necks. Today's 35mm films, of course, surpass the quality of even the 4″ × 5″s of the fifties and sixties.

This same transition may come about soon in digital and film imaging. (Be sure to read chapter eleven, "The Public Domain System," page 208.) Photographers and digital service bureaus are perfecting the "ressing" process of improving even a smaller image's resolution through fractal technology.

Of course, there are times you do not devote a complete roll of film to one

subject. In this case, you can cut the film and make two or more contact sheets (each with a different ID number), or you can let the subsequent subject matter remain on your original roll and cross-reference it using computer software or an index card. No big problem.

Should You Identify By Year?

I have seen some studio and commercial photographers use a date system to identify prints, slides or digital pictures. However, this doesn't work out well for the editorial stock photographer. For one thing, since the first number in this system should denote the number of rolls you have taken to date in that category, after a few years of taking many rolls of film, your left-hand number will get too lengthy. For example, 3675-24. If you added a date in front of this, say, October '00, your number would read 10-00-3675-24. As a stock photographer, you might make a dozen prints of the same picture for multiple-submission purposes. That's a lot of numbers to be writing on invoices and the backs of prints, not to mention negatives and negative sleeves, and captions in your database. If you need to know when a picture was taken, just write it on the back (or front) of the contact sheet.

The biggest hazard with the date system is that you reveal the age of your pictures. Labeling a picture 10-99 will dampen its reception by a photobuyer. (Like day-old bread at the bakery, somehow it's not fresh.) Out of a selection of equally excellent pictures, a photobuyer tends to purchase the most recent.

Here's a chart of sample print ID numbers for B&W prints.

Letter	PS/A Category	Number of Negative Rolls Taken	Frame Number	Print Number
A	Camping	708	12	A-708-12
B	Rural/Agriculture	556	6	B-556-6
C	Aviation	28	36	C-28-36
D	Family Living	28	30	D-28-30
E	Automotive	138	6	E-138-6
F	Construction	250	15	F-250-15
G	Underwater	15	24	G-15-24

For negatives: File your black-and-white/color *negatives* in a negative drawer alphabetically and then, within each catetory, file the negatives numerically by the first number. For prints: File your *prints* in manila folders alphabetically and then, within each letter category, file the prints numerically by the first number (see page 137).

A photobuyer may not be fully conversant with equipment that is pictured or current trends in clothing, and feels safest buying the most recent photo. If you are compelled to include the date, put it in Roman numerals or use the letter system explained on page 134.

Steve Knox, a boating and aircraft photographer from Virginia, has developed a unique way of coding and identifying the year a photo was taken. He uses any ten-letter word and assigns each letter a number. The word should not have repeated letters. Here's an example.

V O L K S W A G E N
1 2 3 4 5 6 7 8 9 0

A picture taken in 1998, for example, would be EG.

"I just include the two-letter year designator in my regular file number, such as FL-EG3126. FL is the category (in this case Flying), EG is the year, and 3126 is the next sequential number in the Flying block," says Steve.

"The 'real' file number in this example is 3126. That and the year identify a single photo. The category just helps me refile it."

Here's a trick most photographers use. For ease in writing your ID numbers on your negatives and contact sheets, shoot "blank" the first two frames of your roll (numbers one and two). After you have shot up and exposed the roll, cut off frame number one, and write your number and any other identification on frame number two with permanent ink or pen. When it's dry, make a contact print. Your shortened roll of developed film will fit exactly (cut into groups of six frames) in your negative sleeve. (Since black-and-white/color negative rolls are actually thirty-seven frames long, if you didn't snip off the first frame, you would have to snip off the thirty-seventh frame and have it float loose in your negative sleeve. The last picture on a roll is very often an important one.) Store your negatives in flat or fold-up (accordion-style) sleeves.

I found that trying to save film by writing my ID number in tiny letters on some unused portion of the film was counterproductive. In the long run, it cost me more in time spent deciphering my numbers. Also, by allowing myself a full frame for identification purposes, I had more room for identification of the subject matter—for example, WPBA Tournament, Aug '97.

Your ID number should also be written on the back of each print, with a china marker or very soft pencil and very light pressure. In a corner near the edge of the print (but not too near, to leave space for trimming the edges later), gently press your rubber stamp or computerized label with © plus your name, E-mail address and phone number. Do not enter the year on your copyright notice (again so that you don't date your photo). Use a system similar to Steve Knox's mentioned above.

Some scanning papers and wet photographic papers won't take ink readily. If you are handwriting ID info on your prints, place a blank computer label on your print and then pen in the label.

Eventually you *may* find it expedient to bar-code your filing system. The bar-coded label can be affixed on both black-and-white prints and slide mounts. Again, don't include an identifiable date.

Should you look into bar coding? Probably not. Of the many photographers I've talked with through my business and at my seminars, very few have found

bar coding a convenient tool. However, with improvements catapulting along in our industry, bar coding may eventually prove to be useful even to the independent photographer with a small file.

After you've made and coded a print, you're ready to file it. A file program, such as Extensis Portfolio, NSCS Pro2, StockView or FileMaker Pro, is a time-saver.

If you're at the entry level, you can test the system you want to try by starting with a basic format. Photocopy your contact sheet. Cut out the photocopied contact print of the picture you just printed, paste it under the file tab on a manila folder and mark the tab with the print number.

This will readily identify the print inside the folder, plus serve as a visual guide when the folder becomes empty because the print is out making the rounds. (Of course, if you've advanced to the stage where you are dealing in digital images with clients, then disregard much of the above system.) Note that a manila file folder system works better than storing pictures in, say, 8″ × 10″ Kodak boxes.

Used manila folders are often available (cheap) from companies switching over to hanging file folders or computers. So are used dental X-ray cabinets—great for prints, negatives or slides. Or if you want to go first class, order a prebuilt slide cabinet from Elden Cabinets, P.O. Box 3201C, Charleston, WV 25332; phone: (800) 950-7775; fax: (304) 344-4764. Request their booklet "Helpful Hints."

For prints (black-and-white or color), file the file folders alphabetically and then, within each letter category, file the folders numerically by the first number.

If you've kept tracking records of picture sales, you'll know which type of picture you should print multiple copies of. Print four or five at a time depending on the size of your market list. Store the extras in your manila file folders. When a picture is sold, indicate it on the file folder. This will be your best sales barometer.

For example, if sales are brisk on a certain picture, and it is a timeless picture, this system will visually suggest to you that you ought to make ten or fifteen more prints of it when you are next at the scanner or in the darkroom.

Keep a running record of your submissions to your market list. At the entry level, a simple in/out ledger is all you'll need.

Transparencies

For filing transparencies, here's the best system for the newcomer to stock photography that I've come across to date. Use the alphanumeric ID system mentioned for prints or negatives (see page 135). File your transparencies numerically in plastic sleeve pages and a hanging-style notebook. This type of binder—usually free when you buy a couple dozen vinyl (plastic) pages—hangs upside down in a letter-size filing cabinet. Since the binder hangs free, the vinyl

pages do not buckle and curl as they do when in an upright notebook. Figure out basic categories that reflect your picture-taking interests: camping, rural subjects, classroom, snow skiing, fishing. Decide on your categories when you evaluate your PS/A, in the beginning, and prepare several three-ring books. When you expand your supply of pictures, your numbering system will grow along with you. (Three-ring hanging notebooks are available at stationery stores. Check out the Web for suppliers of plastic pages.)

Paul Kivlin, who operates a small stock house in Wisconsin, prefers to use a Pendaflex holder, a plastic spine available at camera stores. The spine will hold as many as ten hanging vinyl sheets and can be flipped over a light table to locate a picture quickly. A similar product is the Snap-Hinge, available from Bardes Products, 5245 W. Clinton Ave., Suite 3, Milwaukee, WI 53223.

Toss away all technically inferior slides, but keep in mind that digital enhancement can sometimes revive an otherwise useless photo. If you aren't using a computerized labeling system, such as the Cradoc Caption Writer, hand letter the code numbers (neatly!) on your slides on either vertical side, near the top. You can file "in-camera duplicates" (or reproduction-quality dupes) in sequential order by giving them subsequent numbers. The slides should always remain in plastic sleeves. If your budget can afford it, encase each slide in a single-slide protective sleeve before inserting it into your plastic page.

To be able to locate specific pictures, cross-reference your picture subjects on your computer or 3″ × 5″-card system.

If you don't have a labeling system yet, rubber-stamp the right-hand or left-hand vertical side of your slide mount (as you look at it, right side up) with the copyright notice (© Your Name). Include your E-mail address and, if you have one, your toll-free phone number. Even if you move, these will not change. The top and bottom of the slide should be left clear in case your slide ends up in a stock photo agency. The agency will want that space for its own identification system and description.

If your mounts have a date imprinted on them, place a label with your name and the copyright symbol over the top of this date. Blank self-sticking labels are available in one-quarter-inch size from stationery supply catalogs and local office supply chain stores.

Displaying Your Copyright Notice

The Copyright Act of 1978 no longer requires you to display your copyright notice on your slide in order to be legally protected. However, for the sake of identification and extra sales, I encourage you to affix the copyright notice to your pictures. Again, do not enter the year, so as not to date your photo and diminish its sale potential. You should always request the © and credit line in your cover letter to a photobuyer for your use of the tearsheets later for self-promotion, for possible copyright registration and for documentation of the picture as your property.

As you increase the number of slides in a particular category, you'll find you're developing a substantial portfolio of pictures on a single subject, and when a photobuyer calls for, say, farm scenes, you'll be able to efficiently sort out specific pictures to send off. Since all your agriculture slides are filed under one category, selecting pictures becomes less of a chore than if you had to search through your whole selection of slides.

If you computerize, choose software that allows you to categorize by PS/A and not sequentially by number, as a large library would do.

A Cross-Referencing System for Retrieving Your Pictures

A photobuyer contacts you and wants a certain image—perhaps a lake in Utah or a picture of a bulldog. Can you locate it readily? If not, it might mean a missed sale. However, if you are able to consult your computer or a file-card cross-referencing system that will pinpoint the subject quickly for you, the sale could be yours. Here's how to do it.

For prints (black-and-white/color), after each roll of film is processed, make a contact sheet on 8½″ × 11″ paper. Always place your print number (as shown on page 135) on the upper left of the sheet so that when you're looking for a particular picture, you can flip through the upper-left corners of the contact sheets rapidly (a graphics box used for filing these sheets usually holds forty to fifty contact sheets). Next, make a photocopy of your original contact sheet. File the original alphabetically, then in numerical order under each letter, in a contact-sheet carton.

On the back of the photocopy, jot down several subject titles that could be used to refer to the subject matter of the pictures on that contact sheet. Be liberal with your cross-referencing. For example, aviation could also be cross-referenced as flying, planes, airplanes and jets. A "rug" on the East Coast might be a "carpet" on the West Coast.

If you are computerized, make sure your captions tag along with your pictures in your files or Web portfolio. Reason? Many photobuyers will look for sources of pictures, not the pictures themselves. If you are not liberal with your captioning, the prospective buyer might miss your collection on the Web.

The software section (see page 219) lists several software programs that will help to categorize and catalog your photos.

I talked with a software producer, James Cook of Colorado, about his product, searchLynx, which is basically a piece of software that gets installed on a Web server computer (either locally or at a distant commercial service company) along with the images and data making up the image library.

"Our objective with it," says James, "is to make it easier and more affordable for stock photographers to put searchable stock libraries on-line.

"Assuming the photographer can get the photo researchers to their sites, the photographer can effectively compete with large conglomerates like Corbis, PhotoDisc or any other big on-line library.

"The easier it is for the researchers to determine what's available, the more

likely sales become. I see it especially attractive for those who have a strong, specialized stock file," says James (jim@hindsightltd.com). The software is available for both Macintoshes and PCs.

Programs like searchLynx are ideal for the independent editorial stock photographer like you. You can post thousands of images to such a site. No matter where in the world you are, or what time of day or night it is, potential photobuyers can be digging through your files. You don't spend time doing the research or shipping submissions because it's all self-service with instant gratification. The buyers enjoy some privacy in the matter, too. If desirable images are found, they can use the phone or E-mail to start negotiating the usage and rates.

Photographer Georgienne Bradley uses searchLynx to link her file of forty-two thousand images to the Web. "My stock photo file is completely digitized [she uses a Nikon LS-1000] and cross-referenced through two programs produced by the HindSight software company: InView [handles business aspects] and StockView [coordinates the stock photos]," says Georgienne. "I'm now able to transport my stock files to the Web efficiently. When I come back from an assignment I pour the results into StockView and send a selection [72 dpi] to my Web site, where they can be viewed and used as mock-up for my clients. If a client likes something they see, I can use my LS-1000 to produce a high-resolution image which I can deliver E-mail, courier, or I'll burn a CD for them. The InView part of my software keeps track of all of this."

Bud Nielsen has over 250,000 photos in his collection and uses the software Extensis Portfolio 4.0. He is in the process of putting his collection on the Web.

Another program that is popular and inexpensive is ThumbsPlus 3.0 (http://www.thumbsplus.com). It is an image-cataloging program and creates thumbnail-size images, providing you with a visual record of your photo collection.

Besides cataloging, it can rename, move or delete files and lets you edit an image by clicking on the image. Another feature is the "slide show" of the current directory's files. The price is right, only $65. One drawback is that it can't create albums using files from other directories.

The Boyd Norton stock photo software (http://www.nscspro.com) is also popular among photographers. Thumbnail images can be included in the database to serve as a visual reference. You can also caption your slides and label them—which is all integrated into your client database along with invoicing, picture pricing and exporting features. (See page 141).

FileMaker Pro (http://www.filemaker.com) often comes up in discussion about software for stock photographers. It's a generic program, which means you can tailor it to your own liking. But you have to be a nearprogrammer—and have the time—to do the tailoring. It comes down to the question, Do I want to make my own clothes, or buy them ready-made?

With any software, be sure to test it out with a couple hundred entries. Don't wait until you've put in a couple thousand.

Final advice: Buy from someone with a track record in the field. Ask fellow photographers what they're using successfully.

© Boyd Norton

If your catalog is not computerized, here's what's next in your entry-level filing system.

Set the photocopy of the contact sheet in a special file or shelf. When you've amassed a few dozen photocopies of contact sheets in this way, set aside an evening to enter information on your $3'' \times 5''$ file cards. This could include subject matter, brief descriptions, date and place, film and roll ID numbers. (Keep the photocopy sheets; don't toss them.)

I found that by paying our baby sitter an extra fee per hour after the kids were in bed to tackle the cross-referencing chore, it was a good way to get the job done efficiently. By selecting the right baby sitters, I found few errors or omissions. If your family situation doesn't include a baby sitter, you'll find that time passes quickly on this tedious job if you play your favorite music as you work at your computer or handwritten system.

For color transparencies, again, if you stick to a select number of specialties, your filing chores will be much easier than trying to file and retrieve a wide assortment of categories (and your sales to specific markets will grow). Cross-reference your color slides basically by the same system used with black-and-white/color negatives and prints. For example, assign a letter of the alphabet to each of your categories. Put numbers on your transparencies in sequence (5 for the fifth horse picture in your files, 52 for the fifty-second and so on).

Tracking

"If you don't know where you are going, how are you going to get there?" is the adage we hear often. Numbers let you know where you are and where you've been and where you're going. They can also predict how soon you will be there, and which buyers are bringing in the most sales and the greatest revenue. Tracking the results of your photo sales is made easier and less boring these days with computer accounting, spreadsheets and photo-tracking software.

On your cross-reference 3″ × 5″ cards, you'll recognize which are referring to color if you put a *c* (for color) beside the entry or use a colored pen to make the entry. (For your digital images, should you designate different digital resolutions or format sizes? You could.) Your color may consist of different formats (35mm, 120mm, 70mm). If you plan on amassing a large collection of color transparencies, you may want to allow space on each index card to give each size a characteristic number. For example, under the category of A (we used Camping), start numbering your 35mms at number 1, your 120s at 5001, your 70mms at 8001 and your digitals at 10,001 (see table below). If your collection in any one PS/A category or size grows beyond 5,000, you can revert to the beginning and assign a small letter *a* to the next series of 5,000. For example Aa and Bb. This ID system will also give you a quick reference: If a photo editor refers to one of your transparencies over the phone by ID number, you'll know the size. Of course, if your picture collection is weighted more to digital pictures and less to 35mm film, you might want to reverse the order of the numbering system. And, in the early stages of your photo-marketing career, you might just want to hold off on any library science and use a plain-vanilla alphanumeric system that tells you simply the category (alpha) and the sequence (number).

Number designations for photos

Category	Photo Number
A	A-8009
	A-10008
B	B-623
	B-6240
	B-6280
C	C-7350
	C-7600
	C-8121
D	D-493
E	E-488
F	
G	

File numerically, then alphabetically. Then within each letter category, file numerically. You know immediately that the first three in the list are 35mm, the next four are 120s, the next two are 70mm, and the last one is digital.

If you digitize some of your negatives and transparencies, you can piggyback the original film number with the new digital number. Indicate the digital version by placing a letter in front of the exact number of the film version. This way you'll know you have the choice of sending the client a digital version, also.

It's important to avoid certain punctuation when identifying digital photos. Ernest Robl, author of many photography books and a photographer himself, points out how some punctuation marks can get you into trouble when you use them to identify your digital images.

"Forward or backward slashes (/ or \) are used to indicate directories on various computers," says Ernest. "Periods (decimal points) are used to precede extensions. Asterisks are typically used as 'wild card' indicators in file searches and shouldn't be used within a file name. Hyphens are OK.

"Prefixes and suffixes can identify a type of scan, such as the resolution or modifications. File types such as .gif or .jpg can continue to be suffixes in your identifiers. You do not want to change those as they are needed by the operating system to open files. It's good to standardize. For example, on my Web site, http://www.robl.w1.com, which I use as my electronic portfolio, I have standardized on three basic image sizes—thumbnails, which provide a quick identi-

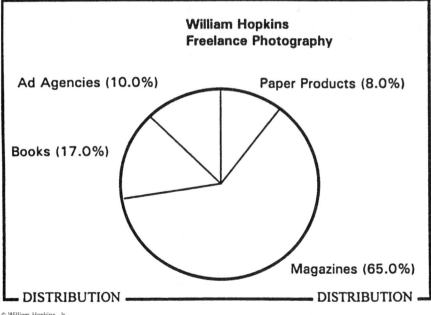

© William Hopkins, Jr.

fication of the image and which are used to link to larger images; the larger images, which, along with their captions, are usually displayed on a page by themselves; and a medium-size image, used mostly as the lead picture on the home page (which changes from time to time).

"So, if the slide indicator is nnnnnn, the raw scan (at the resolution of the large image format) is Snnnnnn.tif. (I do not convert to .jpg format until the final step.) The resulting file is then loaded in an image editor and my copyright notice is superimposed. This file, now saved in .jpg format, becomes Cnnnnnn .jpg. Similarly, the thumbnail becomes Tnnnnnn.jpg, and the medium-sized image (when used) becomes Mnnnnnn.jpg. The image pages that display the large versions of pictures are named I-nnnnnn.htm."

At an office supply center, you can buy an accounting ledger that you can tailor to your needs. If you're computerized, you can start with an accounting program such as QuickBooks.

Photographer William Hopkins uses a simple graphics program to chart progress. He tracks the number of submissions he makes, and then charts the number of photos sold and dollars that came in. He puts these figures all together in a pie chart (see illustration on page 143).

LIVE WHERE YOU WORK, LOVE WHERE YOU LIVE, INCREASE YOUR SALARY

As a self-employed individual, every time you discover a tax deduction, you are in effect, increasing your salary. There are many tax deductions you can claim that relate right to the place you probably do much of your work—your home. Here are some tips from our *PhotoStockNotes* columnist Julian Block, a tax attorney in Larchmont, New York, and former IRS employee.

As a stock photographer your office can be in a house, apartment, loft, condominium, trailer, mobile home or boat. This can also be a separate structure, such as a garage or barn. For IRS purposes this is called a home office. You can deduct the expenses directly related to your home office, such as utilities, insurance, property taxes. You must, however, meet certain requirements for your stock photography work space to qualify as a home office and be able to take these deductions. (The home office rules do *not* apply to C corporations.)

To be able to use these deductions, a specific part of your home must be used regularly and exclusively for business. It can be a separate room or even part of a room, as long as the space is used solely for the stock photography business. A TV set can be in the office if the TV is used in your stock photography work. Your office cannot double as a guestroom, poolroom, kids' playroom or anything else, even when you are not working.

Here's an exception to the exclusive rule: If your home is your sole fixed location for a retail sales business, and if you regularly store your inventory (in this case, your stock photos) in your home, the expense of maintaining the storage area is deductible even if storage isn't the exclusive use of the space.

If your home business is located not in the home but in a freestanding structure, such as a studio, garage or barn, you don't have to meet the principal-place-of-business test. You are allowed deductions for upkeep of the space even if it is not your *principal* place of business. But to qualify, the space still must be used regularly and exclusively for business.

Deductions

Remember that many of your deductions for your business are items that you normally would have to buy if you were not in business. What some people might call a luxury, the small business person will call a necessity: computer, software, dedicated line, etc.

Deductible expenses include a percentage of your rent if you rent your home or apartment, or a percentage of the depreciation if you own your home, and an equal percentage of home utilities, property tax, mortgage interest and insurance. Most people use either square footage or number of rooms in the house to figure these percentages.

A Big Change Back In 1999

The home office rules changed in January 1999. Until then, you weren't able to deduct any expenses for a home office unless it was used exclusively and on a regular basis as your "principal place of business," *or* used regularly by your patients, clients or customers in the normal course of business.

Until this change, the Supreme Court defined principal place of business as "the most important, consequential, or influential location," with the main emphasis on where you do the work that produces the income. This means that consultants, contractors, plumbers, caterers, musicians, independent traveling salespeople, photographers and others who do their income-producing work out in the field or at customers' and clients' homes and offices, have, in most cases, not been eligible for a home office deduction. According to the past law, the fact that your home office is essential to your business, or that you do all of your paperwork there, or even that it is the sole base of operations has not been enough to make it deductible. However, a law change in 1997, put into effect in 1999, has now made it possible for you to deduct home office "space" expenses that previously were not recognized by the IRS. The law applies starting with returns for tax year 1999, which are filed in 2000. The new law eliminates the "principal place of business" requirement. This is often referred to as the Soliman decision. You *will* be allowed a home office deduction if your home office is the only place ("the sole fixed location") where the business owner conducts "substantial" administrative or management activities for that business.

Now you are allowed a deduction for your home office *even if you have another business location* and even if you earn the major portion of your income away from the home office, as long as you do a *substantial* amount of your paperwork, or your photo research, or photo supplies ordering, or assignments scheduling, at your home office. Note that you don't have to do *all* of your administrative or management work at home. The key word here is *substantial*. Using the home office to do occasional or minor paperwork will not qualify it for the deduction.

Home repairs, such as painting or plastering, are also partly deductible (though if they are major, they must be depreciated).

The IRS specifically prohibits deductions for landscaping and lawn care, even if done solely to enhance the business (unless you are in the landscaping business).

Note: As a stock photographer, you may be able to convince the IRS that landscaping, even flower or vegetable gardening, is essential to your business, if these are some of your photo specialties.

If you use the home office deductions, you might run into tax complications when you sell your house. In computing profit on the sale, you are required to reduce your home's cost basis by the amount of the depreciation allowed (whether you take the depreciation or not!), which will increase your profit, and possibly your taxes, on the sale.

Carrying a Loss Forward

If your home business shows a loss for the year, part of your home office expenses are not deductible for that year. You may deduct all of your regular business expenses, such as phone, postage, stationery (other than expenses for the office space itself), and may deduct interest and property taxes on the office, regardless of profit and loss. But the remaining home office expenses (including rent or depreciation, insurance, utilities) may be deducted for the year only to the extent that there is no loss. Any expenses you cannot deduct due to this limitation can be carried forward to the next year and deducted again only up to the point where they do not create a loss for the year.

Reporting Expenses

Home office expenses are reported on Form 8829, Expenses for Business Use of Your Home. Note that you do *not* report *home* office depreciation, utilities, property taxes or other expenses on the expense category tax form normally used for your business deductions. All *home* office expenses are reported on Form 8829. Be mindful that the rules are complicated. You might want to check with a tax professional for help.

For more information, see IRS Publication 587, "Business Use of Your Home." For background information on the work-at-home advantage, send a self-addressed stamped envelope marked with "Work at Home" PSN June '97 to PhotoSource International, 1910 Thirty-fifth Rd., Osceola, WI 54020, or call up the Web site at http://www.sellphotos.com/psn/June_97.txt.

USE A FORM

With the automation available on the Internet, forms have been the godsend of the individual home office stock photographer. Why? Because forms help automate routine business tasks, and in many cases can serve to convey professionalism to photobuyers.

One exception, up front, is that some inquirers to your business operation

refuse to look at FAQ (frequently asked questions) forms. They believe their questions are unique and would prefer personal response to them. Be prepared to have a place on your Web site to answer personal questions. The best bet is to have an E-mail response section.

However, many customers prefer to deal with you on a "standard" basis until they have established personal relationships. This is where forms come in handy.

If you have designed a form on your Web site on which customers can fill in blanks with appropriate information, you save yourself, and them, important time.

How to Find Forms

If you don't have any forms on your present Web site, check out the forms that other similar Web sites use. Ask yourself these questions.

1. Is this form applicable to the activity and content of my Web site?
2. Is it easy to use (understandable)?
3. Do the links work?

If you can give an affirmative to these questions, copy the form for your own Web site.

Don't worry about copying someone's forms. Copyright law says that forms cannot be copyrighted. Besides, we all help each other to improve our Web sites if we can borrow from the best of each other's forms.

Speaking of forms, probably the best one for you to use on your site is the Stock Picture Delivery form from ASMP (American Society of Media Photographers). This one (see pages 148-149) is good to use when you are sending a potential photobuyer a group of images for consideration. Although the form has no legal authority, its structure gives the impression that it means business. Incidentally, if you are not a member of ASMP and you are an assignment/stock photographer, you might consider joining this important organization.

A typical rights transferal form used by ASMP appears on page 148.

An added bonus of stock photo sales is that your work becomes familiar to a photobuyer who might then give you an assignment. You'll need a form to outline assignment expenses you'll incur. A form to copy appears on page 150.

SOME LEGAL CASES OF INTEREST TO STOCK PHOTOGRAPHERS

At PhotoSource International we follow court cases that affect the editorial stock photographer. In *PhotoStockNotes*, our monthly newsletter, Attorney Joel Hecker outlines cases of interest. The examples starting on page 149 are some excerpts from his columns. Joel lectures and writes extensively on issues of concern to the photography industry. His office is located at Russo & Burke, 600 Third Ave., New York, NY 10016; phone (212) 557-9600.

[Place your letterhead here.]
Stock Picture Delivery/Invoice

To:

Date:
Subject:
Purchase Order No.:

Client:
A.D./Editor:
Shooting Date(s)
Our Job No.:

_____ Assignment Confirmation _____ Job Estimate _____ Invoice

RIGHTS GRANTED

Onetime nonexclusive rights to the photographs listed below, solely for the uses and specifications indicated; and limited to the individual edition, volume, series, show, event, or the like contemplated for this specific transaction (unless otherwise indicated in writing).
SPECIFICATIONS (if applicable).

PLACEMENT (cover, inside, etc.)

SIZE (¼ pg., ½ pg., etc.)

TIME LIMIT ON USE

USE OUTSIDE U.S. (specify, if any)

COPYRIGHT CREDIT: © _____

MEDIA USAGE

ADVERTISING
- ☐ Animation
- ☐ Billboard
- ☐ Brochure
- ☐ Catalog
- ☐ Consumer Magazine
- ☐ Newspaper
- ☐ Packaging
- ☐ Point of Purchase
- ☐ Television
- ☐ Trade Magazine
- ☐ Other

CORP/INDUSTRIAL
- ☐ Album Cover
- ☐ Annual Report
- ☐ Brochure
- ☐ CD
- ☐ House Organ
- ☐ Trade Slide Show
- ☐ Other

EDITL/JOURNALISM
- ☐ Book Jacket
- ☐ Consumer Magazine
- ☐ Encyclopedia
- ☐ Newspaper
- ☐ Sun. Supplement
- ☐ Television
- ☐ Textbook
- ☐ Trade Book
- ☐ Trade Magazine
- ☐ Web
- ☐ Other

PROMOTION & MISC
- ☐ Booklet
- ☐ Brochure
- ☐ Calendar
- ☐ Card
- ☐ Poster
- ☐ Press Kit
- ☐ Other

continued on next page

Description of Photographs Format:	35mm	2¼	4×5	5×7	8×10	Other	Use Fees
							$
Total B/W Total Color							

If this is a delivery kindly check count & acknowledge by signing & returning one copy. Count shall be considered accurate & quality deemed satisfactory for reproduction if said copy is not immediately received by return mail with all exceptions duly noted.

Subject to terms pursuant to article 2, uniform commercial code and the 1978 Copyright Act Acknowledged and Accepted

TOTAL USE FEES; $ _____
MISCELLANEOUS: _____
Service Fee: _____
Research Fee: _____
Other: _____
TOTAL: $ _____
DEPOSIT: _____
BALANCE DUE: $ _____

Signature: _____

Tiger Woods Suit—Invasion of His Right of Publicity

A company which heads up the marketing activities for Tiger Woods, the super star golfer, has sued Rich Rush, a painter of sporting scenes, for distributing editions of serigraphs and lithographs of Tiger Woods, which were part of the painter's extensive collection called "The Masters of Augusta."

The issues, similar to those facing photographers who capture on film individual athletes participating in professional sporting events, concern the balancing of an artist's (or photographer's) freedom of expression and the ability to market or merchandise that expression, against the right of the individual to exploit and capitalize on the economic value of his or her own publicity rights, which can be considerable.

In this pending case in the Northern District of Ohio, suit was brought for violation of Tiger Woods' right of publicity through the use of his likeness, as

Your Letterhead

EXPENSES

From: (Your Name)

To:

Date:

Subject:

TRAVEL

Taxi .. $ _____

Auto (_____ ¢ per mile) ... $ _____

*Plane, train, bus ... $ _____

*Car rental ... $ _____

Tips ... $ _____

*Meals _____ *Lodging _____ $ _____

PHOTOGRAPHIC

Processing ... $ _____

*Color: _____ Rolls @ $ _____ $ _____

*B&W: _____ Rolls @ $ _____ $ _____

*Rental of special equipment.. $ _____

*Scanning ... $ _____

*Digital Transfer .. $ _____

Other .. $ _____

PROPS ... $ _____
<center>(Construction of/Rentals)</center>

MODEL FEES .. $ _____
<center>(Hiring or nonprofessional releases)</center>

LOCATION CHARGES .. $ _____

MAILING, UPS, FEDEX, TRUCKING ... $ _____

INCIDENTALS

Long-distance phone calls ... $ _____

Messenger, porter, assistant, guard ... $ _____

Liability inusrance ... $ _____

SPECIAL SERVICES

Casting .. $ _____

Hair and makeup ... $ _____

Home economist .. $ _____

Costumes, clothing .. $ _____

Location search ... $ _____

OTHER.. $ _____

TOTAL EXPENSES: $ _____

*Receipts attached This sale or assignment is in accord with the code of practices as set forth by ASMP.

well as trademark infringement for use of his name (which is a registered trademark).

The relief sought includes a permanent injunction prohibiting the marketing of the image; destruction of all remaining prints; profits from prior sales; treble damages; attorneys' fees and costs. The case is presently in discovery.

I have always advised my photographer clients in similar circumstances to request the consent of the athlete, which usually can be obtained for an appropriate fee or percentage of the revenue or profits generated. The product involved is dependent upon the talent of both parties—the image and reknown of the person pictured, and the creativity of the photographer.

Without consent, you run the very real risk that now faces Mr. Rush. As the old proverb says—better to be safe than sorry!

Tootsie Photo Alteration—an Infringement?

A recent Federal District Court decision awarded the actor, Dustin Hoffman, 1.5 million dollars in actual damages, and scheduled a hearing on his claim for punitive damages, against *Los Angeles* magazine and its owner, Fairchild Publications, which in turn is owned by Capital Cities ABC, for invading his publicity rights.

The magazine took a photo still from the movie *Tootsie* in which Hoffman was wearing woman's clothing, and computer altered it to place his head on a body wearing designer clothes. It then ran the photo in an apparent attempt at satire. The Court found otherwise, holding that "the photographs were manipulated and cannibalized to such an extent that the celebrities were commercially exploited and robbed of their dignity, professionalism and talent." Other celebrities, who did not sue, were also depicted.

The defendant argued that this was editorial usage, and a satire; thus protected by the First Amendment's Freedom of Speech.

Presumably, if the photographer of the photograph retained copyright to the image and also sued, the liability result would have been the same. Damages would be a different story, however, since privacy or publicity violations allow for much broader theories for damages, including defamation claims.

On the other hand, if the photographer had licensed use of the image to the magazine with knowledge of the intended use, it is certainly possible that the photographer could also have been a party in the action—*on the wrong end!*

This is just one of the latest examples of what could go wrong if you are not on top of your business practices.

Is That Photo in Public Domain?

A recent Southern District of New York case, *The Bridgeman Art Library, Ltd. v. Corel Corp.*, has confirmed that the marketing of photographic copies of public domain master artworks, without adding anything original, cannot constitute copyright infringement when the underlying work is in the public domain.

Bridgeman claimed to have exclusive rights in photographic transparencies plus digital images of a number of well-known works of art located in various museums.

Corel markets CDs containing photographs of a significant number of the artworks. Unable to prove copying by Corel (which claimed independent creation), Bridgeman alleged Corel "must have" copied his images.

Applicable foreign law issues were also involved. The Court held that British law applied to the copyright issues, but since the United States Copyright Act and British Copyright Law were substantially the same in the relevant areas, the result would have been the same under either law.

A key point was that Bridgeman "strives to reproduce precisely those works of art" which are in the public domain. Therefore it could not meet the originality requirement of either law. The Court pointed out that "one need not deny the creativity inherent in the art of photography." This creativity was not lacking; what was lacking was only the "originality" of the work. The court summarized the point as "skill, labor or judgment merely in the process of copying cannot confer originality."

Bridgeman did claim that it added a color bar to each image, and that this transformed the works into something that was protectable. The court easily dismissed this argument since Corel's images did not include that feature. Accordingly, even if this addition would be considered as transformative, only that portion of the work which was allegedly copied could be considered, and since the reproductions were all of public domain images, no infringement could have occurred.

Finally, the court dismissed trademark infringement claims as being covered by the Copyright Act, and on the grounds that Bridgeman did not claim any trademark rights nor was there any confusion to the public.

Editorial Use Held to Be Invasion of Privacy

It is axiomatic in the photography industry that a model release is not required if the use of a person's likeness or image is editorial in nature, such as to accompany a newsworthy story. The belief stems from judicial decisions interpreting the various state privacy statutes, which generally prohibit the use of a person's likeness or image for purposes of advertising or trade without the model's written consent.

Editorial Photos Used in a Misleading Way

In a recent federal case brought in the Southern District of New York, a model, Jamie Messenger, sued the publishing giant Gruner & Jahr USA for invasion of her privacy for publishing photos of her in *YM* Magazine. The Judge had dismissed other claims based upon negligence and libel but permitted the invasion of privacy claim to go to the jury for decision, on the theory that the photos were used in a way that could have been misleading. The jury found that, indeed, the photos had been used in a misleading manner.

The court made a distinction between the "newsworthiness" of a story which exempts the photo use from the statutory requirement of a written model release—and a misleading use, which is by definition, not newsworthy. It is puzzling, however, how use of a photo in an admittedly newsworthy magazine, where the photo was also found to be reasonably related to the story, can be an invasion of privacy because it was deemed misleading, while at the same time the libel claim based on the same facts was dismissed. Both sides have indicated an intent to appeal.

In any event, the lesson is clear; one never knows what tomorrow will bring, so be aware of just *how* your images will be used before granting usage consent.

States Can Infringe Your Copyright!

The Eleventh Amendment to the constitution deprives federal courts of jurisdiction to hear lawsuits which are filed by citizens against any state. This extends to any agency of the state. This immunity is particularly harmful to Copyright owners when damages are sought, because the Copyright Act confers exclusive jurisdiction for such claims in federal court. Thus, the Copyright Act precludes suits seeking damages for copyright infringement in state court. Therefore, copyright infringement claims seeking monetary damages cannot be pursued in either federal or state court!

Congress has tried to get around this dilemma by amending the Copyright Act to authorize such a suit. However, two recent cases in Texas, *Chavez v. Arte Publico Press* and *Rodrigues v. Texas Commission on the Arts*, have held that Congress does not have the constitutional power to grant this type of jurisdiction to the federal courts.

This constitutional restriction applies only to monetary damages, since states may still be sued in federal court for injunctive relief. This means you can stop a state from infringing your work, but you cannot collect damages. Accordingly, until or unless the law is modified, when dealing with a state entity you should take particular care to insure that your contracts contain provisions which will override these concerns.

Infringement Abroad—Whose Law Controls?

A troubling issue that surfaces from time to time is what to do when an image is infringed in a foreign country. The United States Court of Appeals for the Second Circuit, has recently clarified two of the thornier problems, in *Itar Tass Russian News Agency v. Russian Kurier, Inc.* These issues focus on which laws apply to the question of copyright ownership, and which apply to the question of copyright infringement.

The Court determined the first issue, copyright ownership, by stating that "the law of the country with the closest relationship to the work will apply to settle the ownership question." Generally, the Court said, this would be the country where the work originated. Of course, however, this pronouncement

may require an analysis of the evidence in each case to determine the degrees of the "relationship" to each country.

The Court then went on to determine the second issue—whose law would apply to determine the issue of copyright infringement—by holding that the law of the place where the infringement took place controls. Thus, a copyright claim may require application or interpretation of the laws of more than one country.

It is, however, not entirely clear how this test case is to be applied in a situation where a photographer creates numerous images in different countries, say on an African photo safari, which were published without consent by a European magazine distributed worldwide!

Buildings as Trademarks? The Owners Say Yes (Maybe)

A continuing thorny issue facing many photographers is whether, and to what extent, images of public buildings may be used in photography without consent of the building owner.

The decision of a United States District Court, which issued an injunction prohibiting one photographer from selling his images of the Rock and Roll Hall of Fame on the grounds that such use constitutes trademark infringement, was reversed on appeal, but still remains to be decided "on the merits."

In another pending case, the New York Stock Exchange has sued a Las Vegas casino for trademark infringement. The casino uses replicas of several of New York's most recognizable buildings, including of course, a facade of the New York Stock Exchange, in its motif. The casino is, as they say, "vigorously" defending its "right."

In *Cecere v. R.J. Reynolds Tobacco Co.*, R.J. Reynolds and its advertising company created a "Joe Camel" ad for camel cigarettes, which was superimposed on a photograph of the side wall of the plaintiffs' landmarked Classic brick building in Greenwich Village.

The owners of the building alleged trademark infringement, contending that the ad constituted a false representation of the building and that it could hamper their ability to use this wall in the future to obtain advertising revenue from others, because of the confusion the ad supposedly created.

The Court said no—and threw out the case. It found plaintiffs had not alleged "sufficient likelihood of commercial injury," by "failing to articulate any concrete economic loss suffered to date" or "any theory of commerical harm."

Plaintiffs had apparently never rented the wall in the prior 36 years they owned it, nor stated any intent to rent it in the future. The Court discussed the need to establish the existence of an actual commercial asset, and not just a potential one.

Since the ability to rent the space remained "fundamentally unimpeded," more than a subjunctive belief that plaintiffs were likely to be injured was

needed. Allegations, and of course, eventually proof, of actual harm is necessary. Here such proof was utterly lacking.

Of course, we do not know what the result would have been if such evidence had existed—and that certainly is the problem that continues to face photographers.

This case therefore highlights the problem; without supplying any solution.

Other owners of well-known landmark buildings are joining this trend towards controlling (or at least attempting to control) use of their property, and anticipating being able to collect resultant licensing fees for the use of images of their buildings.

There is significant interest on both sides of the issue, with plenty of money behind both antagonists. The advertising industry is strongly opposed to any restrictions, since they use these publicly available locations in many ads—including those shot by the photographers they retain. The Courts will be asked to rule on the issues as they are raised. In addition, lobbying for legislative clarification may enter the fray.

It Can Be Very Expensive to Be an Infringer on the Net

Numerous questions have arisen as to what, if any, rights exist regarding use of copyrighted photographs on a Web site when the copyright owner objects. Copyright owners have of course taken the position that unauthorized use on a Web site is no different that any other infringement. A recent California case confirmed this belief, to the tune of $3,737,500, plus costs and attorney fees.

The Court, in *Playboy Enterprises, Inc. v. Sanfilippo and Five Senses Productions,* held that the uploading of 7,475 separate images, were 7,475 separate infringements, and rejected the defendant's contention that since each *Playboy Magazine* issue had a separate copyright, the uploading of all photos from each magazine constituted only one infringement.

The Court reasoned that each image has an "independent economic value" and is viable on its own; that each is subject to reuse (as stock or otherwise), separate and apart from the other photos appearing in an issue, and each represents a "singular and copyrightable effort."

Along with the monetary finding, the Court issued a permanent injunction banning the defendants from any further use, and ordered the retention or destruction by *Playboy* of all relevant data files and the electronic storage media upon which the data files reside.

This case demonstrates what I have been counseling for years. Copyright infringement usually does not pay when a copyright owner has taken proper precautions to protect his copyright!

The Annie Leibovitz Case—Commercial Parody as a Fair Use

The United States Court of Appeals in New York recently affirmed a lower Court's determination that a knock off of the famous nude profile photograph by Annie Leibovitz of a pregnant and serene Demi Moore which appeared on

the cover of *Vanity Fair* magazine, was a parody and not a copyright infringement under the *fair use* defense.

The "knock off," in which the head of Leslie Nielsen was superimposed on a body recreated to be identical to that in the Demi Moore photograph, was used to advertise the movie, *Naked Gun 33⅓: The Final Insult.*

The key factors to the Court were what is called the "transformative" nature of the new work and the acknowledged absence of any harm to the original work. The "transformative" nature is the addition of "something new with a further purpose or different character, altering the first with new expression, meaning or message."

The use was clearly commercial in nature. But when coupled with the absence of any damage, such commercial use was not enough to defeat the fair use defense.

This opinion appears to add little in the way of actual guidance on the subject, however, since it is so fact intensive, and does not address damages since Ms. Leibovitz conceded there were none.

Accordingly, it will be left to the District Courts on a case by case basis to determine whether future claims of parody are truly entitled to prevail, or whether such claims are nothing more than non-exempt commercial copyright infringements.

Expanding Your Marketing Efforts

MULTIPLY YOURSELF

Since you've read this far you're well aware that this book is concerned with the well-known reality in the field of stock photography that taking good pictures is only part of the quotient for success. Marketing yourself plays just as important a role.

Over the years, I've had the opportunity to watch hundreds of photographers come on the scene, linger a while and then phase out. It wasn't because of lack of talent. They had plenty. It was their lack of marketing know-how.

When I graduated from Maryland Institute College of Art, no professor held my hand or served as a mentor on how I might survive once I left the cozy confines of college. I was on my own to figure it out.

I had a few friends who were professional photographers. I observed their work style and came to the conclusion that I didn't care to hop on a plane Monday morning, spend the week in a hotel while photographing objects or buildings, fly home on a Friday evening carrying forty pounds of camera equipment and film, spend the weekend processing it and answering business correspondence, and then fly out again on Monday morning after kissing my wife and children goodbye, to spend the next week in another hotel.

I sat down one weekend with my wife, Jeri, and laid out a plan that would allow us to move to a farm in western Wisconsin, enjoy the serenity of rural life and still accomplish my goals of enjoying my photography while making it pay for itself and provide for our family.

The marketing method I devised is called Multiplying Yourself. There are several ways to do this. My own method worked like this: Rather than take a week to produce five different photo articles to submit to five different magazines, Jeri and I (she was the writer) would take five days to produce one major in-depth photo article that we would then sell to several magazines on a "simultaneous submission" basis (always advising each magazine of this, with a list of the other publications).

Since we selected markets with no cross-readership, it worked. We pulled back from doing exclusive stories for major magazines. They paid good money, but they were in control of the text and the slant of the piece, the art director always wanted to have his say and it was a one-shot sale. Our simultaneous

submission method gave us the freedom to choose whatever subjects we wanted to cover and to operate from our farm location. The pictures we took for our self-assignments wound up in our stock photo file and continue to sell today.

Early in his career, well-known and widely published photographer Bill Thomas wrote about our system in the July 1965 issue of *Writer's Digest*. Thanks to the Web, the system works better today than ever before. Following are examples of some different "spins" you can take on the basic concept of multiplying yourself.

The Naturalist

Naturalist photographer David Liebman is by trade a handwriting analyst. His services are requested in all parts of the country. His airfare and other expenses are covered. Before he leaves for the trip, he uses the World Wide Web to research the geographical area he'll be traveling to in relation to his area of photographic expertise: butterflies, moths and insects. He then matches his database of clients with these locales and subject areas. He checks with buyers on his market list until he gets enough clients who are in need of photographs from that geographical area. He then stays there an extra week or two, depending on the success of his marketing efforts. By multiplying himself on self-assignments, he not only realizes a good financial return, he has built up a personal collection of over 500,000 arthropod photos that are constantly in demand. And since arthropods have been on the earth much longer than Homo sapiens, he expects his photos will never go out of style.

The Space Man

Wil Sanford is at the other end of the spectrum. He covers man-made flying objects, from helicopters to NASA spacecraft. As a specialist in this area, he knows many top administrators in the field on a first-name basis. "Permissions is the key to opening doors," says Wil. "Many art directors at companies that produce aerospace products don't want to go through the arduous process of finding out who gives the permissions to photograph, let alone handle the convoluted negotiations to get the contact person to actually bestow a permission. If you are specialized like I am, you know the right buttons to push. I probably would fail in another area such as agriculture or manufacturing."

Photographers in the recent past, to find their target markets, would read *The Wall Street Journal* or *Barron's Weekly* to learn who's doing what in the area of aerospace. Nowadays, Wil goes to a Web search engine and begins a daily routine of learning about the up-to-the-minute activity in his area of interest. "I like to use AltaVista," Wil says. "The home page features a section called, 'Industrial Communities.' I click on that. Then I click on the section called 'aerospace.' [Other search engines may have a different name for the same category, e.g., 'NASA' or 'space.']

"In that section I'm asked to search either by product/service or company

name. If my next travels are to Israel, for example, I type in Israel in the adjacent search slot. 'Products' will produce a list of aerospace products that are manufactured in Israel. 'Company' will produce a list of aerospace companies along with their address, phone, E-mail and fax. Many of them I'll already be familiar with. Some of them have American subsidiaries."

I asked Wil how all of this helped him.

"If I'm flying to Israel, many American companies might have their products in use at the Ben Gurion International Airport or the Israeli Gas Turbine Association's Jet Propulsion Lab. I let the CEO of the American company know I'll be in Israel at such and such time and would be happy to photograph their product, in use, in Israel. Since I spent many years building my business and contacts, I already have a security clearance and know the people who make decisions at many of these places. I've hurdled the barrier of the usual red tape. I might get as many as fifteen assignments this way. The resulting photo in each case will pull in a fee ranging from $1,500 to $2,500, depending on the size of the company and usage of the photo. I always work in 35mm transparencies, by the way.

"The benefit to the CEO or art director is that he doesn't have to have someone make a special trip to Israel, nor pay for my travel, lodging and meals, nor get security clearances. I cover all that myself, or I should say the fee for just one of those clients pays for those costs."

The Rural Guy

Ever wonder who takes those beautiful rural scenics of the bluegrass country in Kentucky or those spacious skies in Nebraska? Denny Eilers is one such photographer. He's been photographing rural scenics since 1990 and from his

Pricing Yourself for Assignments

Freelance photography handbooks in your library are helpful in researching how to price yourself for your day rate. Three tips: Since each publication you work with will offer a different "day rate," based on such things as circulation, advertising revenue and size, you'll find day rates ranging from $250 a day to $2,000 a day. In addition to the base day rate fee, it is acceptable to also submit a statement for expenses, such as mileage ($.29 per mile *outside* your general metropolitan area; if you live outside the general metropolitan area of the publishing house, do not charge a fee for coming into the city), car rental, plane, train, meals, lodging. Also, photographic expenses: processing, renting of special equipment, props, model fees, location charges (such as rent), mailing and/or carrier charges, phone calls (beyond the ordinary), messengers, porters, guards. Be sure to keep your receipts and staple them to your statement. For a sample expense form see page 150.

PRICING YOUR PHOTOS

These three popular pricing guides will help you price your photos: fotoQuote by Cradoc Corporation, Jim Pickerell's on-line newsletter *Selling Stock* and Michal Heron's *Pricing Photography*.

Iowa location since 1996. "I tried the corporate route," says Denny, who early on was staff photographer for Webb Publishing in St. Paul, Minnesota. He then spent some years as an advertising executive in Philadelphia and Atlanta. "I guess my rural upbringing drew me back to the farmlands. I left the advertising profession after twenty years and returned to the Midwest."

Denny has learned to multiply himself. As an ad agency executive, he amassed a great number of contacts over the years. He's put this to good use now in his freelance photography business, using the "network" approach to assignments.

He first used the telephone, then the fax and now E-mail, to contact selected numbers of potential clients before going out on a major assignment. The World Wide Web has become an indispensable tool for him for market information concerning his contacts, and his communication with them.

Using the search engine method, he works backward. If he is going to a particular region of the country, say to Florida, he begins rounding up information about Florida, what's going on there in the way of agricultural development, farm techniques, new genetics development and so forth. If he will be in the citrus or beef cow regions, he will match what places might be using equipment, methods or agricultural practices of the clients he has developed in the past.

"Very often the art director is not fully aware of what's happening with their company's product in particular areas of the country. They're always happy to have suggestions from me. Often, I serve as sort of a PR guy for them. And since I'll be in the area, I take pictures on speculation, knowing (from experience) what will sell and what won't.

"It doesn't bother me if for some reason a photo doesn't sell right away. I just add it to my stock file. Someone else in a similar special interest field usually buys it."

In agricultural photography, the farm machinery that's pictured can easily be out of date in a year or so. Denny works fast with his clients. "They usually have a six-month lead time on their articles, so it's necessary to get equipment that's new, bright and shiny," says Denny.

Denny's photo work falls into three categories: the assignment work, commercial stock photos and editorial stock photos. "Whenever the situation lends itself, I take the 'hero' shot for the assignment—usually a close-up making a product the hero. Then I step back fifty feet, where the product doesn't steal the thunder, and I place more emphasis on the scene. I use that for my editorial file.

"I consider these three areas—assignment work, commercial stock and editorial stock—the 'three-legged stool' of my business, and I give equal attention and research to all three."

And what of new clients that are in the regional area he'll be traveling to? How does he convince them that he ought to be taking some pictures for their art files?

Multiply Your Assignments

You can gain leverage with potential clients if you are traveling to an area of the world where they might need photos. You offer to piggyback your travel expenses (which are usually paid by your original assignment giver). You say to the client, "I'm going to be in _____ [you fill in the country]. Will you need any photos?"

If you belong to an organization such as ASMP, you can broadcast your travels through its network of contacts. ASPP (American Society of Picture Professionals) provides a similar service.

Two public services that broadcast photographers' itineraries to photobuyers are Photo District News's Assignment/Resource Exchange (http://www.pdn-pix.com/interact.html) and PhotoSource International's Traveler's Abroad (http://www.photosource.com/abroad/index.html).

"The Web comes in handy here," says Denny. "A manufacturer or major distributor that I've never worked with usually has a Web site. Background information is readily available. You don't have to send away for literature. News of their latest products is featured on the Web site, even information about local distributors and upcoming trade shows. With a little homework, using the Web as your resource library, it's amazing what can be accomplished—when I contact the new client they're impressed with my familiarity with their products and operation and I usually get an assignment."

Denny Eilers also multiplies himself another way. "Often as I travel around the country, I will make pictures of ag industry innovations that I know will be of interest to my editorial contacts. Then in the wintertime when the shooting slows down—I send off queries for a brief article to editors. The photos are convincing and always help make the sale. If you're not a writer, you can always do this successfully teaming up with a writer friend. I always get paid more for a photo/text package, than for each of them separately. The package is more impressive to the buyer and saves him/her time and money."

Denny suggests these handy references for photographers, both editorial and commercial, working in the agriculture field: *The Farmer's Guide to the Internet*, which lists E-mail and Web sites of businesses, publications and organizations in agriculture; *AAEA Directory* (American Agricultural Economics Association); and *ARC Directory* (Agricultural Relations Council).

The illustrations on pages 162-163, show one of Denny's commercial 'hero' shots and the related "fifty feet back" photo for his editorial stock file.

The Lazy Man

Tom Carroll is probably the hardest working photographer in the country, and he's been at it for fifty years. But he insists he takes a "lazy man's" approach. That is, in leisure, he sits back, has fun researching areas he's interested in, finds the assignments and then assigns a photographer from his cadre of a half dozen to do the work. And the work is usually focused on construction projects in the United States and foreign countries.

The "hero" shot.
Photo by Denny Eilers

Fifty years in the photography business and Tom Carroll is still a pioneer. "Since setting up my first home office with used packing crates when I was fifteen years old, I haven't given a thought to retiring," he said.

Tom long ago figured out that success in the stock photography business is not just a case of being able to produce a quality photograph, but being able to creatively market your talent so that you spend as little time as possible on the nitty-gritty of promoting and administration, and as much time as possible on the adventure of making photographs, enjoying travel and sharing your knowledge with promising young photographers.

This is not to say that he developed his marketing techniques in an overnight dream, or that photographers don't have to put effort into discovering their own pathways to marketing success. Many find their efforts to engineer their own marketing systems rewarded. "But I'm still puzzled," says Tom, "to see that many photographers are willing to spend endless hours, even weeks, developing clients that will lead nowhere. Once they reach a dead end, they employ the same marketing procedure all over again, and go down the same road with another client that leads nowhere.

"Do your homework," advises Tom. "Work from the top *down* to art directors. Middle managers usually don't have the authority to say yes. Committee meetings will only hold you up. Instead, go right to the top."

That's easily expressed, but how do you actually do it? I asked Tom what his method is to successfully reach the top person in a company. (This is when your pathway is corporate commercial work.)

"Obviously you have to have a portfolio to start out. But since everyone

The "editorial" shot.
Photo by Denny Eilers

has one, the next step is to get your foot in the CEO's door, or better still, his ear on the phone, or his attention on the Internet.

"You have to have quality pictures, but the CEO is not really interested in your portfolio, he's interested mainly in your *access*."

"Access?" I asked. "What's that and how so?"

"Fortune 500 companies, and other major corporations, would love to have photos of their products in use, in foreign countries, or in inaccessible places, such as the Tappen Zee Bridge in Tarrytown, New York, or on a military maneuver in Panama. The problem is, try as they might, they are usually refused permission to send one of their staff photographers."

Like Wil Sanford, Tom has learned how to land those all-important "authorizations to photograph" that are the key to the assignments.

"You mean you have a way of getting access to those kind of places, and a Fortune 500 company cannot?" I asked.

"Yes," says Tom. "Take the case of a mining operation in Chile. There are probably five or six various products (heavy equipment, computers, helicopters, earth movers, etc.) to be photographed. If I get an assignment from all of the companies that manufacture those products, I have some leverage when I go to a government official to get permission to access the area. They'd much prefer to make arrangements with one photographer (my company) than five or six unrelated photographic companies. And presto! They throw out the red carpet for me, even suggest other related sites and products I should photograph."

Tom doesn't leave his California studio to learn of possible self-assignment activities in foreign countries. At the Gemini Web site, the one that provides continual satellite photos of global activities, he observes construction projects and their progress. If they're in a country where one of his photographers will be traveling, he makes contact with the company. Since he has already paved the way with permissions, transportation, guides, rental vehicles—the corporate decision maker needs only to say yes or no. "It's important to act quickly, on their part and mine," says Tom. "Otherwise the project may change and the opportunity is lost.

Tom says, "When we complete one of these multiple vendor assignments we shoot heavy enough to acquire three complete sets of original transparencies. Plus we produce an extra set for our stock photographic files. Each vendor is given the three sets for distribution to suppliers and colleagues along with a complete release of use and copyright worldwide. This is the winning part of the relationship. The vendor then forwards, along with our thank-you note and copyright release, a complete set to the sponsoring corporation that has given us complete corporate releases in return for the courtesy transparencies. We don't send prints, as that would be too labor-intensive for us.

"Now what you have effectively accomplished is clearing the worst nightmare of the commercial stock photo business: getting property releases and model releases cleared. It's a win-win situation. This way you're always welcomed back by the sponsoring entity such as a corporation or governmental division. And your clients are extremely pleased with the photographic results!"

Tom now has hundreds of "access" places around the world, and more work than he can handle. His crew of a half-dozen photographers is constantly on the move worldwide.

Tom finds most of his jobs on the Web. The precise way it works goes like this: He surfs the Net to find information about, say, a NATO project going on in Turkey. He finds seven companies that have products being utilized there. They might include a new all-weather bivouac tent or a ground-level radar device. Without leaving the comforts of his Capistrano Beach home, he assembles a plan and sends queries out to the person at each company who has the authority to make assignments. It might be the art director, the CEO or even the CEO's secretary. This person knows the value of a photo of her company's product, in use, in an exotic location—and makes the assignment to Tom, who in turn schedules the jobs with one of his photographers.

Remember, Tom Carroll is not a newly discovered Nintendo-fed hotshot on the photo scene; he's been in the business fifty years. He's an inspiration to silver-haired seniors out there who say the new digital age is too much for them. He's proving that the Digital Age is for the ageless.

The Traveler
Growing up in Nebraska, Phil Coblentz developed a yen for traveling the oceans. He got his wish, and 300,000 photos later, he can prove it.

© Tom Carroll

"My pictures appear everywhere—on major magazine covers, on posters and prints, on CD-ROMs and in books. I'm working on a book on Venice. I've been there thirty times, and one day I'll have the book finished," says Phil. "I've been too busy meeting deadlines and assignments. I'll have to take a sabbatical to complete the book!"

Phil started out as most travel photographers do, by doing assignments for magazines, book publishers and corporations who have subsidiaries in foreign countries.

"After a while I realized that the fee I received for each trip just about paid my film and location expenses, and there wasn't much left for me!" says Phil. "If I wanted to survive as a travel photographer, I'd have to learn how to 'piggyback assignments.'"

What he meant was that he would not take a future assignment unless he could get a half-dozen additional clients to commit to at least look at his work when he returned.

"In the beginning, it wasn't easy for an unknown like me to convince art directors that they should use my work. But little by little, when they saw I could produce a professional package, they began accepting my proposals. Pretty soon, some of these clients began initiating assignments with me, and I would contact a few of my other clients to come aboard each time. Now that I have a track record with dozens of clients, it's very easy for me to go on a trip."

His method is to get an E-mail out to his client list to let them know where he will be traveling in the next couple of months. "I realize that the newcomer to travel photography can't use this method tomorrow, but if you love what you are doing and hang in there, you can build up to it. It's possible to do anything in the field of photography."

Phil speaks from experience. Back in 1984, his studio burned to the ground and he lost all of his photo collection and his equipment. Two years ago, when he was in Central America, he was getting ready to return with two weeks of work (about 275 rolls of exposed film). Someone stole the film from his rental car along with $40,000 worth of camera equipment. Phil was not deterred. He dug deep into his bank account, bought more film and a secondhand camera and lenses, went back to Central America and in three weeks got even better shots. He sold enough of the resulting photos to buy all his equipment again.

"I think talent is only one ingredient that goes into becoming a successful stock photographer," Phil says. "Persistence is a good virtue to have if you want to be successful in this field."

Nowadays, there are very few days in the year that Phil is not out on a trip. "My wife and I are a team, and we both love traveling. I guess we're just built that way. She speaks six languages and loves photographing as much as I do."

Phil has photographed in eighty-six countries, from Costa Rica to Russia. His Web site (http://www.worldtravelimages.com) illustrates his breadth of travel and photographic style.

Phil sees the day when most photography transactions will be carried out

not through next-day FedEx with original transparencies, but through digital images and the Internet and Web sites. "New markets are cropping up every day. I've sold my pictures for CD-ROM use in learning companies, electronic encyclopedias and software programs. Ten years ago, these markets didn't exist. I've even sold my entire library of photos, twice, to two different CD-ROM outfits."

Phil is a longtime Tony Stone Images photographer. Getty Images bought out TSI several years back. "I could see it coming," says Phil. "Massive corporate stock photo houses are more interested in their stockholders than their photographers. That's the way the world runs, whether it's dairy cows or photographers. The bottom line is profits at all costs. I decided I wanted no part of that scene, and I said goodbye to Corporate Stock Agency America. Besides, I see the day where the Internet will be a direct marketplace for photographers—with no need for a middleman like TSI or Corbis or the others. It's moving that way, so I've decided to position myself and get my business ready to meet the eventual demand from the Web and the Internet that's sure to come.

"As long as I keep building my stock file, and keep letting buyers know where to find me, I see a very positive road ahead for my travel photography."

THREE-TIER MARKETING—IT COULDN'T GET ANY BETTER

In the early days of Hollywood, grabby movie producers signed promising stars to long-term contracts—not unlike slavery. The next wave of actors saw what was happening and elected to become independent contractors, able to pick and choose their scripts. Maybe our stock photography industry is evolving along a similar pathway.

It will be interesting to see if midsize agencies in the commercial stock photo industry will combine forces to offer convenient, personalized services to local regional clients, much like how quick-stop grocery stores survive very well in the shadow of massive food chains.

History has shown us that consumers will often choose convenience over price, brand and quality. If regional stock agencies survive, it means that you, as a freelance stock photographer, will have three ways to market your photos: (1) You'll send your commercially oriented general stock pictures to an automated, digitized giant (Getty, Corbis, FPG, Index Stock Imagery, The Image Bank, etc.); (2) you'll send your regionally oriented stock to a local agency; and (3) you'll personally market your highly specific editorial stock photos to special interest buyers whose needs match your strong coverage areas.

Here's the advantage of this three-tier selling strategy: Number one will pay the bills. Your commercially oriented stock photos will go stale after five or six years, but you'll continue to keep on top of the trends and pump out new stock. Number two will enable you to anchor yourself to something other than an E-mail address. You'll give personalized service and receive first-name attention from your regional agency. Number three will allow you to photo-

graph in the areas of editorial stock closest to your heart (environment issues, developments in education, Native American issues, the homeless, rodeos, gardening and so on). These photos will eventually become of period or historical significance, and you can pass them on to your heirs.

Specialization

In this book and in my previous marketing book, *Sell & Re-Sell Your Photos*, I emphasize that in order to be successful in the world of editorial stock photography, you should choose a select number of special interest areas and begin photographing in those subject areas. Eventually you will have amassed a large file of specialized photos that will be of high interest to particular segments of the photobuying universe.

Take a cue from successful stock photographer Mitch Kezar (http://www.kezarphoto.com) of Minneapolis, who says, "I think that filling niche markets is where it's always been for the independent stock photographer, and nothing could be more applicable in today's market."

Many photographers I meet, and who attend my seminars, are interested in more immediate monetary gain. They ask me, "What sells best?" I interpret this to mean that they will then enter that field of stock photography, whether it matches their own interest areas or not. This is a recipe for failure.

To put it another way: In the fifties and sixties, the richest person on the planet was Aristotle Onassis. The Greek magnate owned a huge fleet of freighters and tankers. Someone at that time looking at "what brings in the most money" would use Onassis as his model and get a job in the shipping industry and work his way up, whether that held real interest to him or not. Today, changes have diminished the shipping business from the highly lucrative field it was a few decades ago. The young man, now middle-aged, who invested a lifetime in the shipping industry to follow the dollar instead of his heart might realize he made a terrible mistake in choosing his life's career.

Lesson: Choose a specialty area (or areas) that appeals to you. If you have a talent for photography and you focus it on an area you enjoy, you'll be able to withstand the pitfalls and roadblocks you're bound to meet up with. In the short term, it might not start out highly profitable, but in the long run, it will pay off, and you'll have enjoyed every minute of it.

And remember, the new century and its advances in electronic communications are going to allow you more flexibility and freedom than ever before in working directly with buyers to market your stock imagery.

EXPAND YOUR MARKETS ABROAD

Michael Sedge has been selling his photos and articles to foreign markets for nearly two decades. When his most recent book, *The Writer's and Photographer's Guide to Global Markets* came out, I talked with Michael and asked him about marketing to foreign buyers.

"I first began selling images to foreign publications in 1983," Michael says.

"Today, more than 80 percent of my photographs sell in places outside of North America—in Africa, Asia and Europe. It is not difficult to sell overseas. In fact, technology today has made marketing to foreign publications as easy as selling to your local newspaper."

"How do you get started?" I asked.

"Start first with an E-mail query letter. It's the best way to approach international publications for the first time. It saves on expensive overseas postage and often will bring a faster reply than will an unsolicited submission of photos. Include a list of your stock images for the photobuyer or art director. Initially, concentrate your efforts towards publications printed in English. Australia, England, Ireland, New Zealand and South Africa all have English-language periodicals, as do nearly all other countries in the world. In Japan there is *Mini-World*; in Hong Kong, *Off Duty*; in Singapore, *Silver Kris*; in Italy, *Going Places Doing Things*; in Sweden, *Scanorama*; in Germany, *R&R*; in Spain, *Lookout*."

"How do you locate these and other markets?" I asked.

"Finding foreign markets is not as difficult as you might think. One good source is the *International Writers' and Artists' Yearbook*. This book with over six hundred pages, is published in England and lists more than forty-five hundred overseas markets. It is available in major bookstores in the United States, or your library through the Interlibrary Loan Service.

"The *Willings Press Guide*, also published in the UK, is found in many libraries, though it does not list rates or specific editorial needs."

I asked Michael about his own newsletter that he publishes, *Markets Abroad* ($31 per year; $27 per year E-mail). In *Markets Abroad*, Michael lists newspapers around the world that buy English-language original and reprint articles, as well as photographs. Also included are names of editors, rates and other marketing information.

When Michael sends selections of his images, he says, "I prefer to send laser-dupes rather than original transparencies to foreign publications. For most editorial needs, these are sufficient. And I ship all photo packages by courier—UPS, FedEx, etc. This provides me with a method for tracking shipments via the Internet, or through a toll-free number. Also, my experience is that if you utilize courier service to deliver images, the client often returns this courtesy, and returns your photos the same way after use.

"Opportunities to display your photo story, essay or individual images on your (or a photobuyer's) Web page now exist, and as more and more international photobuyers become Web savvy, you'll be able to get your work in front of increasing numbers of buyers."

I asked Michael what reception he gets if he submits digital submissions.

"Foreign buyers who are accustomed to dealing with English-speaking photographers are at the forefront when it comes to Internet literacy. You have an advantage dealing overseas if you find buyers who are Internet-ready. They can view thumbnail submissions and make their decisions in a matter of hours

(not days). You then have the opportunity to submit a high-resolution image on-line or send a disk to them overnight. The digital revolution has transformed the possibilities of foreign marketing!"

No Cross-Readership Conflict

"Like periodicals in the United States, nearly all overseas magazines use one-time publication rights," reports Michael. "This means you are free to sell and resell your package or photo as many times as you wish. Because there is no cross-readership conflict among foreign publications, international photobuyers welcome the opportunity to buy their material this way; they know it gets them higher quality.

"Slowly, international editors are getting into E-mail, and nearly all have faxes. And, unlike their American counterparts, in most cases photo editors abroad like using these modes of communication for initial contact.

"The financial return, in many cases, can be greater with overseas publications than domestic U.S. markets. Foreign in-flight magazines average $750 for a short text-photo package—and most use lots of photo essays. Publications for women pay in the $75 to $150 range per photo, while travel magazines pay $100 to $200 per photo. Many international publications will pay with a bank draft in U.S. dollars, often drawn on a U.S. bank. Cashing checks is, therefore, no problem. Others may offer to make a wire transfer directly into your account."

A System

"Have you refined your working methods into some kind of a system?" I asked.

"When I first began marketing my images abroad, I came up with a system which I think works for me," Michael says. "I decided to send one query/stock list a week to a foreign photo editor. After sixty days, I had received three replies (one sale), and had another five queries out. I continue sending a query/stock list overseas each week. Remember, because there is no cross-readership conflict, I can send the same photo/article package to a couple dozen photobuyers. If they all use it, no problem, because their readers are in different countries, and usually in different languages.

"The photobuyers are amenable to this, because they know I can invest more time and talent into my photos and photo stories when I know I can market them several times, which results in higher quality material for them.

"Today, nearly fifteen years after I first began, I have some one thousand stock lists on file with foreign markets. During the past five months, I have had images published in England, Germany, Italy, Spain, South Africa, the Middle East, Singapore, Hong Kong, the Philippines, Japan and, of course, the United States."

Profile

When Jagdish Agarwal was a teenager in Bombay, India, he was an amateur photographer and dreamed of being a professional one day. However, his parents, who were in the textile business, would hear nothing of it. They wanted him to continue in the family business and follow the commercial path of his forefathers.

After he completed his schooling, Jagdish initially followed the wishes of his parents, but only for a few years. The magnetism of photography was too strong, and he soon found himself setting up a darkroom and a marketing plan. For the first few months, things were bleak. He had zero accounts.

"Persistence paid off," says Jagdish. "In 1971, I sold my first photo."

From a modest one-table office, he began researching an idea—to represent not only his own but also several of his friends' photography. That would give him an immediate broad base of photographs when clients came to call. Rather than offer his new clients choices from only his own modest collection of fifteen hundred pictures, he could offer them fifteen thousand images to chose from.

In the early stages of his stock photo agency, cash flow was down, bills were high and clients needed to be educated. "Most of my early clients didn't know the difference between a print and a slide," says Jagdish. "It was a long road upwards, but I survived."

And so did his photographer friends, plus now almost two hundred more photographers who have joined his agency.

Photo © Rajesh Sharma/Dinodia Picture Agency

I asked Jagdish what helped him along in his success besides persistence.

"I think my love of photography was one of the most enduring factors of my success. When times were bad and the bills weren't getting paid, I'd ask myself, 'Why am I doing this?' I couldn't always answer the question, but when I asked myself, 'Would I rather be doing something else other than this?' a definite *no* would come roaring back."

Jagdish now calls his operation the Dinodia Picture Agency. You can find him on the Web at (http://www.jagdishagarwal.com/). He represents nearly two hundred photographers, from all over the world. He is India's largest stock picture agency with over 500,000 images. He employs nine staff members.

"It's been a long while since I first subscribed to your original *PhotoLetter* back in the late seventies," Jagdish told me. "Back then, I had no overseas clients, and your *PhotoLetter* helped me get a foothold in the USA. After several decades, I'm now firmly established with USA markets, some of them acquired from my early *PhotoLetter* contacts."

Since his is a full-service stock photo agency, Jagdish's focus has moved from editorial stock photos to supplying ad agencies, graphic houses and corporations with commercial photos that are model released. "I'd say about 10 percent of my sales are to editorial markets and the rest to commercial sales."

Jagdish has found that more and more ad agencies are beginning to accept digital files over the Internet. "This brings my clients even closer to me," says Jagdish. "In the past, it used to take more than a week to deliver a selection of photos. Then, carriers such as FedEx and UPS came along. That cut the time down to a matter of days. Now with E-mail, though, in a number of hours I can be in touch with a client, have them preview some 72-dpi selections and choose one, then send them a digital file or the image whatever way they want to receive it. Most clients, at the moment, choose to have me send the original transparency so that they can take it to their printer and have it digitized to their own specifications.

"In the near future, once photobuyers and sellers become more integrated and in synch with one another, I can see that buyers will easily accept on-line submissions. This will make the circle complete."

In the meantime, Jagdish uses part of the old and part of the new in his operation.

Profile

Jeanne Apelseth lives in Norway. She operates a mini stock agency called Photo Net, with an impressive archive that includes images from Rwanda to Paris, Nepal to London, but deals primarily with photos of Norway.

"I find that photobuyers come to us when they need an image that says 'Norway,' " Jeanne says. "If an American corporation needs a photo of two Norwegian youngsters, for example, they find they can't just use a picture from an American print catalog of two American youngsters who are obviously not Nor-

wegian looking (clothing styles, background, architecture, hairstyles, etc.)."

How does Jeanne reach her clients?

"Almost exclusively by E-mail," she says. "When a prospective client sends us a photo request, we send digital samples for review. Without the Internet, it would take five to ten days to send original slides off to a client for consideration. Digital submissions work well. We don't work with any clients who can't accept a scanned image, usually 72 dpi. This allows us to compete with American companies. Without the Internet, we would just be a local Norwegian stock house, without much traffic outside of Norway. Thanks to the Web, we are international!

"About 15 to 20 percent of our sales are to the U.S. We are working to increase that market. We usually send the preview images as attachments. If a client requests to see the preview images on a CD-ROM or by fax, of course we'll send them in that manner, too. Once the client has a selection of digitized preview images, they can make a decision and we send them either the film images (most of them request film) or we transmit a high-resolution digital image to them. Most companies here in Norway have ISDN lines, so the transmission doesn't take too long. FedEx and UPS also have a presence in Norway."

The Photo Net Web site is located at http://www.photonet-gallery.com. Clients are able to take a look on the Web at images available in the subject areas they need, ranging from People & Lifestyles to Architecture & Design—most of them with a Norwegian spin. If visitors don't see what they need, they are able to request a preview of more recent entries to the agency. In most cases, they can also request to make an assignment for a specific shot. With Norway's small size, distance is not the factor it would pose in the United States. For clients who need images of Norway frequently, Photo Net offers an E-mail service plus a printed monthly newsletter that keeps buyers up to date on new entries into the Web portfolio.

When it comes to the actual delivery of the images, about 90 percent of Jeanne's clients prefer that actual transparency.

"They don't seem convinced that the quality of a digital image can be good enough, or maybe they prefer having control over the prepress stage," says Jeanne. "If they have the original, they know they can have their in-house people or their local service bureau scan the images to their own specifications. However, I believe that in the next couple of years, we're going to see most clients accepting digital submissions. It saves them the extra step (and money)."

Jeanne Apelseth was born in South Dakota and migrated to Norway in 1981. "I've always had an interest in photography. When the opportunity came along of combining photography with Internet traffic, I saw the possibility of representing many of the fine photographers here in Norway. Barriers are beginning to fall for photographers who want to work on an international scale. For example, I can now be in contact with my relations in South Dakota as fast as I can with downtown Oslo!"

More Global Marketers

Joel Day lives in Perth, Australia, and operates the STOCKPHOTO Forum (http://www.stockphoto.net), probably *the* most popular of newsgroups, for stock photographers. In addition to his moderated newsgroup his site offers a cornucopia of news and information about stock photography: past discussions, stock agency listings, photo organizations worldwide, lists of other stock photographers, occasional surveys of photographers' opinions and a market lead service. Joel also maintains a personal Web site (http://www.joelday.com). And all of this from far western Australia!

The publishing house PIAG, of Baden-Baden, Germany, publishes *Visuell International* (http://www.piag.de/Englisch.htm), the only magazine-format publication in color devoted to the stock photographer. Its readers are stock photo agents and freelance commercial and editorial stock photographers. *Visuell* is published in German, English and French. Although much of its emphasis is on European activities, some of the content is geared to the Ameri-

can reader. In a special section set aside for traveling photographers, you are able to publicize your upcoming trips. Other sections deal with association news, the coordination of European stock agencies (CEPIC) and photo competitions. The Web version of *Visuell* also includes a gallery of searchable images (http://www.piag.de/IndexEnglisch/IndexVisuell.htm).

The British magazine publisher *Elfande* produces CONTACT photographers and CONTACT designers, a Web meeting place for European buyers and sellers of stock photography.

YOU CAN START YOUR OWN MINI STOCK AGENCY ON THE WEB

So you're thinking about setting up a modest stock agency to sell your photos plus those of a select number of fellow photographers you'd bring into the fold.

OK, what are the ingredients of a mini stock photo agency?

1. Photos, of course, and a good supply, in a specialized category or a select few categories
2. Buyers (your customers)
3. A plan, and a person to work the plan (you)

Your plan would revolve around "Find a need and fill it." That's of course what enterprising entrepreneurs will tell you is the secret of business success.

Today thanks to the World Wide Web, you need spend only a fraction of the time it used to take to research a need to be filled. Through the Web you can also locate the customers who have that need (for photos in a specific interest area) and the photographers to help you fill that need.

Setting up the Business

Let's backtrack. Say your primary interest is in horses—racehorses specifically. Wouldn't it be satisfying to be involved with a business that is also filling *your* need? By doing a little homework, using a search engine on the Web, you can determine how much interest there is (how great a need) for photos of racehorses.

If the Kentucky Derby is any indication, the national interest in horse racing is not minor. Once you are convinced that a market exists for your specialized interest area, two more ingredients are important: photographers who have strong coverage of racehorses and customers. The Web will help you find both.

The World Wide Web is the ultimate people finder. Finding persons who love to photograph horses is easy.

Here are the results of a Web search for "photographer + horse."

AltaVista	1,350,200
Thunderstone	1,323
Infoseek	867
Yahoo!	125
Lycos	10
Direct Hit	10
GoTo	10

Incidentally Infoseek also included Horse Industry Directory—photographers with the URL http://www.premierpub.com/directory/photog/default.htm.

Searching for members for your specialized agency is no problem.

Use the Web to find markets, too. Here are some sites I found when I did a preliminary search with these parameters: "horse + racing + photos."

ICQ List—Sports in Europe: Horse Racing
 http://www.mrhorse.com/ippica/icqlist.htm

Photo Museum of Horse Racing
 http://www.wellmet.or.jp/~kokubo

Photo Pages—Horse Racing
 http://horseracing.miningco.com/library/pics/blasoup.htm

And for horse racing publications and guides, companies that publish race-horse books and for companies that produce racehorse products, I used the search engine to sites like these.

CNN/SI—World Horse Racing
 http://www.cnnsi.com/more/

High Stakes—Sports and Gambling Quarterly
 http://www.gamblingbooks.co.uk/grey.htm

Horse Racing Australia Magazine
 http://www.horseracingaustralia.hl.com.au/BestOf/punters.html

HORSE RACING: TRC Thoroughbred Notebook
 http://cgi.nando.net/newsroom/ap/oth/1997/oth/m...7/mor60548.html

Armed with the knowledge that on the one hand there are hundreds of photographers, organizations, museums, collectors and hobbyists who own horse racing photos and on the other hand there are hundreds of markets who need a continuing flow of horse racing photos, you have the perfect situation to start a mini stock photo agency.

In the economy of yesteryear, the energetic entrepreneur would have been shot down on her first attempt at pulling all of these elements together. It would have been a Herculean task to find photographers all in one niche area. It would have been equally as tough to find enough markets for them.

Gathering a large enough photo collection and finding appropriate photo-buyers would have been only part of the challenge for your mini stock photo agency. There are the issues of storage, cataloging, distribution, fulfillment, market surveys and advertising. Without a healthy cash flow, the task might have been impossible.

Let's examine the advantages of the new digital economy and how it helps solve these challenges.

We've already seen how the World Wide Web will help you to find photo collections and photographers who could be interested in working with you to help them earn money from their photo collections/files. No postage, no phone calls to find this information. We've also seen how you can find photo-

buyers by effectively using search engines. No postage, no phone calls.

Thanks to E-mail, your postage bill for market surveying, promotion and advertising can be zero. And your promotion doesn't have to be limited to the unexciting limitations of E-mail. By using hyperlinks to pages on your Web site, you can get thought-provoking photos and colorful layouts in front of your visitors.

Further low-cost promotion is available to you by forming partnerships with other mini stock agency Web sites that don't conflict with your own.

If Web site construction and design become a cash problem for you, use what the financial world has used for commerce and trade since ancient times: bartering. Use your photography talents. Say to a Web page designer, "I've designed and built my Web page up to a point where now I need professional help. I'd like to trade you my services as a [wedding photographer, portrait photographer—fill in the blank] in return for your help." By allowing the Web designer a credit line on your home page, you can avoid some wallet-crushing expense.

There's no need to keep your agency photographers' original slides and prints at your location. Instead, you can do one of two things: (1) You can invite your photographers to send you their slides for a period of, say, a week. They will supply captioning material, on-line or on disk, keyed to each photo. You will scan the slides with your flatbed scanner (see page 226 for scanning info) and return the slides. (2) You can require your photographers to scan the slides themselves and send you the results, along with captions keyed to each image.

As you assess all this, you might ask, "Wait, why should I start my own mini stock agency? Couldn't I put my pictures with an already existing agency?"

You could, but some stock agencies are having a struggle changing their operations to fit the twenty-first century. For the average agency of the eighties and nineties, the process is proving cumbersome. Some stock agencies are merging with each other, others are dropping out, and others are waiting in hopes of being bought up by one of the conglomerate agencies, such as Corbis or Getty.

Putting your photos with a stock agency at this point might be somewhat like putting your canoe into a flash flood at night. No one knows right at this time where the analog stock agencies of the twentieth century are going or not going.

One thing is certain, as you read this chapter, more photobuyers are learning the advantages and benefits of the Web and more photographers are beginning to realize that they can profit by getting their images out into the Web marketplace.

Alan Carey, co-owner of The Image Works in Woodstock, New York, and former president of PACA (Picture Agency Council of America), recently advised up-and-coming photographers: "Getting into a major stock agency is not going to be easy for you. Selling generic pictures on your own will be

difficult. The best bet is to focus on a specialty and find a small stock agency that also specializes in that subject area."

So we're back to the question, Why should you start your own mini stock agency? A good reason is because there might not be any specialized stock agency that matches your photo-marketing strength area. Another reason is that you might not have enough photos in your specialty area to attract the attention of photobuyers. By joining forces with several other photographers, you could all concentrate on a field of interest that you enjoy and you can easily communicate, plus take advantage of what financial advisors call economy of scale.

By teaming together with other photographers, you not only find a common language to speak, but you also share talents and skills to benefit the group. Today's technology makes it just as easy to team with people across the nation as across the street.

Thanks to the World Wide Web, highly specialized mini stock agencies will be springing up all over the world. Photobuyers who themselves specialize in your particular niche, whether it be pediatrics, hang gliding or soccer, will know that shopping is easy when they come to your site. They'll be able to find a deep selection of highly selective images, directly related to their pressing needs.

If you wish to look further into more advanced techniques for your mini stock agency site, I've asked computer guru Crimson Star (who writes a Web column for the *PhotoStockNotes* newsletter) to expand on some of the technical points above. He will show you how to take a simple e-commerce site and transform it into a full-blown commercial site that is on a par with the large stock photo houses. You'll find this information on the Web at http://www.photosource.com/ecommerce3b.html.

For information about PACA (Picture Agency Council of America), the primary trade organization (with over 100 members) for stock agencies in the USA, http:// www.pacaoffice.org.

Anatomy of a Mini Stock Agency
The Web has made it convenient for stock photography entrepreneurs with an idea to get into business—quickly. Skye Chalmers and Peter Miller, New Englanders, saw the writing on the screen and exited from their commitments to The Stock Market and The Image Bank respectively to launch a mini agency of their own. Their target customers are clients at ad agencies, design firms and book and magazine publishers who are seeking images of the New England scene.

"We saw the major stock agencies increasing their fees and lowering commissions, and the number of images selected into their core libraries decreasing," said Skye.

"Some agencies are fighting for the 'Wal-Mart' position and are overlooking specific needs of the creative buyers and the producers of stock photography.

We are not attempting to compete against the large agencies; we are trying to start another aspect of the market. We believe staying small and unique can be to our advantage."

Their agency, which they call Yankee Images Inc., specializes in people, outdoor sports and New England landscapes. They also have images displayed as photo essays to add content to the stock agency Web site. For promotion they send out a monthly postcard and a quarterly catalog that feature a single photographer or a specific series of images. They keep their number of photographers to fifteen and actively promote their identities and styles. The Yankee Images Web site (http://www.yankeeimage.com) features a separate page for each of its members, who will be able to attract clients for assignment work.

"Automation has helped the giant stock houses in our industry, but the same automation can help us, too," said Skye, who, along with Peter, has an office in a converted farmhouse in rural Vermont. They use Mac G3s for their computer needs. The agency uses the HindSight software InView and Stock-View and interfaces them with its Web site. Their equipment includes a scanning lab (Agfa DuoScans), black-and-white lab and automated color processing. For high-resolution scans, they travel into town to the local service bureau.

Yankee Images requires exclusivity only on the photos accepted into the YI files and displayed on the Web site. The photographer receives a 50 percent share of sales made through the agency.

CD-ROM and RF Catalogs

USING CD-ROM TO DELIVER YOUR PHOTOS

The new kid on the block in the stock photo industry is royalty-free, or as some people say, photo clip art. All new kids do their best to fit in. The jury, as far as stock photographers are concerned, is still out on RF.

As it's been often said, "The only thing constant is change." Our stock photo industry is changing, and rapidly. A decade ago, no one in the industry would have believed that royalty-free—or photo clip art—would be accepted. Now, few people believe that it won't be accepted. The concept of royalty-free says that, thanks to automation and middlemen, it's easier to sell a picture a thousand times using the World Wide Web or a CD-ROM disc for one dollar than to sell one picture once for a thousand dollars. Photographers are separating into the "if you can't lick 'em, join 'em" or "no way Jose, not for me" lines.

Photobuyers are also polarized. Some say they will never use RF photos. "They are canned images—I don't want that kind of thing in my publication," says one photobuyer. "I'm not sure of the legalities involved," says another buyer. "If I use a picture as an illustration in a drug abuse article, will I get sued by the models—or their parents?"

There's also the problem of a periodical losing its uniqueness. On his Web site stock photo agent Royce Bair (http://www.inkjetart.com) explains, "Often, only one or two photos on each disc are usable, either because of poor quality or lack of variety. These same one or two images are used by everyone else who buys the disc. The result is that your photo-illustration's impact becomes diluted. It's not uncommon to see two products, i.e., two different book covers, using the same photo!"

It's Your Choice

Should you team up with a CD-ROM company that invites you to display your images on its disc? Should you self-publish your own CD-ROM? This chapter will give you background information on the emerging royalty-free/CD-ROM landscape. It'll help you decide if CD-ROM technology is an additional avenue to follow as you enter our Digital Age of photography.

The Changing Landscape

The traditional distribution model for standard commercial stock photography by a stock agency has always been that a stock agency receives payment for onetime use of a photo. For that price the photobuyer usually receives a history of the photo's former usage (as a managed-rights, royalty-controlled, or rights-protected photo).

In the royalty-free model, the photo may be used multiple times for a onetime fixed fee. In other words, there is no fee to the photographer for second use (and more) of the photo. Royalty-free photos are usually sold on CD-ROM or on-line sites. A buyer pays a onetime price for the disc of one hundred or more photos and can use the photos as many times as he wishes, paying no other fee. But a buyer, when choosing to use a royalty-free photo, has to accept that many other buyers will be using that identical image. Although this can be a disadvantage to some buyers, it is no problem to a segment of the market that in the past may not have been able to use traditional stock photography because of its high fees. Buyers who see royalty-free, along with its lower fees, as an advantage are corporate communication and multimedia sectors, small businesses and educational institutions, where there is a growing need for photos for presentations, Web sites and communication purposes.

Clip art photo companies are saying to the traditional stock agencies, "We're not taking away from your market (the traditional market); we are opening up a new market of photobuyers out there." That prediction certainly has come true, with lower-budget markets who never used photos for their projects before now able to afford to utilize photography.

But this doesn't come without its problems. As Jim Pickerell says in his book *Negotiating Stock Photo Prices*: "The high end user of photography will want rights control and they will want to know that their people images are properly released. Clip art photography cannot provide either assurance."

There will always be those buyers who require photos with a guarantee of exclusivity (for national campaigns, calendars or TV promotion), but there's no doubt that royalty-free/clip art is dramatically changing the landscape of commercial stock photography.

The first stock photography application of videodisc technology started in 1982, pioneered by First Vision in Newport Beach, California. Next came Video File. A little while later a major stock photo agency, The Image Bank, jumped in. None of these efforts ever really got off the ground, but they laid important groundwork.

By the late eighties audio CD-ROMs had become well established, and it didn't take long before entrepreneurs began to place sets of photographers' images onto CD-ROM, selling them at low prices. Thus was born the CD-ROM photo industry, later to be labeled photo clip art, and currently called royalty-free. The term *RF* was borrowed from the music industry, which had used *royalty-free* to indicate when royalties weren't required on certain records when played, for example, at an event or on a radio broadcast.

User groups on the Internet started buzzing about this new trend in stock photography and wondered if this new bombshell would pull the rug out from under the stock photo industry.

However, after a decade of CD-ROM activity, the stock photo industry is healthier than ever. According to studies, some of which PhotoSource International has participated in, traditional-use (managed-rights) photography hasn't suffered. Neither has the new upstart, royalty-free.

Royce Bair, head of The Stock Solution agency (http://www.tssphoto.com), offers this take regarding the impact of RF on the traditional stock industry: "Can traditional stock photography survive the onslaught and popularity of RF? I believe there will aways be a need for traditonal, 'rights-controlled' [RC] stock photography. RF has only done well where the imagery appeals to the masses. RF is only profitable if thousands of RF licenses are sold for each disc or each image. Unique imagery or niche subjects do not do well if marketed royalty-free, therefore it is doubtful if RF will ever invade those market areas.

"However, what is surprising is how RC stock is holding up even in the mass-appeal subjects. There is no doubt that RF stock has taken a big chunk out of each photographer and agency's 'generic' sales. [It's been about four years since we've sold a 'marble surface' image, and we used to sell those regularly for background usage at $300 to $600 per license.] Yet, despite this market erosion, we've been able to survive by setting up 'limited-use' RC pricing that closely mimics RF pricing, but still limits and controls usage rather than 'giving away the farm' [unlimited, forever and ever usage that comes with most RF licenses]. You can see an example of our limited usage, controlled license fees at http://www.tssphoto.com/prices.html.

"Many people rarely need to use an image 'forever,' but we still get resistance occasionally and receive calls from on-line clients who question why we are charging $100 to $180 for a limited use of an image when they can get 'the same image' from PhotoDisc for a little less and have unlimited use. We tell them to go right ahead [which usually surprises them, and they often reply, 'Wh-wh-well, i-i-it's not exactly the *same* image. OK, send it to me.'] The point is, that even with mass-appeal, traditional stock subjects, every image is unique, and there are many tastes out there. Often, a seemingly 'generic' image will have just the right elements or look that many clients are looking for, and a photographer should not buckle under to the pressure and sell himself or herself short.

"Mark Anderson, a photographer and a partner in RubberBall Productions [a royalty-free agency (http://www.rubberball.com)] is concerned about the 'saturation factor' in the RF market. He recently told me that he believes many RF clients are not repeat buyers like traditional stock photobuyers are. He is seeing many clients buy a few RF discs that fit their needs and just continue to use those same images. He says he is already starting to see RF sales start to flatten as the market becomes more saturated."

Partner or Enemy?

Clip art photo discs—are they good or bad? Yes, they are good or bad. My position maintains that clip art photo discs embrace only a certain mode of photography: standard clichés (beautiful scenics, for example). If you've been taking those kinds of pictures up to now, photo clip art discs are going to give you competition. If you haven't, you've got clear sailing.

Why? Because this ever-popular cliché style of photography is becoming "staticized" (new word). It's being cemented onto static polyester CD-ROM and DVD discs and other digital storage formats. Editorial photobuyers, however, more often need contemporary, noncliché pictures. If you have them, the buyers will come to you when they need them. And you'll be able to charge much more for your up-to-the minute, highly unique, noncliché images.

Who's Afraid of Clip Art Photos?

Seen any good clip art photos lately? Of course you have. They are the generic photos we see in trade magazines and travel brochures, in Web sites and catalogs, in ads and newsletters and office announcements. In chapter four of this book, I describe what now are called clip art photos, as Track A pictures. They're everywhere. And now that they've become more available, we're going to be seeing even more of them.

Does this affect your stock photo business? It could. It depends on the way you are doing business. If you are threatened by clip art photos, it's probably because you've been producing clip art photos all your photography career and haven't realized it.

Clip art photos have a parallel in the music industry. When recordings were introduced first on vinyl 78s, then 45s and eventually on audiotapes, each successive wave brought predictions of gloom and doom to musicians. The threat, it turned out, was not to musicians but to the way they were delivering their music. Musicians either got out of the business or changed their delivery methods.

Clip art photo discs can offer photographers a means to reap extra income from their excess stock photos—photos that otherwise might be gathering dust in a shoe box or sitting on a tray in the studio, waiting since last October to be cataloged. As photographer David Brownell from New Hampshire says, "I think the stock photo agencies of the early nineties did a good job of letting in photographers who had the highest quality work and rejecting those who did not.

"But there were a lot of photographers who had good work who did not get in. A few photo marketers realized this, and at the right time they started royalty-free photography image sales.

"It's all supply and demand *and* there is a great supply of good images!" says David.

Should we ban clip art photos? Photography is communication. In the last century, photography was perceived as an art form. Today, it's taking a role

in our society as a communications tool and is becoming as important and as pervasive as the written word. Back in the Dark Ages, written words were confined to monasteries. The resulting lack of education and communication opportunities set learning back hundreds of years throughout Europe. No, we should not ban clip art photos. To restrict the free flow of photos today could result in a similar far-reaching impact.

Clip art photos needn't be a negative dimension in the stock photography field. We shouldn't be afraid of clip art photos; even though they may take away part of a market you once enjoyed. You can regroup. Who's to say some other type of photography might not have done the same if clip art photos hadn't come along?

As David Brownell said, there was a lot of it around, and it had to find a good home somewhere. The only thing consistent in our industry is change. There's room for clip art photos. You may not choose to join their ranks. But there are other photography avenues emerging for you to choose from, thanks to new technology.

Looked on with an open mind, clip art photos open up a new form of communication for many editors, graphic designers and art directors who, in the past, never considered photography as one of their communicative options because the cost of photography was out of reach of their budgets. Now thousands of art budgets will include photography thanks to the fees and speedy delivery system clip art photos provide.

The Major Difference

Opponents of clip art photos usually make a distinction in their assessment. On the one hand, they declare the lower-priced clip art photo discs ($39.95 and lower) as inferior and not worthy of stock photography. On the other hand, they assess high-end discs ($250.00 and up) at high value. In reality, both types of discs contain typical Track A pictures. The major factor that differentiates these clip art discs is their technical quality.

High-end clip art discs are usually produced by industrial-strength flatbed scanners or by drum scanning (equipment cost: $50,000 to $150,000), and the quality of these machines can substantially shortcut the production process, saving the photobuyer hundreds of dollars. Low-end discs are scanned on low-end equipment. The resulting images usually can't be used larger than a quarter-page, or are used in projects for which professional reproduction quality is not paramount (newsletters, brochures, Web sites, etc.).

Just What are Clip Art Photos?

In my opinion, clip art photos are of the same genre as clip art, the cookie-cutter drawings and universally accepted sketches that can be clipped from a clip book and pasted into a paper print layout. Clip art photos are convenience photos. They are always politically correct. Whether they come in the form of

royalty-free image collections or drum-scanned images or come on-line, they can be called clip art photos.

There are currently three echelons of companies that produce clip art photos: the majors—Digital Stock, PhotoDisc, Comstock, Tony Stone Images, Stock Workbook Disc, The Black Book, Agfa, Westlight, The Image Bank, Visual Comm Group, The Stock Market, Corbis, Getty Images, Superstock, Artville; the middle-ground companies—Educorps, Corel, Master Series, Seattle Support Group, Direct Stock, West Stock; low-end companies—usually small enterprises that market to low-budget publications and art buyers.

Who's Using Them?

Everyone uses clip art photos. People have been using them since before clip art photo discs were created. A mountain or a cloud is a mountain or a cloud, whether it's on a postcard, on a calendar, on a clip disc or in an agency catalog. In magazines, clip art photos usually reside in the advertising section—rarely in the editorial section. Have you looked at a newsstand magazine or a book recently? You'll find an occasional clip photo, but not many.

And why don't editorial art buyers use clip art photos? Because of the specific nature of their special interest areas. Eagles don't fly with butterflies. Blatant clip art photos would detract from the uniqueness of their books or magazines that they wish to convey to their readers.

Most users of clip art photos are medium to small publishers and medium to small ad agencies and graphic houses.

To argue the aesthetic quality of clip art photos is not necessary. Photobuyers don't buy photos because they *like* them; they buy them because they *need* them. Value is in the eye of the beholder.

SELLING TO THE CD-ROM MARKET—AN INEXPENSIVE MEDIUM

The dream of setting up a Web photo gallery and watching the checks roll in isn't the only enticing scenario for stock photographers that's sparked by the ever increasing flurry of digital activity. Another is the dream of placing one hundred of your photos on a CD-ROM and sending it off to a photobuyer who declares, "Thank you! You've saved me hours of photo searching, plus hundreds of dollars of prepress charges."

But here are a few dream stealers: (1) Most photobuyers in the editorial market aren't yet equipped to receive images via CD-ROM. (2) With those who are equipped, with the exception of Kodak Photo CDs, too often the equipment in their production departments or at the printers isn't compatible with the discs you send them. There are no standards as yet with regard to digital delivery methods. (3) Photobuyers aren't interested in seeing your disc unless you are highly specialized in one area (the area they need) and can come up with one hundred blockbuster photos in that specialty area. Why? Too many high-quality, royalty-free generic discs are now available for buyers to choose images from, at a very low cost. (4) Producing the images on a CD-

How to Identify a Clip Art Photo

Here's a test to tell if it's a clip art photo.

1. Using a tripod and similar lighting and models, could you (with some trial and error) reproduce the same scene or situation?
2. Cut out the published photo and paste it in a stock photo catalog. Does it blend in with the rest of the images?
3. Compare it with the images on a royalty-free CD-ROM. Does it blend in with the rest of the images?
4. Does it look contrived, manufactured, too good to be true, artificial or politically correct?
5. Can the same photo be produced by an amateur with professional equipment?
6. Does the overall effect appear to be an artistic fabrication?

If you answered yes to any of the above, you're probably looking at a clip art photo.

ROM is one task, but packaging it is another roadblock. Unless you package your CD-ROM in a format and design that can compete with the above-mentioned RF competition, your submission will be regarded as substandard.

The New Way

If your stock photography is centered on a few specialty areas, however, you *do* have the opportunity to start capitalizing on the developing CD-ROM technology. Here's how.

While most photobuyers in the editorial field are still not prepared to utilize CD-ROM submissions from you, a few phone calls to your select markets will reveal some of them who have "just last week" become computer literate. The new assistants they hired have grown up in Nintendoland and have shown the buyers how simple it is to acquire images from CD-ROMs.

Let's take an example. Say one of your specialty areas is aviation and a subspecialty is antique airplanes. You have a market list of thirty-six photobuyers in those areas. Phone calls to them reveal that eleven of them are somewhat familiar with CD-ROM technology.

On a standard CD-ROM, you'd be able to put thousands of low-resolution thumbnail images. Or you could choose to use Kodak Photo CDs, which take only one hundred images but have the advantage that each of your images will be produced in five different sizes. This will give the buyer a choice when selecting dots per inch.

Since most publishers and printers are familiar with Kodak Photo CDs, you decide on that format for your first project. You cull together one hundred of your best shots and take the 35mm transparencies to a local Kodak Photo CD service bureau. Caution: Like film processors, CD-ROM and Kodak Photo CD service bureaus vary in competence. Get feedback from other local photographers to find out who produces quality discs.

The average cost for a master Kodak Photo CD disc for one hundred images will be around $100. Each image will be numbered one to one hundred.

Using your color printer, make an 8½″ × 11″ mini catalog to accompany the discs you send to buyers. Use Photo CD numbering plus the picture number from your original slide.

Rather than invest in jewel boxes for packaging, buy the heavy plastic pouches available at discount office supply houses, such as OfficeMax. You'll also want to buy precut self-adhesive disc labels. On your computer, design the wording for your label, and use one of your antique airplane images as an illustration.

Prearrange with your photobuyers that you will be mailing them your discs. Package each disc in a white mailing carton available at an office supply store or from Mailers at (800) 872-6670. Put one of your disc labels on the white mailing carton, and put the whole thing in a Priority Mail envelope, the kind you can send off for $3-plus.

Be prepared to handhold the photobuyer on his first attempt to call up your images.

Even if your buyer has smooth sailing in using your disc, the print house that produces his publication may not be knowledgeable in handling Kodak Photo CDs. If it isn't, you may find yourself sharing your knowledge with the print house.

Consider providing buyers with CD-ROMs for their permanent files. This is a system of delivery of CD-ROM photo discs to engender sales (see "Will They Steal Your Scanned Images?" on page 126 and "Repeat Business" on

Stick With Your Specialty Areas

CD-ROM technology lends itself well to editorial stock photographers who focus their work in select specialized areas and want to put their specific subject areas on discs.

There are two reasons why. First of all, remember that the average-size publishing house spends about $40,000 per month on images. Publishing houses are usually specialists themselves and need to buy from photographers who can supply them with images in their highly specialized areas. Secondly, CD-ROMs that are filled with general pictures on a variety of subject areas, as opposed to specialized discs, require sophisticated CD-ROM software to search for specific subject matter. Most publishing houses don't have this kind of software and search procedures yet. So if your photos are all in a select category, it eliminates the need for search software and your photobuyers can utilize your "specific coverage" discs.

Stick with your specialty areas and you won't find yourself in competition with the major stock photo conglomerates that feature millions (not hundreds) of generic CD-ROM images, all of which need sophisticated searching software.

Note: Kodak Photo CDs come with software called Access, which allows the viewing of thumbnails of all images on the disc. Adobe Photoshop and Microsoft Publisher can also view Photo CDs, but one image at a time, not several on the screen at once.

page 208). This system is similar to the permanent-file system that I espouse in my book *Sell & Re-Sell Your Photos* in which the photographer leaves a supply of photos on file at the central art library of a publishing house so when art directors are in a bind and need a quality filler for a page layout, they choose an image from this permanent file.

The advantage of CD-ROM delivery for this purpose, of course, is that because the image is already in a standard digital format, the publisher can save hundreds of dollars by avoidance of separation costs. Many print houses have now switched to digital prepress production, so there's no doubt that in the future, many purchase decisions will be based on the answer to the question, Is it already in digital format?

How to Establish Your Own CD-ROM Service

Freelance stock photographer Lori Lee Sampson of Minneapolis has been using Kodak Photo CDs to her advantage. One of her photo specialty areas is cats. She was recently approached by a publishing company producing an encyclopedia on cats; the publisher wanted to see all of her best cat shots.

"I have around 260 great pictures of various breeds," said Lori Lee, "but I wasn't enthusiastic about sending my originals to a company that I wasn't familiar with. A loss of that group of slides would put me out of business."

Lori Lee inquired and found that the company was versed in CD-ROM technology and could accept the Kodak Photo CD format. After exploring around the local stock photography community, she found out which service bureau got the best grades in Kodak Photo CD production. She placed the 260 images on three discs, made distinctive labels for her discs and sent them off to the publisher. The total cost for the venture was around $300.

"I'll reap several advantages from this project," says Lori. "Even if the

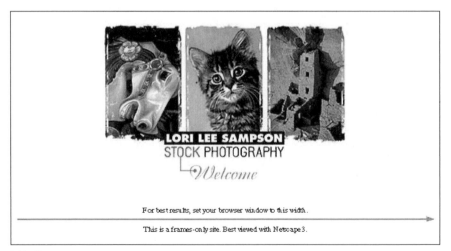

Lori Lee Sampson

company purchases only 10 out of the 260 images, I'll still be ahead. Plus, I now have a digital record of all of my best cat images and won't have to send originals off to other publishers who can accept work in digital format. I'll be able to E-mail images for potential clients to review, and I'll be able to keep my originals safe at home."

The Next Stage

As more and more photobuyers join the digital revolution, CD-ROM delivery will become more popular. You'll be able to send duplicate discs of your specialized selections of photos to the choice photobuyers on your market list. Right now to get duplicates of one hundred images costs around $60. We can expect to see that cost come down as more and more CD-ROM-producing companies start providing services.

The questions are now asked, "How long will this CD-ROM system be around? Would I be investing in technology that will become obsolete?" The answer to the second question, as you might guess, is yes. But as the saying goes, "Nothing ventured, nothing gained." Already there are new and faster digital transfer and imaging systems on the horizon. But who knows when they will become practical, inexpensive and universally accepted by the stock photography industry? Right now, the Kodak Photo CD system is practical and continues to gain in popular use. Until something better comes along, conventional wisdom says stick with what works.

Here are three additional resources to help you sell to CD-ROM markets.

Repeat Business

Car dealers do it. Grocery stores do it. Banks do it. They cultivate their customers to come back again and again for repeat business. Each of them figures out a way to keep you as a happy *repeat customer.*

As a stock photographer, how can you do this, too, with your buyers, and avoid the "one sale only" blues?

Easy answer. Establish yourself as a specialist in your photo interest areas, develop extensive photo coverage in those areas and find publishing houses that focus on those subject areas. That'll mean you direct your picture-taking excursions (for your "for sale" photos) to cover photo needs for publishing houses whose focuses match your specialty areas.

CD-ROM technology offers you an opportunity to put hundreds of your specialized photos on discs and place them at the central art libraries of the publishers on your market list. You have the choice of either selling the discs to them or giving them away free. Only *you* can make that decision, based on previous sales to the publishers and your working relationships with them.

My recommendation would be to use the time-honored "risk-reversal" approach in this situation. That is, *you* incur the cost of the disc and give it away. Repeat future sales will more than cover the cost of the disc and software. Plus, you'll become one of the companies' star suppliers and they'll remember you when it comes time for assignments.

(1) For a thirty-five-page catalog of CD-ROM drives, recorders and mastering systems, contact APS Technologies, 6131 Deramus, P.O. Box 4987, Kansas City, MO 64120-0087; phone: (800) 374-5688. (2) If you plan on producing a CD-ROM, or placing images with a CD-ROM production company, refer to the list of CD-ROM companies on page 230 in Resources. (3) For a catalog of clear vinyl pockets for CD-ROMs, contact Visual Horizons, 180 Metro Park, Rochester, NY 14623; phone: (800) 424-1011; E-mail: info@storesmart .com.

WILL ROYALTY-FREE TAKE OVER FROM TRADITIONAL STOCK?

The battle cry these days among the commercial stock photo agencies who consider royalty-free stock photos a menace is that to combat this threat the single-use stock agencies should figure out a way to create a differential between themselves and the RF companies. The aim of the stock agencies would be to make a distinction between royalty-free clip art and single-use commercial stock photography.

Is that possible? How can you differentiate commercial stock photos? Have you seen commercial stock photography catalogs lately? They contain the same standard subject matter as royalty-free discs. There's so much cloning among stock catalogs and RF discs that the photos appear to be manufactured from the same assembly line. An objective viewer would find it difficult to differentiate between what could be called clip art on a royalty-free disc and what is called single-use commercial stock photography in print catalogs.

Clever Merchandising

As time moves along, it's likely the difference between a royalty-free company and a commercial stock photography agency will be in the *label*. Nike knows this. Pepsi knows this. Nordstrom knows this. You can charge three, even ten times the value of a product if the buyer perceives an exclusive value in the merchandise. If an art director can convince her boss that it's better to go with a single-use stock photo (and pay ten times the RF fee) than use an RF photo and risk possible model release problems or the chance that a competitor may have previously used the same image, all parties are happy.

A clever merchandiser of traditional stock photos will emphasize that he can guarantee the exclusivity of the photo and provide uniqueness, trendsetting value, the name recognition of the photographer, image history, usage information, caption text and special rights. The merchandiser will also guarantee that the buyer will have a face and a name at the agency who is accountable and accessible. An E-mail address just doesn't cut it when you're five hours before production and a problem comes up.

In the history of stock photography, up to this point there's been no such thing as bare-bones royalty-free photography. All art buyers went single-use "pampered-class." This is much like the early days of the airlines when every customer went first class, which included fine cuisine and attentive steward-

esses. But now, many commercial stock agencies are beginning to ask themselves, Do we want to offer all of these labor-intensive frills or just sell images? They see an opportunity to jump on the RF bandwagon but face the dilemma of deciding which of their photos they want to offer as RF and which to continue to sell in the traditional mode.

The Hard Sell

Used-car salespeople and Madison Avenue hucksters are familiar with the sales pitch we recently received in the mail:

> Don't be fooled by inferior images, cheap clip art, or the high cost of stock libraries. Order a $19.95 Starter Kit, product catalog, or purchase any QUALITY Series CD volume—all for less than you'd pay for a single-use image!

Get ready. We are going to see more and more price-cutting in the RF arena.

The commercial stock agencies would like to have it both ways. But they can't. Pepsi-Cola can't sell a full-priced Pepsi and a half-priced Pepsi from the same store shelf unless they are labeled differently. As major stock agencies such as Corbis and Getty Images begin to move into the royalty-free field, the differentiation won't come based on the asthetic quality or content of the picture, but on whether Getty and Corbis want to become discounters and offer creative labeling to their clients.

Can a commercial stock photographer differentiate between herself and the discounters by offering pampered class to her clients? Texaco faced competition with discounters a decade ago and figured the general public would elect service over the new discounted self-serve gasoline stations that were competing against Texaco. Texaco dressed its attendants in clean uniforms and smiling faces and rewarded customers with bonus gallons if "we don't clean your windshield." It didn't work. Gasoline is gasoline, and if customers can get the same product cheaper, they'll take it. A rose is a rose is a rose . . .

Texaco no longer emphasizes service.

A Lesson in Economics

Traditional single-use commercial stock photography, in the model that we know it today, in my estimation, is doomed. (Remember I'm talking *commercial* stock, not *editorial* stock photos.) And not because Getty, Corbis et al. will engage in price wars—but because of a more important tenet in retailing that says, "If you want to live with the masses, appeal to the classes. If you want to live with the classes, appeal to the masses."

RF appeals to the masses.

Anyone attempting to sell photos based on clever label merchandising that appeals only to the classes can expect to live where Mark Getty and Bill Gates *don't*.

A second reason traditional single-use commercial stock photography is doomed is that history shows the company that achieves the classic economics formula, m = c + v + t (market share = cash flow + volume, inventory, product line selection + technology, automation, speed, service), will prevail over its competition and control prices.

Editorial Stock Photography

Editorial stock photography is a different ball game. All of these changes bode well for the individual editorial stock photographer. The situation takes a different tack, since editorial stock photographers work in a vertical market (selling single-use, content-specific images and working in volume with close-knit special interest clients), not broadly across the board as with RF or commercial stock. So editorial stock photographers are spectators in the battle now roiling in the commercial stock photography field, where royalty-free will soon become a primary source of choice for *commercial* images among art directors who don't mind using manufactured photos.

No, Thank You

Many stock photographers are not enamored with royalty-free clip art photos. Like they do with the weather, many complain but few take steps to assure they won't be affected by it.

Here's one photographer who took a good look at clip art photography, said, "No!" and then went out and did something about it for his own stock agency business.

In August 1997, Joe Viesti and his wife, Diane, packed up their stock agency's collection of over 700,000 images and moved from the canyons of Manhattan to the mountains of Colorado. They'd had a second residence in Colorado since 1993, and when their landlord sold their Upper Westside townhouse, which served as both home and office, Joe felt ready to leave the city. After twenty years in The Big Apple, and hitting the big 5-0 in age, the time was right. Joe rented a warehouse in Colorado for fulfillment of his catalogs and other products. Thus, despite a move of over two thousand miles, the transition took place without missing a single photo submission. (The files were sent by FedEx over a three-day weekend.)

Joe's move to the Rockies was energized by the realization that the advance of royalty-free images on the horizon might doom the traditional-style stock photo industry. He says, "At no time did I consider taking the royalty-free path, as I feel that for me it would be hypocritical. I just can't tell our agency photographers that we will do our best to generate royalties for their work, and out of the other side of my mouth offer the same work for the onetime, typically quite low fees of royalty-free."

Instead, he decided to engineer a new career direction and publish images from the various stock files of the photographers in his photo agency in wall

and engagement calendars, note cards and mouse pads. He was in for a pleasant surprise. This new division would become a major additional outlet for his agency's stock library.

"I'm My Own Client Now"

"We've become our own best client," says Joe. "I'm enjoying taking the raw material of images and seeing them develop into useful products for people. In 1995, we started with just four calendars. We now have nearly one hundred products, and work with twenty-four sales rep groups (over 120 reps), in the book, gift and stationery trade, domestically and internationally. Our products are sold in The Kennedy Center in Washington, The Asia Society, the Smithsonian, the Museum of Natural History and hundreds of independent and chain stores throughout the country."

Joe's personal hallmark specialty area is festivals, and he has photographed over 200 events in 104 countries for his festival calendars. He's offering two wall calendars for 2000 (Fiestas, bilingual in English and Spanish, and Sacred Places Sacred Monuments) as well as a fifty-two-week engagement calendar featuring photos from 100 countries and listing over 1,000 events. This will be called The Whole World Is Celebrating 2000 and is being copublished with Barnes & Noble.

All of the products can be viewed on Joe's Web site (http://www.theviesticoll ection.com). "We're very proud that we have sustained the increased volume of work which appears in our published products, exclusively from the files of the photographers in our agency. We have no plans to deviate from this strategy," says Viesti. Also, Joe employs the marketing technique of using his calendars as promotional tools for his stock photo agency.

Clip Art Be Gone

"I offer clients a calendar of their choice," says Joe. "In this way, we're confident that our stock photo images will be hung in their office. We get many stock photo requests directly from the calendars."

In the beginning, profits from the photo agency were used to initiate and bolster Joe's publishing division. No longer. The publishing division now stands on its own feet, and the resources of the photo agency have returned to producing digital and print catalogs. Thus, the two divisions enhance each other. "And the beauty of the whole thing," says Joe, "is that it is not only a real kick taking our images all the way through to finished products, but we haven't had to sell our souls to clip art or royalty-free images.

"When we first moved out here, we weren't sure if we would lose some of our clients or not. But they all seem to still keep coming back," he says. "Without computers and new digital innovations, I don't think we could have done it. And with overnight and on-line delivery, it doesn't matter where you happen to live."

A Way of Life or a Way of Death

When Philip II of Macedon married the teenage bride Cleopatra, it wasn't for romantic reasons; it was to acquire the biggest and best breadbasket of the world, the fertile wheat fields of Egypt.

In a somewhat parallel move, Getty Communications—formerly of London, now of Seattle—has entered into matrimony with the successful clip art photo company PhotoDisc, also of Seattle. ("Please don't call us clip art," a PhotoDisc representative told me. "Call us royalty-free.") I've talked with a number of stock photographers and stock agencies to get a feeling for the impact they sense this alliance will have on the commercial stock photography industry as a whole. Most of the photographers I contacted felt that the Getty-PhotoDisc merger will be a positive move for commercial stock photography. (Note: Editorial stock photographers are not affected by the gunfire and battles waged by the commercial stock photo community. Editorial buyers make up a different segment of the market, and editorial photographers have the luxury of being observers of the clip art scene.)

Alan Klehr, writer-photographer from Chicago, says, "The world of commercial stock is changing so fast we can only fasten our seat belts and enjoy the ride." He welcomes the alliance of Getty and PhotoDisc, "if only to insure that the commercial stock clip art business is run in a professional manner and won't intrude on the traditional stock agencies."

A photographer from Los Angeles agrees: "This is a very sharp move on the part of Getty—if they can control the advertising of PhotoDisc in order to greatly differentiate clip art from traditional stock in the minds of photobuyers. If they show buyers that they basically get what they pay for, quality-wise and exclusivity-wise, I believe Getty can decrease the threat that clip art poses to stock agencies and stock photographers."

Some photographers see Getty Images acting as Big Brother, holding a big stick and pronouncing to the world that picture A is a clip art photo and picture B is a traditional stock photo. Those photographers are also candidates to purchase oceanfront property in Montana. It's really just wishful thinking to harbor the idea that there's a distinction, content-wise, between clip art photos and traditional commercial stock photos.

Getty Communications knew from the beginning that automation is today's key to financial success in the commercial stock photography field. "Digitize everything! Database it! Cyberspace it! Automate it! Let the customers view it/choose it/order it! Photos for sale. Untouched by human hands." That's the battle cry in London/Chicago/Seattle.

Dennis Cox of Cox Photography in Ann Arbor, Michigan says, "Automation is a much more cost-effective way to sell generic stock, as it requires fewer employees and lower overhead."

Thus a future representative of Getty Images will arrive at a photobuyer's shop (small or large ad agency, publisher, university, museum, library, corporation,

etc.) with a suitcase of DVDs filled with the entire Getty Images library. "Keep them as long as you wish. We'll update you monthly on-line with a new supply."

You Can Automate, Too

But automation doesn't have to be the dominion of solely the giant stock photo agencies. As an individual stock photographer working in the editorial field, you can automate also. See "How to Establish Your Own CD-ROM Service," page 188 and some examples of web portfolios in chapter two which are blueprints on how to begin to automate your own editorial stock collection.

The Dissipation Factor

We have another reality: supply and demand. Right now, the supply of generic clip art photos is plentiful. They are not in the elite photo catalogs that sell 80 percent of rights-protected commercial stock photography today. Yes, there's enough generic stock photography available presently and there will be more to come as more rookies join the ranks and swell the photo supply houses world wide. Will this diminish the quality of commercial stock photography?

It looks like the stock industry will experience the same phenomenon that major-league baseball has. The expansion of baseball leagues has created a shortage of quality players. There are just not enough quality players to fill the rosters of all the professional teams. The teams have to continually dip into the minor leagues to fill their lineups.

The same phenomenon is happening in news magazine TV—programs such as *60 Minutes, 20/20, Dateline NBC* and other wanna-bes. As these news magazine programs become more plentiful, the supply of top-notch stories diminishes. It's a lesson in economics, and stock photography is not immune.

Another factor comes into play here, too. As the body of knowledge increases in any profession, it takes a longer time to find specific information. Also, the information becomes outdated very quickly. Massive clip art photo agencies will have to address that reality, as photo researchers begin to realize that the shelf life of a commercial stock photo is short.

The Getty Images Advantage

Getty Images has a trump card with its new alliance with PhotoDisc. Much synergy will come from not only the pictures Getty has electronic rights for but the synergy that happens when those images are combined into completely *new* images. These new images belong to, guess who, Getty Images. According to the Copyright Act, if sufficient "authorship" is invested in the remaking of an image, the copyright of this new composite belongs to the remaker. With millions of images to work with, Getty Images can conceivably invent new pictures exponentially and own every one of them. Most other commercial stock agencies don't have this capacity.

And the Tony Stone Photographers?

What will this do to photographers who presently have their stock photos with Tony Stone Images (TSI), the stock agency that holds the bulk of Getty Images' traditional collection? Heaven knows, or maybe the devil knows. Or maybe you know. Would you want to continue submitting images to a company that sells them for peanuts, except in some rare case in which a buyer might want to know the history of the picture or obtain exclusive rights to it? If you are a photographer who has become dependent on some large stock photo agency to sell your pictures, better take a long look at the principles set forth in this book on how to market your photos yourself. You may best be served by learning how to establish your own mini stock agency that sells editorial stock photos to a vertical list of buyers who are waiting for your creative talents at this moment as you read these lines (see chapter nine). The writing is on the screen: Traditional commercial stock photography is being transformed. Clip art photography, for commercial buyers, is the medium of the future.

And, Editorial Stock Photos?

While clip art photos were introduced back in 1991, we here at PhotoSource International have not seen a drop in requests for content-specific photos. Our marketletters continue to go out on fax and E-mail. Buyers continue to need up-to-the-minute fresh editorial photos that don't have a manufactured look to them. Rather than choose an $0.89 picture from a clip art disc, the midrange budget publishers continue to pay $50 to $75 for onetime use, and the high-end publishers pay $100 to $225 for single usage, for distinctive editorial stock photography. And the photographer receives 100 percent of the license fee.

The buyers of editorial stock photography will continue to look to independent freelancers and buy photos on a person-to-person basis. That system fits their needs for content-specific photos.

The Times—They Are Changing

PhotoSource International's marketletters have always recognized that many midrange publishers do not have the budget to acquire high-end photos from major stock agencies. When I introduced our *PhotoLetter* and publicized the photo needs of photo editors who could pay $20 and $25 per photo, I was maligned by the stock photography community. Times have changed. Now, even major companies such as Corbis are allowing their photos to be used for low-budget publications.

Bahar Gidwani, owner of Index Stock Imagery, recognized early on that "everyone needs photos" and established a section of his business called Photos to Go, aimed at personal and small business buyers.

For personal buyers, he publishes ten suggestions on ways to use photos.
1. Illustrate your thoughts. Are you sad, mad or bad? Write about it and search for pictures of people who share your feelings.

2. Make a collage for your room. Or frame it and send it to your grandmother.
3. Sharp visual communication for your Web page! Avoid bland icons or symbols. Use a picture as an icon or button.
4. Send a birthday E-card. It's fast, simple, and gets the point across. We've got some great images for birthdays and other holidays.
5. Keep up with the Joneses. Make your yard sale flyer the best on the block.
6. Make a place setting or gift tag. Download pictures of cute dogs and cats, country homes, food, or other pictures you like. Then just cut out the particular images you want from the picture. Paste the image onto a piece of thick paper or cardboard and you've added an original touch to your gift or place setting.
7. Create wrapping paper by printing out a photo of a cool pattern. It's a great way to give a personal touch to small gifts like jewelry.
8. Make a screen saver.
9. Create an invitation to a birthday, holiday event, wedding, or theme party.
10. Make a face mask. Our customers love them for parties and holiday events.

And for small businesses, here are his ten suggestions.
1. Spruce up a brochure.
2. Improve the look of your Web site.
3. Add images to a company newsletter.
4. Use photos as icons or symbols instead of graphics.
5. Are you creating your own advertising? You'll definitely want to include photos.
6. Media kits.
7. Sales kits.
8. Direct mail campaigns.
9. Power Point presentations/Tradeshows.
10. Use a photo to grab your customer's eye in a postcard or customized holiday greeting card.

Photography is becoming the second language for people worldwide. Royalty-free photos will play a major role in that communication process, and I've predicted difficult times for rights-protected, single-use commercial stock photography. Bahar Gidwani, however, sees its future differently. He has confidence in the staying power and continuing demand for traditional commercial stock.

He says, "Despite the presence for years of the stock photo industry, most commercial photographers still make money from assignment work. Further, many of these use the services of an assignment representative, to market their services. While some photographers gripe about the decline of the assignment

business, others are buying bigger cars and nicer houses. . . .

"In the same way, traditional stock image licensing should continue to provide solid earnings for large numbers of artists for many years. A well-run stock agency should reserve certain images for the 'managed rights market,' while dedicating others to the royalty-free market. Even better, agents could and should allow images to be seen in both markets side by side. In that way, a royalty-free buyer can see what he or she could get by 'trading up' to rights-managed images, and a managed-image buyer could see how much can be saved in the RF market. The secret to this type of system is to make all of the images available on-line. Both catalog-based traditional licensing and RF CDs are obsolete when compared to the speed, convenience, and comprehensive image selection of the major on-line sites.

"Another way of looking at this is from the artists' perspective. An artist benefits from having someone else take care of the licensing and marketing issues that arise from this shift towards a single marketing presence. By pushing these mundane tasks onto an agent, the artist keeps his or her time free for creating more and better material for all of her or his licensing activity. As long as an agency can create value for an artist, it will be needed. Therefore, I expect to see more and more agencies return to a proper focus on serving their artists."

LEGAL PROBLEMS WITH ROYALTY-FREE— DO YOU HAVE IRONCLAD MODEL RELEASES?

A major problem with the royalty-free industry is that the photographer, and even the publisher, loses control of how such an image is eventually used.

If the image is used for an editorial purpose, a model release is usually not required, unless the particular editorial usage involves sensitive areas, such as drug abuse, child abuse, mental retardation and so on. In such cases a model release would be required.

For commercial use (and most clip art is used in this category), a model release is *always* required.

Numerous lawsuits have been springing up involving RF images; the persons in photographs have found themselves pictured in advertisements or other promotional uses. They have objected, and with good cause, especially if the ads or usages have embarrassing connotations.

The plaintiff's attorney usually goes after the entity that has the "deepest pockets." This could mean the client, the ad agency, the publishing company, the photo clip art publisher or the photographer (usually in that order).

A recent lawsuit involved the forties movie star Hedy Lamarr. Her picture (a drawing) was put on the front cover of a CorelDRAW software box, without her permission. She sued Corel Corporation for $15 million, according to *The Wall Street Journal*. Lamarr sought royalties on certain CorelDRAW sales, punitive damages and compensation for emotional distress.

When the stakes get high, the defendant's attorneys usually attempt to dis-

www.phototogo.com

credit the plaintiff. In this case, in an attempt to suggest Lamarr's image was not worth $15 million, the attorneys reminded the judge that Lamarr had a "criminal past," citing an old shoplifting charge. The parties settled for an undisclosed sum. Corel will continue to use the image on its software box for the next five years.

Lesson: If you expect to self-publish or to get published on a photo clip art disc that will be used for commercial purposes, be sure to get ironclad model releases, meaning that you outline the specific ways the photo might be used. If you are publishing a disc that will be sent to editorial markets, be sure your attorney has included a disclaimer that is included both on the disc and in the accompanying promotional material, spelling out that the images are to be used for *editorial purposes only*. Any commercial use of the images would require a special license.

Paula Berinstein, author of *Finding Images Online*, points out that in the real world, persons using royalty-free should be aware of these cautions.

A. Royalty-free images claim to carry model releases, but you can still potentially violate a model's rights if you use a picture in a negative or defamatory way.

B. Watch out for the term "moral rights" in image licenses. Even if you see

no such terminology, be careful about using images of people in depictions of controversial issues like abortion and politics.

C. Don't go by what customer service people tell you. Go by the printed license.

D. Royalty-free does not necessarily mean you can do anything you want with the picture. Check the license. You may be surprised to find that your purchase price affords you some rights, but not others.

An Easy Remedy

As we move further into the Digital Age, we are going to find that ironclad model releases will not be the major problem that they appear to be in today's world of clip art stock photography. In the future, clip art photos will contain "generic faces" and bodies that cannot be identified as anyone you know. Software already exists for use by moviemakers that allows the artist to substitute a different face or body angle on the pictured models. Expert computer artists can accomplish this with software such as Photoshop.

Photo clip art by itself is not documentary in nature. We expect, as viewers, that the images portrayed are not real. We expect that the sky has artificial clouds, and that the colors worn by the models are not really as bright as they appear in the photo. It will be only a short jump from reality to fantasy when photo clip art companies make it mandatory to submit images that are graphically altered and require no model releases—because the persons pictured do not exist.

Watch Out for These Pitfalls

What are the pitfalls you, as a small business person, should be aware of? Whether you place your images with a traditional CD-ROM production company (see "Resources," page 229 for a list) or self-publish the product, here are some issues to consider.

The Better Business Bureau Issue. I hear grief stories from photographers about CD-ROM companies that have tied up a photographer's images in court for a long period of time. It goes like this. A fledgling CD-ROM company puts its money into slick advertising and attracts a good number of quality photos from participating photographers. These images are given to a production company to make the discs. About midway into production, money runs out. The production company wants its money before it will release the finished discs. Your images are unavailable to you while the court proceedings spin out. Lesson: It's a compliment to have your images selected by a CD-ROM company, but make sure the company's cash flow can get it through the fulfillment stage of the business plan.

The Model Release Issue. Placing your photos on a CD-ROM without ironclad model releases for them is an invitation to trouble. Because many producers do not outline the use limitations of CD-ROM pictures to customers, and because final end use of images on a disc is not able to be controlled, a

photographer could be the target of a legal suit if, for example, a picture of his models were used in an advertisement about child abuse or some other sensitive issue. If you already have made a deal with a CD-ROM producer, it would be in order to find out how the "fine print" reads. It might be necessary for you to either withdraw your images or get a more encompassing model release from your models.

The Give 'Em What They Want Issue. Do you plan to design and produce your own CD-ROM catalog? Most art directors and photobuyers open their mail above a wastebasket. If your CD-ROM package does not conform to what they consider a professional presentation, they drop it into the circular file.

Is your packaging inviting and well conceived? If it's not, the viewer may never look inside. The design, layout, text and cover image should reflect the quality of your photos.

Checklist: Finding photos on a CD-ROM catalog should be fun, not mind-numbing. The process should be easy and speedy. Photos should be large, clear and sharp. Your catalog should provide the viewer with a wide selection of photos on one specialized subject. (Viewers don't like to waste time flipping discs trying to find a picture in the subject area they need.) As soon as the viewer opens the catalog, she should not have to figure out how to get the search software into operation. It should be transparent and easy to maneuver.

If your CD-ROM does not fit these criteria, consider starting over.

The Distribution Issue. Many creative people learn too late the maxim that goes like this: Producing a product is only one-third of the venture. The other two-thirds are made up of *distribution* and *marketing*. If you plan on producing your own CD-ROMs, be sure you have figured out how you will advertise and distribute your product. Many fine CD-ROM catalogs are sitting on shelves of their producers, going out of date, because the photographers had no funds left for marketing and distribution.

The Black Market Issue. Any enterprise seems to have its dark side, and the CD-ROM market is no exception. Software companies have long been aware of piracy on the Internet, which is commonly called the Dark Net. Music, movies and even photo CDs are pirated for foreign sales through the Internet, using not the conventional Web sites and search engines but FTP (file transfer protocol), the earliest form of Internet communication. The pirates are difficult to detect because they can change their electronic addresses day by day.

Many stock photographers fret about the possible loss of revenue to the Dark Net. Should this be of concern to you? Probably not—as loss of these overseas sales would be negligible to your bottom line.

Taking Advantage of the Digital Revolution

The digital revolution expands the marketing possibilities for stock photographers. Here are some examples.

THE WEB AND NEWS PHOTOS

What happens if you witness an important national or world event and get a photograph of it. What do you do next? Trying to sell your photo directly to a news service or even to your local metropolitan paper can be an arduous task. Besides, how do you contact FOX News or ABC TV? Here's another area where the Web is becoming a solid resource.

If you catch an earthshaking photo or have a bent for investigative or photojournalistic photography, your best bet is to be in touch with an agency that handles on-the-spot news photos and has direct lines to the news magazines and Internet and cable news organizations. Typical agencies are Sygma, Magnum, Black Star, Saba Press, Gamma, SIPA-Press and Contact Press Images.

Scott McKiernan formed the agency ZUMA Press (http://www.eZuma .com) in 1993 and represents more than two hundred editorial photographers who supply him with newsworthy photos. His company has supplied scores of magazines and news agencies in the United States and worldwide with headline news photos.

"Often, it's not how good the photo is but how fast you can deliver it," says Scott, whose Web site alerts magazines, newspapers and Internet news services to what he currently has available for publication.

"We find that the World Wide Web is an excellent tool that we can use to sell our photos directly to customers," says Scott. "Our pricing makes our photos affordable for all ranges of use, from double-page spreads in *Newsweek* to use as graphics on T-shirts for consumers."

Scott has been a photojournalist for twenty years and enjoys a solid reputation in the field. His experience in photojournalism equips him to negotiate fees for his group of photographers, whose photos are also included in the ZUMA Press Web site. He will also negotiate a fee for you if you land a newsworthy photo.

Build Your Own Pictures

When Larry Mulvehill of Florida first visited me here at the farm a while back, he was on assignment for several companies and publishing houses. At the time, he was using conventional film and cameras. The next time I saw him he was still using film, but he was flying high with computer graphics.

"How do you like this photo I got of an ultralight up in the clouds at thirty thousand feet?" he asked me.

I stared. Then I smiled. "You're into making new images with computer graphics!" I said.

I asked him to show me how he was able to create this picture.

He wrote it down for me:

Picture window1.jpg original shot on the ground at Raleigh Durham Airport (see page 204).

Picture window2.jpg removed workmen leaving window area blank.

Picture clouds.jpg original stays unchanged (see page 205).

Picture ultralight1.jpg original (see page 206).

Picture ultralight2.jpg ultralight silhouetted out of original.

In Photoshop clouds.jpg placed under window2.jpg.

Then ultralight2.jpg placed in middle window. Then image is flattened creating ultralight3.jpg (see page 207).

So, there!

For more of Larry's creations, visit his Web site (http://members.aol.com/fogfilter).

BUILD YOUR WEB SITE WITH VIDEO

Have a camcorder? You can set up your on-line mini stock agency and test the waters by using the "Web cam" technique to display photos from your stock files.

"Slim" Simmons uses this approach when photobuyers contact him to review a selection of his photos. He lives in Colorado and specializes in ghost towns, small-gauge railroads, mountain climbing, skiing and anything else that might say, "Colorado."

If you don't have a video camera, you can buy a product called a Web cam. It attaches to your computer. The unit is a small digital video camera that is ideal to sit on top of your computer. It will take pictures, record movies and do videoconferencing—all from your computer.

Probably the most popular units are Kodak's DVC323, COMPRO's D-Cam and Logitech's QuickCam. They're in the $150 to $250 price range at this writing.

The unit can automatically take a picture and upload it to your Web site. "If I get a call from a photobuyer who wants to know if I have pictures of locomotives in a certain section of Colorado, I simply take a shot of my images with my Web cam [he uses the Logitech QuickCam] and upload it to my Web

Original shot at airport.
Larry Mulvehill

Original shot of clouds.

Larry Mulvehill

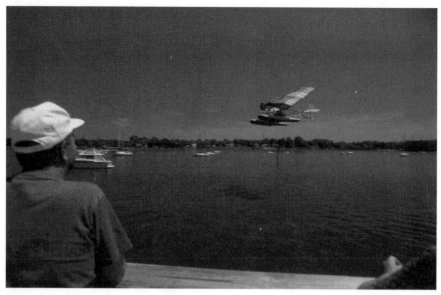

Original shot of ultralight.
Larry Mulvehill

site. In a matter of minutes the photo researcher can call up my Web site and see the picture. The researcher can immediately decide whether it's the kind of thing they want," says Slim.

"The technical quality of the picture is not there, but the *impact* of the picture is, and that's basically what the photo researcher is looking for at the moment. If they make a decision to buy, I either E-mail a high-resolution scan to them [he uses the Nikon Super CoolScan] or send a disk. They don't usually ask for the original transparency, but I can send that to them if they request it. With my Super CoolScan I no longer have to worry about an inept editor scratching and ruining one of my slides. The scanner doesn't capture the outer layer of emulsion when it scans, which makes many of my scratched negs perfectly usable again. Five years ago, a scanner like this might have cost $15,000. Today, it's only $3,000."

And what does Slim suggest for hardware, to do your own Web camming?

"I think any of the newer PCs with Windows 95 or 98, or a Mac running system 7.0 or higher, will easily handle the job," says Slim. "You'll need a video in/out board. The processor should be 120MHz with a minimum of 16MB of RAM, and the monitor should display at least 256 colors. For extra disk space, 200 to 300MB would be fine.

"Of course, an Internet connection is necessary, and you should have at least a 28.8 kilobits per second modem. For your Web page design, you're going to need a Web authoring tool to create the pages and an FTP program for uploading your Web pages to your server. Most new computers include

The composite image created on the computer.
©Larry Mulvehill

the necessary software, such as a browser and WinZip or StuffIt Expander,"
explains Slim.

A Web page would not be necessary if your photobuyer contact would be
willing to accept your photos via E-mail, but as yet, most don't. They'd rather
call up a Web site (yours) at their convenience, and look over the selection
you've uploaded for them.

There are many innovations you can introduce on your page as you progress with its construction. One example is a Web page slide show. You set up a series of Web pages, each with one photo on it. The photos can be varying views of the same subject, or they can be different unrelated subjects. Then, using your Web page editor, set up each page to automatically advance to the next page after so many seconds. Multimedia experts say that more than two seconds is too much to view a photo of this type. If you've advanced in your techno-know-how, you can even design your slide show to go in reverse, fast forward, pause or enlarge on command.

A book on the subject is *The Little Web Cam Book* by Elisabeth Parker.

THE PUBLIC DOMAIN SYSTEM

You paid for them. They are yours. I'm talking about the many government photos that are in the public domain and are housed at the Library of Congress, NASA, U.S. Department of Agriculture, military agencies and other federal and state governmental archives of public domain photos.

These photos were acquired by tax dollars, and they are for use by the general public as well as the government. Trouble is, these photo collections are not widely publicized, so the general public doesn't know how to access them.

You *can* access them and include them in your stock collection or use them to answer photo requests from photobuyers. In the past week here at PhotoSource International, we published two requests of this type. One was for an aircraft carrier and another for a Russian MiG.

To access these photos and utilize them, you need only know the method to acquire them. Again, these photos are rightfully yours, since you or your forebears helped build the collection.

Tom Carroll, photography entrepreneur extraordinaire from California, is an expert at finding hard-to-locate photos for his clients, and has found public domain archives to be especially helpful in many cases.

"I once got a photo request for the interior of a nuclear submarine," Tom says. "In the past I would usually throw such requests away. Then I thought, *Maybe I can find it at a government agency, through the Internet.*"

Using search engines like Yahoo! or AltaVista, Tom found several photos of the interiors of nuclear submarines at the U.S. Navy Web site. "Searching for information from a U.S. government office always takes a minimum of six office inquiries," says Tom. "But I finally found the right location to obtain that particular picture."

Enlarging the Small Ones

Because the pictures Tom located were for editorial use, there was no need for model releases. However, the pictures were all in compressed 72-dpi format, called thumbnail images, and not the reproducible quality that photobuyers need.

Very few buyers care to use a picture that small. On top of that, the deadline was close. Tom didn't have time to go through the usual process of having a

color dupe or black-and-white print made by the government agency.

He learned of software that will uncompress images from 72 dpi to as high as 300 dpi, which is acceptable to most photo editors when they are using the photo at a quarter-page size. The program Tom uses to uncompress the images is Genuine Fractals. A pro version costs $299.

"Depending on who the customer is, I've found this an easy as well as lucrative way to supply my customers with highly specific photos which they normally can't locate," says Tom. The photo on page 210 was taken from an Internet Navy (public domain) site. Using the fractal method it was blown up to 300 dpi and used in an annual report (shown on page 211). Tom received $875 from his client for his research and photo enhancement. He didn't charge for the picture itself, since the photo is free, as public domain. In his invoice he wrote, "Photo (Public Domain): no charge. Research and Fulfillment: $875."

Tom once filled a request for a sunken Russian submarine. "I've never been on a submarine, but I found the photo." Because the photo was used postage-stamp size, he didn't have to use the fractals process. He E-mailed the image to the photo editor of a major magazine and was paid $800.

The process goes like this. You get a request for a Russian MiG (the request for a MiG that came in to our *PhotoDaily* marketletter this week paid $250). You go to the Air Force Web site (http://www.af.mil) and click on the "Images" button. At the search slot, type in "MiG AND image." Notice that I didn't enter the word *Russian*, because not only would the search bring up the word *MiG* but also many pages with the word *Russian*. Several selections will appear.

Now that you have a picture of a MiG, you screen capture it and load it onto your hard drive, where you process it through the Genuine Fractals software to increase the dpi from 72 to 300. This will be enough resolution for a satisfactory quarter- to half-page picture.

Genuine Fractals, by the way, is available in both Windows and Mac versions.

"I find the system works best in the Windows environment," says Bill Copeland, president of Working Knowledge, a software management company in Irvine, California; phone: (949) 260-9211; E-mail: glacierpark@earthlink.net. In explaining the technology, he says, "The program requires a Photoshop plug-in. It's an encoding process that takes the picture through a mathematical formula and generates the fractal within each pixel. [In digital photography, photos can be broken down into millions of pixels.] Like fonts are enlarged or reduced, this process is like a photographer's postscript. We are applying the theory to images."

Some photobuyers can accept a digital file as is, but most prefer a print.

Tom Carroll says, "The photo can also be printed in color or black and white. Not all printing companies are capable of handling fractal files. I found the best printer is the LightJet 5000 (Cymbolic Sciences International). Service bureaus in most major cities will have this printer."

Carolyne Walton of Altamira Group, Inc., (800) 913-3391, the company

Aircraft Carrier, 72-dpi original.
Photo from Internet, by Tom Carroll

that produces Genuine Fractals says that the software works equally well with
the Mac. Altamira has partnered with the Epson Stylus 1200 as the printer of
choice for stock photographers.

Photomation (http://www.photomation.com), a digital imaging company
in Anaheim, California, (714) 236-2121, is the company that makes prints of
Tom's fractal files.

"We use the Genuine Fractals software to res up the image," say Bob Wal-
dren, Account Executive. "Photoshop doesn't do as well as Genuine Fractals
in this aspect when you need to print a file beyond the capabilities of an original
scan. We can adjust contrast, density and saturation. There are limits to what
we can do to make a small file look sharp at larger printed sizes however, even
with Genuine Fractal and our Digital Master prints."

Aircraft Carrier, 300-dpi image used in DRS Technologies annual report.
©Tom Carroll

Photomation uses the LightJet 5000 using regular photographic paper, making it a true photographic process. The system uses no lenses, only laser. At Photomation, all workstations have at least 200MBs of RAM.

Carolyne says, "It is always better to start with a tiff image as that is a truly lossless image of the best quality. JPG images have been compressed and may

produce unpleasant artifacting upon enlargement. If you do use Genuine Fractals with JPG images it is sometimes possible to produce a better image if you introduce a slight blur before encoding the image then using an unsharp mask after making the enlargement."

Can a photographer send a fractal file via E-mail? "It's possible, but we don't recommend it." says Bob Waldren. "The file is so large, it is better to send via FTP or as a zipped, Jaz or CD file." (Check out the glossary, page 256, for definitions of technology terms.)

Using Public Domain Photos

Most federal and state government offices hold a treasury of public domain photos that are free to be used by the citizenry. For example, the Library of Congress (LOC) holds millions of photos acquired over the last century. "But not all of them are in public domain," says Craig D'Ooge of the LOC public affairs office. "Patrons need to be aware of the several kinds of rights which might apply: copyright, donor restrictions, privacy rights, publicity rights, licensing and trademarks.

"Some photos might have been acquired through a contract photographer, in which case if no 'work for hire' agreement was signed, the photo is not in public domain. Also some donated collections are not in public domain. However, most all of the Library of Congress photos on the Internet are public domain," says D'Ooge.

For guidance on what may be in public domain and what may not be, read pamphlet number 195 at http://lcweb.loc.gov/rr/print/195_copr.html. I searched through some of the popular government sites to find their copyright restriction statements.

The National Archives and Records Administration (NARA)

The majority of images on the NARA Web site (http://www.nara.gov) are in the public domain. Therefore, no written permission is required to use them. "We would appreciate your crediting the National Archives and Records Administration as the original source. Please note that a few images on our site have been obtained from other organizations and that these are always credited. Permission to use these photographs should be obtained directly from those organizations."

The CIA

Unless a copyright is indicated, information on the Central Intelligence Agency Web site (http://www.cia.gov) is in the public domain and may be reproduced, published, or otherwise used without the Central Intelligence Agency's permission. "We request only that the Central Intelligence Agency be cited as the source of the information and that any photo credits or bylines be similarly credited to the photographer or author or Central Intelligence Agency, as appropriate."

Library of Congress

As a publicly supported institution the Library of Congress (http://www.loc .gov) generally does not own rights to material in its collections. Therefore, it does not charge permission fees for use of such material and cannot give or deny permission to publish or otherwise distribute material in its collections. It is the patron's obligation to determine and satisfy copyright or other use restrictions when publishing or otherwise distributing materials found in the Library's collections.

The Air Force

Information presented on Air Force Link (http://www.af.mil) is considered public information and may be distributed or copied. Use of appropriate byline/photo/image credits is requested.

NASA (National Aeronautics and Space Administration)

NASA (http://www.nasa.gov) images generally are not copyrighted. You may use NASA imagery, video and audio material for educational or informational purposes, including photo collections, textbooks, public exhibits and Internet Web pages.

U.S. Fish and Wildlife Service

All images are for public use, but please credit the photographer and the U.S. Fish and Wildlife Service (http://www.fws.gov).

IN PRAISE OF PHOTO CONTESTS (OF THE FUTURE)

Photo contests, as we know them today, are a turnoff to most photographers. The administration of entering a photo contest is labor-intensive. Security is another problem. Will the photos ever be returned? And then there's the aspect of who actually is the contest winner. In most commercially sponsored photo contests, the winner is usually the sponsor. In return for a blue ribbon or a trophy and a miniscule monetary reward, the photographer surrenders rights to the photo to the contest sponsor. The sponsor then has a first-class photo to use over and over again in promotions. But the biggest roadblock to photographers has always been the delivery and return of the images. The hassle of packaging alone is enough deterrent to discourage most photographers from entering a photo contest.

Enter CD-ROMs, DVDs and Web sites. As they become more prevalent in our visual industry, we will see a new photo contest emerge. No longer will photographers need to send in original prints or slides. They'll be able to enter by sending low-resolution images burned on to a disc or by sending digital images directly via E-mail to the contest headquarters.

The contest sponsor, in turn, will place the entries onto a CD-ROM, DVD-ROM or Web site. The contest judges will view the entries and make their assessments from their own homes or offices, without the usual expense of

meeting and judging in a central place. This will make it easier for judges to accept the job, plus assure a variety of qualified judges. An added benefit to photographers: They will be able to purchase CD-ROM copies of the contest entries to see how their photography stands up against the photographs of other entrants.

Famous Winners

Contests have traditionally offered amateurs opportunities to exhibit their talents to the world. Luciano Pavarotti, the famous Italian operatic star, got his start when, as a schoolteacher in Italy, he entered a local singing contest. Americans have always enjoyed talent contests, from Major Bowes to Showtime at the Apollo to Ed McMahon's Star Search.

When I was a teenager, I entered a photo contest in a magazine called *Modern Photography*. Although the winning check was only $15 (this was a *long* time ago!), capping the prize helped encourage me to look seriously at photography as a possible career.

Depending on what stage of your photographic career you are in, you might want to try your luck at a photo contest. You might not presently find the kind of contest that I've described here, but in addition to the photo contests you will find on a Web search engine (search for "contest + photo"), there are books that list contests. One such books is *Guide to International Photographic Competition* by Dr. Charles Benson, a retired chemist from Eastman Kodak. In it you'll find contests on every subject ranging from nature to editorial photography, from travel to electronic imaging.

In the future, part of the enticement to photographers to enter a contest will be the opportunity to have their entries included on a disc that can be available to photobuyers—photo researchers, art directors, photo editors, interior decorators, gallery owners and others. Entrants will be protected by a secure system that will prevent theft. Because of the great number of entries, photo contests will take on the look of a photo gallery. CD-ROMs holding over a thousand entries will become available to photobuyers looking for specialized photos. Although a photographer might not win a prize, a subsequent sale of a photo or establishing contact with a new buyer could be the reward.

And, of course, the biggest reward in this procedure will be that the photographer need not send an original photo or slide. Only low-resolution images need to be sent. All originals will remain at home in the photographer's possession.

CHAPTER 12

Equipment

WHAT HARDWARE AND SOFTWARE WILL YOU NEED?

If you've been waiting for prices to come down and hardware to get faster, your timing is excellent. The cyberocket is about to leave the launchpad. I hope you have your seatbelt buckled because the World Wide Web Express is about to reach warp speed.

The Web is built for us. Photographers no longer have to stagger under forty-pound bags of equipment (on each shoulder) and entrust our delicate transparencies to the care of strangers.

The Internet and its tools—software, modems, faxes, cell phones, computers, photocopiers, voice answering units, scanners, discs and CD-ROMs—can make us paragons of efficiency and give us direct access to our markets. The pioneering days are over. Bandwidth is improving every day, and the prices keep going down.

You've seen the dozens of books about computers and software and probably have read half of them. But what if you haven't and you're not even sure whether you should make the investment? It might surprise you to know that with very few outright purchases of anything, you can be up and running on the World Wide Web in a matter of an hour or two—and that's at the most.

You might say, "I don't even have a computer!" No problem. If you're just testing the waters to see if marketing your photos is for you, you can find free hardware, software and training at your local library. Or, some local vocational-technical schools provide low-cost night courses. In a matter of a few evenings, you'll be ready to go.

If you've already decided that you do want to get in on the advantages of marketing your photos via the Web, you'll need your own computer and a modem. Most computers nowadays include modems. And most modems are speedy enough to meet the requirements of the Web. A perfectly adequate computer and modem will cost you under $1,000. You don't need a Cadillac system.

The software that comes (free) with the purchase of your computer will contain an E-mail program and all you need in the way of other programs, such as a browser, to get you onto the Web. The software is already loaded into your computer. Just follow the directions.

When buying your computer, don't be tempted to buy a used model. The reason: Older computers are fine for word processing and spreadsheets, but they are too slow (in today's world of high-speed processing) for the Web. Also, they probably won't have the hard-drive capacity (storage space) that you will eventually need.

Don't be tempted to assemble your own computer. We did build our own, when personal computers were new on the scene in the seventies and early eighties. It was smart back then to save money by buying parts from here and there and assembling your own computer. But there are now two drawbacks to this kind of tantalizing tinkering: (1) When you buy parts from various companies, the parts might not be compatible with each other. You'll waste time sending materials back and trying to get a refund; (2) if the parts are not Year 2000 compliant, you'll have internal computer problems.

In contrast, when you buy from a reputable company, it is accountable for warranties and troubleshooting. The best companies (at this writing) for buying long distance (mail order) are Dell and Gateway. We all hear horror stories, whether they're about IBM, Compaq or Hewlett Packard, but in the long run it's best to buy a prepackaged computer.

The most convincing reason of all not to build your own computer is that today's prices have come down so dramatically that you can't go wrong purchasing a ready-made model, and you'll save yourself a great deal of time and trouble.

Should you buy your equipment at auction on the Internet? Our Operations Manager at PhotoSource International, Bruce Swenson, always uses the auction sites for pieces of equipment to enhance his home computer. "But I stay away from consignment Web auctions," says Bruce. "I prefer commercial houses such as Egghead and Deal Deal. At the 'flea market' type of public auctions, no one's accountable."

Our Webmaster, Owen Swerkstrom, was dead set against auctions until he needed an obscure part for a vintage video camera he inherited from a local college. He tested an auction site and found an amiable seller and a more than reasonable price. Since then he's purchased a couple more items at auction.

To find the auction sites, use the search engines. Currently the most popular are eBay.com, Amazon.com, Egghead.com, eBid.co.uk and EZbid.com. Buying a computer or high-priced scanner at a public auction might not be a good idea, unless the seller is located within a half day's drive from you.

The question of which computer or software is best is wide open. A lot depends on your plans for the size of your stock photo operation; whether you're part time or full time; whether you plan to employ graphics; and so on. Talk to at least a half-dozen friends or salespersons before you make your decision. And here's a happy thought: Whatever decision you make, if you do your homework, you won't make a mistake.

A big question you will want to answer: How much RAM will you need? Most programs today require at least 32MB. However, as a stock photogra-

pher, you're probably better off buying 64MB or higher. If you are into graphics, you'll want to pass the 100 mark.

Which computer, Windows or Mac? This question always comes up. When I make visits across the nation, I notice that photographers and photobuyers both look more to the Macintosh. Of the several hundred people I've seen or talked with in the photography world, I'd say about 80 percent use a Mac and the rest Windows. Either one will do nicely. The only thing to remember is that the Mac has only about a 5 percent share of the computer market. In some areas of the country, service and parts may not be readily available.

A free browser will come along with your computer or modem when you buy it. This is the software that allows you to view content on the Web. The most popular browsers are Microsoft's Internet Explorer and Netscape.

You will need an ISP to connect to the Web. An ISP (Internet Service Provider) is a local company that offers you access to the Internet via their servers for a monthly fee. Or you may choose to sign up with AOL (America Online), which provides you with easy Internet and Web services. In my opinion, you'll want to stay with AOL as briefly as possible and graduate to a standard ISP. From my experience, AOL has a history of too many problems with E-mail, especially attachments.

If you plan to go forward and set up your Web site, you will need to hook up with an organization that provides a server. This is a company that acts as a storage place for your Web site, plus directs incoming and outgoing Internet traffic for you. In our case, although we operate our Web site from the hinterlands of Wisconsin, our server is located in Mountain View, California. Your server will cost around $20 to $30 per month.

The Missing Ingredient—Speed

Your computer, modem and Internet service provider are all hooked via the global telephone system. Because the system was never built for high-speed activity, such as transmitting photos on the Web, most of us have to put up with the slow bandwidth of normal telephone lines.

Using our telephone lines for our Internet activities is the equivalent of driving our automobiles at only twenty miles per hour. The day is coming where we will be able to transmit one hundred or even one thousand times faster than we presently do. Several companies are running preliminary tests of speed services that range from satellite to wireless.

Olympic Speed on the Internet

Computer screens that come up in an eye blink? Photos that appear instantly? It's happening already. And what's the secret of speedier Web sites and E-mail transmissions? Cable TV and modems.

Photographer Tom Carroll, who lives in the San Diego area, is experiencing what I've just described. "My cost is only $29.95 per month, paid to my local cable company, Cox Cable. Similar companies are conducting tests across the

Free Advice

For help from Crimson Star, our *PhotoStockNotes* columnist who covers Web doings, search his section on our home page at http://www.photosource.com/crimson/learning.html. He covers several topics.

THE PRINTER

Selecting a good printer is like selecting a good enlarging lens. Crimson tells you the secrets that computer salespeople never heard of.

DIGITAL CAMERAS

Will a digital camera deliver the results you need? Crimson teaches you the secret formula that tells you, before you spend thousands of dollars.

SCANNERS

"Everybody wants to sell you a scanner," says Crimson. There are cheap ones, medium-priced ones and expensive ones. What do you need? You need the special formula from Crimson, plus the even more secret explanation of what really makes one scanner superior to another. It has nothing to do with resolution!

SOFTWARE

"The media loves to test photo-editing software. Too bad they concentrate on how the software works," says Crimson, "rather than how it can be used to create the image you need." He tells you the single feature that convinced him to toss his Cibachrome drums and go for broke with Adobe Photoshop. "It was worth every penny!" says Crimson.

THE COMPUTER

Do you need the most expensive computer on the market? Not unless your name is Bill Gates. Crimson shows you how to select the right stuff at a price that mere mortals can afford. "You won't make many new friends at the computer store, though," says Crimson.

nation," says Tom. The cost is slightly higher if you rent a modem rather than own your own. No phone lines are involved; it's all cable.

Some of the conveniences Tom has experienced already: quick Web searches, sharper color, no local server involved, on-line connection doesn't "time out" and has no interruptions. Already Tom is enjoying benefits of speedy communications with an agency he deals with in Spain.

A Plus for the Individual Photographer

Eventually, when the cable technology becomes widespread, interactive TV will become available. This will mean photobuyers will be able to give you a call, once they find out your specialty, and ask to see (immediately through interactive TV) a selection of your images from your database.

This is a plus for the individual stock photographer, and it could rejuvenate

the smaller stock agencies who currently deal in specialty markets. This technology would help stock photo agencies be capable of marketing and moving your images more aggressively, rather than have your photos molder in their files. You could continue to keep a portion of your photos with an agency and it would handle the administration of them, leaving you more time for picture taking.

Software

Software has come a long way from the initial programs offered to photographers. Some companies have dropped out of the scene; new ones are coming on the scene. The software listed below gets good grades from most photographer customers.

Here's a brief description of what we have found in magazine articles, Web sites, photo forums and ads and by word of mouth.

The Boss, for commercial stock photographers, covers a wide range of features from business management to software for the stock photographer. It keeps track of clients, evaluates profit progress, prints estimates and invoices, keeps the books, writes checks, balances statements and prepares mailings. BOSS Development, 310 Mockingbird Lane, Suite F, South Pasadena, CA 91030. Phone: (818) 799-3400. Fax: (818) 799-3403.

Contact Sheet File assists you in keeping track of your contact sheets and specific images on those contact sheets. It can be useful if you have a multitude of contact sheets. This freeware is available on CompuServe and America Online. Rick Dieringer, 19 W. Court St., Cincinnati, OH 45202. Phone: (513) 621-2544.

Cradoc Caption Writer has been around a long time, so it must be good. Caption Writer is easy to use and fast. Perfect Niche Software, Inc., 6962 E. First Ave., Suite 104, Scottsdale, AZ 85251. Phone: (602) 945-2001. Fax: (602) 949-1707. E-mail: sales@perfectniche.com. Web site: http://www.perfectnic he.com.

FotoAgent is a standard software for stock photography and features a version for photographers and one for stock agencies. FotoAgent automatically prints a bar code on your labels. If you don't use bar codes presently, you'll be prepared if you make the changeover. Pro Publishing, 4839 SW 148th Ave., #222, Ft. Lauderdale, FL 33330. Phone: (305) 690-1771. Fax: (305) 680-8996. E-mail: sales@fotoagent.com. Web site: http://www.fotoagent.com.

FotoFind, first designed in 1985, helps stock photographers to organize. Labeling combined with find capabilities allows quick retrieval of thousands of photographs. The functional $10 demo disk is worth $20 off the purchase price. Conversions from other programs are available. Process Technologies, Inc., P.O. Box 19129, Johnston, RI 02919. Phone: (800) 443-9922. Fax: (800) 751-3541. Email: mdilugio@aol.com.

FotoQuote is a complete guide to pricing and selling stock photos, both to the book and magazine industry as well as ad agencies and corporate ac-

counts. The new version 2.0 has added thirty electronic usages, including Web pages and CD-ROM information on negotiating in the electronic age. It is for Windows or Mac. Cost: $129.95 plus $6.00 postage and handling. Thirty-day money back guarantee. Cradoc Corporation, P.O. Box 1310, Point Roberts, WA 98281. Phone: (800) 679-0202. Fax: (206) 842-1381. E-mail: infow@cradoc.com. Web site: http://www.cradoc.com.

Grip 32 is for the commercial stock photographer as well as the service photographer. This 32-bit studio management system for Windows 95, Windows NT and Windows 3.11 is network-ready. Features include client and contacts tracking, scheduling, invoicing, double-entry accounting, mailing lists and labels, and stock picture management. Grip 32 provides on-screen or printed estimates, job confirmations, in-progress job reports, estimate to job comparisons, profitability reports and invoices. Printed reports are customizable. The manual is impressive. Grip Software, 420 N. Fifth St., #707, Minneapolis, MN 55401. Phone: (612) 332-8414. Fax: (612) 332-0052. Web site: http://www.gripsoftware.com.

Images is a shareware program to create and organize a catalog of your negatives and prints. It is IBM-compatible. Cost $6. KWN Systems, 220 Stonehurst Blvd., Freehold, NJ 07728. Phone: (908) 431-4244. Fax: (908) 308-3955.

Images 2.1 is a photographers' database system used by photographers, photojournalists and newspapers in the United States and abroad. It catalogs images and tracks your photographs and submissions. It prints reports and slide and print labels on dot matrix and laser printers. This software conducts high-speed searches and sorts on all fields. System includes Client Contact Manager and Equipment Database. Cost: $49 for IBM/DOS. Demo is available on CompuServe PhotoForum for $6. Accountability Business Systems, Inc, 230 Old Turnpike Rd., Barrington, NH 03825. Phone: (603) 942-5523. Fax: (603) 942-7434. E-mail: 71240.460@compuserve.com.

InView and StockView is comprehensive photo business software for Windows or Mac. InView handles the business side of your stock photo operation: contact data, marketing, correspondence, estimating, job costing, invoicing, collections, scheduling, to-do lists, phone dialing, payables, check writing, equipment files, etc. StockView (see page 223) handles captioning, cross-referencing, file searching, digital photo filing, submissions, etc. Both have customizable ASMP-style forms. Cost: Version III of InView and StockView, $750 (includes Panorama Direct). Hindsight, 9249 S. Broadway, #200-126, Highlands Ranch, CO 80126. Phone and Fax: (303) 791-3770. Web site http://www.hindsightltd.com

Labeler, for captions, stores up to 150 characters in database files for retrieval by searching on any word, phrase or character string in the caption. It prints captions to three standard sizes of pin-fed labels small enough to fit on the base of 35mm slides or exhibition mounts. Use Labeler to create slide presentations, including title and sequence number, for label printing. Labeler is upgradable

to companion programs FFoto and/or FFindr. Free demo is available at Web site. Franklin Service Systems, P.O. Box 202, Roxbury, CT 06783. Phone: (860) 354-8893. Fax: (203) 350-9249. E-mail: 76762.2001@compuserve.com. Web site: http://www.hudsonnet.com/foto/foto.htm

Label Power, another labeling program, can work with dot matrix or daisy wheel. Cost: $50. Power Software, 702 Gist Ave., Silver Spring, MD 20910. Phone: (301) 589-1690.

MacStock Express (Photo Collection Organization) was written by an editorial stock photographer. It handles photo categorizing, searches and lists, which can be self-customized. It accepts scanned images; records models/releases and links them to photos and labels (captions); prints labels for slides and larger formats, including captions, copyright notice, credit line, etc. Help screens are available at all times. Software is compatible and upgradable to MacStock X + or MacStock. It requires any Mac with 8MB. Cost: MacStock Label, $100; MacStock Photo, $150 (with graphics $250); MacStock Tracker (stock photo with tracking), $450; complete system, $850. MacStock X 3.5, $195 ($295 with Runtime Helix). Ninety-day demo is available for $40. Unlimited free technical support is available. For upgrade, call or E-mail. Photo Agora, Hidden Meadow Farm, Keezletown, VA 22832. Phone: (540) 269-8283. Fax: (540) 269-8283. E-mail: PhotoAgora@aol.com.

Modec LP-440 Label Printing System incorporates a magnetic-read label similar to labels on a credit card. Cost: $125. Modec Corporation, 7501 Washington Ave. S., Edina, MN 55435. Phone: (612) 944-2905.

(Boyd) Norton Slide Captioning System Pro—(NSCS Pro) now allows the use of thumbnail images in the database system. This feature gives photographers and picture file managers a visual record of pictures in their files. It also features slide captioning and labeling, picture cataloging, stock photo management, powerful search and sort features, picture submission tracking, a client database, invoicing, picture pricing, database importing and exporting and more. Detailed information on NSCS Pro2 and NSCS Pro can be found on the Web site. Phone for brochure. Cost: $189. NSCS, P.O. Box 2605, Evergreen, CO 80437. Phone: (303) 674-3009. E-mail: 74504.1634@compuserve.com. Web site: http://www.nscspro.com.

PC-Foto is a shareware program that labels slides for DOS and compatible printers. Cost: $30 (ask for disk #1040). PCP-SIG Inc., 1030-D E. Duane Ave., Sunnyvale, CA 94086. Phone: (408) 730-9291. Fax: (408) 730-2107.

PC-Foto Version 3.5C. will accept most printers. Cost: $69.95. Foto 64 Inc., P.O. Box 2130, Saratoga, CA 95070-2130. Phone: (408) 243-6848.

Photobyte has to be the Cadillac of business software, not only in price but in features. When you're ready to graduate from plain-vanilla Photography Accounting 101 to software that you can manage (not the other way around), PhotoByte excels. Professional stock management takes two elements: talent and business awareness. PhotoByte can't improve your images, but as the promotional material says, it can improve your profit picture. You can take

a look for $50 and get an hour's free help from the technical desk. Cost: $995 plus postage and handling. Vertex Software, 31 Wolfback Ridge Rd., Sausalito, CA 94965. Phone: (415) 331-3100.

Photo Label is a shareware label program (version 1). Cost: $30 registration fee. Gregory E. Borter, 5909 Santa Fe River Dr., #102, Tampa, FL 33617.

Photo Management System locates images. It works either as a stand-alone database program for the visual arts or in conjunction with the Cradoc Caption Writer. Features include the use of a single-database file; the ability to sort, filter or tag records; import and export of records; and reports that let you create a delivery memo, invoice or listing of select images. Perfect Niche Software, Inc., 6962 E. First Ave., Suite 104, Scottsdale, AZ 85251. Phone: (602) 945-2001. Fax: (602) 949-1707. E-mail: sales@perfectniche.com. Web site: http://www.perfectniche.com.

PhotoMaster Version 1.0 is Dbase-compatible. Cost: $69. International Project Services, 3229 Lander Rd., P.O. Box 305, Jefferson, MD 21755. Phone: (301) 834-9984

Pic Trak Version 2.1 works with a small or large file. It can organize on a micro or macro level. Cost: $89. Glacier Software, 916 Parkview Way, Missoula, MT 59803-2320. Phone: (800) 234-5026, Fax: (406) 251-5870.

PI/E is for the commercial stock photographer and comes in Mac and Windows versions. PI/E provides the forms and reports for creating and producing the job from the first estimate to scheduling, casting calls, location searches, delivery memos, letters, faxes, etc. It manages stock images with user's codes, imports photos from CD, invoices and tracks stock sales, prints labels and sends stock delivery memos with terms and conditions. User's guide, on-screen help and free technical support are available. RLW Concepts, 5940 Highridge Rd., Calabasas, CA 91302. Phone: (818) 993-7577. Fax: (818) 887-4601.

ProSlide II 4.0 is in its ninth year. ProSlide functions as a search engine as well as a label maker. The company offers a unique four-sided "window" label. The program will print on the label both vertically and horizontally in various type sizes and styles. It's ready to go out of the package. Software manual is included. (Imports from various programs, for example, Dbase, 1-2-3, ASCII Files, etc.) Cost: $139 plus postage and handling. Ellenco, P.O. Box 159, Tijeras, NM 87059. Phone: (505) 281-8605.

QuickBooks 6.0 and QuickBooks Pro 6.0 make small business accounting easier than ever. Intuit set three design goals when developing the QuickBooks 6.0 product line: (1) Make QuickBooks easier to learn and use overall; (2) add new Internet features that help customers save time and money; and (3) provide customers with a truly easy-to-use multiuser accounting software solution. Cost: QuickBooks 6.0, $119.95; QuickBooks Pro 6.0, $219.95. Intuit, P.O. Box 7850, Mountain View, CA 94039-7850. Phone: (800) 446-8848. Web site: http://www.intuit.com.

Seekeasy is useful in retrieving info about photographs. This shareware for

IBM PCs and compatibles performs a "fuzzy match" so you don't have to get the titles you're looking for exactly right. Correlation Systems, P.O. Box 39, Lomita, CA 90717. Phone: (310) 833-3462.

Silentpartner Basics 7.0 is financial/business management software designed by a service photographer and tailored for photographers, illustrators, designers and smaller agencies. It runs on Macintosh or Windows. Basics will help commercial stock photographers market their services, develop and track estimates and invoices, and manage money. It includes help buttons, and a mini word processing program. Cost: $1495. Demo disk, $35. The Medi Group Ltd., 180 Black Rock Rd., Oaks, PA 19456. Phone: (215) 666-1955. Fax: (215) 666-5911.

Slide Manager for Windows is a software program for labeling and managing a slide or image collection. Slide Manager allows the user to categorize images by group, category, image numbers, keywords (up to four per image) and free text (any number of words or phrases). SlideScribe Products, a division of Image Innovations, 7685 Washington Ave. S., Edina, MN 55439. Phone: (612) 942-7909 or (800) 345-4118. Fax: (612) 942-7852.

StockView provides a Macintosh-based cataloging and captioning system, maintaining extensive information, cross-references, subject matter, format, where images are, when they're due and previous usage. Six label formats can be altered slightly or completely overhauled. User-defined defaults, numbering systems and search modes are provided. Software includes optional-use bar code and digitized image storage. It generates stock delivery memos and leasing invoices and optionally links to InView. Printed reports are customizable. Panorama II or Panorama Direct is required. Cost: $395 with Panorama Direct; Database functions, $250; $300 without Panorama. Combines with InView (see page 220) to form complete business package. An additional piece of software, called searchLynx, allows photographers to coordinate selected photos and keywords for inclusion in the StockView database for easy searching. HindSight, 9249 S. Broadway, #200-126, Highlands Ranch, CO 80126. Phone and fax: (303) 791-3770. Web site: http://www.hindsightltd.com.

StrucSure works in conjunction with Claris Corporation's FileMaker Pro for Mac or Windows. This management software is 100 percent customizable and includes eight cross-linked modules. FileMaker Pro is sold separately. Cost: $279.95. Free demo disk available. StrucSure Software Company, P.O. Box 11633, St. Louis, MO 63105. Phone: (314) 993-7577. Fax: (314) 863-8018. E-mail: strucsure@inlink.com.

Studio Manager business management software is for commercial/editorial stock photographers. PhotoSoft Company, 754 Piedmont Ave., Atlanta, GA 30308. Phone: (404) 872-0050. Fax: (404) 892-4055.

SuperLabel is available for both the Mac and IBM. Cost: $99.95; Demo, $5.00. Phototrack Software, Fax: (303) 693-4750.

ThumbsPlus 4.0, an image-cataloging program, creates thumbnails of your

images, providing you with a visual record of your multimedia files. Besides cataloging, ThumbsPlus can rename, move or delete files, and lets you edit an image just by double-clicking its thumbnail. For instance, the autocrop option removes any edges composed of the same color as a predetermined pixel. You are free to adjust colors, flip the image or zoom in. Another feature is a slide show of the current directory's files. Registration fee: $65. Cerious Software Inc., 1515 Mockingbird Lane, Suite 1000, Charlotte, NC 28209. Web site: http://www.thumbsplus.com.

20/20 Software is studio and stock management software. 17 Center Dr., Old Greenwich, CT 06870-1446. Phone: (203) 637-9939.

The ViewFinder prepares estimates and delivery memos, and transforms them into invoices while updating accounts receivable and a "research" JobFile. Stock module included, with research and label-printing capability, can query images into delivery memos. Working demo is available for $25 refundable deposit. Demo data is saved if program is purchased. Unlimited, free tech support is offered via phone, fax or CompuServe. Retail Merchandise Systems, 8122 SW Eighty-third St., Miami, FL 33143. Phone: (305) 271-8941. Fax: (305) 274-6220. E-mail: dickr@shadow.net. CompuServe CIS ID# 73767,3655.

Zap is for captioning and filing slides. Cost: Database functions, $199. Isc Western Inc., 207 Miller Ave., Mill Valley, CA 94941. Phone: (415) 381-4488. Fax: (802) 748-2131.

WHAT CAMERAS, PRINTERS AND SCANNERS WILL YOU NEED?

When technology figures prominently in a book, as in this one, it's difficult to recommend specific types of equipment and their prices. By the time the ink is dry on the book's print run, the cameras, printers and scanners I could recommend for your Internet use are likely to be replaced by something better and cheaper. But I can talk about fundamentals here, to give you a good foundation to make your own decisions when you look at what's out there for you.

Should you replace your film camera with a digital camera? Here are two ways to find out: (1) Check out the latest issues of photography magazines and newspapers. Are film cameras still prevalent in the ads? If so, you've got your answer. You can be sure that the major camera manufacturers do a lot of market research before they invest in a new line of cameras. (2) If you already have contacts in the publishing industry, ask one of the photo editors you work with, "The photo on page 45 of the current issue of your magazine— was that picture shot originally in film or digital format?" I've posed a similar question at trade shows, at the booths of publishing companies or popular photo magazines, in relation to articles or books they've done on the subject of digital cameras. (Since they are not manufacturing or selling digital cameras, they have no agenda.) I ask them, "Were these accompanying photos made with a film or digital camera?" (Remember—their features are about digital photography.) Invariably the answer is, "Film."

Why? Because pixel for pixel the resolution of film-based images is still much higher than images from a standard digital camera of equivalent cost. At the time of the writing of this book, film camera images are still the preferred medium for print publication.

When Do You Think Digital?

You probably already own a good film camera with good optics. Can you use it for your Web activities?

Certainly. With a scanner (mentioned later in this section), your present camera will serve you well on the Web. You may not achieve professional print quality (for paper publication) with the plain-vanilla scanners that I'll be suggesting you start out with. For print publication, of course, the quality is not there. But the results are plenty fine for Web work.

If a client does request a high-resolution digital image from you, you can always run down to a local service bureau and have it process a digital file that will meet the quality demands of your client. Where do you locate a service bureau for your high-end scanning? Start with recommendations from local processing labs (you'll find them in the yellow pages). Also, check out scanning services through the Internet. Start by searching for "service bureau" + scanning + [your nearest metropolitan area]. Use the plus signs as written to indicate you're searching for information on all three topics together.

The Low-Cost Digital Camera

However, if you're in this for the long haul, a digital camera should be in your future. In fact I suggest you consider getting one (as an adjunct to your film camera) as soon as your budget allows. Digital cameras don't come cheap, but on the other end, for images you plan to use on the Web, even an inexpensive digital camera ($150 to $350) will eliminate the cost of film and processing as well as the need for scanning. Any of the digital cameras advertised at an "affordable" price will serve you well in your initial entry onto the Web. So will a used digital camera you see advertised in the Internet auctions or classified ads. Like a watch or other delicate instrument, cameras are usually handled carefully by their owners, and you shouldn't have a problem finding a used one in tip-top condition.

Don Tibbits, a stock photographer in Sun Lake, Arizona, says, "After the initial expense of a digital camera, a person can just go out there and shoot, shoot, shoot with no additional expense (well, OK, maybe for extra digital storage units and the like).

"The digital camera is fine for newspapers, the Web and low-res publications. Even for printing on ink-jet printers the better digitals are fine. For magazines and books and high-end-res publications, however, film is still the medium of choice.

"Film, of course, is more of a hassle. Making sure you have enough film, worrying about the X-ray machines at airports, the cost of the film, shooting

twenty rolls then coming home and finding only three good pictures, keeping the film usable, etc. With digital you don't have any such concerns . . . except maybe for storage space."

Don owns an inexpensive digital camera ($300), and says, "The quality of this Agfa camera is just fine for the Web, but not for print. I do have one image of me that was taken on a more expensive digital camera ($900 range) and the print quality up to 8″ × 11″ was very good. But I'm still staying with doing my serious picture taking with slide film. Of course, with technology constantly increasing the quality of digital cameras and overcoming memory restrictions, this media segment will probably accept submissions from stock photographers digitally in the near future.

"New papers, inks and software are coming along every day that allow us to improve the quality of our images. For a person who has the time, it's now possible to manipulate digitally many of those images you are considering throwing away."

Again, although the "print quality" produced by an early model digital camera may leave much to be desired, the "Web quality" will be excellent. After all, a client who wants to see your images on the Web is interested (at the early viewing stage) primarily in the *impact* of the image. Rarely will you find a first-time buyer interested in buying directly "off the shelf" from your Web site catalog of images. Just as with a catalog of fine art, the buyer does not use the picture in the catalog; he sends for an original.

With this in mind, until you are prepared to buy a top-of-the-line digital camera, shoot with film and a low-cost digital.

Scanners

When photocopy machines were first introduced, small business owners considered them a luxury. "Luxury" soon metamorphosed to "necessity." Scanners, no doubt, will follow the same path.

Should you invest in a high-quality scanner? As with digital cameras and printers, there's a wide range of quality, with the sky the limit. However, unless you plan to move over into the area of commercial studio photography, a low-tech scanner will do just fine for your Web operation.

Scanners can solve the problem of how to send a preview to a photobuyer of the photos you have available. For example, using the UMAX Astra 1200S with a transparency lid, you can scan a dozen slides at 200 percent and then fax or mail them or place them on your Web site for a photobuyer to view. The buyer can indicate by caption number which ones she wants by return E-mail.

Don Tibbits advises that "Polaroid and Nikon make slide/negative scanners with 2,700 dpi, and now Polaroid has one for 4,000 dpi, and for a relatively reasonable price ($1,500 to $2,000). Flatbed scanner quality is not in the same league. While most flatbed scanners are not as good as drum and other high-end scanners, you *can* get a great scan from 4,000 dpi (or

2,700 for that matter). However, by the time you're reading this, flatbed scanners may have surpassed the quality of drum scanners!

Kodak produces scanning seminars for advanced amateurs and pros. Call (800) 336-8868, ext. 606.

Digital Printers

As for printers, Epson, HP and other printers can produce stunning photographic prints. In chapter eleven I mention sending out your high-end printing jobs to a service bureau that has a high-end printer, such as the LightJet 5000. However, all of your printing situations might not need the firepower of an industrial-strength printer. Epson, for example, produces the Stylus Photo 1200 printer, which works well with the Genuine Fractals software. And printing papers just keep getting better and more varied. There's one line of paper and ink for Epson from Luminos (http://www.luminos.com) that can supposedly retain a photograph's color for thirty-five to seventy years, depending on the ink that's used.

"The changes going on with printers, papers, and ink [and digital imaging] are fantastic," says Don Tibbits.

Do your homework. Check out vendors' specification sheets. The photography press competes in featuring articles on the newest scanners and printers. When selecting a scanner and printer for your own operation, determine just how it will fit into your business forecast. If you foresee cost-effective use of a high-quality scanner, as you would if you will be producing studio (commercial) work, you might want to consider leasing a scanner. For tax purposes, leasing might be a benefit for you. If a low-cost scanner fits your Web operation plans—if, for example, you will be producing Web-only images—check out an

Photo Delivery

Sending E-Mail images might not be the best way to deliver a selection of your photos to a photobuyer to look over for possible purchase. Although the delivery method sounds workable on paper, the problem arises when the buyer views the images on the screen. It's too easy for the buyer to reject the small thumbnails and to accept the more impressive real thing from a competing photographer who has sent original transparencies.

Currently, digital scan literacy is in its infancy. Many photobuyers and researchers are not totally comfortable or familiar with this new process and instead tend to resort to "the way it's always been done." Of course, those buyers who are up to speed with digital transfer technology laud its advantages: no need to handle original transparencies, nothing to send back, no time delay, a wide variety of choices, easy to automatically respond to photographers via E-mail.

While the telephone and modem system continues to have growing pains, and until photobuyers become more comfortable with accepting scans for preview, it might be best to send photos *both* ways: Mail or overnight the original transparencies or prints, and E-mail a scanned form when appropriate.

Internet auction or the classified ads in your local metropolitan newspaper, national photography magazines, such as *Shutterbug*, or digital imaging magazines, such as *PC Photo*.

Joseph Meehan, photographer and senior editor for the "New Products" column in *Photo District News*, says that according to his observation, from having received dozens of digital cameras, scanners and printers, "Digital products have come a long way toward relieving photographers of the tedium associated with film-based products—but the bottom line, at this time, is that the final product, your stock photo, can best be produced by film."

Probably the most helpful book on this subject is *Real World Scanning and Halftones*, by David Blatner, Glenn Fleishman and Stephen F. Roth. It's available at Amazon.com.

The digital process, as you can see, reaches beyond the average photographer's routine of snapping a picture and then sending it off to the film processor. The trio of digital cameras, scanners and printers is transforming photographers into photographers-prepress people. This may be something you didn't bargain for when you became a photographer. On the other hand, you might enjoy knowing that you can now gain much more control of your photo—from creation to finished product!

Resources

Web Links for Small Businesses

CELCEE—The Center for Entrepreneurial Leadership Clearinghouse on Entrepreneurship Education. http://www.celcee.edu

Fortune and Your Company—News and tips for small business owners. Updated biweekly. http://www.pathfinder.com/yourco

Retailer News Online Magazine—Business information for the retailer. http://retailernews.com

A Small Business Resource and Help Center—A resource and help center for small or home-based business owners. http://www.smallbizhelp.net

The Small Business Advisor—Helpful info on building and operating a small or home-based business. http://www.isquare.com

Small Business Resource—Management of small businesses. http://www.irl.co.uk/sbr

Small Business Taxes & Management—Tax law changes, finance and management news and analysis. http://www.smbiz.com

Smalloffice.com—From Home Office Computing; how-to for the home and small office. http://www.smalloffice.com

Stock Photo Services

AG Editions Inc.—Contact: Ann Guilfoyle
41 Union Square W., Room 523, New York, NY 10003, phone: (212) 929-0959, fax: (212) 924-4796, E-mail: office@agpix.com, Web site: http://www.ag-editions.com

Global Photographers Search—Contact: Bob Greenberg
11761 S.W. Ninth Court, Pembroke Pines, FL 33025, phone: (954)433-8888, E-mail: webmaster@photographers.com, Web site: http://www.photographers.com

1 Stop Stock—Contact: Frank Borges Llosa
6845 Chelsea Rd., McLean, VA 22101, phone: (703) 927-8683, E-mail: llosa@frankly.com, Web site: http://www.1stopstock.com

Painet—Contact: Mark Goebel
 20 Eighth St. S., New Rockford, ND 58356, phone: (701) 947-5932, fax: (701) 947-5933, E-mail: mark@painetworks.com, http://www.painetworks .com
Photo Market Place—Contact: Stefan Hartmann
 Stefanienstrabe 25, Baden-Baden D-76530, Germany, phone: 49 7221 30175 64, fax: 49 7221 30175 70, E-mail: webmaster@fotomarktplatz.de, Web site: http://www.fotomarktplatz.de
PhotoSource International—Contact: Rohn Engh
 Pine Lake Farm, 1910 Thirty-fifth Rd., Osceola, WI 54020, phone: (715) 248-3800, fax: (715) 248-7394, E-mail: info@photosource.com, Web site: http://www.photosource.com
Picture Search—Contact: Chris Barton
 Demon Internet Limited, 322 Regents Park Rd., Finchley, London, N3 2QQ, England, fax: 44 181 541 1979, E-mail: info@picture-search.demon .co.uk, Web site: http://www.picture-search.demon.co.uk
Stock Photo Deskbook—Contact: Dave Lesser
 767 Winthrop Rd., Teaneck, NJ 07666, phone: (800) 391-3903, fax: (201) 692-8173, E-mail: info@stockphotodeskbook.com, Web site: http://www .stockphotodeskbook.com
STOCKPHOTO—Contact: Joel Day
 P.O. Box 302, North Fremantle 6159, Western Australia, phone: (773) 506-9365, E-mail: joel@stockphoto.net, Web site: http://www.stockphoto.net
Visual Support PhotoNet—Contact: Don Dormeyer
 1162 E. Valencia, Fullerton, CA 92631, phone: (800) 869-5687, ext. 110, fax: (714) 680-8756, E-mail: vsii@vsii.com, Web site: http://www.vsii.com

CD-ROM Publishers

A La Carte Digital Stock, Mesa, AZ, phone: (602) 807-6577
Arc Media Inc., Toronto, Ontario, Canada, phone: (716) 633-2269
Artbeats Software Inc., P.O. Box 709, Myrtle Creek, OR, phone: (800) 444-9392, E-mail: info@artbeats.com, Web site: http://www.artbeatswebtools .com or http://www.artbeats.com
Aztech New Media Corporation, 1 Scotsdale Rd., Don Mills, Ontario M3B 2R2 Canada, phone: (416) 494-4787, fax: (416) 449-1059, E-mail: cseepe @aztech.com ,Web site: http://www.aztech.com
Barker CD Projects, 757 SE Seventeenth St., Causeway, #230, Ft. Lauderdale, FL 33316, phone: (305) 463-2557, fax: (305) 463-0514
Beach Ware, Escondido, CA, phone: (619) 735-8945
CD Plus Technologies, 333 Seventh Ave., New York, NY 10001, phone: (212) 563-3006, fax: (212) 563-3784

CD Publishing Inc., 4960 Wolf Creek Trail, Flower Mound, TX 75028-1954, phone: (214) 724-0023, fax: (214) 539-7645

CD-ROM Galleries Inc., 36 Seascape Village, Aptos, CA 95003, phone: (408) 685-2315, fax: (408) 685-0340

CDRP Inc., 101 Rogers St., #204, Cambridge, MA 02142-1049, phone: (617) 494-5330, fax: (617) 494-6094

Classic PIO Partners, 87 E. Green St., Suite 309, Pasadena, CA, phone: (800) 370-2746, fax: (626) 564-8552, E-mail: sales@classicpartners.com, Web site: http://www.classicpartners.com

Clip Shots, Toronto, Ontario, Canada, phone: (800) 551-3826

Computer Imageworks, Ltd., 277 Alexander St., Suite 212, Rochester, NY 14607

Copernicus Software, 267 A Ave., Suite 2, Lake Oswego, OR, phone: (800) 368-6231, fax (503) 636-8171, E-mail: mike@copernicus-software.com, Web site: http://www.copernicus-software.com

Corel Corporation, 1600 Carling Ave., Ottawa, Ontario K1Z 8R7 Canada, phone: (613) 728-8200, fax: (613) 728-9790, Web site: http://www.corel.com

Dataware Technologies, 222 Third St., Suite 3300, Cambridge, MA 02142, phone: (617) 621-0820, fax: (617) 621-0307, E-mail: info@dataware.com, Web site: http://www.dataware.com

Digital Impact Inc., 177 Bovet Rd., Tulsa, OK, phone: (800) 775-4232, fax: (650) 356-1910, E-mail: info@digital-impact.com, Web site: http://www.digital-impact.com

Digital Publishing Company, 8100 Wayzata Blvd., Golden Valley, MN 55426, phone: (612) 595-0801, fax: (612) 595-0802

Digital Stock Corporation, Solana Beach, CA, phone: (800) 545-4514, Web site: http://www.digitalstock.com

Digital Wisdom Inc., P.O. Box 2070, Tappahannock, VA 22560-2070, phone: (800) 800-8560, (804) 443-9000, fax: (804) 443-3632, E-mail: info@digiwis.com, Web site: http://www.digiwis.com

Digital Zone Inc., P.O. Box 5562, Bellevue, WA 98006, phone: (800) 538-3113, fax: (206) 454-3922

D'pix, a Division of Amber Productions, Inc., P.O. Box 572, Columbus, OH 43216-0572, phone: (614) 231-9611, phone: fax: (614) 231-9694, E-mail: amber@infinet.com, Web site: http://www.dpix-direct.com

Dynamic Graphics Inc., 6000 N. Forest Park Dr., Peoria, IL 61656-1901, phone: (309) 688-8800, fax: (309) 688-3075, E-mail: service@dgusa.com, Web site: http://www.dgusa.com

Earthstar Stock Inc., Chicago, IL, phone: (800) 424-0023

Eldar Company, Stamford, CT, phone: (800) 573-7753, fax: (203) 359-2474, E-mail: info@eldarco.com, Web site: http://www.eldarco.com

EyeWire, Inc., 1525 Greenview Dr., Grand Prairie, TX 75050, phone: (800) 661-9410

FotoSets, San Francisco, CA, phone: (800) 577-1215

4More Inc., New York, NY, phone: (800) 675-5372, E-mail: POPsmear@sonic
net.com

Gazelle Technologies, 7434 Trade St., San Diego, CA 92121, phone: (800)
843-9497, fax: (619) 536-2345

HammerHead Publishing Inc., Deerfield Beach, FL, phone: (954) 426-8114

Harpy Digital Inc., Los Angeles, CA, phone: (310) 397-7636

Letraset USA, 40 Eisenhower Dr., Paramus, NJ 07652, phone: (800) 526-
9073, Web site: http://www.letraset.com

MetaTools Inc., 6303 Carpenteria Ave., Carpenteria, CA, phone: (800) 472-
9025, fax: (800) 566-6385, Web site: http://www.metatools.com

Multi-Ad Services Inc., 1720 W. Detweiller Dr., Peoria, IL 61615-1695,
phone: (309) 692-1530, fax: (309) 692-6566, E-mail: adbuilder_sales@
multi-ad.com, Web site: http://www.multi-ad.com

Neo Custom Painted Environments Inc., Chicago, IL, phone/: (312) 226-2426

Pacific CD Corporation, P.O. Box 31328, Honolulu, HI 96820, phone/fax:
(808) 949-4594

Philips CD-ROM Publishing, 2500 Central Ave., #B, Boulder, CO 80301,
phone: (303) 440-0669, fax: (303) 443-8242

PhotoDisc, 2013 Fourth Ave., #4, Seattle, WA 98121, phone: (800) 528-3472,
fax: (206) 441-9379

Photoriffic, Los Angeles, CA, phone: (310) 289-8753

PhotoSphere Images Ltd., 310-380 W. First Ave., Vancouver, British Colum-
bia, V5Y 3T7 Canada, phone: (800) 665-1496 or (604) 876-3206, fax:
(800) 757-5558 or (604) 876-1482, E-mail: pictures@photosphere.com,
Web site: http://www.photosphere.com

Pixar, 1001 W. Cutting Blvd., Richmond, CA 94804, phone: (510) 236-4000,
fax: (510) 236-0388

Quanta Press Inc., 1313 Fifth St., #223A, Minneapolis, MN 55414, phone:
(612) 379-3956, fax: (612) 623-4570

Rubber Ball Productions, 44 N. Geneva Rd., Orem, UT 84057, phone: (801)
224-6886, fax: (801) 224-3533

Seattle Support Group, Kent, WA, phone: (206) 395-1484, Web site: http://
www.ssgrp.com/home1.html

Softkey International, P.O. Box 629000, El Dorado Hills, CA 95762-9983,
phone: (800) 242-5588, fax: (800) 582-8000

TechScan, P.O. Box 895, Port Hueneme, CA 93044-0895, phone: (805) 985-
4370, fax: (805) 985-7221

Texture Farm, San Francisco, CA, phone: (415) 284-6180

TextWare Corporation, P.O. Box 3267, Park City, UT 84060, phone: (801)
645-9600, fax: (801) 645-9610

Totem Graphics Inc., 6200 Capitol Blvd., Suite F, Tumwater, WA, phone:
(360) 352-1851, E-mail: gototem@orcalink.com, Web site: http://www.go
totem.com

Transmission Digital Publishing, New York, NY, phone: (800) 585-2248

Walnut Creek CD-ROM, 4041 Pike Lane, Concord, CA 94520, phone: (800) 786-9907, fax: (510) 674-0821

Wayzata Technology Inc., 2515 E. Highway 2, Grand Rapids, MN 55744, phone: (218) 326-0597, fax: (218) 326-0598

Weka Publishing Inc., 1077 Bridgeport Ave., Shelton, CT 06484, phone: (800) 222-9352, fax: (203) 944-3663

Zedcor, 3420 N. Dodge Blvd., Suite Z, Tucson, AZ 85716-1469, phone: (520) 881-8101

Web Sites for Stock Photographers

Adobe
http://www.adobe.com

Against All Odds Productions
http://www.againstallodds.com

AG Editions Inc.
http://www.ag-editions.com

Jagdish Agarwal
http://www.pickphoto.com

Agfa
http://www.agfahome.com

Altavista
http://www.altavista.com

Amazon.com
http://www.amazon.com

American Society of Journalists and Authors (ASJA)
http://www.asja.org

American Society of Media Photographers (ASMP)
http://www.asmp.org

American Society of Picture Professionals (ASPP)
http://www.aspp.com

Apple Computer, Inc.
http://www.apple.com

Ask Jeeves
http://www.askjeeves.com

Author's Registry
http://www.authorsregistry.com/authorinfo.html

Paula Berinstein
http://www.berinsteinresearch.com

Black Star
http://www.blackstar.com

Paula Borchardt
http://www.borchardt-photo.com

Canon U.S.A. Inc.
http://www.usa.canon.com
Churchill & Klehr Photography
http://members.aol.com/aklehr/C-K.html
Phil Coblentz
http://www.worldtravelimages.com
Communication Arts
http://www.commarts.com
Copyright Clearance Center
http://www.copyright.com
The Copyright Website
http://www.benedict.com
Corbis Media
http://www.corbis.com
Comstock
http://www.comstock.com
Cracker Barrel
http://www.photosource.com/board
Creation Captured
http://www.webcom.com/woody
Crimson Star Software
http://www.crimsonstar.com
DacEasy, Inc.
http://www.daceasy.com/daceasy
Joel Day's STOCKPHOTO
http://www.stockphoto.net
Andy Davidhazy's Photo Lists
http://www.rit.edu/~andpph/photolists.html
Deanne Delbridge Consulting
http://www.artpage.com/htm/pdnrepor.html
Digimarc
http://www.digimarc.com
ditto.com
http://www.ditto.com
DoubleTake Magazine
http://www.doubletakemagazine.org
Earth Water Stock
http://www.earthwater.com
Electric Library
http://www.elibrary.com
Elfande
http://www.elfande.co.uk
Rohn Engh
http://www.photosource.com

Find Law
 http://www.findlaw.com
FotoQuote
 http://www.cradoc.com
Fuji Film Worldwide
 http://home.fujifilm.com/index.html
Getty Images
 http://www.getty-images.com
Charles B. Gillespie
 http://www.imagesbycbg.com
Gary Gladstone
 http://www.gladstone.com
Global Photographers Search
 http://www.photographers.com
Graphic Artists Guild
 http://www.gag.org
Philip Greenspun's Photo.net
 http://photo.net/photo
The Guilfoyle Report
 http://www.gronline.com
John Harrington
 http://www.johnharrington.com
HindSight Ltd.
 http://www.hindsightltd.com
Horticultural Photography
 http://www.gardenscape.com/hortphoto.html
Image Bank
 http://www.imagebank.com
Impact Visuals
 http://www.impactvisuals.org
Index Stock Imagery
 http://www.indexstock.com
InfoSight
 http://www.infosight.com
InsWeb (Insurance Shopping)
 http://www.insweb.com
Mitch Kezar Photos
 http://www.kezarphoto.com
Kodak
 http://www.kodak.com
Ladera Press (Copyright)
 http://www.laderapress.com
Leica
 http://www.leica.com

George Lepp and Associates
http://www.leppphoto.com
Library of Congress Photos
http://memory.loc.gov/ammem/amhome.html
Live Picture
http://www.livepicture.com
Frank Borges Llosa
http://www.frankly.com
MacWorld
http://www.macworld.com
Jay Maisel
http://www.jaymaisel.com
Minolta
http://www.minolta.com
Mira
http://www.mira.com
National Press Photographers Association (NPPA)
http://metalab.unc.edu/nppa
Netscape
http://www.netscape.com
New Deal Network
http://newdeal.feri.org/
Newsmakers
http://www.newsmakers.net
Nikon
http://www.nikon.com/
Richard Nowitz
http://www.nowitz.com
O'Shaughnessy Studios Photography Resources
http://www.cmpsolv.com/los/links.html
Outdoor Photographer
http://www.outdoorphotographer.com
Outsight Environmental Photography
http://www.outsight.com
Para Publishing
http://www.parapublishing.com
Photo Direct
http://photodirect.com
Photo District News
http://www.pdn-pix.com
Photo Electronic Imaging
http://www.peimag.com
Photo Eye Books
http://www.photoeye.com

Photoflex
http://www.photoflex.com
Photographers Index
http://photographersindex.com
Photographers on the 'Net
http://www.photographersonthenet.org.
Photographers News Network
http://www.photonews.com
Photographers' Portfolios
http://www.vsii.com/portfolio/homeport.html
Photography Discussions Group
http://www.rit.edu/~andpph/photolists.html
Photo List (Andy Davidhazy)
http://www.rit.edu/~andpph/
PhotoNet
http://www.photonet.com
PhotoResource Magazine
http://www.photoresource.com
PhotoServe
http://www.photoserve.com
PhotoSource International
http://www.photosource.com
PhotoSourceBank
http://www.photosource.com/psb
PhotoSphere
http://www.photosphere.com
Photo Techniques Magazine
http://www.phototechmag.com
PictraNet
http://www.pictranet.com
Picture Agency Council of America (PACA)
http://www.pacaoffice.org
Picture Network International (PictureQuest)
http://www.publishersdepot.com
Picture Search
http://www.singlesourcephoto.com
Polaroid
http://www.polaroid.com
Portfolio Central
http://www.portfoliocentral.com
Portfolios Online
http://www.portfolios.com
Postal Rate Calculator
http://www.usps.gov/business/calcs.htm

Presslink
http://www.presslink.com
Professional Photographers of America (PPA)
http://www.ppa-world.org
Carl and Ann Purcell
http://www.purcellteam.com
Ratty Seminars
http://www.photo-seminars.com
Seth Resnick Photography
http://www.sethresnick.com
Galen and Barbara Rowell
http://www.mountainlight.com
Royal Publishing
http://www.royalpublishing.com
L.L. Rue Photos
http://www.rue.com
Lori Lee Sampson Stock Photography
http://www.sampsondesign.com/stock
Michael Schwarz Links
http://www.michaelschwarz.com/links.html
Scour.Net
http://www.scournet.com
Ron Sherman
http://www.ronsherman.com
sellphotos.com
http://www.sellphotos.com
Shutterbug
http://www.shutterbug.net
Small Business Administration (SBA)
http://www.sba.gov
Sony Pictures ImageWorks
http://www.imageworks.com
Spacestar
http://www.spacestar.com
Stock Connection
http://www.pickphoto.com/stockconn.html
The Stock Market
http://www.stockmarket.com
Stock Photo Deskbook
http://www.stockphotodeskbook.com
Stock Photo Electronic Directory
http://www.lightpencil.com/stockphoto/index.html
Stock Photography Online
http://www.mediafocus.com/stockspecials.html

Stockphoto.com
http://www.stockphoto.com
The Stock Solution
http://www.tssphoto.com
Tony Stone Images
http://www.tonystone.com
Submit It
http://www.submit-it.com
SuperStock
http://superstockimages.com
Don Tibbits Photography
http://www.dastcom.com/dastphoto/dastphoto.html
Time Warner's Pathfinder
http://pathfinder.com
Dave Trozzo
http://www.annap.infi.net/~trozzo
USA Today
http://www.usatoday.com
Joe Viesti
http://www.theviesticollection.com
Visual Support PhotoNet
http://www.vsii.com
Visuell International
http://www.piag.de/Englisch.htm
West Stock
http://www.weststock.com
Jim Whitmer Photography
http://www.whitmers.com
Art Wolfe Photography
http://www.artwolfe.com
World Press Photo
http://www.worldpressphoto.nl
World Profit (web tools)
http://www.worldprofit.com
WorldPhoto
http://www.worldphoto.com
Writer's Digest Books
http://www.writersdigest.com
Yahoo! People Search
http://people.yahoo.com
ZUMA Press
http://www.eZuma.com
Zzyzx Visual Systems
http://e-folio.com/zzyzx

Web Digital Workshops

Anderson Ranch Arts Center, P.O. Box 5598, Snowmass Village, CO 81615

Arles Journees de L'Image Pro (JIP), Sylvie Havez, Press Relations, 1 Rue Copernic, 13200 Arles, France, phone: 33 90 96 44 44, fax: 33 90 96 47 77

Gene Boaz Workshops, Route 5, Benton, KY 42025

Paul Bowling Workshops, P.O. Box 6486, Annapolis, MD 21401-0486

Brooks Institute of Photography, David Litschel, 801 Alston Rd., Santa Barbara, CA 93108, phone: (805) 966-3888, ext. 211, fax: (805) 564-1475. Web site: http://www.brooks.edu

Barbara Brundege Workshops, P.O. Box 24571, San Jose, CA 95154

Laura Buckbee Workshops, NESPA, P.O. Box 1509, New Milford, CT 06776

Michele Burgess Seminars, 20741 Catamaran Lane, Huntington Beach, CA 92646, phone: (714) 536-6104, fax: (714) 536-6578

China Photo Workshop Tour, 2506 Country Village, Ann Arbor, MI 48103-6500, phone: (800) 315-4462

Colorado Mountain College Workshops, P.O. Box 2208, Breckenridge, CO 80424

Communication Unlimited Workshops, P.O. Box 6405, Santa Maria, CA 93456

Coupeville Arts Center, P.O. Box 171, Coupeville, WA 98239, phone: (360) 678-3396, fax: (360) 678-7420

Creative Vision Workshops, Orvil Stokes, 317 E. Winter Ave., Danville, IL 61832

Jay Daniel Workshops, 816 W. Francisco Blvd., San Rafael, CA 94901

Richard Day Workshops, 6382 Charleston Rd., Alma, IL, 62807

Dillman's Sand Lake Lodge Workshops, P.O. Box 98, Lac du Flambeau, WI 54538

Rohn Engh's Workshops, Sell & Re-Sell Your Photos, Pine Lake Farm, 1910 Thirty-fifth Rd., Osceola, WI 54020, phone: (800) 624-0266

Charlene Faris Workshops, 610 W. Popular, #7, Zionsville, IN 46077

Friends of Photography Workshops, 250 Fourth St., San Francisco, CA 94103

Gerlach Nature Photography Workshops, John Gerlach, P.O. Box 259, Chatham, MI 49816

Jon Gnass Photo Images, P.O. Box 7860, Bend OR 97708, phone: (541) 383-5039, fax: (541) 317-9230

Great American Nature Photography Weekend Workshop, 5942 Westmere Dr, Knoxville, TN 37909-1056, phone: (615) 539-1667, fax: (615) 539-1348

Guide to Photo Tours, Bill Hammer, 39 Westchester Dr., Rocky Point, NY 11778

Images International, 37381 S. Desert Star Dr., Tucson, AZ 85739, phone: (520) 825-9355, fax: (520) 825-9802

Art Kane Photo Workshops, 1511 New York Ave, Cape May, NJ 08204

Ron Levy Workshops, P.O. Box 3416, Soldotna, AK 99669

Local camera stores often sponsor half-day workshops. Consult the yellow pages.

Los Angeles Photography Center Workshops, 412 S. Park View St., Los Angeles, CA 90057

Macro/Nature Photography Workshops, Robert Sisson, P.O. Box 1649, Englewood, FL 342295-1649

Maine Photographic Workshops, 2 Central St., Rockport, ME 04856, phone: (207) 236-8581

Missouri Photo Workshop, 27 Neff Annex, Columbia, MO 65201

Motivating the Reader and Selling the Graphic Arts Buyer Workshops, Dynamic Graphics, Inc., 6000 N. Forrest Park Dr., Peoria, IL 61614

National Press Photographers Association Seminars, Inc., 3200 Croasdail Dr., Suite 306A, Durham, NC 27705

Nature Images Workshops, Helen Longest-Slaughter, P.O. Box 2019, Quincy MA 02269, phone: (617) 847-0091, fax: (617) 847-0952

Nature's Light, 7805 Lake Ave, Cincinnati, OH 45236, phone: (513) 793-2346

New School Workshops, 66 W. Twelfth St., New York, NY 10011

New York Institute of Photography Workshops, 211 E. Forty-third St., Dept. WWW, New York, NY 10017. E-mail: nyi@soho.ios.com

Ogunquit Photography School Workshops, P.O. Box 2234, Ogunquit, ME 03907

Olden Workshops, 1265 Broadway, New York, NY 10001

Otter Creek Photography, Hendricks, WV 26271, phone: (304) 478-3586, fax: (304) 478-3422

Owens Valley Photography Workshops, P.O. Box 114, Somis, CA 93066

Palm Beach Photographic Workshops, 2310 E. Silver Palm Rd., Boca Raton, FL 33432, phone: (407) 391-7557

Parsons School of Design Workshops, 66 Fifth Ave., New York, NY 10011

Photo Adventures Workshops, JoAnn Ordano, P.O. Box 591291, San Francisco, CA 94118

Photographic Society of America Regional Seminars, 3000 United Founders Blvd., Suite 103, Oklahoma City, OK 73112

Photography and the Art of Seeing Workshops, Karen Schulman, P.O. Box 771640, Steamboat Springs, CO 80477-1640, phone: (970) 879-2244

Photography and Travel Workshop Directory, Serbin Communications, Inc., 511 Olive St., Santa Barbara, CA 93101

Photography in Nature Workshops, Bob Grytten, P.O. Box 3195, Holiday, FL 34690, phone: (813) 934-1222

Photography magazines often list current seminars and workshops (for the pro and amateur)

Photo Marketing Outdoor Workshop, Ron Sanford, P.O. Box 248, Gridley, CA 95948

Maria Piscopo Workshops, Creative Services Consultant, 2038 Calvert, Costa Mesa, CA 92626

Professional Workshop for the Visual Artist, The Graphic Artists Guild, 11 W. Twentieth St., 8th Floor, New York, NY 10011

Professional Workshops of America, 1090 Executive Way, Des Plaines, IL 60018

Rochester Institute of Technology Workshops, P.O. Box 9887, Rochester, NY 14623-0887

David Sanger Workshops, David Sanger, 920 Evelyn Ave., Albany, CA 94706, phone: (510) 526-0800, fax: (510) 526-2800

Santa Fe Photographic Workshops, Lisl Dennis, P.O. Box 9916, Santa Fe, NM 87504

Self-Publishing for Artists Workshop, Harold David and Marcia Keegan, Wilderness Studio, 299 Pavonia Ave., Jersey City, NJ 07302, phone: (201) 659-4554

ShawGuides The Guide to Photography Workshops, Dorlene Kaplan, 10 W. Sixty-sixth St., Suite 30H, New York, NY 10023, phone: (212) 787-6021, fax: (212) 724-9287

Shenandoah Photo Workshops, P.O. Box 54, Sperryville, VA 22740, phone: (703) 937-5555

Shutterbug/PhotoPro Workshops, 5211 S. Washington Ave., Titusville, FL 32780, phone: (407) 268-5010

Sierra Photographic Workshops, Lewis Kemper, 3251 Lassen Way, Sacramento, CA 95821

SIPI, 5 bis rue Jacquemont 75017 Paris, France, phone: 33 40 25 96 65, fax: 33 42 29 02 22

Carol Siskind Workshops, 501 Course Rd., Neptune, NJ 07759

63 Ranch Workshops, Sandra Cahill, P.O. Box 979-S, Livingston, MT 59047

Elaine Sorel Professional Photographer Workshops, 640 West End Ave., New York, NY 10024

David M. Stone Photo Workshops, 7 Granston Way, Buzzards Bay, MA 02532

Carren Strock Workshops, 1380 E. Seventeen St., Brooklyn, NY 11230, phone: (718) 375-8519

Summer Photography Workshops, Rochester Institute of Technology, Technical and Education Center, One Lomb Memorial Dr., Rochester, NY 14623

Tallac Photography Commission Workshops, Steven Short, P.O. Box 488, Glenbrook, NV 89413

Texas Parks, Big Bend Ranch Spring Photo Workshops, Jim Carr, 1019 Valley Acres Rd., Houston, TX 77062, phone: (713) 486-8070, fax: (713) 486-8112

Touch of Success Photo Seminars, Bill Thomas, P.O. Box 194, Lowell, FL 32663

Travel Photo Workshop/Santa Fe, P.O. Box 2847, Santa Fe, NM 87504

Travel Writer's Workshops, Louise Purwin Zobel, 23350 Sereno, Villa 30, Cupertio, CA 95014, phone: (415) 691-0300

Travel Writing Workshops, Effin and Jules Older, P.O. Box 163, New St.,
 Albany, VT 05820, phone/fax: (802) 755-6774
Ultimate Image Workshops, Bob Deasy, P.O. Box 22, Lawton, PA 18828
Universities, colleges and technical schools conduct seminars and workshops.
 Consult your telephone directory.
Vail Valley Arts Council Workshops, P.O. Box 1153, Vail, CO 81658, phone:
 (970) 476-4255, fax: (970) 476-4366
Visual Studies Workshop, 31 Prince St., Rochester, NY 14607
Voyagers International Workshops, P.O. Box 915, Ithaca, NY 14851, phone:
 (607) 257-3091, fax: (607) 257-3699
Web Sites Workshops—Rohn Engh, Pine Lake Farm, 1910 Thirty-fifth Rd.,
 Osceola, WI 54020, phone: (800) 624-0266
West Coast School of Professional Photography Workshops, Allen Roedel,
 P.O. Box 395, Imperial Beach, CA 92032
Wildlife Research Photography Workshops, P.O. Box 3628, Mammoth Lakes,
 CA 93546-3628, phone: (619) 924-8632, E-mail: moose395@qnet.com
Winona International School of Professional Photography Workshops, 1090
 Executive Way, Des Plaines, IL 60018
Robert Winslow Photo Tours, Inc., P.O. Box 334, Durango, CO 81302-0334
Woodstock Photo Workshops, 59 Tinker St., Woodstock, NY 12498
Norbert Wu Workshops, 1065 Sinex Ave., Pacific Grove, CA 93950
Truman Yeager Workshops, 921 Pine Terrace N., Lake Worth, FL 33460-2411

How to Search on a Search Engine

You can search most sites using simple words, or you can compose complex
queries with the advanced syntax described below.

Search Term Syntax
Natural Language
A natural language search string can be made up of a single word, a list of
words or a natural language question. For example, entering the search term
computer, returns only documents containing the word *computer*. However,
entering the seach terms "how do I attach a printer to my computer" returns
documents about printers and computers but ranks documents that discuss
attaching printers to computers at the beginning of the result list.

Phrase Searching
Phrase searching is used to ensure that one word is followed by another in the
returned document (with no other words in between) by enclosing several
terms in double quotations. For example, entering the search string: "cordless
telephone" returns only documents that contain the phrase, *cordless tele-*

phone. Documents that contain only the words *cordless* and *telephone* separately will not be returned. An alternative is to use the adjacency operator, ADJ, between terms. For example, "cordless ADJ telephone." This phrase is not equivalent to "cordless telephone."

Wild Cards

Wild Cards are specified by ending a word with an asterisk (*) or a question mark (?) as a wild card character. This is interpreted as a search on words matching the base characters before the asterisk and ignoring any trailing characters.

For example, a search string containing the phrase "geo*" may retrieve documents containing the word *geographer*, *geography*, *geologist*, *geometry* or *geometrical*.

Boolean Operators

The Boolean operators, AND, OR and NOT, aid in establishing logical relationships between concepts expressed in natural language. These operators are especially useful in narrowing or expanding a search.

Note: Boolean operators must be entered in uppercase letters; otherwise they will be treated as natural language queries.

And The AND operator is useful in restricting a search when a particular pair of phrases are known. For instance, when searching for documents containing information on the weather in Boston, a search string such as "weather AND Boston" finds only those documents containing both *weather* and *Boston*. An alternative syntax for this search is "weather && Boston."

Or The OR operator is used to join two different phrases of a Boolean search together. A search string such as "hurricane OR tornado" finds all documents containing either *hurricane* or *tornado* (or both). An alternative syntax for this search is "hurricane || tornado."

Not The NOT operator is used to reject documents that contain certain words. The search string "basketball NOT college" finds all documents that contain the word *basketball* but do not contain the word *college*.

Precedence of Operators

When search terms contain more than one operator, operator order (precedence) may be controlled with parentheses.

Newsletters and Magazines

Adobe Magazine, 411 First Ave. S., Seattle, WA 98104, phone: (206) 386-8823, fax: (206) 343-3273. Emphasizes digital imagery.
Advertising Age, 740 Rush St., Chicago, IL 60611-2590. Weekly advertising

and marketing tabloid, reporting trends and marketing news.

Adweek, A/S/M Communications Inc., The Merchandise Mart, Suite 936, Chicago, IL 60654, phone: (312) 464-0880. Advertising and marketing trends and updates.

American Photo, 1633 Broadway, New York, NY 10019, phone: (212) 767-6267. General interest photography.

Art Business News, 60 Ridgeway Plaza, P.O. Box 3837, Stamford, CT 06905, phone: (203) 356-1745. Art dealers and related business. Information on the fine art poster world. Calendars and paper products sometimes featured.

Art Calendar, P.O. Box 199, Upper Fairmount, MD 21867, phone: (410) 651-9150, fax: (410) 651-5313. Emphasizes business-side of being an artist or photographer.

ArtNetwork, P.O. Box 1268, 18757 Wildflower Dr., Penn Valley, CA 95946

The Art of Self Promotion Newsletter, P.O. Box 23, Hoboken, NJ 07030-0023, phone: (201) 653-0783

ASJA Contracts Watch, American Society of Journalists and Authors, Inc., 1501 Broadway, Suite 302, New York NY, 10036

ASPP Newsletter (American Society of Picture Professionals), The Picture Professional, 437 E. Eightieth St. #4, New York, NY 10021. For the editorial stock photographer and photo researcher.

BoardRoom Reports, Boardroom Business Reports Inc., 330 W. Forty-second St., New York, NY 10036

BottomLine, Boardroom Business Reports Inc., 330 W. Forty-second St., New York, NY 10036

Chicago Artists' Coalition, 11 E. Hubbard, 7th Floor, Chicago, IL 60611, phone: (312) 670-2060, fax: (312) 670-2521

Communication Arts, 410 Sherman Ave., P.O. Box 10300, Palo Alto, CA 94303. Covers design, illustration and photography.

Communication Briefings, 700 Black Horse Pike, Suite 110, Blackwood, NJ 08012, phone: (609) 232-6380

CopyRights, Lynda Utterback, 1247 Milwaukee Ave., Suite 303, Glenview, IL 60025-2425

Decor, 330 N. Fourth St., St. Louis, MO 63102, phone: (314) 421-5445. News that includes photo decor.

Desktop Publishers, 462 Boston St., Topsfield, MA 01983-1232. E-mail: nadt p1@shore.net., nadtp@aol.com, 74064.2334@compuserve.com

Editor and Publisher, The Editor and Publisher Company, Inc., 11 W. Nineteenth St., New York, NY 10011, phone: (212) 675-4380. Weekly covers latest developments in journalism and newspaper production.

Editorial Experts, Inc., 66 Canal Center Plaza, 200, Alexandria, VA 22314-1538

Editors Only, 275 Batterson Dr., New Britain, CT 06053

Entry, P.O. Box 7648, Ann Arbor, MI 48107. Contests.

F8 and Being There, P.O. Box 3195, Holiday, FL 34690, phone: (813) 934-1222, (800) 990-1988

Folio, 6 River Bend, P.O. Box 4949, Stamford, CT 06907-0949, phone: (212) 972-6300. Monthly magazine featuring trends in magazine circulation, production and editorial content.

Guilfoyle Report, AG Editions Inc., 41 Union Square W., Room 523, New York, NY 10003

Home Based Business Directory News, Mountain View Systems, 930 S. Washington Ave., Suite 111, Scranton, PA 18505

Home Office Computing, 411 Lafayette St., New York, NY 10003, phone: (612) 633-0578, fax: (612) 633-1862. For the small office/home office (SOHO).

Home-Run Business, 7627 Iron Gate Lane, Frederick, MD 21702

Ilford Photo Newsletter, 70 W. Century Rd., Pramus, NJ 07653

Imagist Photographic Administrators, Inc. (PAI), 1150 Avenue of the Americas, New York, NY 10036

Inter@ctive Week, 100 Quentin Roosevelt Blvd., Suite 508, Garden City, NY 11530, phone: (516) 229-3700, fax: (516) 229-3777. Emphasis is on TV interaction, the Web, net PCs.

International Photographer Magazine, American Image Inc., 6495 Shallowford Rd., Louisville, NC 27023, phone: (919) 945-9867, fax: (919) 945-3711. For service photographers. Contains product reviews, equipment buyers' guides, moneymaking tips, service photographers' success stories.

Internet World, Mecklermedia Corporation, 20 Ketchum St., Westport, CT 06880. E-mail: info@mecklermedia.com. Updates on the Web, E-mail and electronic highway.

Markets Abroad, Michael Sedge and Associates, 2460 Lexington Dr., Owasso, MI 48867

Mind Your Business, P.O. Box 14850, Chicago, IL 60614

Natural Image, Lepp and Associates, P.O. Box 6240, Los Osos, CA 93412, phone: (805) 528-7385

New Media Magazine, P.O. Box 5310, Pittsfield, MA 01203-9998, fax: (413) 637-4343. Emphasis on CD-ROM, on-line, Web and soon.

Outdoor Photographer, 12121 Wilshire Blvd., Suite 1220, Los Angeles, CA 90025, phone: (310) 820-1500. Monthly magazine emphasizing equipment and techniques for shooting in outdoor conditions. How-to articles often feature wildlife, nature and outdoor recreation.

PartyLine, 35 Sutton Place, New York, NY 10022, phone: (212) 755-3487, fax: (212) 755-4859, E-mail: byarmon@ix.netcom.com, Web site: http://www.partylinepublishing.com

PC Graphics and Video, 201 E. Sandpointe Ave., Suite 600, Santa Ana, CA 9270, phone: (714) 513-8400, fax: (714) 513-8612. Emphasis on PCs, the Web and the electronic highway.

PC Photo, Werner Publishing Corporation, 12121 Wilshire Blvd., Los Angeles, CA 90025-1123

Petersen's Photographic Magazine, 6420 Wilshire Blvd., Los Angeles, CA

90048, phone: (213) 782-2000. Monthly magazine for beginning and semi-professional photographers in all phases of photography.

PhotoDaily, Photo Source International, Pine Lake Farm, 1910 Thirty-fifth Rd., Osceola, WI 54020, phone: (800) 624-0266

Photo District News, 1515 Broadway, New York, NY 20036, phone: (212) 536-6595

Photo Traveler, P.O. Box 39912, Los Angeles, CA 90039, phone: (213) 660-0473

Photograph Collector, 301 Hill Ave., Langhorne, PA 19047-2819

Photographer Guidelines, Picture This, 88 Howard St., Suite 1002A, San Francisco, CA 94105

Photographic Resource Center Newsletter, 602 Commonwealth Ave., Boston, MA 02215

Photographic Trade News, 445 Broadhollow Rd., Melville, NY 11747, phone: (516) 845-2700, fax: (516) 845-7109. Reports on the photography industry.

Photography for Industry, 38 Rick Lane W., Peekskill NY, 10566

PhotoLetter, PhotoSource International, Pine Lake Farm, 1910 Thirty-fifth Rd., Osceola, WI 54020, phone: (800) 624-0266

Photomedia, 1909 Corliss Ave. N., Seattle, WA 98133, phone: (206) 363-0470 or (206) 745-9069, fax: (206) 364-4697. Commercial photographer orientation for the Northwest.

PhotoStockNotes, PhotoSource International, Pine Lake Farm, 1910 Thirty-fifth Rd., Osceola, WI 54020, phone: (800) 624-0266

Photowork, 317 E. Winter Ave., Danville, IL 61832-1857. Orvil Stokes's monthly.

Popular Photography, 1633 Broadway, 43rd Floor, New York, NY 10019, phone: (212) 767-6326, fax: (212) 767-5629. Monthly magazine featuring wide range of equipment and techniques for general photography audience.

Print, 104 Fifth Ave., 9th Floor, New York, NY 10011. Bimonthly magazine focusing on creative trends and technological advances in illustration, design, photography and printing.

Professional Photographer, Professional Photographers of America (PP of A), 57 Forsyth St. N.W., Ste. 1600, Atlanta, GA 30303, phone: (800) 786-6277, fax: (404) 614-6400. Monthly magazine emphasizing techniques and equipment for service photographers.

Publish, 501 Second St., San Francisco, CA 94107, phone: (800) 656-7495. Emphasis on computer graphics; aimed at desktop graphic artists.

Publishers Weekly, 249 W. Seventeenth St., New York, NY 10011, phone: (212) 645-9700, fax: (212) 463-6631, Web site: http://www.bookwire .com. Weekly magazine covering industry trends and news in book publishing, book reviews and interviews. Often will make announcements of works in progress.

Publishing Poynters, Para Publishing, P.O. Box 4432-881, Santa Barbara, CA 93140-4232, phone: (805) 968-7277

Quick Trips Travel Letter, P.O. Box 3308, Crofton, MD 21114, phone: (301) 262-0177. Newsletter featuring three- to five-day getaways.

Range of Light Works, P.O. Box 100, Yosemite, CA 95389, phone: (209) 372-4024

Selling Stock, Jim Pickerell, 110 Frederick Ave., Suite A, Rockville, MD 20850, phone: (301) 251-0720, fax: (301) 309-0941, E-mail: sellingstock@chd.com

Shutterbug, 5211 S. Washington Ave., Titusville, FL 32780

SPAR Newsletter, (Society of Photographers and Artists Representatives), 127 W. Twenty-sixth St., New York, NY 10001, phone: (718) 691-4242

Stock Photo Report, 7432 N. Laymon Ave., Skokie, IL 60077, phone: (708) 677-7887, fax: (847) 677-7891. E-mail: bseed@wwa.com

Studio Photography, 445 Broadhollow Rd., #21, Melville, NY 11747-4722, phone: (516) 845-2700, fax: (206) 364-4697. Commercial studio photography.

WCPP Newsletter (World Council of Professional Photographers), 10915 Bonita Beach Rd., #1091, Bonita Springs, FL 33923, phone: (813) 992-4421, fax: (813) 992-6328

Webmaster, 492 Old Connecticut Path, P.O. Box 9208, Farmingham, MA 01701-9208, phone: (508) 872-0080, fax: (508) 879-7784. Reports on World Wide Web.

Western Photographer, 2031 E. Via Burton, #C, Anaheim, CA 92806-1202

Windows Magazine, CMP Media Inc., 600 Community Dr., Manhasset, NY 11030. Web site: http://www.winmag.com

Wired, P.O. Box 191826, San Francisco, CA 94119-9866, phone: (800) 769-4733 or (415) 222-6200, fax: (800) 666-5629, E-mail: wired@neodata.com. For high-tech enthusiasts. Much info on the electronic highway.

Associations and Organizations

Advertising Photographers of America (APA), 7201 Melrose Ave., Los Angeles, CA 90046, phone: (213) 935-7283, fax: (213) 935-3855, Web site: http://www.apanational.com

Advertising Photographers of New York (APNY), 27 W. Twentieth St., New York, NY 10011, phone: (212) 807-0399, fax: (212) 727-8120

American Film Institute (AFI), John F. Kennedy Center for the Performing Arts—Washington, DC 20566, phone: (202) 828-4000

American Society of Journalists and Authors (ASJA), 1501 Broadway, Suite 302, New York, NY 10036, phone: (212) 997-0947, fax: (212) 768-7414

American Society of Media Photographers (ASMP), 14 Washington Rd., Suite 502, Princeton Junction, NJ 08550, phone: (609) 799-8300

American Society of Photographers (ASP), P.O. Box 52836, Tulsa, OK 74158

American Society of Picture Professionals (ASPP), 409 S. Washington St., Alexandria, VA 22314-3629, phone/fax: (703) 299-0219, E-mail: aspp1@idsonline.com

Arts Information Center, 280 Broadway, New York, NY 10007, phone: (212) 227-0282

Association for Multi-Image International (AMI), 8019 N. Himes Ave., Suite 401, Tampa, FL 33614, phone: (813) 932-1692

Author's Guild, 330 W. Forty-second St., New York, NY 10036, phone: (212) 563-5904, fax: (212) 564-8363, E-Mail: staff@authorsguild.org

British Association of Picture Libraries and Agencies (BAPLA), 13 Woodberry Crescent, London N10 1PJ England, phone: 44 81 444 7913, fax: 44 81 883 9215

Graphic Artists Guild, 11 W. Twentieth St., 8th Floor, New York, NY 10011

Greeting Card Creative Network, 1200 G St., NW, #760, Washington, DC 20005, phone: (202) 393-1780

International Fire Photographers Association (IFPA), P.O. Box 8337, Rolling Meadows, IL 60008, phone: (708) 394-5835

International Food, Wine and Travel Writers Association (IFW&TWA), P.O. Box 13110, Long Beach, CA 90803, phone: (310) 433-5969, fax: (310) 438-6384

International Glamour Photographers Association (IGPA), P.O. Box 620, Dept. B, Washington, MO 63090

National Association for the Cottage Industry, P.O. Box 14850, Chicago, IL 60614, phone: (312) 472-8116

National Press Photographers Association (NPPA), 3200 Croasdaile Dr., Suite 306, Durham, NC 27705, phone: (919) 383-7246, (800) 289-6772, fax: (919) 383-7261, E-mail: sweitzer@wish-tv.com loundy@lightside.com, Web site: http://metalab.unc.edu/nppa

National Writers Union, 837 Broadway, Suite 203, New York, NY 10003, phone: (212) 254-0279, fax: (212) 254-0673, E-mail: nwu@netcom.com

North American Nature Photographers Association (NANPA), 10200 W. Forty-fourth Ave., Suite 304, Wheat Ridge, CO 80033-2840, phone: (303) 422-8527, fax: (303) 422-8894, E-mail: nanpa@resourcenter.com, Web site: http://www.nanpa.org

Photographic Society of America (PSA), 3000 United Founder Blvd., Suite 103, Oklahoma City, OK 73112

PhotoGreen, 30 Musconetcong River Rd., Hampton, NJ 08827-9540, phone: (908) 537-4313, E-mail: bobs@photogreen.org, Web site: http://www.photogreen.org

Picture Agency Council of America (PACA), P.O. Box 308, Northfield, MN 55057-0308, phone: (800) 457-PACA, Web site: http://www.pacaoffice.org

Professional Photographers of America (PP of A), 57 Forsyth St., NW, Suite

1600, Atlanta, GA 30303-2206, phone: (404) 522-8600, fax: (404) 614-6400, E-mail: jhopper594@aol.com

Small Office Home Office Association (SOHOA), 1765 Business Center Dr., Reston, VA 20190, phone: (703) 438-3060, (888) SOHO-11, E-mail: msgm od@aol.com

Society for Photographic Education (SPE), P.O. Box 222116, Dallas, TX 75222-2116, phone: (817) 272-2845, fax: (817) 272-2846, E-mail: SocPhot oEd@aol.com, Web site: http://www.spenational.org

Society of Photographers and Artists Representatives (SPAR), 1123 Broadway, Room 914, New York, NY 10010, phone: (212) 924-6023

Society of Professional Videographers (SPV), P.O. Box 1933, Huntsville, AL 35807, phone: (205) 534-9722

University Film and Video Association (UFVA), School of Cinema Television, University of Southern California, University Park, MC2212, Los Angeles, CA 90089

Wedding and Portrait Photographers International (WPPI), 1312 Lincoln Blvd., Santa Monica, CA 90401, phone: (310) 451-0090, fax: (310) 395-9058, Web site: http://www.wppi-online.com

Books

Artist To Artist, Clint Brown
Jackson Creek Press, Jackson Creek Dr., Corvallis, Oregon 97330, phone: (541) 752-4666

ASMP Stock Photo Handbook (American Society of Media Photographers), 419 Park Ave. S., #1407E, New York, NY 10016

Basic Book of Photography, Tom and Michel Grimm
Viking Penguin Inc., 375 Hudson St., New York, NY 10014-3657

Basic 35mm Photo Guide, Craig Alesse
Amherst Media, Inc., P.O. Box 586, Buffalo, NY 14226, phone: (716) 874-4450

Big Bucks Selling Your Photography, Cliff Hollenbeck
Amherst Media, Inc., P.O. Box 586, Buffalo, NY 14226, phone: (716) 874-4450

Black and White Portrait Photography, Helen T. Boursier
Amherst Media, Inc., P.O. Box 586, Buffalo, NY 14226, phone: (716) 874-4450

BPI Syndicated Columnists
BPI Media Services, 1515 Broadway, New York, NY 10036

BPI Television Contacts
BPI Media Services, 1515 Broadway, New York, NY 10036

Canadian Markets for Writers and Photographers, Melanie Rockett

#304 1128 Quebec St., Vancouver, BC V6A 4El, Canada, E-mail: ppp@proofpositive.com

Chicago Talent Sourcebook, William Morrow & Co.
1350 Ave. of the Americas, New York, NY 10019

Computer Photography Handbook, Rob Sheppard
Amherst Media, Inc., P.O. Box 586, Buffalo, NY 14226, phone: (716) 874-4450

Congressional Yellow Book
H&M Publishers, 44 W. Market St., P.O. Box 311, Rhinebeck, NY 12572, phone: (914) 876-2081

The Copyright Law of the United States of America
The Library of Congress, 101 Independence Ave., SE, Washington, DC 20540, E-mail: lcweb@loc.gov

Creative Black Handbook
401 Park Ave. S., #1407E, New York, NY 10016

Creative Cash, Barbara Brabec
Prima Publishing, 3875 Atherton Rd., Rochlin, CA 95765, phone: (916) 632-4400

Cut Your Photo Costs, Bill McQuilkin
43 Pennsylvania Ave., Glen Ellyn, IL 60137

Directory of Washington Representatives
H&M Publishers, 44 W. Market St., P.O. Box 311, Rhinebeck, NY 12572, phone: (914) 876-2081

Direct Stock
Direct Stock, Inc., 10 E. Twenty-first St., 14th Floor, New York, NY 10010, phone: (212) 979-6560

Family Portrait Photography, Helen T. Boursier
Amherst Media, Inc., P.O. Box 586, Buffalo, NY 14226, phone: (716) 874-4450

Feature News Publicity Outlets
H&M Publishers, 44 W. Market St., P.O. Box 311, Rhinebeck, NY 12572, phone: (914) 876-2081

Federal Yellow Book
Kluwer Academic Publishers, 101 Philip Dr., Assinippi Pk., Norwell, MA 02061, phone: (781) 871-6600

Finding Images Online, Paula Berinstein
Information Today, Inc., 143 Old Marlton Pike, Medford, NJ 08055, phone: (609) 654-6266

Focus on Photography Information
P.O. Box 2182, Madison, WI 53701-2182

Freelance Photographer's Handbook, Fredrik D. Bodin
Curtin and London, Inc., P.O. Box 363, Marblehead, MA 01945

Getting Serious About Photography, Ernest H. Robl
P.O. Box 3270, Durham NC 27715-3270, E-mail: her@mindspring.com

Geologic, Jerome Wyckoff
　　Adastra West, Inc., Publisher, P.O. Box 874, Mahwah, NJ 07430
Gold Book of Photography Prices, Tom Perret
　　Photography Research Institute Carson Endowment (PRICE), 21237 S.
　　Moneta Ave., Carson CA 90745
Guide to International Photographic Competition, Charles Benson
　　Amherst Media Inc., 155 Rano St., Suite 300, Buffalo, NY 14207
A Guide to Travel Writing and Photography, Ann and Carl Purcell
　　Writer's Digest Books, 1507 Dana Ave., Cincinnati, OH 45207
Historic Photographic Processes, Richard Farber
　　Allworth Press, 10 E. Twenty-third St., Suite 210, New York, NY 10010,
　　phone: (800) 491-2808
Homemade Money, Barbara Brabec
　　Betterway Books, 1507 Dana Ave., Cincinnati, OH 45207
Homeowner's Property Tax Relief Kit, Lawrence J. and Vincent P. Czaplyski
　　McGraw-Hill, Inc., Two Penn Plaza, 20th Floor, New York, NY 10121,
　　phone: (212) 904-4509
How to Market You and Your Book, Richard F. O'Conner
　　O'Connor House Publishers, 734 D Cieneguitas Rd., Santa Barbara, CA
　　93110, phone: (809) 654-2853
How to Shoot Stock Photos That Sell, Michal Heron
　　Allworth Press, 10 E. Twenty-third St., New York, NY 10010, phone: (800)
　　491-2808
*How You Can Make $25,000 a Year With Your Camera—No Matter Where
You Live*, Larry Cribb
　　Writer's Digest Books, 1507 Dana Ave., Cincinnati, OH 45207
International Writers' and Artists' Yearbook
　　Writer's Digest Books, 1507 Dana Ave., Cincinnati, OH 45207
The Internet Research Guide, Timothy K. Maloy
　　Allworth Press, 10 E. Twenty-third St., New York, NY 10010, phone: (800)
　　491-2808
Legal Wise, Carl W. Battle
　　Allworth Press, 10 E. Twenty-third St., New York, NY 10010, phone: (800)
　　491-2808
Lesly's Handbook of Public Relations and Communications
　　NTC Contemporary Publishing, 4255 W. Touhy Ave., Lincolnwood, IL
　　60464
Lighting Techniques for Photographers, Norman Kerr
　　Amherst Media, Inc., P.O. Box 586, Buffalo, NY 14226, phone: (716) 874-
　　4450
The Little Web Cam Book, Elisabeth Parker
　　Peachpit Press, 1249 Eighth St., Berkeley, CA 94710, phone: (800) 283-
　　9444, Web site: http://www.peachpit.com
The Little Windows 98 Book, Alan Simpson

Peachpit Press, 1249 Eighth St., Berkeley CA 94710, Phone: (800) 283-9444, Web site: http://www.peachpit.com

Looking Good in Print
Ventana Communications Group, P.O. Box 13964, Research Triangle Park, NC 27709

Macintosh Bible, FileMaker Pro 3, Charles Rubin
Peachpit Press, 1249 Eighth St., Berkeley, CA 94710, Web site: http://www.peachpit.com

Making a Living Without a Job, Barbara J. Winter
Bantam Books, 1540 Broadway, New York, NY 10036, phone: (800) 223-6834

Metro California Media
H&M Publishers, 44 W. Market St., P.O. Box 311, Rhinebeck, NY 12572, phone: (914) 876-2081

Microsoft FrontPage, Laura Lemay and Denise Tyler
Macmillan Computer Publishing, 135 S. Mount Zion Rd., Lebanon, IN 46052

Microsoft Office 2000
Macmillan Computer Publishing, 200 Old Tappan Rd., Tappan, NJ 07675, phone: (800) 428-5331

Easy Microsoft Outlook 2000
Macmillan Computer Publishing, 200 Old Tappan Rd., Tappan, NJ 07675, phone: (800) 428-5331

Moonlighting, Jo Frohbieter-Mueller
PSI Research, 300 N. Valley Dr., Grants Pass, OR 97526, phone: (800) 228-2275

Multimedia Law and Business Handbook, J. Dianne Brinson and Mark F. Radcliffe
Ladera Press, 3130 Alpine Rd., Suite 200-9002, Menlo Park, CA 94025, phone: (800) 523-3721

Naked in Cyberspace, Carol A. Lane
Information Today, Inc., 143 Old Marlton Pike, Medford, NJ 08055, phone: (800) 300-9868

Nature and Wildlife Photography, Susan McCartney
Allworth Press, 10 E. Twenty-third St., New York, NY 10010, phone: (800) 491-2808

Nature Photography: A Current Perspective, Ted Anderson and Katheryne Gall
Roger Tory Peterson Institute of Natural History, 311 Curtis St., Jamestown, NY 14701

Negotiating Stock Photo Prices, Jim Pickerell
110 Fredrick Ave., Suite A, Rockville, MD 20850, phone: (301) 309-0941

Non-Designer's Web Book, Robin Williams
Peachpit Press, 1249 Eight St., Berkeley, CA 94710, phone: (800) 283-9444

One Digital Day, Rick Smolan
 Times Books, 201 E. Fiftieth St., New York, NY 10022, phone: (800) 726-0600
One Hundred and One Tips, Billy Barnes
 313 Severin St., Chapel Hill, NC 27516, phone: (919) 942-6350, E-mail: bbarnes@aol.com
Outdoor Photography: 101 Tips and Hints, Heather Angel
 Saunders Photographic, Inc., 21 Jetview Dr., Rochester, NY 14624, phone: (716) 328-7800
PageMaker 6.5, Ted Alspach
 Peachpit Press, 1249 Eighth St., Berkeley, CA 94710, phone: (800) 283-9444, Web site: http://www.peachpit.com
PC Bible, Robert Lauriston
 Peachpit Press, 1249 Eighth St., Berkeley, CA 94710, phone: (800) 283-9444, Web site: http://www.peachpit.com
Permanence and Care of Color Photographs, Henry Wilhelm and
 Carol Brower
 Preservation Publishing Company, 719 State St., P.O. Box 270, Grinnell, IA 50112-5575, phone: (800) 335-6647
Photographer's Digital Studio, Joe Farace
 Peachpit Press, 1249 Eighth St., Berkeley, CA 94710, phone: (800) 283-9444
Photographer's Guide to Getting and Having a Successful Exhibition
 Consultant Press, 163 Amsterdam Ave., #201, New York, NY 10023, phone: (212) 838-8640
*The Photographer's Market Guide to Photo Submissions and Portfolio
 Formats*, Michael Willins
 Writer's Digest Books, 1507 Dana Ave., Cincinnati, OH 45207, Web site: http://www.writersdigest.com
Photographer's Publishing Handbook, Harold Davis
 Images Press, 89 Fifth Ave. #903, New York, NY 10003-3020
Photo Marketing Guidebook, Peter Gould and Shama Hekim
 Images Media, 89 Fifth Ave. #903, New York, NY 20003-3020
PhotoWorks Plus: How to Use Every Feature, Joe Farace
 Seattle FilmWorks, 1260 Sixteenth Ave., Seattle, WA 98119
Pricing Photography, Michal Heron
 Allworth Press, 10 E. Twenty-third St., Suite 210, New York, NY 10010, phone: (800) 491-2808
*Professional Photographer's Guide to Shooting and Selling Nature and
 Wildlife Photos*, Jim Zuckerman
 Writer's Digest Books, 1507 Dana Ave., Cincinnati, OH 45207
Professional Secrets for Photographing Children, Douglas Allen Box
 Amherst Media, Inc., P.O. Box 586, Buffalo, NY 14226, phone: (716) 874-4450

Professional's Guide to Publicity
Public Relations Publishing, 220 E. Forty-second St., 8th Floor, New York, NY 10017, phone: (212) 601-8005
Programming Intelligent Agents for the Internet, Mark Watson
Computing McGraw-Hill, 2600 Tenth St., Berkeley, CA 94710
Publishing Your Art as Cards, Posters and Calendars, Harold Davis
Consultant Press, Ltd., 163 Amsterdam Ave. #201, New York, NY 10023, phone: (212) 838-8640
The Question-and-Answer Guide to Photogrpahic Techniques, Lee Frost
Sterling Publishing Company, Inc., 387 Park Ave. S., New York, NY 10016-8810, phone: (800) 367-9692
Real World Scanning and Halftones, David Blatner, Glenn Fleishman, Steve Roth
Peachpit Press, 1249 Eighth St., Berkeley, CA 94710. Phone: (800) 283-9444, Web site: http://www.peachpit.com
Reed's Worldwide Directory of Public Relations Organizations
H&M Publishers, 44 W. Market St., P.O. Box 311, Rhinebeck, NY 12572, phone: (914) 876-2081
Re-Engineering the Photo Studio, Joe Farace
Allworth Press, 10 E Twenty-third St., Suite 210, New York, NY 10010, phone: (800) 491-2808
Sell and Re-Sell Your Photos, Rohn Engh
Writer's Digest Books, 1507 Dana Ave., Cincinnati, OH 45207, Web site: http://www.writersdigest.com
Self-Publishing Manual, Dan Poynter
Para Publishing, 530 Ellwood Ridge, Santa Barbara, CA 93117, phone: (800) 727-2782
Selling Stock Photography, Lou Jacobs Jr.
Amphoto Books, 1515 Broadway, New York, NY 10036, phone: (800) 278-8477
Stock Photo Deskbook, David Lesser
The Exeter Company Inc., 767 Winthorp Rd., Teaneck, NJ 07666, phone: (800) 391-3903
Stock Photography, Ulrike Welsch
Amherst Media, Inc., P.O. Box 586, Buffalo, NY 14226, phone: (716) 874-4450
Stock Photography: The Complete Guide, Ann and Carl Purcell
Writer's Digest Books, 1507 Dana Ave., Cincinnati, OH 45207
Stock Direct
American Photography Showcase, 724 Fifth Ave., New York, NY 10019
Successful Fine Art Marketing, Marcia Layton
Consultant Press, Ltd., 163 Amsterdam Ave. #201, New York, NY 10023, phone: (212) 838-8640
Stock Workbook, Scott & Daughters Publishing
940 N. Highland Ave., Los Angeles, CA 90038, phone: (800) 547-2688

Taking Pictures For Profit, Lee Frost
 Sterling Publishing Company Inc., 387 Park Ave. S., New York, NY 10016-8810, phone: (800) 367-9692
Techniques of Natural Light Photography, Jim Zuckerman
 Writer's Digest Books, 1507 Dana Ave., Cincinnati, OH 45207
Travel Photography, Susan McCartney
 Allworth Press, 10 E. Twenty-third St., Suite 210, New York, NY 10010, phone: (800) 491-2808
Travel Writer's Handbook, Louise Purwin Zobel
 Surrey Books, Inc., 230 E. Ohio St., Chicago, IL 60611, phone: (800) 326-4430
Washington Information Directory
 Congressional Quarterly, 1414 22nd St., NW, Washington, DC 20037, phone: (800) 638-1710
Web Site Stats, Rick Stout
 Pemberton Press, 462 Danbury Rd., Wilton, CT 06897
Where to Sell Your Photographs in Canada, Melanie Rockett
 Proof Positive Productions Ltd., 5315 108th St., Edmonton, Alberta T6H 2Y6 Canada
Webster's New World Dictionary of Media and Communications
 MacMillan Publishing, 200 Old Tappan Rd., Old Tappan, NJ 07675, phone (800) 428-5331
The Windows 98 Bible, Fred Davis
 Peachpit Press, 1249 Eighth St., Berkeley, CA 94710, Web site: http://www.peachpit.com
Winning Photo Contests, Jeanne Stallman
 Images Press, 7 E. Seventeenth St., New York, NY 10003, phone: (212) 675-3707
Workbook: The National Directory of Creative Talent
 Scott & Daughters Publishing, 940 N. Highland Ave., Los Angeles, CA 90038
The Writer's and Photographer's Guide to Global Markets, Micheal Sedge
 Allworth Press, 10 E. Twenty-third St., Suite 210, New York, NY 10010, phone: (800) 491-2808

Glossary

ADSL (ASYMMETRIC DIGITAL SERIAL LINE): Provides inexpensive, high-speed dedicated Internet access. Not available in many areas. See also *DSL; cable modem.*
ALGORITHM: A mathematical formula or set of rules. A step-by-step computational/logical process typically designed for maximum efficiency.
ANALOG: Refers to sounds, sights and objects in the real world. Data that is

not finitely divisible or quantified in nature. To capture real-world, analog data onto your computer, some device needs to digitize the data. See also *digital*; *digitize*.

ASCII (AMERICAN STANDARD CODE FOR INFORMATION INTER-CHANGE): A machine-readable code for representing printable text characters, such as numbers, letters and punctuation. There are standardized ASCII sets, which allow different computers to read the same letters out of zeros and ones, and there are specialized and extended ASCII sets.

.ASP (ACTIVE SERVER PAGE): An HTML document that's dynamically created (on-the-fly) by a Microsoft Web server. It is used for less-intensive Web-based forms, such as registration processes.

BANDWIDTH: The amount of resources and disk space used when transferring files over a network or via the Internet. Typical modem bandwidths are 28.8K, 33.6K and 56K. Higher modem speeds are called "broadband."

BINARY FILE: A data file containing zeros and ones that don't translate into printable characters; rather, these zeros and ones translate into CPU instructions or binary-encoded data. Attempting to open such a file with a text program results in a garbled mess of letters and other characters.

BITMAP: A binary image file format that gives each pixel of an image a color value. Non-bitmapped images are generated from mathematical formulas or lossy compression algorithms. See also *lossy compression*.

BROWSER: Internet client software that is used to browse the WWW for various kinds of Internet resources.

CABLE MODEM: Allows high-speed Internet access through an existing cable TV connection. Cable modems download faster than they upload (like ADSL). Does not generally offer a dedicated line. See also *ADSL*; *DSL*.

CAM: A device or combination of devices that capture images and video to your computer.

CASE-INSENSITIVE: Disregarding capitalization. A search facility or other text-sorting tool that is case-insensitive finds a match regardless of capitalization.

.CGI (COMMON GATEWAY INTERFACE): Full-blown server-end programs that take input and return output across the Web. It's used for intensive processes, such as searching or Internet database functions.

CHANNELS: One evolution of the "push" technology fad. Channels allow users to have select content sent to their desktops automatically. Most channels contain data that's updated daily.

CLIENT: An Internet software program that is used to contact and communicate data to and from another computer running a server software program (a Web site).

CLIP ART: Generic drawings used for desktop publishing, usually packaged as collections rather than single items.

CMY (CYAN, MAGENTA, YELLOW): The print color model in which cyan,

magenta and yellow inks are mixed to produce colors. More commonly called CMYK, where *K* stands for the black values.

COMPRESSION: A process that reduces the size of a file by eliminating repeated data and other common patterns. Compression is handled by algorithms, or formulas, that tell software how to store and retrieve the information in compact form. It may be lossless, whereby the file will be identical upon decompression, or lossy, meaning some data is lost in the compression process to be filled in during decompression. Many image formats, like JPEG and even MPEG-2, used for DVD video and DSS satellite broadcasts use lossy compression. MP3 is a popular lossy-compressed audio format.

CPU (CENTRAL PROCESSING UNIT): The brain of your computer; a piece of hardware that does all of the core computing. Its speed is commonly measured by how many millions of times its crystal oscillator switches per second, in megahertz (MHz). A 450 MHz processor has 450 million cyles per second. Intel manufactures the popular Pentium/Pentium II/Pentium III CPUs. These and others made by Cyrix, AMD and the like are of X86 architecture, which refers to the way the internal circuitry of the processor functions. Other architectures include Alpha, StrongARM, PowerPC—the list goes on and on.

DATA: Information. When stored on a computer's storage device or transferred between computers through a network or over the Internet, this information is digital. Analog information is exchanged by older phone lines, audio- and video-tape recorders and human interaction.

DIGITAL: Describes images, movies, sounds, files and other data formatted for a computer. There is a defined limit, depending on the format, as to how much data may be stored in a certain amount of a medium. For example, a digital audio CD can store exactly so many bits of data, stored in an exact waveform audio format. Digital information, contrary to popular connotation, is more limited, holds less fidelity and is of lower quality than analog information, but since computers can use and process digital data, it is a very efficient, fast and flexible way to store data. See also *analog*; *data*; *digitize*.

DIGITIZE: The process of converting analog data to a digital format for use by your computer. See also *analog*; *data*; *digital*.

DOMAIN NAME: The unique name or alias that identifies an Internet server, for example, www.photosource.com, www.yahoo.com, accinfo.sound.net.

DPI (DOTS PER INCH): The number of pixels per linear inch in a digital image; a one-inch square at 300 dots per inch comprises 300×300 dots, or 90,000 dots.

DOWNLOADING: Transferring data from one computer device to another. It's downloaded or received by the client from the server. Under many Internet setups, downloading is faster than uploading; with old-school modems, local networks and high-end Internet connections, downloading and uploading uses the same amount of bandwidth.

8-BIT COLOR: A display that is mapped to the 256-color system palette or the 216-color Web palette; or a computer's graphics subsystem setting capable of displaying up to 256 colors on the screen. The term *8-bit* refers to eight binary values, or two to the eighth power, which results in 256 values.

EMBEDDED: On the Web, embedded files, such as movies, appear as part of your Web page layout. Embedded files generally require browser plug-ins in order to launch.

FAQs (FREQUENTLY ASKED QUESTIONS): A page or set of pages on a Web site or in a software application's documentation that lists questions frequently received from users, and the answers.

FILENAME EXTENSION: Usually a three-letter set of characters that follows the period in a filename and indicates its format. On the Web, files must have a filename extension so the Web browser knows how to handle the files. Sometimes a file has no extension, a two- or four-letter extension, (movie.qt, index.html) or several extensions (index.html.noswish.backup).

FIREWALL: Software that protects an organization's network from hackers and other potential intruders while allowing its users to access the Internet. You may have to ask your network administrator how to configure your Web cam and video-conferencing software to send and receive data through the firewall. Also called a proxy server.

FLASHPIX: A new image file format developed to facilitate the editing and on-line viewing of digital images.

FRAME GRABBING: Saving a single frame (picture) from a stream of video data.

FRAME RATE: Sometimes called frames per second (FPS). The rate at which a display is updated. Film is projected at 24 frames per second, standard (NTSC) video runs 30 frames per second. Computer monitors have rates of anywhere from 40 to 150. The image actually displayed on a computer, however, isn't necessarily linked to the monitor's refresh rate. High frame rates mean smooth action; frame rates below 15 seem choppy to the human eye.

FTP (FILE TRANSFER PROTOCOL): A method of moving files between two Internet-connected computers. FTP allows the user to sign into an Internet site for the purposes of retrieving and/or sending files.

GATEWAY: Hardware and associated software that provides access to another computer already on the Internet. Also refers to a "bridge" interface, something that allows a server-side program or data set to interact with users over the Web.

.GIF (GRAPHICS INTERCHANGE FORMAT): An established graphics file format created by CompuServe. GIF is the best format for handling graphic elements, such as corporate logos or line drawings. Most word processors, Web browsers and graphics-software packages recognize GIF files, since this format predates the Web. GIF indicates a 256- or 216-color (8-bit) lossless image file type that can be used on the Web, and that allows you to

remove an image's background color or assemble a series of images into an animation. See also *8-bit color*; *compression*.

GIF ANIMATION: A series of GIF images assembled into an animation using a program such as WWW Gif Animator or GifBuilder. The format is backward-compatible with the original static GIF format, but technically called GIF-89a. This new GIF format also allows transparency.

GUI (GRAPHIC USER INTERFACE): Applications and operating systems that allow you to create and manipulate files using icons, toolbar buttons, pull-down menus and dialog boxes rather than entering and reading arcane text commands and messages.

HTML (HYPERTEXT MARKUP LANGUAGE): The text language used to create hypertext documents for use on the World Wide Web. HTML looks like regular text documents with a block of codes that indicate how it should appear (size, bold, etc.). HTML files are to be viewed using a World Wide Web client program, such as Netscape or Internet Explorer. Many tools exist for authoring HTML without knowing any code.

HTML SOURCE CODE: The text document that contains HTML markup tags and supports the Web pages so that the pages can be displayed in a Web browser. See also *HTML*.

HTTP (HYPERTEXT TRANSPORT PROTOCOL): The protocol for moving hypertext files across the Internet. Requires an HTTP client program on one end and an HTTP server program on the other end. HTTP is the most important protocol used in the World Wide Web.

HYPERTEXT: Text that contains links to other documents through the use of HTML. "Clickable" or "hot" text.

INTERFACE: The look, feel and visual elements of an operating system or software application.

IP NUMBER: The unique number assigned to every computer that is connected to the Internet.

ISDN (INTEGRATED SERVICES DIGITAL NETWORK): A type of high-speed, dedicated Internet connection. ISDN is losing popularity due to faster and less-expensive types of connections, such as cable modems, ADSL and DSL.

ISP (INTERNET SERVICE PROVIDER): A company or organization that provides Internet access.

JPEG (JOINT PHOTOGRAPHIC EXPERTS GROUP): A 24-bit or 16-bit image file format that can be used on the Web and offers high-quality image displays at smaller file sizes. Uses a lossy compression algorithm.

.JPG: The extension of an image file that uses JPEG compression.

KB (KILOBYTE): A set of 1,024 bytes. *Kilo* means one thousand, but two (the digital magic number, the number of values a bit can have, 0 or 1) raised to the tenth power is 1,024, which closely approximates kilo.

KBPS (KILOBITS PER SECOND): The speed at which a modem or other

network connection allows you to download and upload (transfer) data, as measured in kilobits (1,000 bits) per second.

KEYWORD: A term that describes a document or image and provides an access point to it. Keywords may be assigned by indexers or may appear as a natural part of the searchable text. When keywords are assigned from a list of allowable terms, they are considered part of a controllable vocabulary.

LAN (LOCAL AREA NETWORK): A group of computers that are networked together (usually through a server) in an office. LANs are usually inaccessible to outsiders but allow users to connect to the Internet through a firewall. See also *firewall*.

LOSSLESS COMPRESSION: A way of compacting a file without losing any of the information contained within it. Used for text or other information from which it is imperative no data is lost.

LOSSY COMPRESSION: A way of compacting a file in which nonvital information is lost. Used for graphics, sound, video and other applications where imperfect reproduction is acceptable.

LOW RES: Attribute of a Web page image. Tells the Web browser to display a lower-quality (and hence smaller) image while a higher-quality (larger) image finishes loading.

MB (MEGABYTE): A unit of measurement for data and file sizes; 1,024 kilobytes (KB) equal 1 megabyte (MB). See also *kilobyte*.

MEGAPIXEL: Refers to digital cameras/monitors that can produce high-resolution digital images made of one million pixels or more.

MEMORY: See *RAM*.

MODEM: MOdulator/DEModulator. A device that enables use of telecommunications services—such as connecting to the Internet and sending faxes—through your computer. Converts digital messages into analog audio signals to send over a phone line, and turns audio signals received back into digital messages.

.MPG: A popular sound-enhanced video file format (MPEG) that was created by the Moving Picture Experts Group. The MPEG is used for compressing sound-enhanced digital video clips.

.MP3: The third (audio) layer of an MPEG file. It is a popular compressed sound format.

MULTIMEDIA: A catchall phrase for combinations of images, video, sound, text and animation. Extends back to slides and reel tapes, and ahead to holographic projectors and stereovision headsets.

NETSCAPE: Makers of the Web browser Navigator, one of the most common pieces of client software. Netscape also creates powerful server-side software and other network software.

OPERATING SYSTEM: The software that comes with a computer, tells it how to run and determines which programs will work on the computer.

Windows is the dominant system, followed by Linux, Macintosh, DOS, BSD, Be, Amiga and many others.

PARALLEL PORT: A computer's communication port that allows you to connect other devices, usually a printer. Parallel refers to the way data is sent through the port. The parallel port is now also used for scanners, external disk drives and other things. Due to the nature of the port, having more than one device chained to it may cause problems.

PHOTO CD: An image storage method for CD-ROM devices developed by the Eastman Kodak Company. Photo CD offers five different resolutions. Both the image format and the compression routine are proprietary.

PIXEL: Short for pixel element. The basic building block of every image.

PPI (STANDS FOR PIXELS PER INCH): Used to state image resolution. Measured in terms of the number of pixels per linear inch. A higher ppi allows for better-looking, sharper images.

PPP (POINT-TO-POINT PROTOCOL): This is the protocol that allows a computer to use a regular telephone line and a modem to make TCP/IP connection to the Internet.

.PPT: A file format (PPT) used for PowerPoint slide presentations. To use PPT for making a PowerPoint slide presentation as an attachment, make sure the recipient has PowerPoint Viewer, a free utility available from Microsoft.

PUSH TECHNOLOGY: A Web feature that allows a producer to send (push) information to clients who choose to receive it.

RAM (RANDOM-ACCESS MEMORY): Hardware that determines the task load a computer can handle without slowing down or crashing. The more useful and impressive multimedia software becomes, the more RAM it requires to run well. Upgrading RAM is very often the easiest way to boost a computer's performance.

REAL TIME: Describes images, video, and audio broadcasted via the Internet while the events being recorded are actually occurring. Also describes a process where actual time, not CPU cycles, determine the progress of an action. For instance, a real-time 3-D rendered object will move at the same speed across a screen on a fast machine as it would on a slower one, even if the frame rate is different.

RESOLUTION: The number of pixels per linear inch (ppi) in an image. A higher resolution means higher-quality images. Also used to describe printer, screen or scanner capabilities.

RGB (RED, GREEN, BLUE): A system used for representing colors of light on monitors. Each color is represented by varying proportions and intensities of red, green and blue. White is a perfect balance of all three at full intensity.

.RTF ["R-T-F"] (RICH TEXT FORMAT): A basic file type recognized by nearly all word processing software. By converting a file to RTF, you preserve most fonts and formatting. RTF enables people who use different applications or operating systems to trade documents. Mac users can read RTF files

created on Windows machines, and WordPerfect users can read RTF files created by Word users.

SCREEN SAVER: A program that displays a series of images (and sometimes plays sounds, too) when a computer is idle. Originally intended to prevent burn-in that can occur when a monitor displays the same image for great lengths of time. Modern displays would never burn in, and screen savers have become novelties.

SENDING RATE: In videoconferencing, the speed at which your video and sound are broadcasted to a conference room or an individual with whom you are chatting. See also receiving rate. In other uploading procedures, it is the same principle: how fast your data packets are being sent out.

SERIAL PORT: Physical ports used to connect modems, cams and other devices to your computer. *Serial* refers to the way data is sent through such a port.

SERVER: A computer and software that provide a specific service to client software running on other computers (browser). The term can refer to a particular piece of software, such as a Web server, or to the machine on which the software is running. One machine could have several different server software packages running.

SHARPENING: Applying an image-correction filter inside an image editor to create the appearance of sharper focus. Oversharpening often results in discolored lines and extra contrast that may be undesirable.

SHORTCUT: In Windows, an icon that you can create on your desktop (or anywhere you want) so you can launch an application or file more easily. The comparable feature on Macintosh computers is called an alias.

16-BIT COLOR: A display using thousands of colors, using a setting that enables up to sixty-seven thousand colors on a computer screen. A good compromise between image quality and smaller file sizes and faster downloads.

SLIP (SERIAL LINE INTERNET PROTOCOL): The older standard for using a regular telephone line and a modem to connect a computer to the Internet. PPP is replacing SLIP.

TCP/IP: The common language of the Internet and the standard way data is transferred. IBMs, Macintoshes and UNIX machines all use TCP/IP when sending data across the Internet.

TELNET: A method for connecting to a remote computer and using it interactively. You can telnet into a library's on-line catalog or commercial search service, for example, and use the system just as if you were on site.

TEXT HTML EDITOR: A program that allows you to create Web pages by entering HTML tags. Unlike graphical HTML editors, text HTML editors require that you work directly with source code files.

THESAURUS: A reference source listing words approved for use in describing images or other information and indicating their relationships to each other. Terms in a thesaurus may be broader than, narrower than, related to or

synonymous with other terms. A typical thesaurus for graphics can be found at http://lcweb.loc.gov/rr/print/tgm1/toc.html.

THUMBNAIL: A small representation of a picture suitable for quick browsing.

TIF or TIFF (TAGGED IMAGE FILE FORMAT): A popular high-resolution image file format for preparing files and images for print. Most cams do not support TIFFs, and TIFF files are not ideal for Web use. May be used with or without compression. Handles 16.7 million colors.

TILING: The process by which a single image is repeated across the background of a Web page or a computer's desktop to form a pattern.

24-BIT COLOR: Millions of colors, or a computer system setting capable of displaying up to 16.7 million colors on the screen. This is also called truecolor since it is capable of color variations so subtle that the human eye cannot detect them. Most 24-bit displays use three 8-bit values, one each for the red, green and blue light values. Other advanced 24-bit systems will distribute the bits across red, green and blue differently, depending on the nature of the image displayed, for maximum quality.

24-BIT IMAGE: An image containing approximately 16 million colors.

UNZIP: The process of opening an archive compressed with WinZip, PKZIP or other ZIP compression utilities.

URL (UNIFORM RESOURCE LOCATOR): The address of any resource on the Internet that is part of the World Wide Web. A Web page's address is entered inside of a URL. For example: http://www.photosource.com.

USENET NEWSGROUP: An Internet special interest bulletin board where public messages are posted by interested parties. Some Usenet newsgroups are meant specifically for the posting of images.

WEB HOSTING COMPANY: A company that provides space and advanced capabilities for your Web site but does not provide Internet access.

.WK1: A spreadsheet file format (WK1) originally created for the Lotus 1-2-3 program. By saving spreadsheets in WK1, you can share your spreadsheets with people using other programs. For example: If you use Excel, you can share spredsheets with someone using Lotus 1-2-3 or Corel Quattro Pro.

WORLD WIDE WEB: A graphically rich portion of the Internet that includes searchable databases, pictures, text, sound, video and software. This is, commercially, the biggest piece of the Internet.

Checklist

What To Do

☐ Discover what you like to photograph (your PS/A—personal photographic marketing strength/areas).

☐ Seek out editorial markets for those categories (make your market list).

☐ Begin making marketable content-specific pictures (P = B + P + S + I)—(picture = background + people + symbol + involvement).

☐ Establish contact with a small nucleus of photo editors in the editorial field whose needs match your collection (vertical theme markets).

☐ Expect to sell over and over again (in volume) to these markets (total net worth).

☐ Expect a long shelf life for your images (annuity).

☐ Become an expert in your field(s) (specialization).

☐ Link your specialization(s) on a personal Web site (home page).

☐ Put your Sunday images with a stock agency (do some research first) or a CD-ROM clip art producer.

What Not To Do

☐ Waste time on commercial stock photography (generic photos, exquisite clichés).

☐ Be all things to all photobuyers (generalist).

☐ Forget to check with photobuyer before sending a digitized file.

Let the Good Times Roll

As the Web becomes more prominent in the offices of editorial photo editors, you are going to find that the above principles are going to fall into place for you. Editorial photography is coming into its own.

Have you been building a collection of images in a specialization area? Photobuyers, once they realize the search power of the Web, are going to be using it to find you.

Editors don't look for pictures; they look for subject matter. If you have their subject matter, you are going to hook up with a buyer—a relationship that may last a lifetime. And because publishers usually publish in a theme (special interest) area, the relationship could last *more* than a lifetime. You'll be able to pass your photo files on to your heirs.

Index